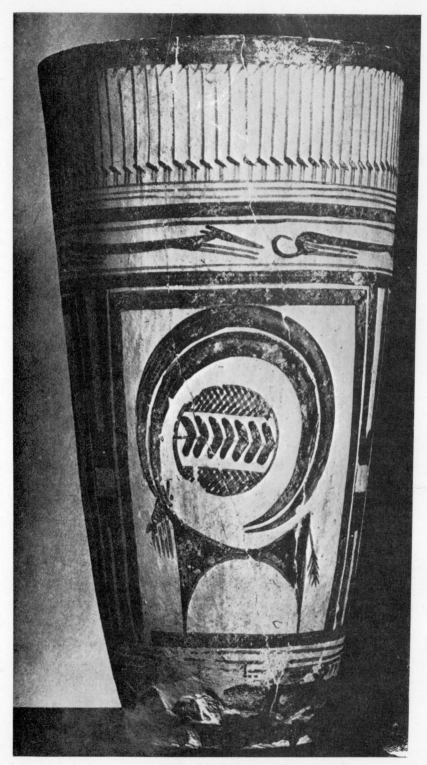

I. BEAKER FROM SUSA
(*pages* 2, 146)

ARREST AND MOVEMENT

At the still point of the turning
world. Neither flesh nor fleshless;
Neither from nor towards; at the still
point, there the dance is,
But neither arrest nor movement. And do
not call it fixity.
Where past and future are gathered . . .
 T. S. Eliot

To the memory of
MY FATHER

Arrest and Movement

An Essay on Space and Time
in the representational Art
of the ancient Near East

by
H. A. Groenewegen-Frankfort

HACKER ART BOOKS, INC.

NEW YORK

1972

First published by Faber and Faber Ltd.
London, 1951
Reprinted by Hacker Art Books, Inc.
New York, 1972

Library of Congress Catalog Card Number: 70-143349
ISBN: 0-87817-069-3

Contents

Contents

Book One. Egyptian Art

Contents

Book Two. Mesopotamian Art

Book Three. Cretan Art

Illustrations

Illustrations

HALF-TONE PLATES

Illustrations

Illustrations

xi

Illustrations

Illustrations

xiii

Illustrations

Illustrations

* The Assyrian reliefs reproduced in Plates LXVII—LXXXI are in the
British Museum.

Illustrations

Illustrations

FIGURES IN TEXT

Illustrations

Illustrations

Illustrations

ACKNOWLEDGEMENT

The author gratefully acknowledges the courtesy of the Institutions and Authors who allowed original photographs or reproductions from their publications to be used for the illustrations. The source of each of these is indicated in the Lists of Plates and Figures.

Abbreviations

Abbreviations

Amarna	N. de Garis Davies, *The Rock Tombs of El Amarna*, London, 1903–08.
Beni Hasan	Percy E. Newberry, *Beni Hasan*, London, 1903-04.
El Bersheh	F. Ll. Griffith and P. E. Newberry, *El Bersheh*, London, 1893–94.
Giza	Herman Junker, *Giza*, Vienna, 1929–47.
JEA	*Journal of Egyptian Archaeology*, London 1914–.
Kenamun	N. de Garis Davies, *The Tomb of Kenamun at Thebes*, New York, 1930
L.D.	Richard Lepsius, *Denkmaeler aus Aegypten und Aethiopien*, Berlin 1849-58.
Meir	A. M. Blackman, *The Rock Tombs of Meir*, London, 1914–24
Mereruka	Prentice Duell and others, *The Mastaba of Mereruka*, Chicago, 1938.
M.M.B.	*Bulletin of the Metropolitan Museum of Art*, New York.
Palace of Minos	Sir Arthur Evans, *The Palace of Minos at Knossos*, London, 1921–35
Ptahhotep	N. de Garis Davies, *The Mastaba of Ptahhetep and Akhethetep*, London, 1900.
Rekhmire	N. de Garis Davies, *The Tomb of Rekhmire at Thebes*, New York, 1943.
Sahure	L. Borchardt, *Das Grabdenkmal des Königs Sahure*, Band II, 'Die Wandbilder,' Leipzig, 1913.
Ti	G. Steindorff, *Das Grab des Ti*, Leipzig, 1913
Wreszinski	Walter Wreszinski, *Atlas zur altaegyptischen Kulturgeschichte*, Leipzig 1923–.
ZÄS	*Zeitschrift für altaegyptische Sprache und Altertumskunde*, Leipzig.

Preface

Preface

This book developed out of a desire to account for the eccentricities of spatial rendering in Near Eastern works of art. The most common explanations, such as the lack of knowledge of perspective and—more subtle and more hypothetical—the respect of early artists for the two-dimensional character of the surface, appeared unsatisfactory. For if one analyses and compares particular types of pre-Greek art, it will be seen that idiosyncrasies of spatial rendering, entirely consistent in themselves, not only vary in different regions but are, in fact, essential to the character of each style.

It would have been justifiable merely to register such idiosyncrasies, but I was tempted to ask if they might not have a significance beyond the field of art proper; in other words, if they should not be capable of interpretation in cultural rather than aesthetic terms. The question, though legitimate, has obvious dangers. For once one admits that the problem of space in art need not be limited to a study of formal characteristics; that this problem cannot be entirely divorced from that of time; and even that the question of the relation between art, life and thought is here particularly insistent, then the crucial problem must be faced: how can this relation be made explicit? For there is no short cut from formal analysis to cultural interpretation. Nor is it helpful to call to aid the content of the scenes depicted, if by this term we mean a mere paraphrase of supposed actions and situations, which by the very nature of this art are often enigmatic, as we shall see.

In trying to penetrate, however, beyond the apparent content of the scenes with the help of historical material in the widest sense, of speculative thought, of social and religious preoccupations; in trying to reconstruct what might—for lack of a better word—be called the implicit meaning of the scenes, I found that the unexpected happened: both significance and formal peculiarities proved strictly correlated as soon as they were seen under the aspect of their space-time implications. In fact changes in the one corresponded most strikingly with

changes in the other, and spatial idiosyncrasies therefore suddenly
became 'significant'.

Unfortunately I found myself soon faced with a peculiar difficulty.
Although the term 'space' in post-Greek art is a familiar concept
which only pedants would stop to define, this is emphatically not the
case here. It is in fact a matter of uncertainty in what sense we can
speak of space at all. I have therefore—at the risk of antagonising
the general reader—first tried to clarify some concepts, and in particu-
lar to show the interpenetration of spatial and temporal categories,
before discussing the actual works of art. Those who dislike abstraction
may well ignore this part which for obvious reasons could not be rele-
gated to an appendix. They will find the necessary references in the
Index.

Apart from this section I have avoided formal abstractions, although
the words 'space' and 'time' appear in the sub-title. None of the three
groups of remains dealt with would have yielded the secret of their
space-time character to *a priori* reasoning. The questions asked, the
categories used, were all prompted by the actual material and will
be seen to vary with each stylistic unit. Yet it appeared that in the
Ancient Near East representational art was haunted by certain funda-
mental problems which were solved in different ways but reappeared
throughout. One of these, the problem of monumentality, has of neces-
sity become the *Leitmotiv* of this essay.

INTRODUCTION

A Clarification of Concepts

A. TWO-DIMENSIONAL SPACE

The problem of space in pictorial art is a problem of relation. It arises wherever points, lines, or surfaces are intentionally related to each other: the interval which separates them is then a significant void. This void will be conceived as two-dimensional if it appears in geometric decorative design on taut surfaces (we include globular or cylindrical ones); but even in representational art it may lack all depth if, as in silhouettes or shadow-figures, bodies are, or appear to be, projected on a plane.

In geometric design, this two-dimensional significant void is the correlate of rhythm, balance, or proportion; in the case of shadowy projections of human or animal figures it may also be the correlate of an implied dramatic or psychological situation. It is then a 'field' for tensional forces. This field represents a spatial world unlike our own, except in so far as its orientation may coincide with ours. A shadow figure on a blank screen is not surrounded by chaos; for, if its position is not arbitrary but related to an imaginary base, it is surrounded by a spatial unit, a flat world in which up and down are orientated like the spectator's high and low.

It must be remembered that the projection of bodies is, generally speaking, a playful trick which, as in shadow play, conjures up a two-dimensional dream world. As such it belongs essentially to the realm of artistic fantasy (or of cheap realism if only outline-likeness is aimed at) and lies outside the serious pre-occupation with actual form which harasses the creator of representational art. But although deliberate projections rarely occur apart from playful use, some ways of rendering bodies on a flat surface come very close to it. We find, for instance, both in decorative and representational art, animal shapes whose outlines practically coincide with silhouette contours. If only the outlines

are given, our imagination is apt to fill in the blanks with rounded forms; the surrounding void may then appear sheer depth. But in the case of Susa pottery (Pl. I, IIa) or Egyptian red ware (Fig. 1) a black-

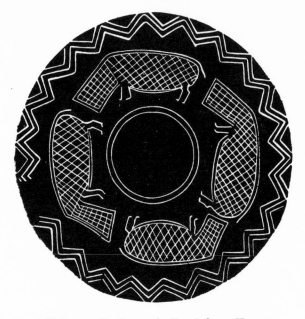

FIG. 1. *Predynastic Bowl from Egypt*

ening or crosshatching of the body frustrates the efforts of imagination. Where rows of such figures occur they appear to move in a two-dimensional 'field' like the curiously flat animals we may see on the skyline against a depth-devouring sunset. Such art is completely surface-bound even where it does not destroy all suggestions of depth by boldly reducing organic forms to a more or less geometric pattern. There are even rare instances of human figures which show this binding to the surface. The sturdy little man on the black-figured vase (Pl. IIb) runs in a posture which comes singularly close in outline to an actual shadow projection of a running figure, for the violent movement of his arms necessitates the twisted torso. Moreover, the running hare on the opposite side explains his actions and makes the void around him a tensional, significant void. Hence the plausibility of his fantastic chase and yet its dreamlike unreality. Banned to the surface of the vase, the little man must run his course around it in a depthless world. Such instances are, however, as rare as freaks and nearly always playful.

2

Space and Corporeality

The problem of space in connection with the rendering of bodies other than in shadow-form is so complex that we intend to proceed from the familiar to the unfamiliar. And a familiar aim (though lately in discredit) in rendering objects is to achieve a maximum of illusionary corporeality; the object must *appear*—not only be comprehended—as three-dimensional. What constitutes corporeality, however, is a functional[1] relation between object and observer and the only way to make this function explicit in an image would be to render the contour and proportion of the object as if it were a projection on a transparent screen cutting the observer's lines of vision—in other words, to render the object as seen. In order to produce an equivalent image, any surface used would have to be considered as substitute for such an imaginary screen. The contour and proportion of such a rendering will not have the validity, the finality of a shadow-form, but can only be understood in terms of reference, of relation to the observer.

This has two implications of importance for our subject. Firstly, all rendering which aims at illusionary corporeality—and we shall in future refer to it as functional rendering—implies, on the one hand, a wilful act in the choice of viewpoint and, on the other, a resignation in that it accepts the 'autocracy' of the solid form, its inner coherence: no mere viewpoint can tamper with the co-ordination of its parts; foreshortening, overlapping must be registered. And secondly, an object thus rendered is conceived as existing in space, the familiar three-dimensional space which comprises both it and its observer; in fact, corporeality and existence in space are concepts which mutually require each other. Consequently, the surface on which the image appears is no longer self-sufficient. As substitute for the transparent screen, it loses, as it were, its solidity, becomes the pretext for a spatial illusion—a mere window. A single projected silhouette is surrounded, as we saw, by an alien flat world; but the isolated image of a figure rendered as observed, by a conceptual, three-dimensional void, appears to exist in space.

We said that objects rendered as seen (that is, in a definite spatial relation to the observer) will usually show foreshortening and overlapping. Where the human figure is concerned, there are two points of view in which the technical problem of foreshortening provides least difficulty: namely, profile and full-face view (here nose and feet

[1] We use the term 'functional' here exclusively as implying a relation between variables.

3

form the main stumbling-blocks). We shall see later that when corporeality in the functional sense is definitely not aimed at, even profile and full-face renderings are often assiduously avoided.

On the other hand, when they are used, a profile or a full-face figure, even in barest outline, will, on the strength of its definite spatial relation to the observer, quite unintentionally, perhaps, appear not only three-dimensional but as existing in space. It is interesting to compare the following isolated figures, one from a period which precedes the 'discovery of perspective' (Pl. IIIa), one from the time when this discovery was fully utilised (Pl. IIIb), and one in which it was deliberately ignored (Pl. IVa). In all three instances a 'halo' of three-dimensional void is unmistakable, all three appear to exist, almost to float, in space.

When bodies which are rendered functionally are depicted in relation to each other, the space which separates them also appears a receding void. Two human figures thus rendered against a so-called neutral background may be related by gesture or mere awareness of each other's presence; they will be separated by the same conceptual void in which both they and the spectator are contained.

It must be realized that although the observer's viewpoint is more or less fixed it is not identical with the centre of observation of scientific perspective. In a small group of, for example, two figures in profile, the spectator's viewpoint has considerable latitude (provided no material setting is indicated), since figures seen in profile may have axes which converge either more or less towards the spectator. With larger groups of figures the spectator may have to move along a line of successive viewpoints (with vase paintings this is, in practice, an inevitable procedure—one turns the vase round), but even this shifting viewpoint need not impair the corporeality of the figures or the character of the surrounding space. Only where adjoining scenes are conceived as spatially unrelated units does the blank which separates them lose its character of conceptual space. It then becomes a mere hiatus.

In the foregoing we have implied that the figures and objects appear on a neutral or blank background. The term 'background', however, may also be used in the sense of a separate feature such as a patterned surface or solid colour surrounding the figure or even as a 'setting'. The effect on space of the first depends on whether or not the ground-lines of background and figure coincide. Where they are separated by even a narrow strip, pattern or colour acts as backdrop and the figures appear in a well-defined stage space.[1] Where they

[1] This term is introduced by Miriam Schild Bunim, *Space in Mediaeval Painting and the Forerunners of Perspective* (New York, 1940).

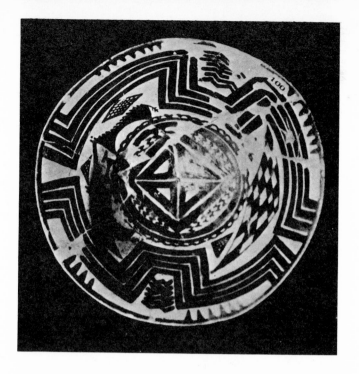

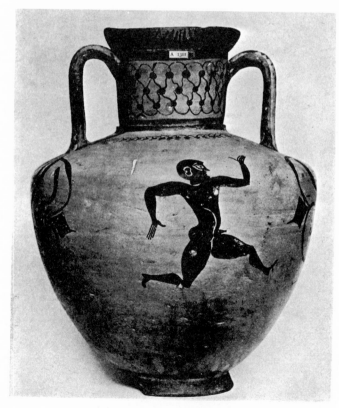

IIA. BOWL FROM SUSA
(pages 2, 146)

IIB. RHODIAN VASE
(page 2)

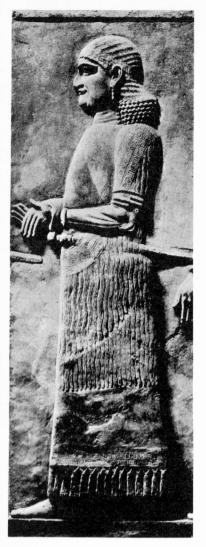

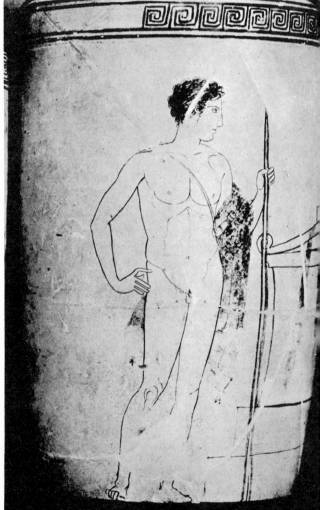

IIIA. ASSYRIAN FIGURE
(*page* 4)

IIIB. GREEK FIGURE
(*page* 4)

coincide or where an isolated figure is set in the midst of such a background, spatial imagination is frustrated and a curious conflict arises between the 'corporeality' of the figure and the depthlessness of the surrounding. The result may either be, as in the case of Pompeian black foil,[1] a decorative absurdity or, as in the case of Byzantine gold backgrounds, a reduced significance of the corporeality of the figures which may enhance their mysterious potency. Only the colour blue will, for obvious reasons, invariably suggest sheer depth.

Background as 'setting' means that a spatial relation is intended between figures and objects, landscape, or architectural units, when their position is not on the same actual or imaginary groundline. Where figures in functional rendering do appear on the same ground-line it acts as skyline, as horizon, but superimposition means that the higher ones are conceived as receding in space. This space may be left a more or less inarticulate emptiness for spatial imagination to wander, vertical features may be brought into view without coherence (Pl. IVb), or a kind of geographic discursiveness may be indulged in (Pl. Va). But a true functional rendering of figures in their setting means that the fluidity of viewpoint must be reduced to the pin-point precision of scientific perspective.

C. THE TIME ASPECT OF ORGANIC FORM

We have so far omitted distinguishing between the functional rendering of organic form and inanimate objects. This becomes inevitable when they are viewed under the aspect of movement, that is, of space and time.

Human beings and animals—we shall consider vegetable forms later—are potentially mobile, their posture and gestures must imply a moment of transient activity or equally transient repose (Pl. IIIa). Therefore, a choice of moment, no less than a choice of viewpoint, determines the pose of functional rendering and the implicit transitoriness of that pose is quite independent of the fact that either a phase of movement or rigid immobility may be chosen, for organic immobility is never absolute. The term 'corporeality' has in connection with such figures a temporal connotation and the term 'space', denoting the surrounding void, a dynamic one—it is the space in which movement may occur. But in this pregnant sense the terms are applicable only where the inner coherence of organic form is left intact; in other words, where the

[1] L. Curtius, *Die Wandmalerei Pompejis* (Leipzig, 1929).
We may note that in Wedgwood pottery with applique figures in thin relief a blue background is preferred.

autonomy of movement as well as the autocracy of form is respected and not destroyed by a more or less wilful arrangement of different parts which would obviate their interdependence.

We thus reserve the term 'organic corporeality' for functional rendering, but it is not merely a paradox that, in a derived sense, it *may* be applied to shadow-figures and the strange flat world they inhabit. For if silhouettes are *understood* as a projection they are thereby functionally related to the projected object—not to the observer—and will not only suggest an analogy to organic coherence but retain dynamic associations. However, even the temporal connotation of a 'lively' shadow-figure will vanish if it is reduced to a pattern or used in purely decorative context.[1] In this case, it may be enslaved and bound to design, reduced to a matter of lines and curves, and will no longer appear a potential centre of activity. The ibexes on Susa pottery are a case in point (Pl. I). They are so superbly characterized by the taut curve of the resilient body, the tense contraction of the legs, the exuberant swing of the horns, that, though by no means projections of actual forms, they appear to have inner coherence and are not built up out of geometric abstractions. But they also form an intricate pattern which harmonizes with the decorative scheme and the essential forms of tall slender beakers and which on round bowls accentuates circumference and radius (see below, p. 147). The result is that these animals seem neither moving nor at rest: they are pure form, all temporal connotation is absent.

Even if functionally rendered organic forms are almost reduced to a pattern, in emblematic and heraldic devices, the figures may lose their actuality and become transfixed rather than caught in motion. Where the lively scene of browsing goats has been made into a mere antithetical group or the violent action of heroes fighting beasts into a decorative arrangement of limbs (Pl. Vb), their posture loses its transitory quality.

Yet another time aspect will have to be considered. For if figures are depicted in relation to each other (see below, E), either explicitly in action or implicitly in a 'known' dramatic situation, the resulting scene has temporal as well as spatial implications: the gestures made are conceived as simultaneous (Pl. XXXIX). We saw that in a large group different spatial units may merge or fall apart—the unity of action, too, may either shift surreptitiously or different stages may be separated by an 'interval'.

[1] We exclude here the use of figures for the embellishment of objects if the relation between the two is merely one of surface and ornament without aiming at the integration of form and pattern, e.g. Queen Victoria's bust on a commemorative teacup.

Ambiguities of Nonfunctional Rendering

It is curious that although the transient quality of a scene depends on the type of action or situation depicted, its transitoriness is usually intensified, as if by contrast, through the presence of inanimate objects or landscape features (Pl. VIII). Spatial and temporal definition, here brought into relation, will both enhance what we shall henceforth call the *actuality* of a scene.

D. THE AMBIGUITIES OF NONFUNCTIONAL RENDERING

We found that when bodies are projected on a plane in shadowform or rendered as observed, the surface space surrounding them is conceived as two- or three-dimensional, respectively. The first manner is mainly restricted to playful or decorative use, the second to Greek and post-Greek art. Ancient Near Eastern art, on the other hand, shares with most 'primitive' and nearly all children's art a way of rendering objects which differs fundamentally from either and has a different significance of the surrounding void as its concomitant. As methods they have often been lumped together and labelled in a variety of ways as 'paratactic',[1] 'vorstellig',[2] or 'ideoplastic'.[3]

In order to avoid all psychological connotations, we suggest calling the manner in which they render objects 'nonfunctional'. This negative term means that, logically speaking, such rendering is independent of the actual appearance in space of a figure—it lacks an unambiguous spatial relation between object and observer and therefore lacks corporeality in the functional sense of that word. By no means does it imply a lack of interest in—or visual knowledge of—natural forms, nor does it simply mean the rendering of what is known rather than what is seen, in the way some 'ideoplastic' children's drawing consists of a mere addition of known features. Non-functionalism (*sit venia verbo*) is a logical concept, not an aesthetic or a psychological one. It is characteristic of nonfunctional representations that the surface is neither a completely dominant factor nor reduced to a mere opportunity for spatial illusion, but that the conflict between the three-dimensional object to be rendered and the two-dimensional opportunity given has not been solved in favour of either.

This conflict is generally least acute in the rendering of animals; for a profile outline happens to be the one most capable of rendering the characteristics of animal form, if its major axes run parallel with the surface plane, and this facilitates a simple transference of contour

[1] G. Krahmer, *Figur und Raum in der aegyptischen und griechisch-archaischen Kunst* (Halle, 1931).
[2] H. Schaefer, *Von aegyptischer Kunst* (Leipzig, 1930).
[3] Max Verworn, *Ideoplastische Kunst* (Jena, 1914).

on surface without reference to viewpoint. The movement of head, limbs, and tail may occur in the plane or parallel to it. Therefore, except in the case of horns, no conflict need be realized between surface plane and the orientation of form and movement.

With solid angular objects a conflict can be avoided by projecting one side only. But if for the sake of a detailed description more sides than one are to be brought into view, their relative orientation must be ignored (Pl. Xa); aspects may be added but they cannot be co-ordinated as long as the surface as such is respected, not used as pretext for a spatial illusion.

It is the human body which presents the greatest problem—a problem unsolved, e.g. in palaeolithic art with its unerring sureness of touch in animal figures. For there is no way of transferring the contour of a human form, especially in movement, to a flat surface in which the problem of depth does not become acute: the most explicit characterization of one part of the body will claim a different orientation from that of another part and the multilateral movements of head and limbs in action will not all be parallel to the surface plane. Therefore, some kind of analysis, some kind of synthesis, will be needed in order to adapt them, unless the conflict is shirked by hiding the body in shapeless garments. Either the three-dimensional co-ordination of various parts must be ignored and, for instance, a profile head and legs, a front-view torso be paratactically combined (that does not merely mean *added*) in order to obey the summons of the surface plane (Pl. VI), or articulation must be sacrificed and the figure made 'amoebic', as it were, by giving it a vague fluid outline (Pl. IXa, bottom). We shall see in the next section what effect this has on the organic coherence of the figure and the problem of movement. We shall here only consider the question of corporeality and space.

Robed and amorphous figures may, even in the case where shoulders prove to be an insuperable difficulty, give a suggestion of cylindrical corporeality (Pl. LXV, left). The notion of a functional relationship in connection with cylindrical forms is, of course, meaningless. Yet the suggestion of roundness will affect the surrounding background, make it appear somewhat like empty space while only the far shoulder appears pushed forward (by the hard surface).

In 'amoebic' figures limbs are not articulate parts of a solid structure but more like soft excrescences. Here, as in the case of molluscs, the question of three-dimensional co-ordination barely arises. The Cretan deer of Pl. LXXXIV and the figures of slain men on Pl. IXa not only lack true corporeality but the space surounding them is also ambiguous; they seem to float in a medium which baulks spatial imagination.

8

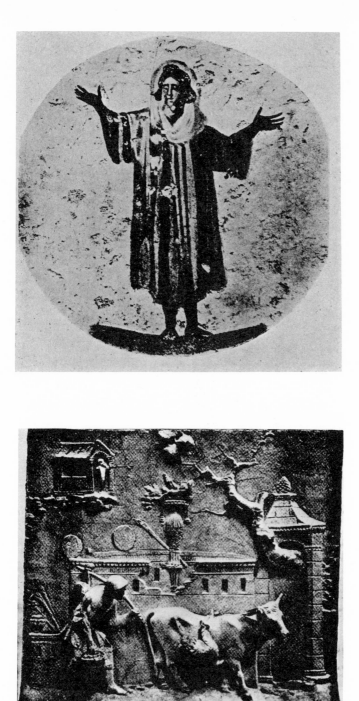

IVA. PRAYING FIGURE FROM CATACOMBS
(*page* 4)

IVB. HELLENISTIC RELIEF
(*page* 5)

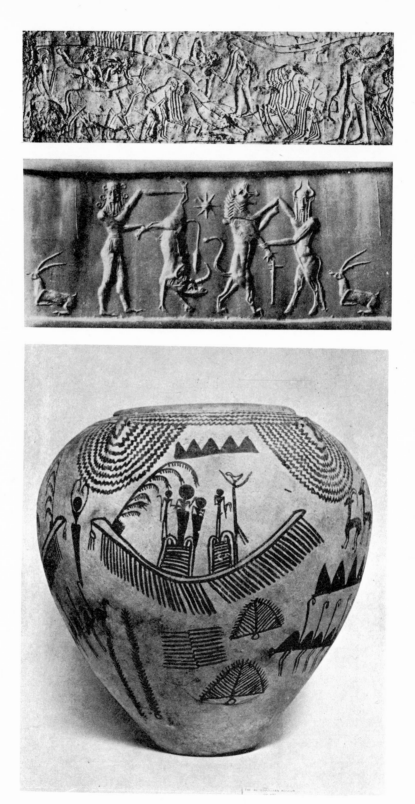

VA. EGYPTIAN AGRICULTURAL SCENE (*page* 5)

VB. IMPRESSION OF A MESOPOTAMIAN SEAL (*page* 6)

VC. 'DECORATED' PREDYNASTIC VASE (*page* 16)

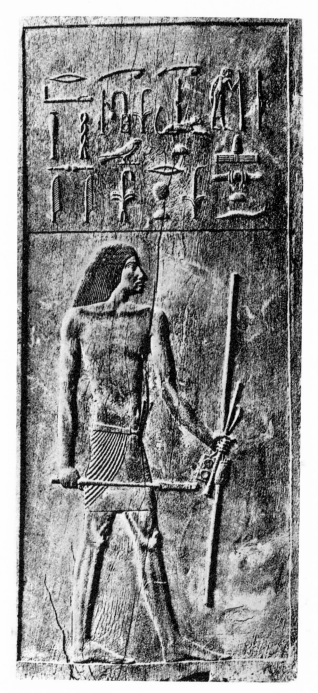

VI. WOODEN PANEL FROM THE TOMB OF HESIRE
(*page* 8)

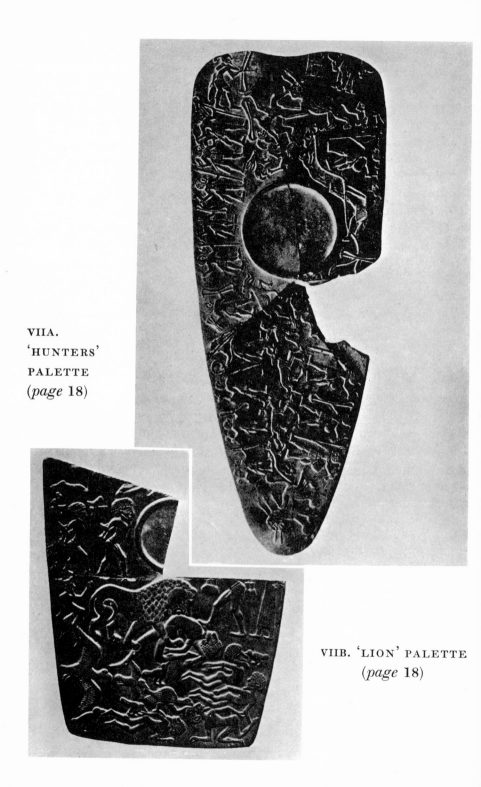

VIIA.
'HUNTERS'
PALETTE
(*page* 18)

VIIB. 'LION' PALETTE
(*page* 18)

Ambiguities of Nonfunctional Rendering

Where, on the other hand, figures are paratactically composed (Pl. VI) and contour and proportions neither merely transferred nor determined by the relation between observer and observed, the images do not hint at a reality beyond the pictured surface nor are they like shadow-forms entirely caught in or part of it. In other words, they seem neither quite round nor flat, the background neither solid nor transparent.

This becomes clear when we compare the Egyptian figure of Pl. VI with the Greek one of Pl. IIIb. The latter, functionally rendered, is so unambiguously corporeal that we can move around it in imagination. To attempt this seems an absurdity with the Egyptian figure. In fact, when once and once only in a historical development of several millennia the three-quarter back view of a serving girl appears in a Theban tomb with the proportions of perfect functional rendering (Pl. XXXIII, top left),[1] the effect is positively startling. She appears a strange disturbing phenomenon in a spatial world which, for better or worse, is alien to ours. It is emphatically not even the narrowest 'stage space'; the emptiness around the figures is neither a mere field for phantom movement nor the dynamic space which, as we saw, is the correlate of organic form, The figures often appear neither active nor in repose; their gestures, even if explicative, seem fixed, robot-like, not transitory. In fact, the time aspect seems here as problematic as the space. This should not be surprising for we saw that nonfunctional rendering in adapting solid form to flat surface must sacrifice either the co-ordination or the articulation of structural parts. This means in the case of organisms that their relative position in any phase of movement must in many cases remain problematic. For only where movements actually occur in one plane can this position be transferred without reference to the spectator's viewpoint and yet not result in ambiguity. Pliable stems of plants, fishes, molluscs, and most quadrupeds are docile forms in this respect. In simple projection their posture may appear quite plausibly organic and therefore transitory. Consequently, the solid background will become diaphanous, as it were, and may represent either the emptiness above a horizon line or the roominess of subaqueous worlds. The human figure alone remains obstreperous; a complex structure of solid parts with multilateral mobility, it will in nonfunctional rendering appear the less organic, the more articulation is insisted on.

It is curious, for instance, that in the case of a Mesopotamian figure, the spiral fringe of a nondescript garment somehow hints at

[1] See on this figure the remarks of Hertha Mohr, *The Mastaba of Hetep Her-Akhti* (Leiden, 1943), p. 6.

organic unity (Pl. LXV). The twisted shoulders seem awkwardly incongruous but the gestures of arms and hands may appear more organic, more lively than the smooth pattern of a far more detailed paratactic rendering such as we find in Egypt.

An articulate figure in nonfunctional rendering will only appear organic if a particular movement necessitates such violent contortions as to bring limbs and torso into one plane. But where a figure is merely composed and limbs are wilfully arranged, not caught in motion, the autonomy of movement is bound to be violated and the problematic space surrounding them can no longer be called dynamic.

The latter term would, on the other hand, apply in a restricted sense to the ambiguous space surrounding 'amoebic' figures (Pl. IXa, bottom). For their posture will show inarticulate coherence and the tentacle-like stretching of boneless limbs may appear transitory; it is paradoxical that in the predominantly paratactic figures of Egyptian art the only instances where the term applies appear in the case of limp postures of slain or falling men.

E. THE PROBLEM OF COHERENCE OF SIGNIFICANT SCENES

Those who were patient enough to follow the rather dreary path of abstract reasoning will have to face one more difficulty before tackling the monuments, namely, the question of what in actual fact constitutes a scene. Can we trust self-evidence if we are to decide whether a conglomeration of figures is intended to represent coherent action, whether juxtaposition means proximity? We shall have plenty of opportunity to note that we cannot, but must rely on imaginative interpretation.

Now the logical difficulty that we should in a sense have to create the unity of a scene, while this unity must be in some manner pictorially manifest if our interpretation is to have any validity at all, is a real difficulty only in nonfunctional representation. Modern art often ignores space-time unity deliberately, while in Greek and post-Greek art the scenic intention is usually obvious—even explicit—where, as in the case of Greek vases, the names of the actors are added and the meaning of the scene can be corroborated by literary evidence. But in pre-Greek art with its 'problematic space', its ambiguity of movement —we shall see it can often not be decided if a figure is striding or standing—the word 'scene' may hardly be warranted, may in fact be utterly confusing just because it has the definite connotation of dramatic actuality. Here to decide if figures are intended to be spati-

ally related is often unanswerable, and the interpreter is in constant danger of reading into a scene what he wants to deduce from it and of explaining the absence or presence of features which do not tally with his interpretation as artistic incompetence.

We cannot by-pass this vexing question, which in practice can never be solved satisfactorily. All we can do is to avoid treating the pictorial evidence high-handedly, to draw on all available material, historical and literary, for our interpretation, and to leave room for what may well have to remain enigmatic in such remote and alien material.

Book One
EGYPTIAN ART

CHAPTER I

The Pre- and Proto-historic Period

A. REPRESENTATION AND DESIGN

The astonishing duration and homogeneity of Egyptian art proper, which appears a *fait accompli* already in the Third Dynasty and keeps its identity through various phases of growth and changes of mood for two thousand years, may well tempt us to ignore its antecedents; but the peculiar temperament of this art as regards 'arrest and movement' is better understood when we see how it emerges in yet experimental stages, how certain forms are accepted and tenaciously adhered to, others rejected. The art of the proto-historic period, however, is linked so closely with still earlier phases that we shall have to deal briefly with the history of representation in Egypt and start with the crude images on prehistoric pottery. It will even be useful to look, for a moment, across the formidable gap in space and time which separates these figures from palaeolithic art; for if, in tackling the problem of space, we consider the relation between figure and surface or figure and figure, we notice a striking difference here.

Palaeolithic cave art, predominantly concerned with animals drawn in profile, shows complete indifference towards their appearance on the surface. The images are scratched into or painted on cave walls and ceilings in every conceivable direction, overlapping, superimposed, upside down, without a trace of orientation. There is, in fact, no relation whatever between form and background; the single form is simply set off against chaos.[1] If we were to see such a figure singly, it might have the usual spatial halo; but this halo will vanish when several figures together make their lack of orientation apparent. Now in comparing this peculiarity with post-palaeolithic art we might look for a difference similar to one we may observe when a child no longer scribbles

[1] G. R. Levy, *The Gate of Horn* (London, 1948), Chapter I.

on a sheet of paper in all directions, because he is merely concerned with the images he wants, but when he keeps the sheet in one position and treats it as a spatial unit, however vague, a world with up and down —his own, the spectator's up and down, in fact. But in neolithic art the matter is actually more complex since representation as such was not yet the main preoccupation.

It must not be forgotten that when neolithic agricultural communities, in Egypt as elsewhere, had lost the palaeolithic hunter's exclusive interest in animal life, their main artistic concern was with ceramics, that is, with the creation of new plastic forms and a type of abstract ornamentation meant to emphasize and to enhance these forms. What these primitive artists achieved was, in fact, a new world of 'order, measure and relation'. When, by and by, representational images appear in decorative context these are applied on shaped, smoothed surfaces which demanded respectful attention. Organic forms, both animals and humans, were then at first boldly treated as a pattern, simplified, dissected, and joined again to form a decorative motif. Where this was not the case, as for instance with the squat forms of hippopotami (Fig. 1), they might be simply arranged in a circle inside a shallow bowl, their orientation entirely subordinated to decorative intent. The earliest type, the so-called 'white cross-lined' pottery, shows this particularly clearly, although it also may occasionally happen that the surface of the vase does not indicate the arrangement of the figures, in which case these will suggest a primitive type of scene. The slightly later, so-called 'decorated', vases seem to hover between the two extremes of pure design and representational art proper. True, the boats, animals, and humans which occur are vertically arranged in groups that form a pleasing rhythm without the slightest consideration for logical coherence (Pl. Vc). No pictorial statement seems implied except, perhaps, in the case of the boats which may have funerary and symbolical significance. Human figures as well as animals are a mere matter of solid triangles and tendrils and none of the figures are in any way spatially related though, in a few instances, the human figures are joined by contact in a schematic action. And yet the mere fact of their vertical orientation gives to the background the quality of depthless, undifferentiated space. Somehow these schematic figures no longer appear in a pure correlation of surface and pattern like the hippopotami on the bowl.

A curious stylistic transition between prehistoric and proto-historic art exists in the wall painting at Kom el Ahmar (Fig. 2), which heralds a trend towards representation for its own sake. The carefully prepared section of the wall gave ample opportunity for pictorial experi-

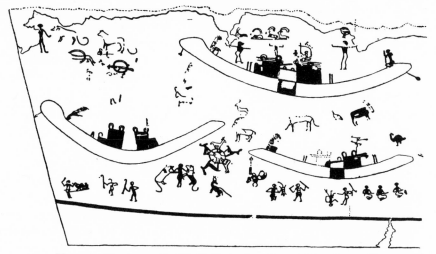

FIG. 2. *Predynastic Wall Painting from Hierakonpolis*

ment; and though some vague general scheme of decoration with large shallow boats appearing at intervals recalls the 'decorated pottery', the innovations are very striking. The figures are no longer shadowy or covered with a pattern: they have a differentiated surface which shows realistic intention; the rendering of a single creature, not an abstract scheme, was aimed at. Moreover, action is depicted and figures are related not only by the simple means of contact but even by proximity. They are rather wildly scattered, but all vertically orientated; one of the animals is pictured with its head turned back—although no pursuer is indicated. And in two instances figures are bracketed by what appears to be a groundline, the ibexes at the top and the human figures in the left bottom corner. These are particularly interesting because, for the first time, an ideogram for the slaying of enemies is evolved in which the three little figures appear as an abstract plural rather than a group. The almost heraldic antithetical group in the centre and the presumably conceptual rendering of such a complex situation as five animals in a trap (if this is actually what is represented) completes a series of experiments never quite equalled by any later Egyptian monument. Even the figures themselves, ill-executed though they are, show a kind of adventurousness in postures and contours. The severe pattern of female figures which we found on decorated pottery is here replaced by ugly, but more realistic, bodies with frantically outstretched arms. In general the figures have a dynamic quality; and the whole arrangement of the figures on the wall is no longer subordinated to, and restrained by decorative purposes. Representation was the primary aim, and the freedom which the large wall could give was exploited

with utter recklessness. The result, at least in the lower register, is some faint illusion of amorphous space, less depthless than that on the decorated pottery.

B. AMORPHOUS SPACE AND SPACE-TIME DEFINITION IN PROTO-HISTORIC MONUMENTS

We do not know of any monuments[1] in the proto-historic period which would give the artist a similar scope. We find beautiful carvings on utilitarian objects, such as palettes, knife handles, maceheads, and their votive replicas. Here decorative purpose can never be quite lost sight of in the arrangement of figures, however much the artist's interest shifted towards representation. Yet it is on these very objects that we can follow the development which leads to the inflexible code of later Egyptian spatial rendering. They do, in fact, embody the proto-history of classical Egyptian art.

The earlier remains of this period—the so-called hunters' palette (Pl. VIIa) and some of the ivory knife handles,[2] often teeming with animal life and human figures in pursuit or bearing standards—show generally such chaotic lack of grouping that one might assume a complete unconcern with anything approaching questions of space: the rounded surface of the palette would naturally invite grouping around the rim and simple filling. Any spatial illusion which the vertical arrangement of rows of figures might evoke—as in Pl. VIIa—is then shattered by the amorphous mass in the centre; and yet some of the groups, when isolated, show definite spatial relation, while even in the single figures, animals in profile (except for the horns), and humans in pure or near profile achieve a vigorous and convincing corporeality, enhanced by a wealth of detailed modelling, far removed from the geometric abstractions or the incompetent realism of earlier periods.

Pl. VIIb, on the other hand, shows no trace of subservience to decorative needs. The circumference as such is ignored, and all interest is focussed on representation. Figures are no longer aimlessly scattered but make a *scene* in which birds, fallen men, and central group have an as yet indefinite but unmistakable spatial coherence which causes the lower group to form a foreground. All figures here are related by either action, interest, or intent. The birds flying towards the slain men or merely looking at them are not explicatory picto-

[1] It has proved unavoidable to treat the rendering of figures in relief and painting indiscriminately. This is justified because in the Ancient Near East both are first and foremost a type of drawing.

[2] G. Benedite, *J.E.A.*, V, Pls. XXXII—XXXIV.

grams, but form a group which, though it has no spatial clarity as yet, has undeniably three-dimensional intention. The effect of a coherent scene is intensified by overlapping limbs (note the prisoners in the right-hand corner and the attacking lion), by the gesture of the figure on the left, running away from, but looking at the lion, and by the odd incidental stepping of the captive on his fallen comrade, which links two disparate groups. It is a pictorial narrative as bold as it is innocent of the problems it seems to solve; it has something of *naïveté* and playfulness, soon to be lost and never again quite to be regained. For evidently already in this period statement, more than illustration, soon became the primary concern. If the names of captured towns and the number of prisoners taken have to be recorded, symbolical signs are needed. The use of these, however corporeal their rendering and plausible their acts (note the standards holding and leading captives), is apt to shatter the illusion of spatial unity.

In this respect the macehead of King Scorpion shows a new venture (Pl. VIII). The figure of the king appears to stand on a groundline, but it is not the topographical abstraction of a later period. It is a lightly undulating line which apparently forms the river bank. The figure itself is not rendered functionally but has both clarity and articulation and its gesture is vigorous, not that of a robot. It has the tension of an organic unit and its pose the transient quality of an actual gesture made, in contrast to the picture of Narmer (see Pl. IX). Also, the over-lapping fans behind the head and the near-profile view of the stooping attendant, whose right hand disappears behind the basket, gives a faint illusion of three-dimensional space. Most curious is the attempt at giving topographical detail—the winding river or canal and the crooked enclosure with the trees. These are no mere explicating accessories; they show a confusion of 'aspects', admittedly, but have an unmistakable air of visual unity. This is perhaps best explained as resulting from the incidental placing of the enclosure, the urgent but not very purposeful gestures of the figures, one of whom holds his pick so ineffectually as to remind one of a genre painting. The bold attempt to combine figures and setting was premature and bound to fail, yet it enhanced the *actuality* of the scene, and gave it its character of a single event. True, there is no question yet of dramatic unity in the sense that the action of the king and that of the figures below are of necessity simultaneous though they seem part of the same occurence. But it is interesting to note that the transitory quality of the gestures is dependent less on the speed or violence of the action than on the space-time integration of the rendering. It is therefore with something like regret that one leaves behind the last illusion-

istic topographical curve (barring a few hillocks in later hunting scenes)
for one and a half millennia and with it practically the last appeal to
spatial imagination. From now on a tyrannical and rigid groundline
is the rule.

We cannot say with certainty when this makes its first appearance.
Somewhere between King Scorpion and King Narmer seems most
likely, for on the fragment we analysed it is already used to bracket
a group of symbols. In the fragment shown in Pl. Xa, its discipline can
be appreciated, for it has tamed the unruly mob of the earlier palettes
(although it seems to have robbed every creature of some of its mys-
terious potency), and coerced them to move evenly. But with Narmer's
palette (Pl. IX) the insidious potentialities of a groundline have be-
come apparent. It binds each figure to a definite unspecified locality.
None of them can longer float in an amorphous or confused setting.
But this same depthless and anonymous locality, this line, bans all
figures to the pictorial surface and limits their spatial coherence to
movement or interaction in one plane and on one level. There is no
possibility for figures on superimposed groundlines ever to achieve
some kind of spatial relationship. Recession and illusionistic fore-
ground are (for better or for worse) barred, while the line itself can act
only as a tenuous spatial link in the case of figures moving in succes-
sion or figures joined in action. If the groundline originated in a
simple 'accolade' with which to link a set of abstractions, it was soon to
give just so much but no more coherence to a number of separate
figures. It is obvious that the use of a groundline must also inevitably
lead to the use of registers. The obverse of the Narmer Palette (Pl. IXb)
already shows these, and it is curious to see what happens to the
figures which, for one reason or another, escape from their ban. The
decapitated enemies in the top register are a mere pictographic state-
ment practically on a par with the hieroglyphic signs above them.
The figures at the bottom of Pl. IXa no longer appear to be slain
humans in the foreground of a scene as on Pl. VIIb, but seem to swim
or float aimlessly in space. The pathetic bull on Pl. IX bottom right
must even step off his groundline in order to crush his floundering
enemy. And, although Narmer's sandal-bearer, spatially unconnected
with the king, is standing on a groundline, the figures holding the long-
necked monsters lack theirs undoubtedly because their spatial relation
with the beasts, though not clearly defined, could not be ignored.

We see, therefore, that within the span of a few generations the
bold efforts to depict coherent scenes in space and local setting are
sacrificed for the sake of a rendering in which depth is destroyed and
unity restricted to a mere sequence of figures or of actions which

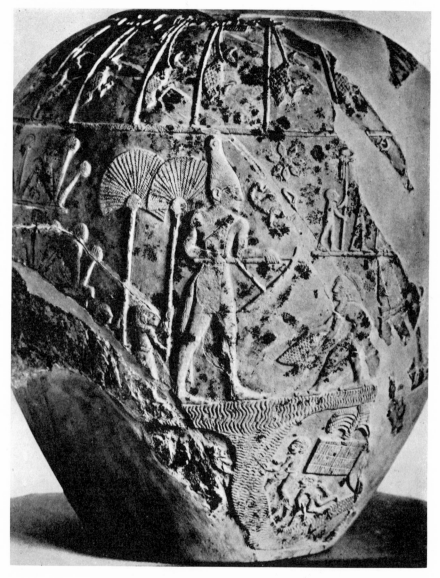

VIII. MACEHEAD OF KING SCORPION
(*pages* 7, 19)

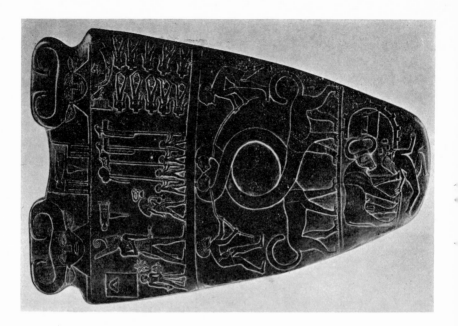

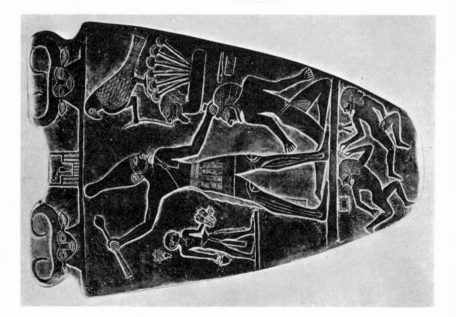

involve their touching (in some cases even overlapping) in a near-plane on one level. The numinous strength of the bull-king trampling on his enemy, the human dignity of King Scorpion, standing in homely proximity between his fan-bearer and his reverent acolyte, have been superseded by a hieratic figure performing a symbolical act (Pl. IX). From this act all confusion inherent in a vague and fumbling spatial rendering has been eliminated. This is not an act performed at a certain place, witnessed from a certain angle; no functional relation exists between the observer and what is depicted, which is utterly remote from any spatial considerations. We saw that the landscape setting on the mace-head enhanced the singleness of the occurrence. But from the Narmer Palette coincidence and contiguity are barred and the king's more violent gesture has therefore the peculiar static quality of a symbol. King Narmer's is a timeless act.

C. THE SPACE-TIME IMPLICATIONS OF MONUMENTAL ART

We have, so far, in explaining the scenes, given what we called before 'a mere paraphrase of supposed actions and situations'; it is, however, also possible to consider their implicit meaning. In most cases the names of the royal participants are given so that the scenes undeniably refer to actual historical events even if, as in the case of the Narmer Palette, the reference is indirect. We do namely know that Narmer did achieve an important conquest. In fact, these proto-dynastic objects are, in the original sense of the word, monuments, they are 'reminders', they commemorate. Historians interpreting their meaning and spelling out the names of the principal actors are well aware of a momentous break with the preceding period in which prevail the slow, anonymous, and undramatic changes of the prehistoric age. But the fact that the proverbial 'dawn of history', so conveniently considered synonymous with the discovery of script, should coincide here with the creation of 'reminders', has been too easily taken as a fortunate contingency. For elsewhere personal identity and secular event have by no means been the main concern of the earliest writers and the artists, their contemporaries. In Mesopotamia, for instance, matter-of-fact accounts, word lists, and religious scenes predominate.[1] In fact, proto-historic Egypt is quite exceptional in that it apparently avoided depicting divinities and fell into the temptation of appraising and proclaiming the significance of human acts. Now the creation of monuments in the sense of reminders, does not only reveal a preoccupation with actual events. For since no doubt from time immemo-

[1] On early word lists and contracts see A. Falkenstein, *Archaische Texte aus Uruk* (Berlin, 1936). See also p. 148.

rial, legend had been the frail depository of significant event, the creation of monuments can only be understood as a challenge. If a single occurrence or achievement is claimed to have more than ephemeral significance, and appears to be threatened by oblivion, this threat may be answered by the creation of lasting reminders that shall give them the dignity of the unchanging. Through an indestructible message or pointer, it may be claimed that one isolated fact or single person is significant beyond the here and now and can be rescued for and from the future; in this assertion the dual aspect of time as both exalter and antagonist of man is implied.

We are here primarily concerned not with monumental intention but with the fact that in the art of the proto-historic period some 'reminders' depict actual events while others seem to avoid this. Are we to call either of these 'monumental art'? At the risk of appearing paradoxical, I would suggest that the term be avoided here. For though monumental intention and artistic representation of actuality *may* coincide, they need not be truly correlated. If the function of a monument is to perpetuate the impermanent, to stress the transcendent significance of human action, then the term 'monumental art' should be reserved for those rare instances where this implicit paradox has found aesthetic expression. Monumental art in this pregnant sense is *sui generis*; it neither renders mere contingencies, nor does it completely avoid actuality; it does not hover between symbolical statement and factual representation; both should determine and require each other within the one achievement. The criterion of monumental art should, in fact, lie in a tension between the ephemeral and the lasting, between concrete event and transcendent significance. And it is, as we shall see, the very absence of this tension which makes it undesirable to apply the term (in the sense in which we shall henceforth use it) to the bulk of Egyptian representational art.

In the proto-dynastic monuments neither the earlier reliefs nor that of Narmer deserve the term, for opposite reasons. On the lion palette (Pl. VIIb) a battle was commemorated, on the macehead (Pl. VIII) the opening of a canal. These occurrences were evidently considered of lasting significance. Yet the actual representation only reveals their transient aspect. It is an artistic rendering of an event, not of the transcendent significance of the event. This, on the other hand, has been achieved on the Palette of Narmer, but at the cost of actuality. We can here for the sake of clarity contrast these scenes with a superb example of true monumental art in Mesopotamia (Pl. LXII). The stele of Naramsin does contain the tension between the human and the exalted, between actual event in time and space and a display of

superhuman royal power which transcends the temporal. We shall in the course of our analysis of classical Egyptian relief and painting repeatedly have to point out the absence of this 'monumental tension' and shall find it confirmed by the predominant choice of subject matter. This always moves between the two extremes of secular scenes in a trivial sense and symbolical abstraction; it also avoids with a consistency which should have surprised the Egyptologist (but apparently never did) all reference to myth. For mythical acts, heroic or divine, have both a dramatic character and a timeless significance which should make them particularly suitable for monumental treatment as the Greeks have shown.

It is tempting to speculate on the historic implications of such revolutionary changes: the sudden appearance on proto-dynastic monuments of a bold emphasis on actuality, its equally sudden disappearance in the rendering of the king from the time of Narmer on. But we have no data with which to corroborate what must remain a mere conjecture, namely, that the strict dogma of divine kingship, which later dominated Egyptian life, may well have crystallized in this very period, and did not allow of any tension between factual and ideal power.[1] Here we can only stress that from Narmer on all royal acts, even if spectacular, appear in art deliberately deprived of their too specific, too ephemeral character, become typical repetitive acts. All royal figures become formal, enlarged; they have something of the restraint, the dispassionateness of ritual actors.

D. EXCURSUS: SCULPTURE IN THE ROUND

We find, therefore, that in the art of the proto-dynastic period a new preoccupation with significant event first leads to the creation of lively descriptive scenes with monumental intent, but that their transitory character was sacrificed in favour of a symbolical rendering, in which the figures appear static, 'timeless', not ephemeral. The paradox of monumental art remained therefore unsolved, and it was only in the plastic figure, which could remain aloof from the problem of activity, that the Egyptian artist achieved true monumentality. It is curious that in the period which separates the efforts of proto-dynastic times and those of the third dynasty, when the character of Egyptian art appears set, we witness the development of sculpture in the round. I shall here briefly refer to it because in one respect its problems are closely related to our subject.

Proto-historic carvings do not in the earlier stages show any trace

[1] H. Frankfort, *Kingship and the Gods* (Chicago, 1948).

of the adventurousness of pictorial art; they are mostly inarticulate oval, cylindrical shapes. Whereas the prehistoric clay figurines, though inarticulate, have bold plastic movements (Pl. Xb), lifted arms, and massive jutting-out lower limbs, in the carvings arms and legs seem pressed together and projecting forms are reduced and flattened, as if to stress the self-containedness of the plastic unit by an unruffled surface.

The first historic monument, however—the baboon inscribed with the name of Narmer (Pl. Xc), has both plastic articulation and coherence; it has, moreover, all the characteristics of later Egyptian sculpture—its cubism (though not yet pronounced); its frontality; its closed, static form. Almost contemporaneous with, but in my opinion just preceding it, is an astonishing small carving (Pl. Xd) which in spirit seems much nearer to King Scorpion's slate palette than to Narmer's. It is the portrait of a stooping, almost hunchbacked, old man with a wide, protruding mouth and misshapen ears, wrapped in a regal mantle—a human presence, so concrete that it seems almost poignantly vulnerable when compared with the unassailable solidity of later figures; it is a living organism, not petrified life. This is not only due to subject matter; physical abnormalities also interested later Egyptian artists, if mainly in a revolutionary period. But never again was the human body treated as a living organism whose gestures and posture are imposed from within. After Narmer, in a few transitional stages, the character of Egyptian plastic is set and never changes in essential. It never breaks away from certain fixed codes, one of these being an un-organic structural scheme for the rendering of human and animal figures.

The concepts used in the analysis of Egyptian sculptural form have been several: Schaefer's monster-word 'geradansichtig-vorstellig';[1] Krahmer's 'static space';[2] Frankfort's 'stereometric approximation'. Each has its special merit; but I prefer the term 'un-organic structure' although the term 'un-organic' has been used by Snijder[3] in a purely deprecating sense, merely to denote the lack of anatomical articulation in Egyptian sculpture as compared with archaic Greek art.

We mean by this term that the Egyptian does not render the human figure as a living, potentially mobile organism, involved in a network of relationships and to be comprehended by the spectator only in a circular movement that can encompass the whole range of its complex functions. The static quality of Egyptian sculpture is not

[1] *Vide supra* p. 7, n. 2.
[2] *Vide supra* p. 7, n. 1.
[3] G. A. S. Snijder, 'Over Egyptische en Grieksche Beeldhouwkunst,' in *Maandblad voor Beeldende Kunsten*, IV (1927), 163–80.

that of an organism in repose (for then rest is a mere phase of movement); it has the immobility of a crystalline structure, of a form reducible to a simple system of co-ordinates (Pl. XI).

Egyptian 'cubism' is therefore not a stereometric mould forced on organic forms, distorting or effacing them; it is a structural system of horizontal and vertical axes which the human robot is made to serve. Within this system limbs have no separate function; incapable of gesture, arms are limply or stiffly arranged; legs are not taut with muscular energy but solid massive pillars, so that if one leg is advanced it appears a diagonal prop.

This inorganic or even anti-organic rendering of the human figure gives it, however, its curious character of non-transience, of a tranquillity deeper than repose—its 'timeless' character, in fact, if we will use this word in an un-sentimental, non-metaphysical sense.

But this represents only one peculiarity of Egyptian plastic. Equally important is the lifelikeness of the face which, though expressionless in the sense that it suggests neither character nor mood, yet suggests an individual. Attempts at formal analyses prove inadequate here. They leave untouched the mystery of a personal presence which these faces convey; and they do not solve the problem of why such a head and a rigidly formalized body were joined to form a superbly dignified if always faintly disturbing whole.

It is this very problem which bears on the subject of time and monumentality which I discussed in the preceding section. We have seen already that proto-dynastic statuettes, though contemporaneous with the palettes, are less revolutionary in character. Yet they are a curious innovation, in so far as the meaning and the function of these figures is both novel and obscure. The pre-dynastic figurines, predominantly female, are invariably found in tombs and must have had some magic-religious significance. The proto-dynastic statuettes, however, were found within the temple enclosure; they are too numerous and too insignificant for cult objects. Can they be votive images of worshippers or figures representing such dead as were worthy of veneration? In either case there would be some relation between the image and an actual individual it would represent. This relation is, we are inclined to believe, one of complete likeness in the case of the ivory figurine (Pl. Xd), a mere *tranche de vie*, a human presence, frail, ephemeral—unmonumental.

It does not seem mere accident that the first statue worthy of this term should date from the very period when in relief the transient character of events is overcome. I mean the magnificent carving we already mentioned of a baboon bearing Narmer's name (Pl. Xc). It has

25

been suggested that this enigmatic figure represents the god Thoth (as
the baboon does in later times) and that the name of Narmer merely
means that he had dedicated it, but this would be contrary to all sub-
sequent usage in Egyptian art, where the name always denotes
identity. It is true that in later times the king was only represented as
a sphinx or a griffin, not as a sacred animal; but if, as appears also from
the contemporary relief, the effort was made to overcome the all-too-
human in the rendering of regal superiority (not only symbolically by
the act of an overpowering bull) we might accept perhaps the correla-
tion of name and image and deduce from it its monumental purpose.
The impressive animal figure would then be pregnant with an ideal
significance and contain implicitly the statement that kingship trans-
cends mere human individuality.[1]

It must be remembered that in this period not only the king but
also his followers lose anonymity—an innovation quite unparalleled
in other early Near Eastern cultures. In the graves of courtiers are
often found stones bearing their names.[2] But, though this might mean
that some form of lasting individuality had become a more general
need, though some dead no longer nameless might magically preserve
their actuality in a sculptured word, it was at first solely in the figure
of the living king that the monumentality of the human form, the
correlation of the concrete and the ideal, could be achieved. For the
king was not a personal, ephemeral being. Whatever the problems, in-
finitely involved, of the significance of Egyptian kingship, the mystery
of its origin, the speculation which obscures it, this one fact stands out:
the king was not a mortal; in him the cycle of existence was com-
pleted and renewed.

The grandiose paradox of sacred kingship, of an ideal become con-
crete, this divine comedy acted and re-enacted through the ages seems
the paradox of monumentality itself. Once this had been tentatively
expressed in animal form a swift developement took place. In a few
generations only,[3] through a few laboured transitional stages, a
plastic form of royal image is evolved—a tensional harmony of
opposites—a form so deeply satisfying to both aesthetic and meta-
physical needs that it could claim the artist's submission during the
whcle of Egyptian history (Pl. XI). An individual head—alert, alive
—and a body lacking all hint at potential movement, an un-organic,

[1] There appears to have been a particularly close connection between the
earliest kings and Thoth; see H. Kees, *Nachrichten der Ges. der Wissenschaften in
Gottingen, Phil.-Hist. Klasse*, 1929, pp. 57-64.

[2] W. M. Flinders Petrie, *The Royal Tombs of the First Dynasty* (London, 1900);
idem, *The Royal Tombs of the Earliest Dynasties* (London, 1901).

[3] A royal head in University College, London, is believed by Petrie to belong
to the First Dynasty.

massive, changeless form—were joined with a superb *naiveté* and a mastery which almost hides its paradox. From that moment the Egyptian sculptor seems—apart from a little playful ornament— destined, doomed almost, to create only monumental art. For the classical canon of Egyptian sculpture and its implicit metaphysical paradox dominated also the later funerary art of private people. In fact, only the recognition that historic individuality and the dignity of the unchanging need not destroy each other but can formally be united in a way not lacking in harmony may explain two correlated facts that in Egyptian art all human portraiture has a monumental charac- ter and that this art requires the setting of a tomb.[1] For if divinity was the prerogative of kings, the human cycle had to pass through death to leave behind the changing character of concrete life. Only the tomb might be the background and the justification of a form which attempted to combine the ephemeral and the timeless. The royal statues alone were sometimes independent of the actual tomb, as in the case of the Sphinx and the later colossi.

If one should ask why amongst several possibilities the cubic and not, as for instance in early Mesopotamia, the conical form should have been chosen as a structural system it would be well to remember that Egyptian art was born in a country where for a length of five hundred miles a lifegiving stream and a narrow strip of fertile land are hemmed in by the ruthless parallel lines of cliffs that mark its boundaries; beyond lies the desert, lies death. The Egyptian south of Cairo does not know a circular horizon; orientations run at right angles, and distinctive directions are not only clear-cut and final—they are pregnant with meaning,[2] Plastic imagination, permeated by an ever- present cosmic antithesis, may well submit and, by submitting, be enlarged and deepened beyond the range of wilfulness. The dignity and also the limitations of Egyptian art—its crystalline harshness, its overwhelming preoccupation with transient life, and its negation— are those of the southern Egyptian landscape.

[1] The fact that in the early middle Kingdom, and probably already in the First Intermediate period, statues of private people were placed in local temples is no doubt indicative of the social upheaval: the formulas with which these statues are inscribed show that the owner hopes to benefit from the temple offerings (see Maspero, *Bibliothèque Egyptologique*, 1, 53 sqq., and Hans Kayser, *Die Tempel- statuen ägyptischer Privatleute im mittleren und im neuen Reich* (Heidelberg, 1936).

[2] For the character of space in mythopoeic thought see *The Intellectual Adventure of Ancient Man* (Chicago, 1946), pp. 20–23.

CHAPTER II

The Old Kingdom

A. THE SIGNIFICANCE OF THE SCENES OF DAILY
LIFE IN PRIVATE TOMBS

Familiarity may breed contempt; it may do worse: it may dull our capacity for wonder. And the fact that the funerary reliefs of the Old Kingdom have made us so familiar with the ancient Egyptian at work and play, his clothes, his skills, his food, and his entertainments, may well make us forget that he is a unique phenomenon in history. No other people paid such elaborate tribute to human existence in nearly all its manifestations. The fact that this tribute was incorporated in a funerary monument is not a paradox; for in the face of death the ultimate value of life may well be assessed, negated, or confirmed. But it is amazing that the Egyptians apparently never questioned the value of life's typical occurrences, that they considered these significant enough for pictorial treatment. This does imply a resignation that is both naïve and almost stoic. No Egyptian hero ever challenged the gods in quest for superhuman achievement, no Egyptian prophet ever rejected life's trivialities in order to attain lasting values. Even if death is praised it is in terms of life. The heroic or the ascetic with its implicit passionate protest, its effort to transcend life's limitations, has never found expression in either word or image.

Yet the familiar 'scenes of daily life' of the Old Kingdom tombs, so worldly, so serene, present a veritable hornet's nest of problems. What was their *raison d'être*, for surely they were not a mere paean to earthly pleasures? Was their intention magical, commemorative, or ostentatious, the summing up of a man's status and his wealth? Is it the dead man who is depicted receiving offerings, watching the harvest, desert hunts, trapping of birds? If so, do the scenes take place in the Hereafter? The answer to these questions, which will prove by no means irrelevant for our problem, is both simpler and more complex

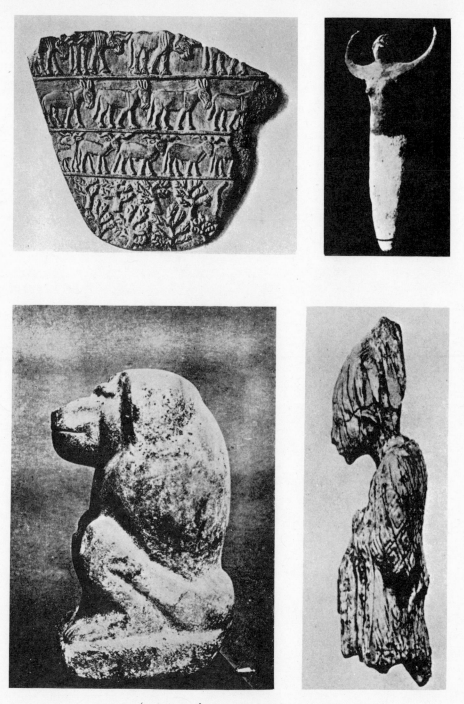

XA. 'LIBYAN' PALETTE (*page* 20)

XB. PREDYNASTIC FIGURINE (*page* 24)

XC. BABOON OF KING NARMER (*page* 24)

XD. ROYAL FIGURINE (*page* 24)

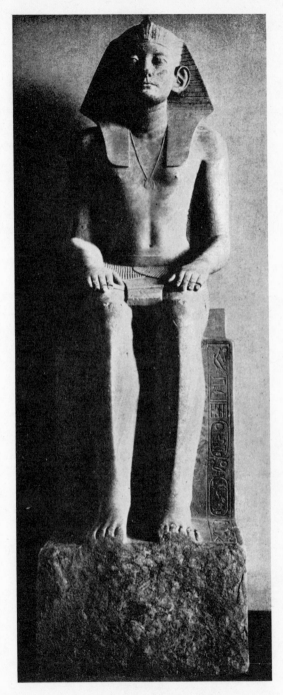

XI. AMENEMHET III

(*page 25*)

than has often been assumed. Simpler because it is possible to recognize in the decoration of the earlier tombs not an almost fantastic outgrowth of primitive practices but a sober scheme which shows logical constraint. More complex because the reliefs of the royal funerary temples, invariably treated as stylistically indistinguishable from private tombs[1], actually differ from them both as regards representational content and intention, so that whenever motifs, or even notions, were borrowed from royal monuments by artists working for private tombs, this entailed a confusion of contradictory schemes, not merely innocent plagiarism. I hope to prove that many inconsistencies which obscure the original scheme already in late Old Kingdom tombs, have their origin in royal temples, where they belong, and that although this original scheme was later rarely strictly adhered to, was seriously threatened in the Middle Kingdom, and even practically discarded during the Amarna period, it remained basic throughout the complex development of funerary art.

The earliest known representations found in a private tomb are those of the royal scribe Hesire, (Pl.VI).[2] His tomb contained a series of of superb wooden reliefs depicting the owner. These were placed in niches on one side of a long passage with a painted frieze running along the opposite side. Only one of the reliefs—presumably the one in the centre—shows the deceased sitting in front of his offering table, a 'scene' known from a few earlier carvings and from archaic seals. In the others he appears, standing inactive, in the nonfunctional rendering and rigid, robot-like posture described in the Introduction. The painted frieze contains no 'scenes' as yet but the images of treasured objects and necessities of life: chairs, beds, games, vessels, and food in quantity. It is obvious that these pictures must have had some kind of magical intent, for though the interment of the dead man's possessions may merely mean that they are taboo for the living— tainted with his now dreaded power—to picture them means to ensure their presence for the owner of the tomb. But this strange link with the material world does not warrant the conclusion that the Hereafter was conceived as a mere continuation of life on earth. There is, in fact, not a single early text to confirm this view (although there are many to refute it) apart from the belief that the dead depend for their existence on food offerings from the living. All other references to the life hereafter up to the New Kingdom utterly lack the concreteness we might expect if such views were held.

Except in the case of food pictures where the purpose is unmistak-

[1] A. Scharff, *Handbuch der Altertumswissennenschaft* (Munchen, 1939), 1, 507.

[2] J. Quibell, *Excavations at Saqqara, The Tomb of Hesy* (Cairo, 1913).

able, there is some danger in using the word 'magic' here; it may tempt us to define and rationalize the purpose of these pictures and to assume that the ancients thought and acted with primitive logic though starting from wrong premises, namely, that life after death entailed the same needs and enjoyments as before. All we can say is that ephemeral life and its necessities still mattered to the dead; in fact, the whole subsequent development of funerary art shows that it mattered greatly. The dead, far from being completely severed from life, were linked with it by ritual sacrifice and by the permanent presence of life's pleasurable aspects in their last and lasting dwellings. To explain so complex and so contradictory a phenomenon as the symbolical presence of treasured goods by assuming that they were a magical device for ensuring use in the Hereafter is as arbitrary as it would be absurd to explain in a similar way the fact that American mourners dress a dead man in his best clothes before burial. The word 'magic' may merely prejudice our understanding of later funerary usages.[1]

The tomb of Hesire is the earliest example known of the mural decoration of private tombs;[2] and it is unfortunately the only one known in the Third Dynasty. The subsequent development of tomb decoration is all the more remarkable for being suddenly interrupted by Khufu's reign. The tombs of Rahotep and Nefermaat in Medum which are contemporaneous with Sneferu, show most significant experiments and innovations, but these find no scope in the austere mastabas of the later Fourth Dynasty in Gizeh, where all decoration is restricted to a small plaque showing the dead man and his offerings.

Most remarkable in Rahotep's tomb (Pl. XII) is the fact that the owner is pictured not only seated in front of his offering table—the classical scene which from now on was never absent in the most important place of the tomb, the recess or false door through which the dead communicated with the living—but, like a living man, watching (so the text says explicitly) a variety of scenes. These scenes are as yet very simple and are vertically arranged in registers without apparent order, the large figure of the standing man bracketing the groups. The text states that he is watching the hunt or the making of

[1] On magic in funerary usages see pp. 50 and 51.
[2] There is one painted fragment in the tomb of Hesire which presents a special problem (Quibell, *op. cit.*, Pl. VII, 2), a crocodile and what appears to be a marshy setting for wild life. This has been rather rashly called a hunting scene since the wooden reliefs of the owner have no relation whatever to the painted catalogue of belongings which contains no human beings, this 'scene', if it is one, may merely mean the symbolical presence of yet another instrument of aristocratic enjoyment and display of skill, on a par with the depicted games and goods. It need not be explained as a picture of Elysian hunting fields.

a boat or the animals belonging to his 'home of eternity'—either his funerary estate or his domain in general. The paradox of a dead man represented as a living person and watching the trivialities of life which include ploughing, the catching, carrying, and cutting up of fish, and bringing of tribute by servants (who represent named estates) might the be neatly resolved by assuming that these scenes took place in a Hereafter identical with actual life or, as Montet has done,[1] by explaining them as posthumous visits to regions of the living, as if the dead man could still claim an interest in and lordship over his domain. Both interpretations are conjectural, and even Kees' assumption[2] that the scenes represent a fictitious, a symbolical domain to compensate the dead for actual loss, or Spiegel's[3] attempt to see in them the summing-up of a life's achievement, ignore the only statement we have of the ancients themselves. The dead man *sees* or *watches*.

This simple statement has never been taken at its face value and the verb *m"* has usually been rendered by 'inspecting', a far more active, far more practical word. The reason for translating it thus is obvious: the liveliness of the scenes, especially the later ones, makes it tempting to draw the figure of the dead man, even when inactive, into the orbit of general activity. But this will prove unwarranted and may, as we shall see, lead to strange misrepresentation,[4] which can be avoided by keeping imagination in check. The reward of this effort may be that the scheme of the scenes appears less charmingly naïve but more significant. If we may take it that the dead man merely sees or watches, then we may admit that it would actually be hard to find a term more subtle and more suitable to express the curious implications of a scene in which the dead man and the living world are confronted. The watcher shares, but he does not participate; his is not merely vulgar greed for the perpetuation of earthly pleasures nor a complete renunciation of all life has to offer. I do not mean by this that the word expresses a purely aesthetic enjoyment. Most scenes have a bearing on food production, and food offerings were to guarantee existence in the Hereafter. This and the ostentatious emphasis on wealth and status undoubtedly have some magical intent. Yet in this strange confrontation of the dead man and gay scenes of daily life, the word 'watching' expresses both an element of resignation and an element of clinging—which makes the word 'magic' appear too primitive, too gross. If magic

[1] Pierre Montet, *Les Scènes de la vie privée dans les tombeaux Egyptiens de l'ancien empire* (Strasbourg, 1925).

[2] H. Kees, *Totenglauben und Jenseitsvorstellungen der alten Aegypter* (Leipzig, 1926), 50f.

[3] J. Spiegel, *Die Idee von Totengericht in der aegyptischen Religion* (Leipzig, 1935), p. 6.

[4] See below, pp. 32 f., and esp. n. 3.

sustenance was all that was intended then the 'thousands of beer, thousands of bread' of the offering lists or the picture of servants bringing tribute would have sufficed. Since they evidently did not we must assume that not only food, but the manifestations of life itself, in effigy, were brought into the tomb in order that the deceased might behold them.

It may be argued that the dead man's inactivity merely means that he wishes to pose as a man of leisure—that in such scenes he might therefore be rendered as he was in his lifetime. It may also be argued that there are instances of 'biographical' and active scenes which would contradict our interpretation. This, however, does *not* hold good for the earlier examples. The often-quoted instance of Nefermaat holding his hounds on a leash and catching birds[1] is invalid, for we have to deal here with a double tomb and it is *not* in *his* tomb that Nefermaat is pictured thus but in that of his wife, who stands motionless to receive the gift. It is a curious fact, which has so far escaped notice, that when Nefermaat and his wife Atet are pictured together in *his* tomb the wife clings to the husband who remains inactive throughout.[2] In her tomb, on the other hand, *he* makes his wooden gesture of protection and is shown active in procuring food for her.

The possibility that the dead man poses as a man of leisure has little in its favour. Where the confrontation of the dead and scenes of increasing liveliness would almost of necessity invite them to participate, it is striking how reluctantly small changes were made in the direction of activity. We do find, for instance, in the middle of the Old Kingdom, not only the dead man facing those who bring the king's gifts or the account of these, but his seated figure with hand outstretched as if to receive the account, though not actually grasping it (Pl. XVIIa).[3] We see him in the so-called 'toilet scene' as if submitting to the treatment of servants,[4] or being carried in a sedan chair,[5] instead of standing or leaning on his staff. It is here that one might be tempted to argue—on the basis of early material—in favour of a 'scene of daily

[1] Flinders Petrie, *Medum* (London, 1892), Pls. XXII and XXVII.

[2] *Ibid.*, Pls. XVII and XIX.

[3] L.D. II, 74c; Luise Klebs, *Die Reliefs des Alten Reichs*, p. 24. It is interesting to note that in *Giza* II, 128 and 129, the 'giving of the list' (namely, of royal offerings) is mentioned, and also 'seeing the offerings which the royal palace has brought, 1000 young cattle, etc', but the cattle are not depicted and the list is only being held out. Only in Sixth Dynasty tombs, Blackman *Meir* IV, Pl. XV, Junker, *Giza* VI, p. 115, Fig. 34 and Pl. IX does the owner grasp the list.

[4] Wreszinski, *Atlas*, III, Pl. 2.

[5] W. M. Flinders Petrie, *Medum*, Pl. XXI, where the context is obscure; *Giza* I, 189, Fig. 37, No. 8, is doubtful; Ti, Pl. 16; Mereruka I, Pl. 14; *ibid.*, II, Pl. 157; F. W. von Bissing, *Die Mastaba des Gem-ni-kai* (Leipzig 1905; 1911) I, Pl. XXII; N. de Garis Davies, *The Rock Tombs of Deir el Gebrawi* II, Pl. VIII; L.D. II, 43 and 50. *Giza* V, p. 85, Fig. 20.

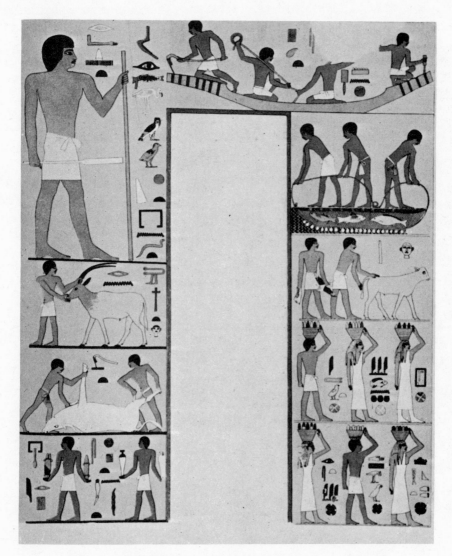

XII. PAINTING FROM THE TOMB OF RAHOTEP

(*page* 30)

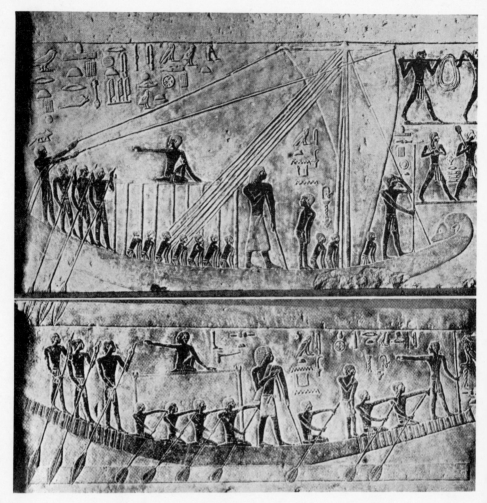

XIII. BOATS FROM THE TOMB OF KANENESUT
(*pages* 34, 44)

XIVA. SCULPTOR'S WORKSHOP, TOMB OF TI (*page* 37)

XIVB. BOAT BUILDING, TOMB OF TI (*page* 38)

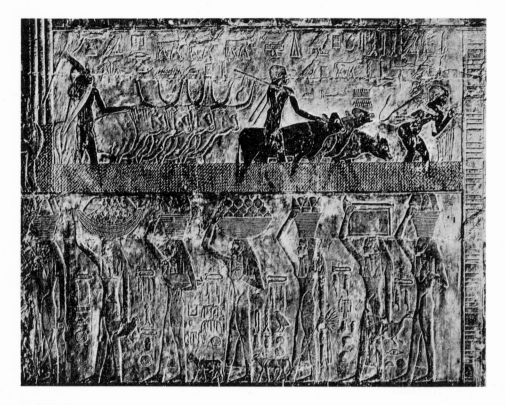

XV. CATTLE FORDING STREAM; TRIBUTE BEARERS, TOMB OF TI

(page 44)

life' which would include the dead. It is also in scholarly descriptions of such scenes as these that expressions like 'pleasure- or inspection-trip', 'morning toilet', or 'morning reception' abound and prejudice the interpretation.[1] But the loving care with which the passive dead is treated or being carried, though not strictly in keeping with what we called the inherent logic of the scene, does not wholly contradict it. For it should be noted that the attitude of the dead remains passive also here and though we must acknowledge that an effort was made to bridge the gap between the worlds of the living and the dead, only our interpretation can account for the fact that while there is frequent mention in the accompanying texts of the activities of others, never once is any reference made to the dead man's actions other than 'watching'—not even the receiving of accounts—and that apart from one instance in Ti's tomb he remains in the earlier reliefs passive throughout. In this one instance, Ti, identified by name but characteristically without mention of his act, is seen to give the signal for closing the bird's net.[2] It is this persistent passiveness which corroborates our interpretation of the term 'seeing' and it is the combination of both which makes us feel justified in considering the original scheme both subtle in meaning and restrained in purpose.

Another fact should be stressed: only the explanation just given can account for the absence in the scenes of biographical material, which is abundant in the texts. This should be surprising only to those who insist on calling the scenes 'narrative'. This term is anyhow misleading. There is no question of a story told in these pictures. Apart from sacrificial scenes life's typical aspects are rendered, especially those with a bearing on food production—agriculture, cattle raising, game provision, and fishing—though industry and even trade occur. We find, in fact, elaborate pictographic conceits rather than images of transient events. These conceits may need multiple statements, consisting of the various phases of one typical occurrence. They should then be 'read': harvesting (Pls. XVIIIa; XIXb, c;) entails ploughing, sowing, and reaping; care of cattle entails fording of streams and milking; boating entails fights between sailors, etc. The sequence of the scenes is purely conceptual, not narrative, nor is the writing which occurs with the scenes dramatic in character. The signs, remarks, names, songs, and exclamations, which illuminate the action much as does the text of a comic strip, do not link events or explain their

[1] It does not seem worth while to collect instances; Luise Klebs, W. Wreszinski, and even N. de Garis Davies have frequently used these or similar expressions.

[2] Ti, Pl. 116. Seneb, in the Sixth Dynasty appears pulling a rope in his boat sailing to the Necropolis, *Giza* V, p. 63, Fig. 14. See below, section E, pp. 56 ff.

development; they are typical sayings belonging to typical situations. If, as we maintain, the rendering of a typical timeless event meant both a potent presence and a source of joy to the dead, then it would be entirely consistent that although the owner of an Old Kingdom tomb might state in lengthy texts his station in life, his achievements, his adventures even, yet no pictorial reference to such transient matters was made in the scenes of his tomb. Hence we find that also in these cases the dead is depicted merely sitting in front of his offering table, *never* actually eating, though occasionally raising a lotus or unguent vase to his nostrils (a rather touching hint at his condition)[1] and watching the activities of life.

It is, however, largely owing to two types of scenes that, notwithstanding the inactivity of the main figure, the general scheme of the decoration has been interpreted as an account of an Egyptian nobleman's daily life in the sense of a *tranche de vie* and explained as a magical device to ensure his pleasures in the Hereafter. These scenes are the boating and the hunting, fishing, or fowling scenes. The boating scenes occur already in the early Fifth Dynasty[2] (Pl. XIII). It has often been forgotten that, although the owner of the tomb appears here as elsewhere as a living person, the scene depicts a posthumous event and has, as in the case of the pulling of papyrus,[3] a strictly religious or ritual meaning. The accompanying texts make it clear in every case that it cannot be interpreted as a pleasure trip on the Nile or even as a journey of inspection. The first is never mentioned, the last only in one instance: an often quoted text in Ti's tomb.[4] But here the owner has in this particular case been significantly omitted, and I do not know of a single case of the dead man participating in a boating scene where a purely secular motive for the trip has been indicated before the Middle Kingdom and that in an exceptional tomb.

The desert hunt in Ptahhotep's tomb[5] has been demonstrably copied in parts from Sahure's temple, but in contrast with these royal reliefs it does not show the dead man shooting. The first instance of such direct plagiarism occurs in the tomb of a local princeling in the

[1] L. D. 53 and Wreszinski, *Atlas*, I, 376. Sometimes the dead touches the stem of the lotus which is being offered: *Giza* III, p. 153, Fig. 21 and Pl. II; *Giza* VI, p. 57, Fig. 13; *Giza* V, p. 91, Fig. 23.

Two instances of the dead touching the offerings placed before them are quoted by Junker, *Giza* I, 33.

[2] *Giza* II, 66–69.

[3] SETHE, in *Z.A.S.*, LXIV, p. 6–9. *Giza* IV, 77; *Giza* V, p. 65 and Fig. 15. W. S. Smith, *A History of Egyptian Sculpture and Painting in the Old Kingdom*, p. 169, Fig. 64.

[4] Ti, 80.

[5] Ptahhotep I, 22. (Cf. our Pl. XVIIc.)

Middle Kingdom in Meir[1] where, as we shall see, the king's prerogatives are often trespassed upon.

There is only a single instance known of a fishing or fowling scene with the dead participating which antedates the scenes in the funerary temples of Userkaf and Sahure. This is in the rock tomb of Nebemakhet[2] at the end of the Fourth Dynasty, when a number of new features appear. In this case there is no question of the prince providing food for his wife, but it should be stressed that when such scenes occur in the earlier Fifth Dynasty tombs, the dead man stands inactive in a small papyrus boat 'watching' the catch. Not till the late Fifth Dynasty was he shown holding the throw-stick or the double-pronged spear complete with fish;[3] and, barring one instance in a late Sixth Dynasty tomb at Deir el Gebrawi,[4] it is not till the Middle Kingdom that captions occur which mention his 'roaming the marshes' and 'catching birds' or fish.

All this evidence appears to justify our assumption that, although an approximation of the two forms of existence, before and after death, seems sometimes aimed at, the 'scenes of daily life' in the earlier Old Kingdom are not a survey of the dead man's activities in life but the image of man-in-death watching life's manifestations. His inactivity should be considered the clue to his status as one of the glorified dead; his watching, the tenuous link with life—not without a vague magical purpose—and the *raison d'être* of the scenes. That this inactivity should be gradually suspended in the fishing and fowling scenes may either be due to the fact that posthumous boat scenes were a regular occurrence or to a rather innocent plagiarism which hardly trespassed on royal prerogatives. It is a change all the more explicable because even the unimaginative Egyptian could undoubtedly picture the dead roaming the shadowy world of dense papyrus marshes or the eerie silence of the desert. It is also conceivable that in this particular case the notion of food provision by the dead man himself played a part, for it is characteristic that though he is pictured in several instances as watching a hunt on hippopotami, he never participates. As far as we know, the hippopotamus was not eaten.

The fact that funerary rites are often elaborately depicted in the late Old Kingdom[5] might seem incompatible with the intention of the

[1] Meir I, Pl. VI.

[2] Nebemakhet, Smith, *Old Kingdom Sculpture*, pp. 167 sqq. *AJA*, XLV, p. 515.

[3] Boeser, *Beschreibung der aegyptischen Sammlung . . . in Leiden* (The Hague, 1908), I, Pl. XIV.

[4] N. de Garis Davies, *The Rock Tombs of Deir el Gebrawi* II, 29 and Pl. XXVI: 'Henqu being conveyed over the backwaters to spear fish'.

[5] See. J. A, Wilson, 'Funeral Services of the Egyptian Old Kingdom,' in *Journal of Near Eastern Studies*, III (1944), 201–18.

other scenes. Moreover, they do represent one single and historical event. However, since this took place a considerable time after death and was to ensure posthumous existence, its symbolical presence in the tomb meant a magical assurance, a lasting guarantee to the dead man, which though different in character was not wholly inconsistent with the other scenes, since watching the properly performed rites must also have been a source of joy.

B. THE NON-ACTUALITY OF THE RELIEFS IN PRIVATE TOMBS

Although our interpretation of the meaning of Egyptian funerary art must necessarily remain conjectural, it may help to understand some of its baffling contradictions: its liveliness and its monotony; its realism and its haunting unreality; its solemn and trivial air. And when we shall find in our analysis that notwithstanding some timid efforts by heretic artists and a more formidable onslaught on traditional schemes in the Amarna period, all rendering of illusionary space was consistently avoided and, generally speaking, the use of a groundline and the nonfunctional drawing of human figures rigidly adhered to, we need not explain this fact by hypostatizing a domineering Egyptian style but may look for an existing correlation between spatial rendering and the speculative thought, the peculiar logic, which the scenes imply. For if the confrontation of the deceased with sacrificial scenes and a variety of scenes of daily life should signify a vague, though potent, presence of the latter for the benefit of the former, then the original and most frequently occurring scheme of a large inactive figure bracketing a number of incoherent groups (Pl. XII) would appear to express such an ill-defined association most satisfactorily, while the paratactic rendering of the larger and many of the smaller figures would never help to conjure up scenic effects, which were not intended.[1]

Now we saw (pp. 8–11) that this type of drawing with its correlate of 'problematic space' may merely embody a rather primitive solution of the question of how to depict human beings on a flat surface, that it may (as in the case of the Scorpion macehead; see Pl. VIII) be due to incompetence rather than intention. This, however, cannot have been the case here, for Egyptian artists in historical times proved perfectly capable of rendering a figure in true profile when they needed it as a preliminary for plastic carving; and they frequently used it in relief in order to differentiate between human beings and

[1] On the very rare Old Kingdom examples of almost front view in subsidiary figures, see W. S. Smith, *op. cit.*, p. 323.

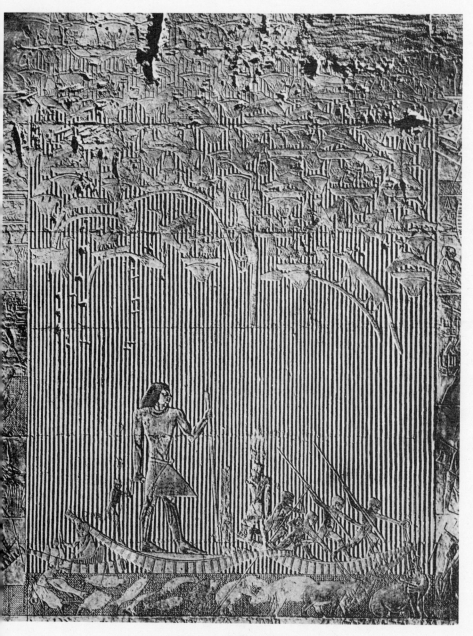

XVI. REED MARSH, TOMB OF TI

(*page* 39)

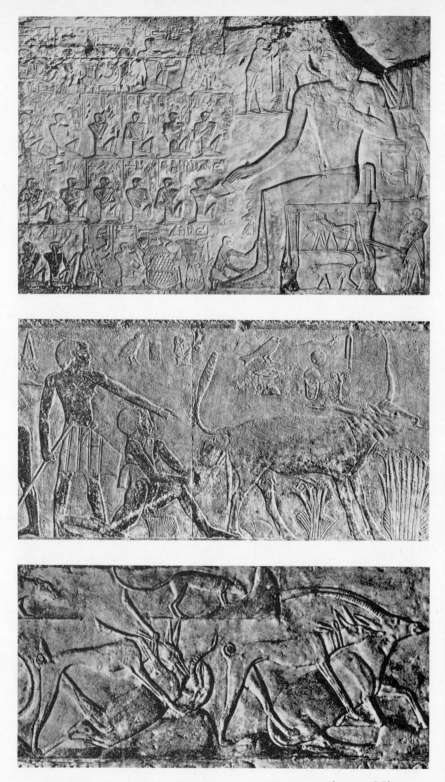

XVIIA. SCENE IN TOMB OF PTAHHOTEP (*page* 32)
XVIIB. COW CALVING, TOMB OF TI (*page* 41)
XVIIC. DESERT SCENE, TOMB OF PTAHHOTEP (*page* 41)

statues as mere objects (Pl. XIVa). We might therefore concede that a paratactic rendering is also eminently suitable in cases where the artist's intention was not primarily to appeal to a spectator by depicting an event in space and time, and that the—unfortunately inevitable— use of the word 'scene' with its implicit functional meaning, is here more often than not misleading.

It may be objected that the same type of drawing prevailed where most lively action was depicted; but here also (and, we shall see, in funerary and other temples as well) an originally primitive trait may have fulfilled an intention which was by no means primitive. This possibility has been ignored by all those who found that a discrepancy existed between the virtuosity of the Egyptian artists and their 'ideo- plastic' methods and who explained this either by extreme conserva- tism and the use of samples from an early date or by a hypersensitive appreciation for the smoothness of stone walls which invited a spread- ing-out of figures. However, constant innovations invalidate the theory of extreme conservatism, and we shall see that Assyrian artists, who render figures in profile and delight in spatial illusions, use a relief as smooth and shallow as the Egyptian. That the matter is more com- plex was sensed by H. Schaefer; he observed, when critics pointed to numerous instances where the rendering of depth was unmistakable, that the main interest of these cases lay in the fact that they were of no consequence whatever.[1] New subjects, new mannerisms might be introduced and copied but never those which rendered human beings functionally or which aimed at illusionary space: these were consistently —and, we may well believe, deliberately—rejected.

We hope to prove that both the paratactic drawing of figures and objects (in which Schaefer was exclusively interested) and the obstin- ate prejudice against illusionary space are different aspects of what we might call an anti-functional tendency (p. 7 above) in Egyptian art and that this is more significant than a mere aesthetic whim.

When Riegl, on formal grounds, stressed the haptic (as opposed to optic) character of Egyptian art in rather equivocal terms,[2] he touched the heart of the problem. He saw that these 'haptic' figures lacked an appeal to the spatial imagination of the observer. He did not see, however (nor did his followers in the narrow path of formal criticism), that they also lacked the intention of affecting him or of communica- ting a pictorial message in the manner of true narrative or true monu- mental art. In fact, they hardly ever depict a situation which the spectator—drawn as it were into the orbit of a 'scene'—was meant to

[1] H. Schaefer, *Von aegyptischer Kunst*, pp. 213–15.
[2] Riegl, *Stilfragen* (Berlin, 1893).

share. Egyptian funerary art is perhaps the only type of nonritual pictorial art known in history which lacks all appeal to the imagination. It renders in each 'scene of daily life' a stage of a typical act, not a phase of a significant occurrence. It does not demand an imaginative response in a temporal or a spatial sense, either as experience of the pregnant moment or as reconstruction of the space in which the act occurs. On the contrary, these 'haptic' representations of typical acts, however 'lively', are neither significant for, nor focused on the living beholder; they are primarily meant to be a presence for the dead who 'own' them. Corporeality and illusionary space, because of their functional implications, would have been an anomaly, but a paratactic figure must have appeared a most satisfactory solution, while a ground-line could come to mean more than a simple device for orderly arrangement; it could be intuitively exploited against illusionary space. It was, however, no panacea, and we find that the problematic space surrounding a paratactic figure adhering to a groundline does actually gain transparency, on certain occasions. These are of two types, one of which has been accepted as compatible with the intention of the tombs, while the second was rejected.

In the first place, it may occur that the paratactic scheme of arranging limbs and torso appears to render plausibly the contortion of figures in action. These may then acquire a more convincing, in fact an organic, corporeality, while at the same time the groundline gains the quality of skyline (Pl. XIVb). Groups of such figures may seem not only to move in space, but even to move simultaneously. It is this device which some egyptian artists have exploited to the full and with great virtuosity, and it is here that the obvious enjoyment in rendering such 'scenes' for their own sake adds a note almost of frivolity to a solemn funerary atmosphere. Such instances may hover between symbolical presence and scene in the full sense of the word.

The second occasion when problematic space gains illusionary depth arises when a dramatic situation is depicted. Dramatic space occurs when figures are rendered in a tensional relationship which makes the distance between them a significant void. We shall give an example from Mesopotamia (Pl. LXIII b). The simplest and most common 'presentation scene', however awkwardly drawn (though, as we shall see, there is no extreme prejudice against profile rendering in Mesopotamia), is a momentous scene: it depicts the awe-stricken figure of a man confronting his god. The spectator shares it as if watching an event. Now it is extremely significant that we can hardly find anything comparable in Egypt up to the Amarna period, either in the dull enumerative processions of tribute bearers (Pl. XV, lower register),

where the interval between the figures is a mere hiatus, or in ritual scenes; and only very rarely do we find it in a more lively portrayal of action. In fact, where it does occur, as for instance when a conversation is depicted,[1] it appears an occasional by-product, not a classical motif, like the presentation scene in Mesopotamia. This reveals a *horror vacui* in a pregnant sense which neither Mesopotamian nor Cretan artists knew—the aversion to rendering the type of void which both divides and binds, the distance of a dramatic situation. Egyptian art, in more ways than one, excludes the spectator, prevents him from sharing an illusionary world.

We shall now demonstrate the various aspects of the anti-functional character of Egyptian art by dealing first with the isolated and unconnected figures, then with the groups and the interrelation of groups in early Old Kingdom reliefs and paintings.

Although the deceased usually differs in size from other figures, the same formula for the composition of the human body is used whether the dead or the living, the divine king or the gods themselves, are depicted. A strict canon is used which has been discussed often enough to preclude the necessity of our repeating the analysis.[2] The dead man is, as we saw, pictured inactive; his posture when he is not seated is often a kind of static stride, neither standing nor walking; or he assumes the least transient of poses—that of leaning on a staff. Even in fishing or fowling scenes the activity of the dead is confined to an upright decorative posture which robs it of all plausibility and transient quality.[3] Although traces of setting may appear—a few joined pillars,[4] as if to represent a booth—which seem to aim at something like a physical approximation of the world of the dead and the living, the figure of the deceased is usually isolated, remote from considerations of space and time. The matted screen against which it is occasionally offset[5] never leaves the narrowest stage space and does not affect the corporeality of the figure, although it does lend a spurious air of concreteness to the scene. Only in one instance do we see the dead against what is unmistakably a background setting: Ti's figure in the fowling scene (Pl. XVI) appears against a wall of papyrus stems. The effect is very startling; notwithstanding the severe regularity of the verticals the scene has something of spaciousness as if a figure in landscape setting were intended; Ti's posture gains through it a

[1] Ti, Pl. 133, p. 67.
[2] Schaefer, *loc. cit.*, pp. 257 sqq.
[3] H. Mohr, *loc. cit.*, pp. 65 sqq. and 69.
[4] Klebs, I, 65, Fig. 53.
[5] L. D. 57, 63, 64, W. M. Flinders Petrie, *Deshasheh*, Pl. IV. N. de Garis Davies, *The Rocktombs of Sheikh Said*, Pl. XV; *Giza* III, Pl. II; *Giza* VI, Pl. IX.

remarkable actuality, which is accentuated by the motif of the ichneumon stalking young birds in a nest. Here the diagonal papyrus stem fulfils a double purpose: it acts as a new groundline and, by upsetting the steady rhythm of the patterned reed wall, it stresses the purely intentional movement of the stalking beast. It is curious that although this did become an incidental motif repeated *ad nauseam*, the solid background was not often copied.[1] In the majority of the later fowling scenes, as in the case of corn reapers, some reeds or cornstalks on either side of the figure are considered sufficient.[2]

But although the dead man may differ from other figures in being passive and remote, there is a similarity in that the latter are equally inexpressive. By this we mean that gestures[3] and postures, although more differentiated, explain an act or indicate a status but do not appear to be dictated by human impulses or emotions.[4] All unconnected figures—that is, those joined in action—form lifeless schemes of tribute bearers, scribes, prisoners and courtiers, officiating priests, bowing stewards. One may object that in these cases a bland formality and identity of posture was indicated. But it is curious that where differentiation of attitude was aimed at (Pl. XVIIa, small figures on the left) a meaningless variation of robot-like gestures was all that was achieved.

It seems that Egyptian artists avoided expression not only as the correlate of emotion but even as the correlate of physical strength. Now this should never be explained by the mere fact of a paratactic type of figure drawing and its lack of organic coherence, for this may conversely be the symptom of a lack of interest in the transient aspect of force. In Mesopotamia, for instance, the less detailed, in fact the rather amorphous shape of a king or god or man may be an 'impressive' figure (Pl. IIIa); massed soldiers may convey potential force. In Egypt, on the other hand, the sprightliness of soldiers and sailors[5] is too much of a mechanical device to be really convincing, while the impassive tribute bearers (Pl. XV, lower register) never seem to feel their burdens as do the slightly stooping figures on the Uruk vase (Pl. LI). The few exceptions in Ti's tomb and especially later in Meir have a humorous

[1] Ti, 113; Mereruka I, Pls. 2 and 19; N. de Garis Davies, *loc. cit.*, Pl. XI. Birds sometimes appear against a background of scattered seeds; Mereruka I, Pl. 52.

[2] N. de Garis Davies, *The Rocktombs of Deir el Gabrawi* II, Pl. V.

[3] See analysis of gestures in Hellmuth Müller, 'Darstellungen von Gebärde auf Denkmälern des alten Reichs,' in *Mitteilungen des Deutschen Instituts, Kairo*, VII (1937), 57 sqq. See also W. S. Smith, *op. cit.*, pp. 310–26

[4] The unique scene of L.D. II, 9, of the man in the midst of obstreperous donkeys, comes nearest to a spontaneous gesture of despair. The scene is certainly late Old Kingdom.

[5] Giza II, Pl. IX; Fechheimer, *Plastik der Aegypter* (Berlin, 1931), p. 127.

touch. In fact, it is interesting to note that in this connection the only peculiarities in posture and physique which the Egyptian likes to accentuate are those of bloated, sagging, or emaciated bodies. The outward signs of infirmity can be added piecemeal more easily than forceful organic tension. We may note here that Pharaoh, when performing an act of preternatural strength, appears as a neat lay figure elaborate with anatomical detail, not as the embodiment of strength.

It is therefore significant that, however sensitively drawn or modelled animals may be, Egyptian reliefs hardly ever aim at making them appear impressive in the sense of being overpowering or terrifying. As we saw before, the coherence of animal forms in drawing is a simpler matter than that of human beings, so it is not surprising that apart from a faithful record of bony and muscular structure, typical events in animal life are sometimes rendered in a way which shows awareness of organic unity, for example in the spasms of birth (Pl. XVIIb)or the agony of death(Pl. XVIIc). But after protohistoric times in Egypt no animal—not even a bull in fight (p. 69, Fig. 9)—appears in Egypt potentially dangerous.[1] We find here a parallel to what Schaefer already noticed in plastic art: the snarling open-mouthed lion of protodynastic times was never rendered later.[2] But what the plastic lion may have gained in monumentality, the placid bulls on the reliefs lost in comparison with their early dynastic prototypes.

Generally speaking, a portrayal of the organic which would entail aspects of transience, functional corporeality, and above all a tensional relation between dynamic centre and surroundings, must have seemed incompatible with the static, alien world of Egyptian relief which shunned spatial illusions. Action is depicted, but it is the lucid trivial action that involves business-like manipulation, not gestures that might be pregnant with meaning, or postures that might be purely accidental: we find that falling bodies of humans or animals occur very rarely and in a decadent period of Old Kingdom art.[3]

The conclusion reached by our study of the single figure is confirmed by the absence of dynamic relations within the group. When several figures are occupied with one single object, some kind of unity results. It is then the sacrificial animal, the boat, the bird or fishing net which gives coherence. In rare instances it may happen that three or more

[1] The only exception is in a Middle Kingdom tomb; see below, p. 70.
[2] Schaefer, *loc. cit.*, p. 15.
[3] One instance of a falling figure in a Fifth Dynasty tomb: H. Mohr, *loc. cit.*, Fig. 25; Boesser, *loc. cit.*, Pl. XIV. Later examples; Mereruka II, Pl. 130; Jean Capart, *Rue des tombeaux*, II, Pls. 70–72. See also *Journal of Near Eastern Studies*, III, Pls. XII sqq.

figures are joined to form a balanced or rhymthic pattern[1] (Pl. XVIIIa, right-hand bottom corner), but hardly ever do we find an expressive gesture of either affection, fear, or threat which may relate two figures. All gestures are practical, explicative of action, not of purpose or emotion; therefore, all figures actually touch the object or the person they are dealing with, and where this is not the case and the gesture merely indicates a speaking or a calling person, it is either a device for differentiating foremen from workmen or it represents a stock gesture in a stock situation.

Family relationships are hardly ever indicated by gestures with an emotional overtone. In one single instance only do we find a mother bending toward her child and upsetting the rhythm of a neat row of prisoners in identical 'detached' postures (Fig. 3). Normally

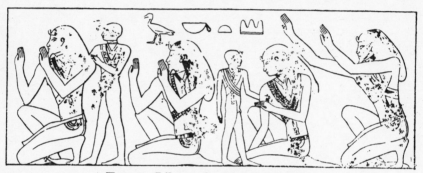

FIG. 3. *Libyan Captives of Sahure*

a single robot gesture joins conceptually the figures of a family group. Those in Rahotep's tomb come closest to being affectionate. Only once in the late Old Kingdom are the owner of a tomb (Mereruka) and his wife, who is playing a harp, depicted sitting opposite each other on a couch—a unique instance of something approaching an erotic scene (Pl. XVIIIb). In fact, the absence of such scenes merely confirms the general avoidance of dramatic situations and need not be ascribed to a hypothetical chastity of the Egyptians.

Mere proximity is indicated only in two instances in Ti's tomb where a conversation is suggested;[2] and, though implied in the figure of a sleeping herdsman, it is not expressed: the figure is not part of a coherent scene, but an added motif (Pl. XIXa). Simultaneity is clearly implied in the Sixth Dynasty Mereruka scene we mentioned, but it is by no means always intended in earlier groups. In the case of

[1] Ti, Pl. III, the three figures in the right-hand bottom corner; Fechheimer *loc. cit.*, p. 139.
[2] Ti, Pls. 117 and 133.

shipbuilding (Pl. XIVb) the different activities may represent different stages of the work. In bird-eatching scenes, signal, catch, and closing of the net cannot have been simultaneous. An exception will be found again in the tomb of Ti where the loading of the grain (Pl. XIXb) appears as one stage in a complex performance of which the stack is the actual centre. This effect is achieved because the heads of the workers are tilted at different angles which cannot be explained by the work they are doing but by the fact that they are all looking at the same object from different distances. In Pl. XIXc the stack appears a mere prerequisite for explaining the action.[1]

It is also significant that scenes of combat are as devoid of serious tension in private tombs as they are formalized in royal art. The same reluctance to depict physical strength makes fights between sailors appear a graceful game on a par with acrobatics; they may, for all we know, have been mere playful sport (Pl. XXa).[2] Compact groups of soldiers or sailors in marching order never appear under the leadership of an officer. In fact, although in fowling scenes the gesture of a signal is recorded as a typical act, the expressive gesture of command, which entails a spatial, as well as a dramatic, distance between officer and soldier, is quite unknown.[3]

We do find isolated attempts to create some kind of link between figures or even groups by the simple device of turning the head of a striding figure in the opposite direction (Pl. XVIIIa, bottom, fourth figure from right).[4] But this 'looking back', apart from creating a plausible contortion, is usually quite meaningless. In fact, the disconnectedness of figures and groups is so evident throughout that the few exceptions (nearly all found in Ti's tomb) seem suddenly to change the spatial character of a small section of a crowded wall. The outstretched hand in Pl. XVIIb merely indicates the status of a foreman not actively employed, but in one desert scene[5] it seems to point towards the distance. In Pl. XVIIIa the 'looking back' of the man, combined with the gesture of his hand, integrates the whole group. In the case of the mother cow worrying about the calf with its

[1] In Wreszinski, III, Pls. 51 and 52, we have a similar if slightly less lively character.

[2] Ti, 110; Ptahhotep, Pls. XXV and XXVI. Further references in Klebs, *loc. cit.*, pp. 115 sq.

[3] It is striking that Hellmuth Müller, *loc. cit.*, only registers a number of exclamatory gestures which might be mistaken for commands.

[4] Ti, 117, shows two men holding the ends of a rope of a fish net looking at the foreman who stands between them. In our Pl. XIXb the men with pitchforks on either side of a heap of grain seem to be looking up with tilted heads at the men thatching the heap.

[5] See also the gesture of the huntsman with greyhounds in Ptahhotep I, Pl. XXII.

head turned back (Pl. XV, top right) there is even a tension such as never appears between humans or even in hunting scenes where, in the whole history of Egyptian art except in one New Kingdom instance, the relation between hunter and hunted never finds expression in a significant void.

The common gesture of sailors placed amidships in the rigging indicates that they transmit observations made by the man sounding forward to the steersman astern (Pl. XIII), but the gesture of a man in a skiff accompanying fording cattle means a spell cast against crocodiles (Pl. XXb).

We shall find that the characteristics of spatial rendering in Old Kingdom funerary art remain the same in essence throughout Egyptian history with few significant exceptions. The paradox contained in these scenes is thereby robbed of much of its absurdity. These paintings and reliefs are not monumental art in the full sense of the word (see p. 22). They lack the tension between the ephemeral and the timeless which, for instance, a preoccupation with biographical detail would of necessity have introduced. Nor do they depict actuality in the sense of single, well-defined occurrences. The consistency with which in the confrontation of the dead and the world of the living all reference to space and time, and all functional relation with the spectator has been avoided, makes this most undramatic of representational art beautifully subservient to its strange intention; and in the light of this intention its limitations, the contrast between 'primitiveness' and extreme refinement, appears less enigmatic.

C. THE SIGNIFICANCE OF THE RELIEFS OF ROYAL MORTUARY TEMPLES

If the character of the scenes in private tombs demands an explanation, those of the royal funerary temples apparently do not: one expects to find, and does, a display of royal power, royal acts. Unfortunately, however, all plausibility is invariably specious in connection with Egyptian kingship, for the divine head of state embodies here an absurdity far more audacious than is the case with his equals in neighbouring countries. His assumed godliness is not merely a mythical justification of authority or an expression of the obsequious way in which his authority was apprehended. For the ancient Egyptians Pharaoh *was* god; that means he was not chosen for his office, directed or inspired by a divinity as in Mesopotamia. He was not primarily the powerful leader, saviour, or guardian of his people but a divine presence on whom the life of the nation depended. Pharaoh thus

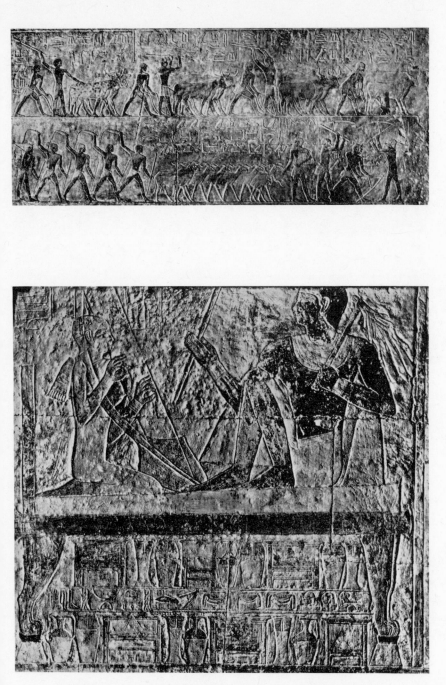

XVIIIA. AGRICULTURAL SCENES, TOMB OF TI
(*page* 42)

XVIIIB. MERERUKA AND HARPIST ON COUCH
(*pages* 42, 57*f*)

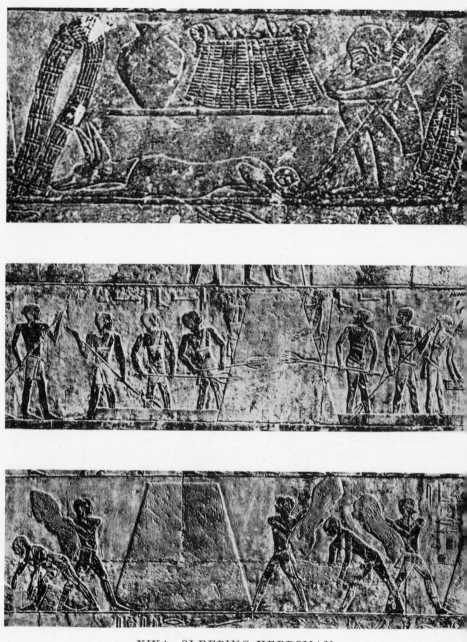

XIXA. SLEEPING HERDSMAN
(*page* 42)

XIXB. STACKING GRAIN, TOMB OF TI
(*page* 43)

XIXC. STACKING SHEAVES, TOMB OF TI
(*page* 43)

appeared in Egyptian life first and foremost a static actuality, both concrete and transcendent; and the term static does not mean here that he lacked the manifestation of power—he was *ex officio* the conqueror of his enemies—but that this power lacked a dynamic relation both with his subjects and with the gods. The question which will occupy us therefore is if, and in what way, this concept of kingship has found pictorial expression.

Now it has been proved beyond a doubt that the idea of a divine king—whatever its atavistic African affinities—became articulate and a dominant political factor largely through the person of Menes-Narmer, whose historical act of uniting the kingdoms of North and South had for later generations the quality of a myth and was enacted in ritual.[1] We saw that already on Narmer's votive palette (Pl. IX), the ephemeral character of the conquest was lost. It should, however, be noted that the palette itself was found in a temple dedicated to a god, so that the proud monumental statement probably entailed a votive or ceremonial act of humility. It may well have been the last of its kind, for we find nothing comparable in the Old Kingdom, nor, for that matter, up to the Twelfth Dynasty. Now it is true that an *argumentum ex silentio* is always dangerous, and it is possibly even sheer accident that—barring two sanctuaries of the sun-god in the Fifth Dynasty—we have no remains of any temples dedicated to a god up to the Middle Kingdom.[2] But if we assume that the absence of temples and votive objects indicates an overwhelming preoccupation with the dogma of kingship in the early Old Kingdom, then two other facts may become significant, first, that we have hardly any commemorative reliefs belonging to the period between Menes-Narmer and Zoser and, second, that in this very period plastic figures of a truly monumental character were introduced and were, at least from the Third Dynasty onwards, placed in the royal funerary temple. This indicates a shift of interest from pictorial statement (e.g. Narmer palette) to plastic form in the round which may conceivably signify a new desire to express unqualified rather than articulate and demonstrable royal power. If this conjecture is correct we might even go further: it would not be too bold to assume that some kind of discrepancy was felt to exist between a strict dogma of the divine king whose power was self-evident and self-sufficient and the representation of his acts, and that this caused the latter to be omitted when pharaonic power

[1] H. Frankfort, *Kingship and the Gods* (Chicago, 1947), chapter I and *passim*.

[2] It may be argued that temples dedicated to the gods were erected in the cities on alluvial soil and are therefore lost to us, but if these were more than small shrines then it remains unexplained why the important sun sanctuaries were built on the desert edge.

was at its height. For it is very striking that at the time when lively figures in painting and relief appear in private tombs of the Third Dynasty, King Zoser himself was depicted in the posture of a ritual dance but *not* performing a historic act.[1] And the builders of the Fourth Dynasty pyramid temples seem, on the whole, to have scorned scenic imagery. Only insignificant fragments, presumably of a ritual or tribute scene, have been found near the pyramid of Khufu[2] and in the appalling austerity of Khafra's granite temples, pictorial treatment must have seemed redundant; his statues, an almost monstrous union of individual life and inorganic rigidity, merely embody unqualified majesty.[3]

It should be noted that such emphasis on the plastic figure cannot be explained by assuming that there was in ritual acts a dramatic confrontation of the divine ruler and his subjects. For these figures were not the focusing point of religious devotion in the way a cult statue would be. In the case of Pharaoh there is no implicit tension between the epiphany of a god in one single form and the human world. The funerary temples—whether or not they form an architectural unit with the actual tomb—differ from other temples in and outside of Egypt, in that they are 'a house of god' primarily as a dwelling for eternity, not as a meeting place of different realms of being, the human and the divine. When in the funerary temples these realms appear to meet in ritual act and sacrifice, it must be realized that the royal heir, himself a god, performed the main rites and that the priests, endowed by the late king, were ministers to his needs, magic sustainers, not interpreters of transcendent power and will. No royal priest was ever called 'seer' as was the high priest of the sun-god in Heliopolis. The late king was lastingly present in an indestructible dwelling. Inside this dwelling the false door, beckoning and warding off, was the focus of the mystery. Near it were multiple shrines, usually five in number, and an arbitrary number of statues was arranged in halls and courtyards, a sheer quantitative increase of potency.

However, it was apparently only for a short period of Pharaonic hybris that pictorial treatment could be considered redundant, for a change did occur already at the end of the Fourth Dynasty. The political disturbances and successional feuds of the early Fifth Dynasty must have affected, if not the dogma, at least the unquestionable character of the power of kingship. The rise of the sun worship in the

[1] Firth and Quibell, *The Step Pyramid*, II (Cairo, 1935), Pls. XV and XVI.

[2] W. Stevenson Smith, *Egyptian Sculpture and Painting in the Old Kingdom* (Oxford, 1947), p. 157.

[3] Uvo Hoelscher, *Das Grabdenkmal des Koenigs Chepren* (Leipzig, 1912), esp. Pl. V.

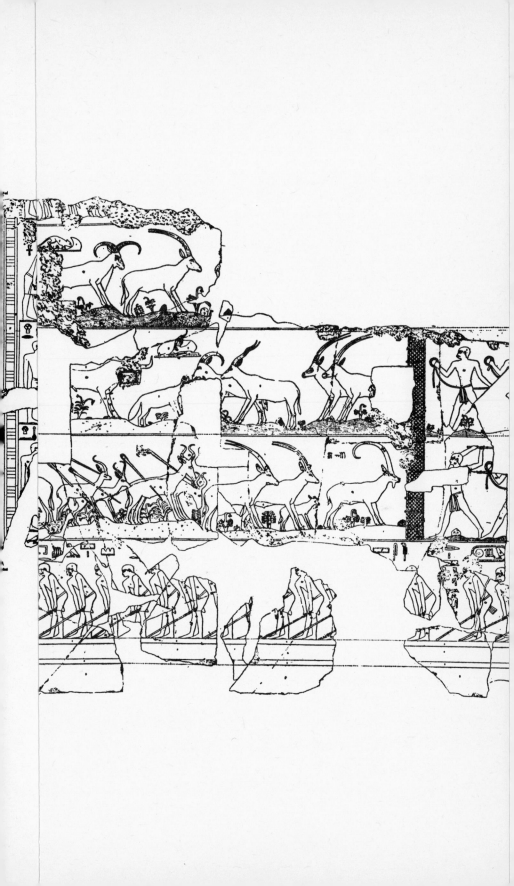

same period also seems to point to a subtle change in the unique signi-
ficance of Pharaoh. It is therefore significant that precisely at this
point it was considered desirable again to articulate his divine charac-
ter: scenic statement reappears, not on ceremonial objects this time
(though, for all we know, it may have survived there), but on the walls
of the funerary temple of Sahure.

The extant scenes are fragmentary and their position on the walls
is rarely certain, but there is some evidence which justifies the assump-
tion that the more secular scenes belong to the entrance passage and
outer temple, and this makes it possible that ritual and religious scenes
occurred in the inner sanctuary.[1] I mean by this that, though divinities
play an important part in the former, no reference to actual event is
made in the latter; in fact, it seems probable that some of the scenes,
such as the king being suckled by a goddess, refer to an event after
death.[2]

It is interesting to compare the content of these scenes with contem-
porary and earlier ones in the private tombs. Boating scenes with
funerary significance and the typical scenes of daily life are conspicu-
ously absent. The term 'watching' only occurs where it is least appro-
priate, namely, in a hunting scene where the king is actually shooting
(Fig. 4).[3] Sacrificial scenes and processions of tribute bearers occur in
both,[4] but here the gods themselves guarantee the king's sustenance,
they either bring or explicitly promise the needed produce.[5] They also
appear to guarantee the king's power, for they lead his fettered enemies
(Fig. 5), while the goddess of writing and accounts—who has been rather
rashly called goddess of history—notes down, not the historic feats of
the king, but the number of his captives.[6] The most striking difference
is that the king is either shown active, or as living cause of the activity
of others, and that a number of scenes refer unmistakably to actual
events. The king is shown active when destroying his enemies in a
formalized gesture[7] and in certain ritual acts pertaining to the Sed
festival;[8] he is also shown active in two instances when he is making
offerings to gods (a polite reciprocation of their concern for his well-
being),[9] and once when he is being suckled by a goddess.[10] We saw
already that he was depicted shooting in the desert hunt and there are
fragments which suggest that he was shown catching birds and spear-

[1] Sahure II, pp. 1 and 2.
[2] This is also the conclusion reached by Jequier, *Le Monument funéraire de
Pepi II* (Cairo, 1938), II, 24.
[3] Sahure II, Pl. 17. [4] *Ibid.*, Pls. 28 and 31.
[5] *Ibid.*, Pl. 23 and p. 102. [6] *Ibid.*, Pl. 1.
[7] *Ibid.*, Pl. 2. [8] *Ibid.*, Pls. 45, 46, 47.
[9] *Ibid.*, Pls. 35 and 36. [10] *Ibid.*, Pl. 18.

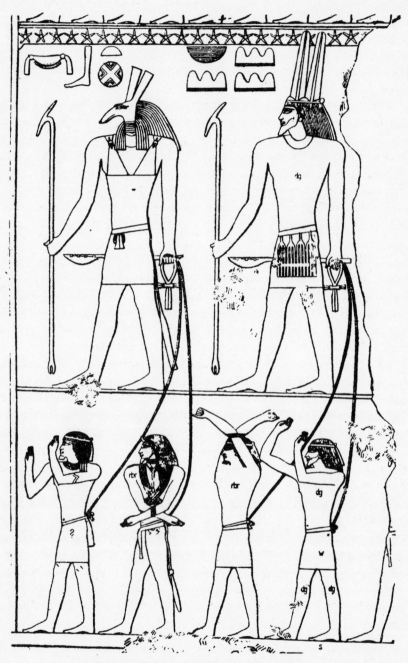

FIG. 5. *Gods with Captive Foreigners*

ing fish.[1] He is the living cause of activity in the Sed festival and in the scene where the gold of honour is distributed[2] (it should be noted that in the Old Kingdom the *receiving* of the gold of honour, as a historical moment in a courtier's career, was *not* depicted in the private tombs), and in the scene of an overseas expedition.[3] In court processions he appears in conjunction with officials and is depicted in a curious static stride.[4]

The last four instances undoubtedly refer to acts and situations that occurred in his lifetime, though one hesitates to call them historical because they are mostly typical and recurrent events except, perhaps, in the case of the expedition and where Libyan captives are mentioned by name with numbers of the captured animals.[5] The fact that courtiers are mentioned by name need not be explained as an effort to stress the temporal character of the event, for this may, as in the case of private tombs, be a concession to officials, who were thereby allowed to share lastingly the benefit of Pharaoh's proximity. Yet in view of an occasional link with actuality, it is striking that battle scenes are absent. Triumphant majesty was not rendered as a warrior's historic achievement, but as a state of being, aloof, self-centred; even Narmer's symbolic gesture has in some cases been superseded by an ideogram: the king in the form of a griffin or winged lion trampling on his enemies.[6]

The private tomb and the royal funerary temple both contain slaughter and tribute scenes, which have obvious magical import, but generally speaking the difference between the decorative themes of tomb and temple is very great. Whereas in the former the keynote of all rendering of the owner is 'watching', passivity, it is evident that a nostalgic confrontation of the dead king with the amenities of life was considered incompatible with his divine character. Are then these reliefs an ostentatious recording primarily aimed at the outside world; are they, in contrast with the private tombs, a monument in the true sense of the word? I believe they are not, although an element of ostentation cannot be denied. The king was divine during his lifetime, but the pyramid texts show that notwithstanding this dogma there was room for fear (amounting almost to an obsession) of humiliating contingencies such as hunger and thirst in the Hereafter. The royal tomb evidently fulfilled a double function: it guaranteed the king's sustenance after death and it emphasized his superhuman stature. If

[1] *Ibid.*, Pls. 15 and 16. [2] *Ibid.*, Pls. 52 and 53.
[3] *Ibid.*, Pls. 11 and 12. [4] *Ibid.*, Pls. 32, 33, 34.
[5] *Ibid.*, Pl. 1. Jequier, *loc. cit.*, II, 14, points out that the same names occur with the Libyan captives of the Sixth Dynasty king.
[6] Sahure II, Pl. 8.

the latter was achieved by referring to his temporal acts, these acts were part and parcel of his divine identity. The central, the implicit paradox was here, so to speak, the very opposite of monumentality, for what was aimed at was not to stress the lasting significance of transient event, but to show static perfection revealed in acts. This was the reason why a divine king of the Fifth Dynasty reliefs could be shown performing the ritual of the Sed festival, which was to ensure his immortality, or in triumph over his enemies, but not winning battles, for his victories were a foregone conclusion; why the aid of a goddess was even allowed to rob his prowess in the hunting field of personal and transient merit and why in connection with his subjects he was depicted as the inactive cause of their activity, the source of their well-being.

The remains of reliefs from later funerary temples are scanty, but it appears that their character remains practically unchanged in essentials up to the Amarna period. One should however notice two significant exceptions, one occurring in a period of incipient decay, the other marking the end of a period of political upheaval. In the temple of Unas we find the unique instance of famine being depicted (Pl. XXIIb) and this must have entailed not only a most humane interest on the part of the king in the lowest of his subjects but *probably*, though perhaps in texts alone, the mention of historical and specific benevolent acts, not the mere typical statement: 'I fed the hungry in years of distress.' In the funerary temple of Mentuhotep at the beginning of the Eleventh Dynasty wild and quite unorthodox battle scenes must have existed, since their fragments have been found (see below). But it should be noted that the famine (in any case a subsidiary scene) never occurs again, while we have no evidence of battle scenes in funerary temples till after the Amarna revolution.

Before we deal with the spatial character of the scenes, however, we must consider the only reliefs of a non-funerary character which we possess in the Old Kingdom, namely those found in the sun sanctuary of Ne-User-Re (Pl. XXIa, b, c).[1] The surprising thing about these reliefs is the complete resignation of the Egyptian in the face of pictorial problems within the realms of religion. To speak of a lack of imagination here is almost an understatement. The sun-god was only represented in the symbol of the obelisk, and although vast brick sunboats have been found, which may have been used in ritual and point to the importance attached to the mythical journey to the sun, no representation of the latter occurs in the sanctuary. In fact, the two

[1] F. W. von Bissing, *Das Re-Heiligtum des Koenigs Ne-Woser-Re* (Leipzig, 1905-1928), Vols. I–III.

sides of Egyptian life and thought that seem predominant throughout, belief in the supreme importance of the king, and a love—which has a strong element of the purely aesthetic—for the manifestations of life, are here again in evidence. In the central part of the open court-yard the king's Sed festival is pictured in great detail, as if to stress the potential renewal of his power in the face of the god, and in the hall leading up to it we find a tribute to nature as manifesting the sun-god's glory: a representation of the seasons and of quiet scenes of agriculture, fishing and wild life, animals and plants. There is in the whole of the Near Eastern world no equivalent for so movingly direct and simple, if unimaginative, an approach to the religious problem of the life-giving sun. It is wholly incompatible with the warrior aspect of the triumphant sun-god, known from Mesopotamia and elsewhere, and is again an undramatic conception, deeply rooted in Egyptian religiosity. All later sun hymns breathe the same spirit and in the Amarna paint-ings we shall find its artistic expression in a different but related manner.

D. THE TRANSCENDENCE OF ACTUALITY IN THE ROYAL RELIEFS

In dealing with the problems of space and time in the royal reliefs we may omit the tribute and slaughter scenes and even ritual or sym-bolical ones such as the king holding a bunch of captives or a griffin trampling on an enemy, since they are typical acts and offer no prob-lems. But it is interesting to see what devices the artist used to render what we called the king's static perfection as revealed in acts that have some bearing on actuality. It is clear that in most cases the aid of gods was summoned to banish all triviality from these acts: the Egyptian pantheon makes its first known appearance here (Fig. 5).

For the student of ancient religion these gods must be disappointing, for they are hardly 'numinous', nor even weird or monstrous; they are pre-eminently dull. Their shape is usually identical with the classical Egyptian canon for the human figure, their sizes vary, they may be of the same size, larger or smaller than the king. Occasionally an animal's head is joined on to a human body in such a matter-of-fact way that the result is more like a pictogram than an uncanny superhuman being. To use the word 'monsters' here means simply to ignore that this term implies a significant incongruity, a disharmony of component parts. No such tension is implied here; animal heads are merely fastened on to human bodies. The potbellied Nile gods with pendulous breasts are covered with zigzag stripes to denote their connection with water and they look, for all the world, more like hieroglyphs in action

than convincing aquatic creatures.[1] Nor is the context in which the gods appear, the acts they perform, helpful in making them seem exalted or remote. They never reveal a superhuman nature or power, as does, for instance, the Mesopotamian thunder-god driving his fearful chariot (Pl. LXIIIa). The king's power and well-being alone are the concern of these deities, the purpose of their acts; they serve and are in turn served by him. But though their proximity is intended to ensure and to enhance Pharaoh's glory, the meeting of equals is an essentially static situation, remarkably devoid of dramatic tension.

A comparison with, for instance, the scene on the Hammurabi stele (Pl. LXV) is instructive. This scene is a truly monumental work of art in the sense that the superhuman implications of a historical event, namely, the codification of law and decrees, have found expression in confrontation of king and god. In the gesture of Shamash, addressing the king, a dynamic relation is revealed, a single and momentous act depicted; hence the extraordinary concreteness, the actuality of the scene, its strong appeal to spatial as well as emotional imagination. But where kingship transcends the human situation as completely as it does in Egypt, protective acts on the part of the gods are purely symbolical, obeisance on the part of the king purely ritual; no divine command or divine protection can ever have so direct a bearing on actuality. The beneficial proximity of king and gods must therefore remain outside the realm of concrete imagination, must lack spatial as well as temporal definition. Hence the monotony of these dispassionate lay figures, divine as well as regal, neatly spread out on a depthless background, a mere calligraphic arrangement of groups. It seems as if the bold concept of Egyptian kingship atrophied some mainspring of religious imagination (which elswhere has nearly always an element of the dramatic) and equally atrophied its artistic expression, because the dullness of all so-called 'religious' scenes is unrelieved throughout Egyptian history: this art is senile at birth.

The scenes in which the king and his courtiers appear together stress his 'static perfection' by similar means; they are a mere matter of grouping one large figure and a number of smaller ones, without the slightest interest in spatial, let alone dynamic, relation. Sometimes the poses of a number of squatting figures are varied, which might give them a spurious air of being simultaneous, but they are too robot-like to achieve the impression of a coherent group.[2] In the so-called 'procession' scene[3] the king, though apparently striding, is not moving purposefully, which might have given the background the quality of dynamic space, In fact, there is no pictorial focus for his movement,

[1] Sahure II, Pl. 30. [2] *Ibid.*, Pl. 50. [3] *Ibid.*, Pls. 32, 33, 34,

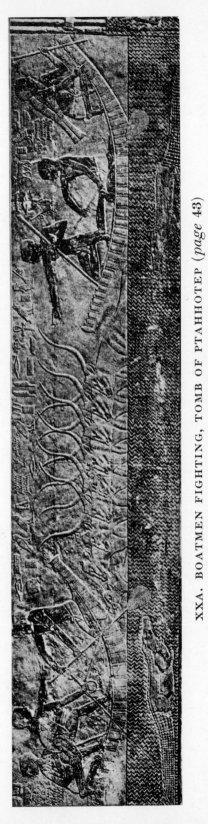

XXA. BOATMEN FIGHTING, TOMB OF PTAHHOTEP (*page* 43)

XXB. CATTLE FORDING STREAM, TOMB OF TI (*page* 44)

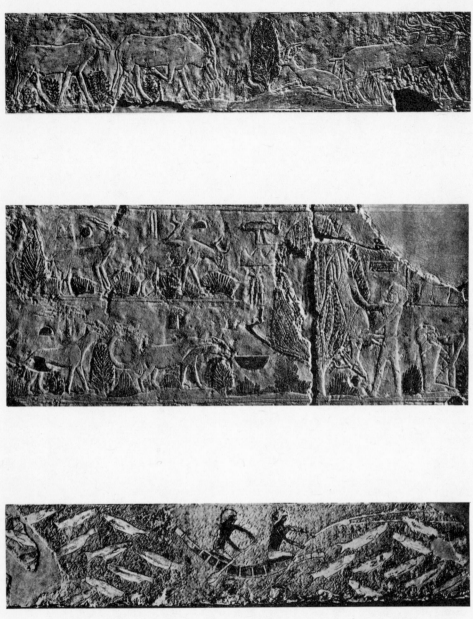

XXIA. THE DESERT, SUN TEMPLE OF NE USER RE
(*pages* 50, 54)

XXIB. SKINNING ANTELOPE, SUN TEMPLE
(*pages* 50, 54)

XXIC. MEN IN BOAT, SUN TEMPLE
(*pages* 50, 54)

and if the emendation of the text is correct, 'coming and going' is the only noncommital statement about his movement.[1]

In the scene recording a naval expedition to Byblos there is no trace left of the large royal figure which undoubtedly presided over the departure and arrival of the fleet. We can only imagine it to have been impassive. The fleet is arranged in two rows on strips of formalized water. No locality is indicated and the rows of sailors on a separate groundline above the ships need by no means be interpreted as formations running along the shore[2]—in any case a most unlikely procedure —they are a mere filling and stress the number of men used in the campaign. The large ship of state, executed with immense love of detail, shows Pharaoh's throne empty, perhaps because the royal figure could not loom large enough in such a detailed setting, more likely because the act of sailing in itself (and a religious purpose can in this context hardly be postulated) must have appeared too episodic.

The only scene which from our point of view is interesting is the hunting scene (Fig. 4). This renders, as do most 'lively' scenes in Egyptian tombs, a typical, not a single event. In Assyrian reliefs we shall find that the king's gesture in slaying wild beasts is depicted as simultaneous with the animal's behaviour. Here the shooting king appears aloof from, or rather not immediately connected with the agony of his prey; the animals are, as it were, the stage props for a typical situation that is to demonstrate his power. Yet the animal enclosure seems somehow conceived as more than a mere conceptual unit; the orientation of the animals on the left fleeing from the king, and on the right shying away from the beaters, gives the group an almost dramatic coherence, as if it were the simultaneous behaviour of penned-in animals. But spatial relation (so beautifully achieved two thousand years later by an Assyrian relief which dispenses with locality and yet binds in space; see Pl. LXXXI) is destroyed by the fact that every animal has been fixed on a separate groundline in the shape of a contour of hillock or stone. Potential dramatic unity disintegrates together with spatial coherence and there remains the impression of separate animals in various stages of flight and fear. Even the small 'genre' pictures of hedgehogs and jerboas, ready to slip into their holes which are inserted on separate groundlines above the main group, fail to add much to the episodic transient character of the scene as a whole.

We shall see, however, that desert hunting scenes provide throughout Egyptian art most interesting experiments in the rendering of space. Here, if anywhere, some form of dramatic tension was difficult

[1] *Ibid.*, Pl. 32 and p. 111.
[2] *Ibid.*, Pls. 9 and 10 and p. 24.

to ignore and might tempt the artist away from rendering unrelated animal figures on fragments of skyline.

Pepi II's funerary temple already is a case in point. Generally speaking, the reliefs for this temple are unspeakably dull. Ritual and religious 'scenes' are unrelieved by a single touch of originality. The docile figures of king, gods, and men are spread out on a relentless surface that refuses ever to become significant; gestures are somehow both stiff and limp, the expressionless gestures of robots. Only in the hunting scene does artistic imagination run riot.[1] On a small scale admittedly, for Sahure's elaborate and exquisitely carved scene has here been reduced to a narrow strip, packed with known motifs. But surmounting this strip and with forefeet planted on a boldly curved line, a large animal must have faced the king alone. Although the reconstruction by Jequier seems unreliable in detail, there is no doubt that this was a bold innovation, which may have remotely resembled the scene of an Eighteenth-Dynasty hunter facing an ibex, which we shall discuss later.

It is unfortunately impossible, as yet, to deal adequately with the relief of the so-called 'Weltenkammer' from the sun sanctuary of Ne-User-Re, for the simple reason that, although it was excavated in the years between 1898–1901, no publication has appeared so far, and only a few tantalizing fragments have been published by especially favoured German scholars. These fragments are, however, of considerable interest.

It appears that large symbolical figures, representing the seasons, headed various scenes of nature. These scenes show man-in-nature reaping the reward of the sun-god's life-giving power in agricultural, fishing, and allied scenes, and also wild beasts and plants that were simply to demonstrate his glory (Pl. XXIa,b). To call the small scenes in which these appear 'idyllic' means to sentimentalize them, unless the word is used in the sense that nature is rendered here in no way subservient to man's greed and power. But—and this is surely to the everlasting credit of the early Egyptian—they do reveal the detachment of aesthetic love; for these animals and plants are not part of a scene that ultimately transcends their significance, they are neither requisites nor symbols, they are merely a beautiful presence, significant in themselves. It is striking that though a hunter and dogs appear on the left of what is usually called a desert scene, the dogs are neither on a leash nor attacking, the wild animals seem undisturbed, and the hunter's meal on the right with a dead antelope hanging in a tree (Pl. XXIb), is totally unconnected with the behaviour of either. There is, in fact,

[1] Jequier, *loc. cit.*, Pl. 41.

a curious air of pure landscape about this scene: the large trees, decoratively spaced between the animals, serve no explicative purpose, as the small plants of Fig. 4 do, namely, indicating desert soil. They never appear exactly in this manner on any hunting scene in Egypt, and seem a subtle way of linking the separate beasts spatially. This holds good especially for the small area which we enlarged in Pl. XXIa, where the pawing antelope—the original shows a streak which indicates the flying sand—plants, trees, and fawn appear to be a unit, as of things seen together on the skyline; a space-time unit absent in the Sahure relief.

This same air of pure landscape pervades two other remarkable fragments. The two men in a small boat (Pl. XXIc) are not firmly planted on a harsh strip of zigzag water, with fishes and net clearly displayed as stage props. These self-contained little figures seem to float in the midst of a stream, a more 'spacious' rendering of water than has ever been achieved at any other time in Egypt.[1] The fishes on the left, disporting themselves outside the net, thereby suddenly gain a scenic independence, they do not appear a mere inventory of possible catches.

Equally remarkable from the point of view of spatial rendering is the picture of a 'crocodile island' (Pl. XXIIa), unique not only because of its subject but, here again, because of the relation between self-contained unit and surrounding. The island with its broad uneven strip of mud—painted black in the original—its little shrine and sacred image (for it is not a live animal that is intended) surmounted by an expanse of formalized water which for once has been left quite bare, does appeal to spatial imagination, invites the spectator to visualize a definite, probably an actually existing, locality. In this it comes nearer to the Scorpion macehead (Pl. VIII), with its winding canal, than almost any of the later, and quite infrequent, attempts at pure landscape, because there, more often than not, the setting is dominated by the action. No human figures, however, appear on the crocodile island, and in the desert and fishing scene they are subordinate.

It is significant that these remarkable fragments should all belong to a decorative scheme that was different in intention from all contemporary art. These scenes were not primarily a potent presence, they *proclaimed* the sun-god's glory. The form in which they did this was, it is true, as undramatic as all Egyptian art, but it can hardly be accidental that, freed from the bonds of funerary purposes, the artist was tempted here and there to create a scene, as functionally related to the observer as the skyline scene, to bind the figures in it (even if no action

[1] Although in the New Kingdom in funerary scenes the boat is sometimes placed in the middle of the pond; Wreszinski, I, 3.

was depicted) as if they were a *chose vue* ; or depict locality in a way which might tempt the spectator to move in imaginary depth.

We must finally consider the most remarkable fragment which the funerary temples of the Old Kingdom have yielded so far, namely, the famine scene from the causeway of King Unas' temple (Pl. XXIIb). That these ghastly figures in various stages of emaciation and exhaustion should appear at all in such a building is the more striking because the texts, sculptured in the adjoining pyramid here as elsewhere, show a gruesome preoccupation with the possibility of hunger and thirst in the Hereafter: 'The abomination of Unas is hunger—he does not eat it. The abomination of Unas is thirst—he does not drink it.' Also, within the framework of divine kingship, a famine must somehow have marred the illusion of infallible and beneficent regal power. We can therefore explain the occurrence of the scene only on the basis of a tendency observed in the temple of Sahure, namely, to refer to actuality in however guarded or remote a form: Pharaoh's perfection did reveal itself in acts. How this was done in connection with the famine scene we have no way of knowing—the scene is unique in the history of art. And though the emaciated figures in a Middle Kingdom tomb at Meir (Pl. XXVa) may have been inspired by it, the horror of the original scene was evidently here turned into a joke.

The rather poor finish of the famine relief might point to a minor artist employed on a mere detail. But he must have been a man of striking originality, for he has not only contrived a number of new and intricate postures, he has achieved something very much like an impressive scene. These are not typical acts; explicative gestures only; here sympathy and despair, collapse and suffering have the poignancy of actuality, of single events. The figures are, it is true, added singly, in twos and threes to form a frieze. Yet the impression of a true, coherent scene prevails. And this illusion is so strong that it is almost difficult not to conceive of these figures as leaning against a wall, invariably the resting place of the beggarly and maimed in an oriental scene. It is interesting—if paradoxical—that illusionistic rendering may on occasion solidify a plain background instead of making it diaphanous.

E. CONFUSION OF MEANING AND DISINTEGRATION OF FORM IN THE LATE OLD KINGDOM AND FIRST INTERMEDIATE PERIOD

In summing up the main results of our analysis we find that originally both content and implicit meaning of the scenes in private tombs

and funerary temples differ; on the one hand, we have a mere presence of typical aspects of life for the benefit of a generally passive though 'living' owner and, on the other, the timeless perfection of a divine king revealed in his acts. Yet both can be adeqately expressed by the same type of spatial rendering, namely, one which shuns illusionistic and dramatic scenes. It is clear that this must have facilitated the copying of motifs from royal temples for use in private tombs in so far as they did not trespass on royal prerogatives; and there must have been considerable danger that the fundamental difference between the two might be lost sight of. For if, as we saw, the artist might already be tempted to bridge the gap between the living and the dead, the activity of the royal figures must have been an added stimulant in this direction. It is an argument in favour of our assertion that it is possible to detect a different basic logic in each scheme, that the two were never assimilated. The only motifs' copied in the private tombs were fishing and fowling scenes, which become indeed a classical motif, a choice which may as we saw (p. 35 f.) have been influenced by the prevailing concern with food provision for the dead. The only new activities on the part of the tomb owner which appear in the Sixth Dynasty tombs are freakish innovations and remain practically isolated instances.

We shall now deal with these tombs and include those of the First Intermediate Period, both the tombs in the cemeteries situated in the shadow of the royal pyramids and those which, from the late Fifth Dynasty onward, begin to appear in the provinces and herald political disintegration and a decline of Pharaonic power.

The most interesting tomb from the point of view of innovations is that of Mereruka, which shows no less than four completely new scenes, in all of which the dead is engaged in well-defined activity. They are (1) Mereruka seated at an easel, painting figures representing the seasons:[1] this scene may have had a magic or at any rate a propitious connotation; (2) Mereruka standing supported by his son and a high official (Pl. XXIIIa), a unique variant of the manner in which the dependence of the dead on the living was often expressed, and one which has a curious actuality and an emotional overtone; (3) Mereruka playing chess or draughts;[2] (4) Mereruka seated on a couch with a woman who plays the harp (Pl. XVIIIb): this scene is the climax of a series which shows the preparation of the couch[3] and is, as we saw, the only one in the Old Kingdom where the confrontations of figures has erotic implications.

[1] Mereruka I, Pls. 6 and 7.
[2] *Ibid.*, II, Pl. 172. Kaiemankh is also shown playing this game : *Giza* IV, p. 36, Fig. 9.
[3] *Ibid.*, I, Pls. 91, 92 93.

It is most remarkable that in all these scenes there is no question of the tomb owner getting surreptitiously involved in the activities of daily life which he watches, or of motifs copied from royal temples. All the scenes, especially the last two, render ephemeral activities; these go beyond the well-known preoccupation with food and property, but do not reveal a monumental intention either, for they do not extol significant, they merely register pleasurable acts. We are, in fact, suddenly faced here with a new developement which might lead to a complete loss of the earlier restraint and dignity. Yet neither in this case nor in the Middle Kingdom when, as we shall see, we find for the first time a recording of historical achievement, have the potentialities of these innovations been grasped. They remain isolated and have not become the starting point of further development. Far from disproving our thesis these exceptional scenes seem to confirm it. It needed the upheaval of the Amarna period to discard even temporarily the fundamental significance of the original scheme.

As regards the bed scene, though no other instance is known, we find the motif of preparing a couch in one tomb, obviously a copy.[1] In this case it brings about an insidious change in a well-known scene namely, that of the dead watching the harvest. Here a chair and a couch are being prepared for the tomb owner whose figure brackets the scenes, the chair behind him, the couch in a lower register. This suggests actuality far greater than in any scene where, e.g., the dead is being carried in a sedan chair but does not appear in any way connected with surrounding activities. The preparation of bed and chair so close to the watching tomb owner seems to bear on his activity and vaguely suggests a rural scene, while the implication that he is going to use them introduces an element of narrative. It is probably insidious changes such as these which made it possible that in the Middle Kingdom, in a tomb which is exceptional from every point of view, the change from timeless confrontation to actuality was made complete; for there we find the record, in writing as well as illustration, of an actual journey made by the owner to his estate and for the first time he is said to *receive* the amount and to supervise the counting of his cattle.[2] We shall in due course deal with every instance of this kind but want to stress here that they are few and far between.

What matters here is that not in a single case was the spatial rendering affected. The flaccid style of the tombs of Mereruka and Kagemni shows no daring in this respect; generally speaking, the old

[1] Wreszinski, III, pl. 13. The preparations of bed and chair is also shown in the tomb of Kaiemankh: *Giza* IV, p. 40, Fig. 10.

[2] See below, p. 75.

scheme was rigidly adhered to. It is true, however, that in the late Old Kingdom and First Intermediate tombs, especially those in the provinces, a number of eccentricities occur.[1] For instance, the elaborate picture of an actual mastaba bracketing a number of ritual scenes suggests a spatial link between the groups, though it does not achieve space-time unity by any means.[2] On various occasions groundlines— though rarely registers— are omitted, and some single figures are put above the groundline; the result, however, is never the suggestion of depth but merely an effect of slovenliness.[3]

On the other hand, we find in some cases curious attitudes and lively accidental groupings which may suggest simultaneity of action, momentariness;[4] for instance, in the mourning scene in Mereruka's tomb[5] where even one of the women collapses—a rare instance of a falling figure. Also in the scene of cattle fording a stream[6] where the last calf dives into the water—usually all animals are pictured in the water— and where the uneven line of horns suggests to us recession, though this may well be accidental.

Similarly the horizontal figures in the boating scene[7] who are probably meant to be swimming, not falling, figures; the complex activity in connection with the stranded ship thereby suggest the rendering of a single accident rather than a typical incident.

Even more remarkable is the time aspect of a man running down the steps with an empty basket.[8] He does not perform an indispensable act in a scene which represents the filling of a corn bin. And whereas, generally speaking, in the description of such scenes all attempts by scholars to introduce the time element, by saying one figure does this while another does that, are not warranted because various figures represent typical stages of one complex activity; in this case it is indispensable. We may stress the fact also that this *Leerlauf* is the only instance known in Egypt.

[1] See Smith, *op. cit.*, pp. 223 sqq.

[2] L. D. II, 35.

[3] N. de Garis Davies, *The Rocktombs of Deir el Gebrawi* I, Pl. VII (calf in third register); Pl. VIII, third register (squatting figure holding cord); Wreszinski, *Bericht* (Halle a. s. 1927), Pl. 53; Wreszinski, *Atlas*, III, Pl. 69, abb. 6; Wreszinski, *Atlas*, I, Pl. 85; J. J. Tylor, *The Tomb of Sebekh-makht, passim*.

A special case arises when the sculptor of the tomb depicts himself outside the scene, as it were, and without groundline (Wreszinski, *Bericht*, Pl. 42).

[4] See Hellmuth Müller, in *Mitteilungen des Deutschen Instituts, Kairo VII* (1937), III, Fig. 49.

[5] Mereruka II, Pl. 130.

[6] H. Kees, *Studien zur aegytischen provinzial Kunst*, Pl. II.

[7] H. Kees, *loc. cit.*, Pl. I; also in Wreszinski, *Bericht*, Pl. 41. We find in J. J. Tylor, *loc. cit.*, Pl. II, what looks like a very debased version of the same theme, but here the accidental character is lost entirely.

[8] Wreszinski, *loc. cit.*, Pl. 35.

The Old Kingdom

By far the most interesting new motif, however, we find in Upper Egypt at Deshasheh (Fig. 6). In an otherwise conventional and rather slovenly carved tomb the siege of a town is given in great detail. A similar scene occurs in a late Sixth Dynasty tomb in Saqqarah, obviously related, but with a number of different motifs (Pl. XXXIIb). The appearance of this kind of scenes in tombs is something of a mystery. They obviously do not fit into the general decorative scheme and it is significant that the earlier of the two occurs in a southern province, well away from the political and artistic centre and at the end of the Fifth Dynasty, that is, when the zenith was passed.

The extraordinary character of these scenes can only be ignored if contemporary Old Kingdom reliefs are treated as a child's picture-book, for then they would mean merely a new invention, a new story. The fact is that they are not only a new story told but the first story ever told in relief since protohistoric times and—with one undramatic exception in the Middle Kingdom—almost the last story told till the Amarna period. There is nothing typical about this Deshasheh scene, it does not render phases of known and recurrent activities, it is dramatic and emotional in the extreme and has an unheard-of 'actuality'. Within the limits of nonfunctional rendering, dramatic space has been achieved, not only in the relation, for instance, between the mining soldiers and the figures listening within the walls, but also between the attackers and the besieged—it is extraordinary to see how the diagonal of the scaling ladder adds to the tension as compared with the vertical ladder in the later painting (Pl. XXIIIb). The use of registers barely detracts from the sense of spatial unity which the scenes of despair inside the town wall convey; the women killing their menfolk to save their honour, the breaking of a bow, the passionate leave-taking, the moving scene of the aged and infirm confronting the chief, who tears his hair. Near the ladder, the figures of falling men riddled with arrows add to the sense that there is some spatial link between events in and outside the town wall. The latter are extremely vivid and full of original detail but remain within the accepted scheme of closely knit groups in registers which have been cut by the ladder.

It is interesting to compare the Deshasheh and the Saqqarah scenes and to note how in the later version the truly dramatic space has already vanished. The miner with his pick, at the top, and the listeners are no longer related nor are the fighting men inside the walls and the attackers. The lively gymnastics of the figures on the ladder are less threatening than the gesture of the one remaining figure facing the ladder in the Deshasheh painting. The only original motif appears in the left-hand bottom corner, where we see an underground shelter

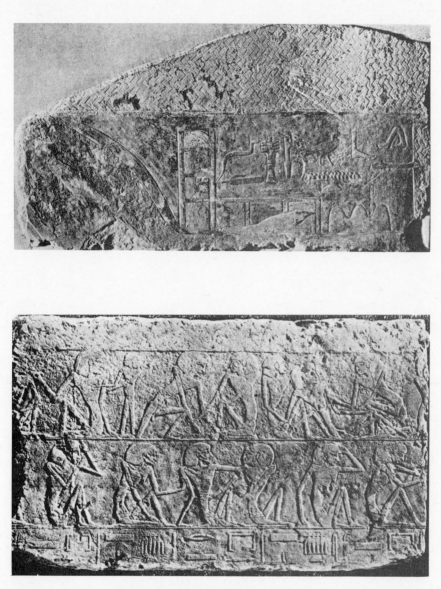

XXIIA. ISLAND WITH SHRINE OF CROCODILE, SUN TEMPLE
(*page* 55)

XXIIB. STARVING PEOPLE, PYRAMID OF UNAS
(*pages* 50, 56)

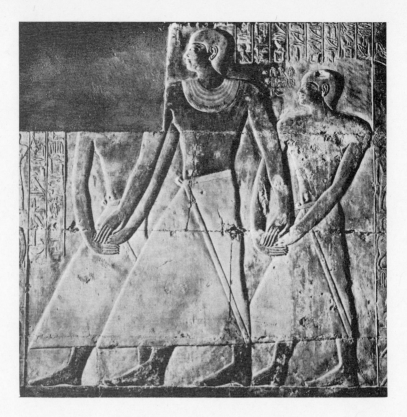

XXIIIA. MERERUKA AND HIS SONS
(*page 57*)

XXIIIB. BATTLE AND SIEGE, TOMB AT SAQQARA
(*page 60*)

FIG. 6. *Battle and Siege*

for women and children; through the urgency with which one figure dives in, while the other stretches out a helping hand, this has an emotional appeal.

In reviewing the mass of material it is equally surprising that such narrative art should suddenly make an appearance, as it is significant that it found no following and never affected the main stream of development in Egyptian art. Even in the Middle Kingdom all reference to military events has been robbed of dramatic quality, and though it is incongruous with the basic scheme of representation, it fits effortlessly into the placid rows of figures engaged in uneventful pursuits.

CHAPTER III

The Middle Kingdom

A. THE CHARACTER OF THE PERIOD AS REFLECTED IN ITS ART

The second efflorescence of Egyptian political and cultural life differs from that of the Old and New Kingdom alike in one respect; no powerful monarch presided over its earlier stages. Pharaonic power had slowly to assert itself over and against that of local grandees, who on a smaller scale had started previously to organize a desperately disintegrated country. Even if court poets—when the Twelfth Dynasty was well established—praised Amenemhet I as a redeemer from chaos,[1] the bitterness of the words ascribed to him in summing-up his life's achievement for the benefit of his son,[2] the confident display of power and wealth by the earlier feudal lords, who do not hesitate to usurp royal titles and even usages,[3] speak a different language. The ultimate triumph of the dynasty was no effortless victory. Yet the conception of divine kingship, which must have fulfilled deep speculative and emotional needs, survived the political chaos of the First Intermediate Period and the all too human efforts to re-establish secular power. It is a sad accident of history that we have practically no reliefs from royal funerary temples which, in conjunction with those of the private tombs, might throw some light on both the changes and the continuity in the relation between divine monarch and subjects. We have found that in the Old Kingdom the cleavage between the two

[1] The prophecy of Neferrohu; see Alan H. Gardiner in *JEA*, I, 100–106, and for the political implications of the text A. de Buck, 'La Littérature et la politique sous la douzième dynastie Égyptienne,' in *Symbolae Van Oven* (Leiden, 1946).

[2] Alan H. Gardiner in *JEA* I, 20–36; A. Scharff in *Sitzungsberichten der Bayerischen Akademie der Wissenschaften, Phil.-Hist. Abt.*, 1936, No. 8; A. de Buck in *Mélanges Maspéro*, I, 847 sqq.; B. Gunn in *JEA*, XXVII, 2 sqq.

[3] This period is described in detail by H. Kees, 'Aegypten' ('Kulturgeschichte des alten Orients,' I, in *Handbuch der Altertumswissenschaft* (München, 1933), pp. 201–208).

found expression in a basic difference between the schemes of funerary decoration in private tomb and royal temple. At no other time—except in the Amarna revolution—could the danger of an unwarranted approximation, a disregard of this difference, have been greater than in the early Middle Kingdom, when princes emulated Pharaoh. And we shall find indeed significant symptoms of such a trend in the tombs of feudal lords; but we possess no royal reliefs sufficiently well preserved that could, either in style or content, reflect a significant change, something related maybe to the haunting humanity of extant royal portraits in the round (Pl. XXIV). Only a few small fragments might point in this direction: among the remains of the earliest temple at Deir el Bahri bits of relief have been found belonging to the reign of Mentuhotep Nebhepet-Re, the greatest king of the Eleventh Dynasty, but one whose name was *not* sung by later poets as a bringer of peace and prosperity. The fragments were part of wild battle scenes, infinitely closer in spirit to the dramatic quality of the Deshasheh siege than the large formal ones of post-Amarna date that appear in Karnak and Abydos. They are, unfortunately, the only significant fragments we possess, barring one conventional scene of Sesostris I performing the Sed dance before the god Min.

We shall, then, have to focus entirely on the tombs of noble families which were hewn into the cliffs overlooking the river valley near various centres of feudal power, at Meir, Beni Hasan, El Bersheh, Thebes, and Assiut. The style of the decoration, mostly executed in paint, is fairly homogeneous, but both as regards content and what can best be called mannerisms, the differences are great; this provincial art had evidently all the self-assertiveness of local pride. Quite new is a preoccupation in several tombs with military matters. We find scenes of marching soldiers,[1] the siege of towns,[2] and the bringing of tribute.[3] These obviously reflect the temper of the times but immediately raise the question —more imperatively here than in the case of the two quite exceptional Old Kingdom scenes we discussed—how such matters could fit into the original scheme we postulated.

The fact is that they do not and that we must see in them, as also in a number of other scenes where the dead is involved in some activity or other,[4] a tentative development—doomed from the start and soon

[1] Beni Hasan I, Pl. XLVII.
[2] *Ibid.*, Pl. XIV; II, Pls. V and XV.
[3] *Ibid.*, I, Pl. XXX.
[4] This is particularly clear in the legends at El Bersheh, e.g. El Bersheh I, Pl. IX and p. 15: 'Canoeing in the papyrus beds. . . by . . . Djehutihetep'; Pl. XII and p. 28: 'Leading oxen of the best of the stalls before the face of the prince'; *ibid.*: 'Arriving in peace, approaching the hall of the counting by the prince Djehutihetep.' On this scene see below.

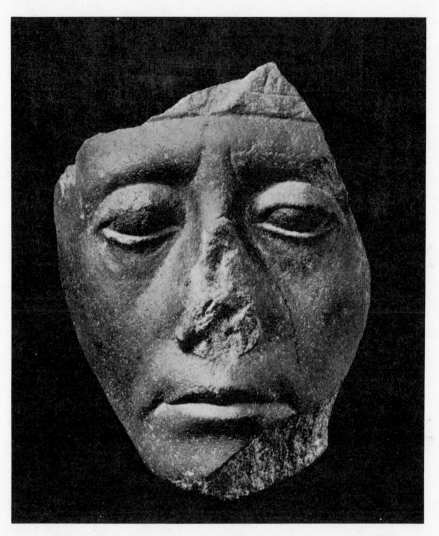

XXIV. HEAD OF A KING OF THE MIDDLE KINGDOM
(*page* 64)

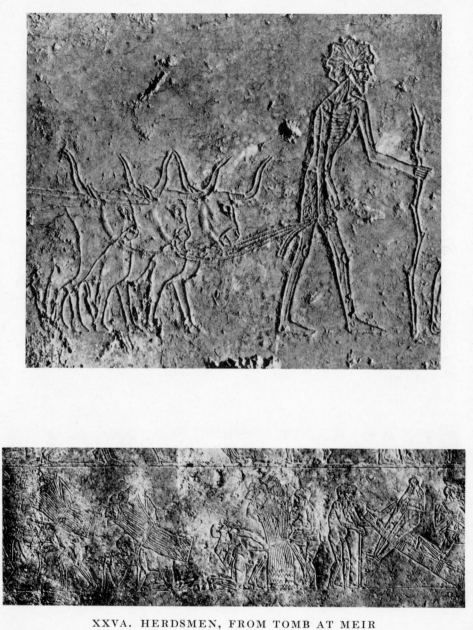

XXVA. HERDSMEN, FROM TOMB AT MEIR

XXVB. PAPYRUS HARVEST, MEIR
(*pages 67, 70*)

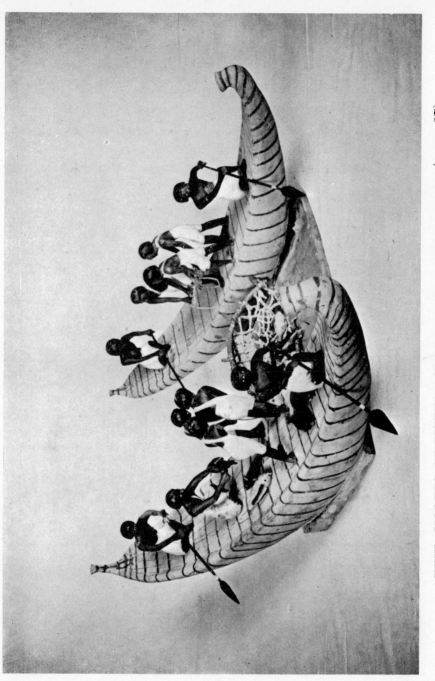

XXVI. MODELS OF FISHING CRAFT, TOMB OF MEKHETRE (*page 67*)

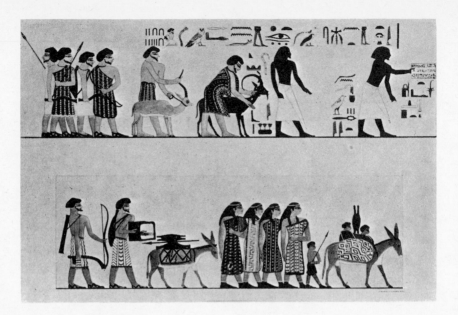

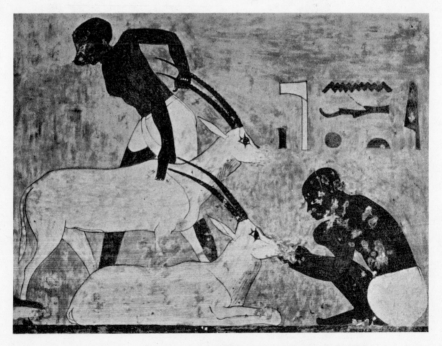

XXVIIA. ASIATICS, TOMB OF KHNUMHOTEP
(*page* 76)

XXVIIB. ANTELOPES AND THEIR KEEPERS,
TOMB OF KHNUMHOTEP
(*page* 77)

frustrated in this particular setting—namely, a move in the direction of monumentality. This move is almost to be expected at a moment when for the first time since the Third Dynasty secular power owed at the beginning of the dynasty so little to royal favour, but had to assert and to proclaim itself, while at the same time the tradition of tomb decoration afforded an opportunity for ostentation. But if commemorative scenes of monumental import were aimed at, these could not easily be incorporated in the old scheme. Monumentality entails, as we saw (p. 21–23), a reference to actuality, with emphasis either on its space-time character or on its transcendent significance. The original scheme of decoration in private tombs, however, was averse to actuality and equally averse to anything transcending the concrete. The realism of the scenes was the realism of typical occurrences, and in the confrontation of the living dead and typical scenes of life there was no room for acts that were pregnant with meaning, or for figures that might suggest a transcendent presence, hence we find no images of gods.

The resistance against an intrusion of commemorative and monumental scenes must therefore have been very strong indeed. The result was that wherever fumbling attempts were made to introduce them with a view to enhancing the owner's prestige, they either appear innocent irrelevancies[1] or mere variations on a known theme,[2] or, as in the case of the transport of a colossal statue (Fig. 7), a flattened-out, dismembered rendering of a single historic event which, as we shall see, effectively dodges all problems of space.

It is interesting to note that hardly any of these innovations were ever repeated, and we shall find a strong indication of their having been considered alien intrusions by later generations. Monumentality was, for a time at least, defeated.

In dealing with the actual material we shall have to treat geographical instead of chronological units; not only because the former are more clearly distinguishable but because, even if all the known tombs could be dated and arranged in chronological order, we would be unable to trace any kind of stylistic development except in a series of hunting scenes at Meir. The execution of Middle Kingdom art is on the whole rather mechanical, even shoddy, with flashes of brilliant experiment in a direction where no development lay. There is, generally speaking, something uninspired in this art, though the facile technique of distemper painting encouraged spontaneity at times and it is curious

[1] Such as a visit by the tomb owner to his workshop instead of the usual scene of craftsmen at work. See below.

[2] The usual tribute scene becomes a real inspection (see above), and the closing of the bird net (Beni Hasan I, Pl. XXXII) gains even more actuality when in El Bersheh I, Pls. XII sqq., servants pull with their master.

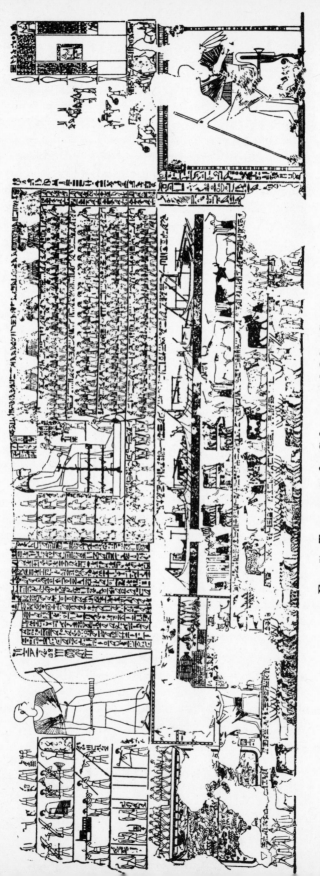

Fig. 7. *Transport of a Colossus and Other Scenes*

that in the few really fine reliefs we possess, namely, those at Meir, we should find even a touch of cynical humour: the emaciated Beja herdsmen (Pl. XXVa),[1] though perhaps inspired by the famine scene we discussed, are rendered without compassion; they are as comic as the rather obese muscular little men (Pl. XXVb) in neighbouring scenes.

The element of naïve faith and stoic restraint which gave the Old Kingdom reliefs both dignity and charm seem to be lacking. Faith must have been badly shaken and fear have entered the consciousness of those who experienced or remembered the tale of complete social disruption and cruel distress. Whoever knows the pessimistic literature of the period, the sad brooding faces of some of the Twelfth Dynasty rulers (Pl. XXIV) or even the portrait of the young Amenemhet III (Pl. XI), dignified but sensitive and vulnerable, must feel some disappointment that the tomb reliefs and paintings do not reflect a more mature humanity.

The reason may well be that the limitations of the original scheme could also in this respect not be transcended without the breaking-up of its inherent logic. For although more scenes bearing on funeral beliefs and practices were introduced, the element of wish fulfilment, implied in the very confrontation of living dead and lively scenes, barred the road to greater emotional depth. The very preoccupation with the terrifying aspects of death, so magnificently subdued in the grand assertion of life's lasting values, must have increased tremendously in an age when funerary estates became a mockery and even royal tombs proved not inviolate, but it could not find expression in a rigid scheme, the limitations of which were final. It did, however, find an outlet in a rather pathetic and childish way, the way of direct reassurance. For the need was evidently felt for something more tangible, something closer to magic practices, than the old abstract confrontation in mural art. Already in the late Old Kingdom plastic figures of servants who, it was hoped, might fulfil the needs of their masters, began to be placed in the tombs, stiff little figures, sometimes well made but rather dull. This habit took on unheard-of proportions in the Middle Kingdom; in fact, there is something embarrassing in finding hundreds of dainty toy figures, servants and workshops, stables, beasts and boats complete with crews—objects that would have delighted any nursery—in the tombs (Pl. XXVI); because the owners of these tombs must have known the sad and profound wisdom of contemporary literature.[2]

[1] Meir I, Pls. IX, X, XXV; Meir II, Pls. III, VI, XI, XIX.
[2] A. Erman, *The Literature of the Ancient Egyptians*, translated by A. M. Blackman, pp. 72–110.

The central concept underlying Old Kingdom pictorial art, naïve but not wholly unphilosophical, seems on the verge of disintegration at this point, and there must have been, as at all times in Egypt, an alarming tendency for significant achievement to become, in due course, a parody of itself. We may therefore well consider it symptomatic of a new development that in the early New Kingdom the elaborate toy servants disappear or lead from now on a shadowy existence as stereotyped shawabti figures, inscribed with a magic formula.

B. THE NEW TREND TOWARDS MONUMENTALITY IN FUNERARY ART

We shall deal with the tombs in Meir first, because in workmanship they are closer to those of the Old Kingdom than any others; though interesting painting occurs in some of the tombs, the best work there is still done in relief. It is surprising to find after the flabby kind of drawing in the late Sixth Dynasty such astonishing vigour and freshness as in the tombs B No.1 and B No. 2, equally surprising that it should remain a completely isolated phenomenon in the Twelfth Dynasty, the work of a single gifted family or group maybe. What distinguishes these reliefs from the best work in the early Fourth Dynasty is mainly

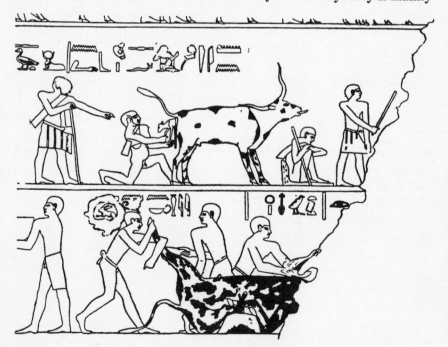

FIG. 8. *Cow Calving*

68

XXVIII. POND AND GARDEN, TOMB OF SEBEKHOTEP (*pages* 80, 88)

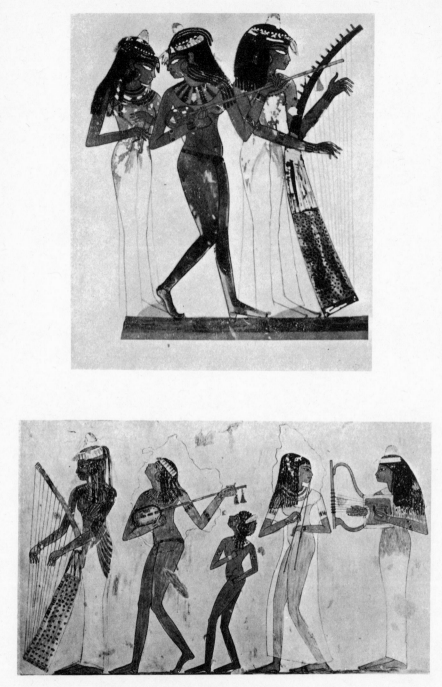

XXIXA. MUSICIANS, TOMB OF NAKHT

XXIXB. MUSICIANS AND DANCER, TOMB OF DJESERKARESONB
(*page* 84)

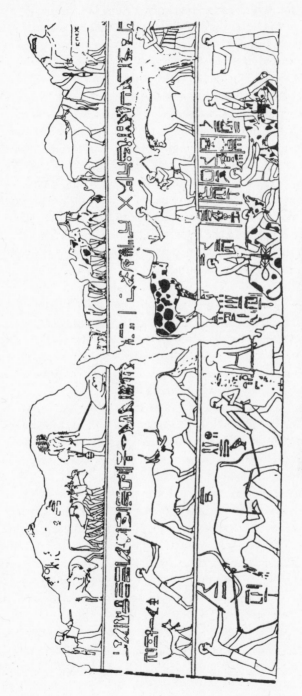

FIG. 9. *Bulls Fighting; Slaughter Scenes*

the grouping, which is far less subservient to a kind of rhythmic pattern than in the older ones. It is loose, in fact rather untidy, sometimes overcrowded, usually with so much space between the figures that they appear less enumerative, more important in themselves. Some of the figures have a curious individuality, like the old man in Pl. XXVb on right, or the extraordinarily dynamic herdsman delivering a cow (Fig. 8). Very striking also is one figure in a slaughter scene (Fig. 9, bottom right), for not only does the attitude come very close to functional rendering but in this single case the slightly bent head covers part of the shoulder. This gives a gratuitous and startling effect of three dimensionality, far greater than in any case where limbs overlap, which is almost inevitable in the drawing of human figures. Figures are often separated not by a neat formal hiatus but by a more or less significant void. The men pulling the rope in Figure 10 appear realistically spaced; they seem to need this distance for their work. This is not the case with the men carrying papyrus bundles (Pl. XXVb and Fig. 10), yet perhaps because they seem so intent on their task and their physique and posture are so convincing organically, it needs a little effort to realize that we do not have here a 'scene' implying simultaneous action, perhaps not even the mere notion of a papyrus harvest depicted as usual in its various aspects (as the harvest is rendered in Pl. XIXb, c, for instance) but the staccato rendering of one single movement in successive stages: a man rising with his bundle.

The group comprising two men separating aggressive bulls (Fig. 9) has a tension totally lacking in the actual bullfight in the same register, which is merely explicative; the taut vigour of the animal on the left holds an implicit threat quite rare in Egyptian art and is more expressive even than the gesture of the man on the right.

Still more remarkable from our point of view are the two extant hunting scenes. It should be realized that though such scenes can and have been treated as typical events, there is a singleness in the situation of each hunting experience which again and again has tempted artists to stress their actuality, while pride in the hunter's prowess may tend to give a certain monumentality to the scene. This frequently becomes a reminder of a kind of reconstructed and composite actuality. The older one in the tomb of Senbi (Fig. 11) shows the first deliberate attempt to break through the rigidity of parallel registers. Not only are contours of hilly and mountainous country given *without* a ground-line (this would fix them on to the surface of the wall and thus vitiate spatial imagination as it does in the temple of Sahure (Fig. 4)), but here such contours, placed high and low on the wall, are boldly joined by diagonals and this inevitably forces one to see the higher contours

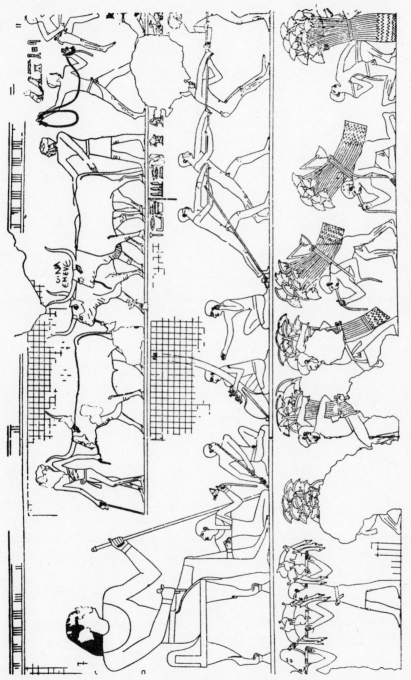

Fig. 10. *Cattle; Orchestra; Men pulling Rope; Papyrus Harvest; Meir*

Fig. 11. *Senbi Hunting*

as more distant: some kind of recession is achieved. This first effort does
not entirely succeed in giving a unified landscape but the animals appear
in a coherent space, not merely on disjointed fragments of sky-line. The
liveliness of the scene is enhanced by the exaggeratedly transient atti-
tude of the shooting figure, whose almost diagonal posture has never been
repeated in later times. We saw already that this is the first instance of
a private tomb owner being depicted in such an act, the only other
known being in a royal funerary temple; the very boldness with which
actuality was stressed almost gives it the character of a challenge.

This challenge was not followed up in the tomb of Senbi's son Ukh-
hotep (Fig. 12), where the figure is upright, the posture conventional;

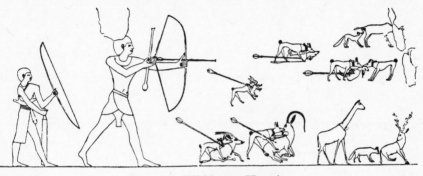

Fig. 12. *Ukhhotep Hunting*

on the other hand, a remarkable experiment in 'landscape' has been
made, groundlines have been omitted altogether, even the fenced en-
closure, so disturbing in Senbi's relief, has been dispensed with; the
animals are strewn over a blank surface. It is interesting to compare
the effect of this innovation with the Assyrian relief (Pl. LXXIX). The
latter does appeal to spatial imagination, for somehow these animals
form a dramatic unit moving together, one feels, in an indefinite plain.
In the former, tension is lacking, there is nothing to relate one small
group to another, and the result is that though the placing vaguely
suggests recession, the scattered figures appear artistically untidy
rather than spatially coherent. There can be no doubt that the attempt
at rendering space is here deliberate, for the group at the bottom left
would have neatly and easily fitted on to the groundline while the one
on the right was evidently wrenched away from it. We have pictured
here only half of the actual relief, which peters out in a misguided
attempt at an idyllic scene. For it cannot be doubted that the rather
senselessly scattered beasts[1] are supposed to render wild life on the
desert's edge away from the hunter's range. This remarkable effort has

[1] Meir, II, Pl. VII.

FIG. 13. *Djehutihotep Hunting*

never been repeated, the numerous hunting scenes in Beni Hasan and El Bersheh lack all interest in landscape. The one in El Bersheh (Fig. 13) does dispense with groundlines, but the beasts cooped up in a fence that acts like a picture frame are stiffly arranged in registers and even a little liveliness of action in the stockade scene at the bottom does not relieve the dullness of sheer enumeration.

The work at El Bersheh and especially at Beni Hasan is, generally speaking, repetitive and uninspired, and efforts to introduce actuality have not, for reasons we suggested above, given new life to pictorial imagination. By far the most interesting example of such an effort is found in the tomb of Djehutihotep at El Bersheh (Fig. 7).[1] Here we have combined in one large scene three kinds of activity on the part of the dead, one exceptional and single and two typical events. In the lower register on the left we find the tomb owner pulling the cord of the bird net; the drawing is quite conventional except for the fact that he is seated in a chair, a concession to his status and that servants help him pulling. On the right, facing and bracketing a number of the usual scenes, surmounted by a picture of several boats, he is stated explicitly to have made a journey in order to inspect the collection of revenue (see p. 58 above). The scene at the top, however, is the most interesting one. Here the tomb owner is seen walking behind a colossal statue, apparently his own effigy, which is being transported to a chapel or tomb. A lengthy text comments on the exceptional nature of this event. This scene is on the face of it a biographical event, the first of its kind, and is not only important in itself but affects the neighbouring scenes. For it is the contiguity of this unique picture with some of the stock-in-trade motifs like fowling or watching cattle or crops which gives the latter an air of actuality normally lacking. Now, even without the accompanying text, it would be difficult to connect the boats merely with funerary usage, or to see in the rather elaborate booth round the figure of a watching man anything but a concrete situation. Where traces of conventional motifs appear in the biographical scene they also and quite naturally acquire a new significance. We saw that the empty sedan chair in other scenes merely forms part of tribute-bringing scenes. Here (in the upper left-hand corner) it is part of the cortege with servants, soldiers, and police, and has a definite function. The striding figure of the tomb owner appears in this case to be moving, together with the colossus, in a definite direction, namely, towards the chapel or tomb on the right. But these spatial implications have not been expressed in terms of dynamic space; the tension which might have existed between the central group and the figures moving towards it

[1] El Bersheh I, Pls. XII sqq.

from the chapel has been effectively frustrated by three bars of hieroglyphs which separate them. Even the manner in which the transport has been pictured is static—none of the figures holding the ropes is actually pulling—and shows no attempt to grapple with the spatial relation between the different groups that do the hauling. Therefore, however ambitious the conception of this monumental scene, the rendering lacks actuality, and since the achievement of the transport did not have symbolical dignity either, the result is, from the monumental point of view, an artistic failure.

We know of nothing quite so ambitious in the tombs of Beni Hasan; the only historical and even dated,[1] event is the bringing of kohl by the Aamu tribe in the tomb of Khnumhotep (Pl. XXVIIa). This is merely shoved into a row of registers, all of them containing typical scenes confronting the dead. This context robs the rather charming and lively picture of the actuality it would have had if its dramatic potentialities had been fully exploited and the arrival at the place where the gift or merchandise was received had been depicted. The rest of the Beni Hasan paintings are on the whole very dull indeed. We said before that Middle Kingdom art shows strong local idiosyncrasies. Beni Hasan artists seem to have been obsessed by the notion of analysing complex movement rather than activities of daily life. This movement they cut up in its various phases much as did the artist of the papyrus harvest scenes: the acts of dancers and wrestlers appear in consecutive series of snap-shot like drawings.[2] These, however, do not represent the choice of a pregnant moment of action; the result is therefore, as often as not, frozen and lifeless gestures or, in the case of the wrestlers, an endless number of variations on the theme of two intertwined figures which neither in themselves nor in the mass clearly suggest factual movement.

Though one might recognise in these efforts at least a new preoccupation with the problem of transience, they had no effect on the rendering of space, and the same holds good of other minor attempts to venture beyond the old scheme, namely, to make some typical scenes appear more single and concrete, to stress their definite spatial character. One of the means by which this was done is by simply indicating locality even where such indication adds nothing to the clarity of the action depicted. We find over and over again architectural features—

[1] The fact that the scene has been given a date is an unheard-of occurrence in the old scheme; Beni Hasan I, Pls. XXX and XXXVIII,and p. 69. Another probably historical scene, namely, the acceptance of an olive branch handed by a deputation, is too badly drawn and too obscure to be of great interest except as an example of a commemorative scene; El Bersheh II, Pl. XVII.

[2] Beni Hasan I, Pls. XIV, XV, XVI; Beni Hasan II, Pls. IV, V, XIII, XV.

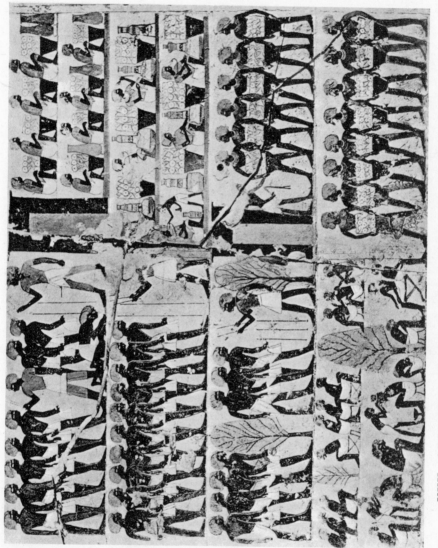

XXX. OFFICERS AND SOLDIERS, TOMB OF USERHET (*page* 88)

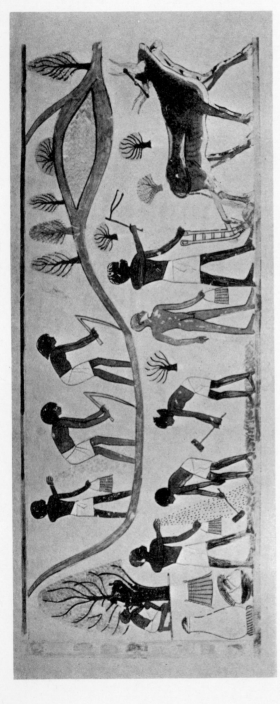

XXXIA. AGRICULTURAL SCENES, TOMB OF NAKHT (*page 89*)

pillars, roof beams, doors[1]—which seem utterly gratuitous but which in every case emphasize that the action, even if it was a recurrent one, took place in a certain setting and that therefore a concrete, rather than a typical, event was intended. These local indications are extremely vague and avoid the problem of three-dimensional space altogether; there is no instance of even the narrowest stage space.

Another step in the direction of the concrete has been taken in two instances where the figure of the tomb owner has not merely been brought closer to but entirely engulfed by scenes of daily life.[2] Here the dead—in a notably passive attitude—forms part of the scene of craftsmen at work and thereby gives it a new actuality, namely, the event of a visit. The rendering of space has not been affected in this case either.

Only in one painting has a gratuitous effort at suggesting depth been made; in Pl. XXVIIb beasts and figures overlap in a way which differs from the normal enumerative rows of overlapping figures. The feet of the man standing behind the oryx could not have reached the groundline by any stretch of imagination; he stands somewhere in space.

[1] Beni Hasan I, Pls. XIII and XXIX (top); Beni Hasan II, Pls. XVI and XXX; El Bersheh I, Pls. XII sqq.; El Bersheh II, Pl. XV; N. de Garis Davies, *The Tomb of Antefoker* (London, 1920), Pls. VIII and IX.
[2] Beni Hasan I, Pl. XXIX.

CHAPTER IV

The New Kingdom

A. THE INTRUSION OF NEW CONCEPTS IN THE CLASSICAL SCHEME OF DECORATION

In the tomb of the vizier Antefoker, the only remaining Middle Kingdom tomb in Thebes, we find traces of a hitherto unknown scene, namely the tomb owner in adoration before the king whom he served in his lifetime.[1] Its appearance in a Middle Kingdom tomb remains puzzling. One may allow for the fact that it was a high official and not a local prince who chose to have it depicted, a vizier who ruled in Thebes, the very region from which the royal family originated. But it appears alien both to the classical scheme and the new trend towards greater actuality; the act depicted is neither a significant historical event nor quite a symbolical gesture; the confrontation implies neither the mere beneficent presence of Pharaoh for the deceased, nor an actual situation which was to demonstrate the latter's status, and yet the scene appears to contain elements of all of these.

I have not mentioned the scene before partly because the remains are fragmentary and the mode of rendering apparently conventional, but also because it is the first of a new type of scenes which occurs very frequently in the New Kingdom.[2] From now on Pharaoh often appears in the tombs of his subjects, so that the case of Antefoker seems a prelude to coming changes. These changes, however, are more important than the mere introduction of new motifs; they actually signify a momentous shift in attitude towards the very purpose of tomb decoration. Generally speaking, the shift is from an exclusive preoccupation with the lasting significance of life in death which we found in the Old Kingdom and from abortive attempts in the direction of monumentality

[1] N. de Garis Davies, *The Tomb of Antefoker* (London, 1920), Pl. XVI.
[2] Max Wegner, *Mitteilungen des Deutschen Instituts, Kairo*, IV, 55–58, has listed the occurrences of the king in the private tombs of the New Kingdom.

of the Middle Kingdom painters, towards a new concept of timeless existence, more individual than the former, less challenging than the latter. Not the typical aspects of life bound up with man's material wealth, not man's single and historical achievement, but his *political* function became the focus of interest, namely, his public activities in what had become a powerful empire and still remained a hierarchic state. To see in this shift of interest a mere sign of ostentatious worldliness, incompatible with funerary art, means to ignore the fact that in a state where the concept of kingship was ultimately a religious one, political function could, in the face of death, have a transcendent quality; it could mean participation in a divine order, sharing in divine grace. The old time-honoured formula, 'an offering which the king gives,' was more than a polite pretence; it connected all bounty with its ultimate source; the new confrontation of king and servant in the latter's tomb insisted on man's individual status and at the same time lastingly linked him with his divine ruler.

The change we postulate here is not a mere surmise based on the appearance of the king's image in private tombs; it is reflected in a number of innovations and adaptations of old themes. The interest in scenes of daily life, for instance, dwindles and where these occur they are more often than not used for the purpose of illustrating the tomb owner's official function[1] as supervisor of works,[2] as collector of tribute or revenue,[3] etc. New scenes are introduced with the same purpose, e.g. the measuring of a field[4] or the holding of a law court.[5] In all these the owner can be said to be represented as he was in his lifetime—though frequently the term *m"* persists—yet the term 'biographical scene' should be avoided here, or at any rate qualified, because even

[1] We find, e.g. in the tomb of the vizier Rekhmire, all the familiar scenes but the tomb owner is not their beneficiary: the bread is baked for an offering to Amon (*Rekhmire*, II, Pl. XLVIII); storehouses are depicted as 'storehouses of Amon' (*ibid.*, Pls. II and L); masons labour to build 'the storehouses of Amon' (*ibid.*, Pl. LVIII).

[2] E.g. a high-priest of Amon is shown 'watching the workshop of the temple of Amon and the activities of the craftsmen' (Davies, *The Tomb of Menkheperra-sonb, Amenmose and another* (London, 1933), Pls. XI, XII, XXI, and p. 11); so also Amenhotpe-se-se, second priest of Amon (*Tombs of Two Officials*, Pls. VII, VIII, X).

[3] E.g. Amenmose, 'Eyes of the King in the two lands of the Retenu,' is shown presenting Syrian tribute to the king (Wreszinski, I, 88); Amenmose, 'steward in the southern city,' is shown returning to his town after having collected taxes in Nubia (Wreszinski, I, 284).

[4] E.g. Menna, 'scribe of the fields of the Lord of the Two Lands of Upper and Lower Egypt,' is shown supervising the measuring of the fields (Wreszinski, I, 232); Khaemhat, shown in the same action (*ibid.*, 191), was 'overseer of the granaries of Upper and Lower Egypt' and Zeserkaresonb, shown similarly occupied, was 'counter of the granary of Divine Offerings of Amon' (*ibid.*, 11).

[5] *Rekhmire*, II, Pl. XXV.

where in rare instances the scenes apply to a single event,[1] such as an installation or the receiving of the gold of honour, they merely aim at elaborating function and status of the dead. Dates or time references, if they appear at all, have practically no bearing on the scenes themselves.[2]

The peculiar way in which the old scheme continues bears out our assumption indirectly. For this scheme, with its element of wish fulfilment, was by no means redundant yet. The pleasurable aspects of life still mattered to the dead, the only difference being that the fullness of life which confronted the Old Kingdom tomb owner had lost some of its simplicity and radiance. The theme of the dead behind his offering table receiving the gifts of his relatives is elaborated and becomes that of the tomb owner and his family facing banquets with garlanded guests, foods, perfumes, wine, and dancers.[3] These solemn feasts have gained a new sensuous quality completely lacking in the old canonic figure drawing which was chaste, if rather jejune.

Another curious feature in the repertoire of these tombs is that certain funeral rites show a new pre-occupation with locality, with gardens and ponds, sometimes chapels, even houses (Pl. XXVIII). This can, I think, partly be explained by the fact that the mainly rural 'scenes of daily life' were considered less appealing in a sophisticated age of predominant town life, while moreover such scenes were now used to demonstrate the scope of an official's function. We do know that the crossing of water and probably the planting of trees was part of the funeral rites from the Old Kingdom on, and it is conceivable that small plantations, perhaps even miniature ponds, were later made

[1] E.g. the installation of the tomb owner as vizier (M.M.B. II, Dec. 1926, Fg. 5); the tomb owner as vizier asking for a coadjutor (*ibid.*, Figs. 2 and 3) (N. de Garis Davies *'The Tomb of Puimre at Thebes* (New York, 1922–23, Pl. XXXVIII); the transfer of standard and warrant to the tomb owner Nebamun on the occasion of his receiving a commission as Chief of Police (*Tombs of Two Officials*, Pl. XXVI and p. 35); the induction of the tomb owner as second priest of Amon (Davies, *ibid.*, Pls. XIII–XIV); the tomb owner, the physician Nebamun giving medicine to a Syrian prince (Wreszinski, I, 115). The unique and rather absurd little scene—note the background dotted with irrelevant flowers—of a man facing a hyaena in the tomb of Amenemheb (Wreszinski, I, 21) may refer to an actual experience, but in that case it is striking that the tomb owner is not identified.

[2] In the case of Menkheperrasonb (Davies, *The Tomb of Menkheperrasonb, Amenmose and another* (London, 1933), p. 3) the scene is said to refer to the New Year's festival, but this was a current event and no date was given. Dates do occur but never related to the scenes, e.g. the date of the retirement from office of Nebamun (*Tombs of Two Officials*, p. 35), while the reference to the Sed Festival of Amenhotep III in a scene which records the reward of officials on the recommendation of the tomb owner Khaemhat (Wreszinski, I., 203) merely stresss the importance of his function.

[3] The latter are a curious case in point, for in the Old and Middle Kingdom they only appear in connection with funeral rites; in the New Kingdom mostly, though by no means exclusively, in banquet scenes.

near the tomb (although it is unimaginable that these should have survived any length of time on torrid cliffs). In any case, both these and their images in the tombs reveal that fragrant shade and moisture had become objects of nostalgic love as much as the 'thousands of bread, thousands of beer' of the traditional formula.

The preoccupation with the *per-det*, the funeral estate, has disappeared.[1] The gods themselves, especially Amon, though sometimes Nut, are stated to be the source of sustenance for the dead and the same formula is used here as appears on the statues of private people in the god's temple, a formula which was to guarantee a share in the offerings. Bouquets, food, and sistrums from the temple are offered or at least shown to the dead and in one case Amon guarantees a passage across to Karnak, to provide food every day.[2] Funeral and ritual scenes abound; in a few instances Osiris or a minor deity occurs in ritual or adoration scenes.[3] All in all, it appears that a new preoccupation with transcendent power has disturbed the balance, the self-containedness of the old scheme.

The change in spirit then seems very great and the logical inconsistency of depicting the tomb owner (a) as deceased but living and passively watching the amenities of life, (b) as he acted in his official function, (c) as deceased and undergoing funeral rites, is more striking than ever. Yet this inconsistency is less naïve than those modern scholars assume who first force an interpretation along the lines of 'genre' painting and then are baffled by lack of pictorial or logical coherence. In order to avoid this one distinction should be kept in mind: in the banquet scene the tomb owner was, as of old, represented after death passively sharing the pleasures of the living. If, therefore on the same wall as the posthumous banquet but unconnected with it, we see the owner depicted in his function as head of the police, or riding his chariot as if to stress the importance of his status while among the living, it is quite unwarranted to connect the latter with the former and the danger of letting one's imagination run riot is very great.[4] Nor is there justification in speaking of 'pleasure trips' on ponds and lakes when these scenes, as we shall see, are nearly always connected with funeral rites and clearly belong to the third category. Interpre-

[1] Menkheperrasonb (*vide supra*) merely mentions that offerings are brought from his estates in the north and in the south of Egypt. Pl. XXIV, p. 21.

[2] N. de Garis Davies, *The Tomb of Nakht at Thebes* (New York, 1917), Pl. IX, p. 48; see also *The Tomb of Menkheperrasonb, Amenmose and another* (London 1933), Pl. XXIV, p. 21; N. de Garis Davies, *Five Theban Tombs* (London, 1913), Pl. XXVII, p. 25 (London, 1913).

[3] Zeserkaresonb, official in the granary of Amon, offers to Ernutet, the grain-goddess.

[4] *Tombs of Two Officials* (London, 1923), Pl. VI, p. 5; Pl. XXI, p. 29.

tations of this kind are gratuitously trivial and miss the central concept which gives these scenes their unity; they miss the metaphysical problem that lay at the root of all Egyptian funerary art: the problem of the *relation* between life and death. Seen in the light of this problem the different types of scenes are merely various approaches, varying answers, but all imply the same assertion—that death is a mere phase of life, that the significance of life is as timeless as death. These scenes are quite literally concerned with eternal values; namely, the immanent values of life such as power, wealth, and abundance seen *sub specie æternitatis*. There is nothing illogical in the choice of motifs of New Kingdom funerary art, nor as we shall see, in their mode of rendering. The essential value of political power was expressed in the relation between the high official and the divine head of state; wealth implied in the first place the subtle beauty of conviviality with music, poetry, and dance, and abundance meant throughout not only possessions and a surfeit of food, but a joyful awareness of earth's fecundity, of beasts and plants and the infinite variety of man's labour. These scenes contain an implicit but emphatic denial that death should be a tragic and violent negation of life; on the contrary, they attempt a harmonious approximation, a mutual interpenetration of life and death on a scale never equalled by any other people. It is true that Death, the unknown, claimed ever-present awareness and unceasing service on the part of the living, but this was not merely the price at which doubt and terror could be kept at bay, but also a tribute paid to the phenomena of life which, when pictured in a funerary setting, became unassailable even by death.

All attempts to make the strangeness of this very mature art less alien by 'reading' it like a story are attempts to rob it of its dignity and its truly religious character. And this is all the more deplorable because the paradox of the oneness of life and death is balanced on a knife's edge between childish and wish-bound thought and profound resignation, between the hope that life's pleasures might last and the recognition that life is eternal only through death. The faith which these pictures reveal seems more delicately poised and more self-conscious than in either the Old or Middle Kingdom. Not only do traces of sadness occur in the scenes, even a hint of the tragic (apart from the official and acknowledged behaviour of the wailing women which occurs throughout, even in the Old Kingdom), but the uncontrollable terror of death was fully articulate at this time even if it only led an underground existence, as it were.

Magical formulae which reveal such terrors appear already during the Old Kingdom inside some of the later pyramids; during the Middle Kingdom, fragments of these formulae were inscribed on the coffins of

private people. But in the New Kingdom the fear of demons and of terrible contingencies after death found expression in elaborate systems of threat and magic countermove, which were codified in the 'Book of the Dead', 'The Book of What Is in the Netherworld' and 'The Book of Gates'. The walls of royal tombs were now covered with the dreary phantoms which made up their content, and the coffins or burial shafts of private people often contained them in the form of papyrus books.

B. THE SPACE-TIME IMPLICATIONS OF EARLY NEW KINGDOM ART

The reliefs and paintings of early New Kingdom tombs, mostly concentrated in the vast necropolis of Thebes and covering a period of two centuries, are both more homogeneous and more subject to stylistic changes than Middle Kingdom art. Yet we shall not treat the material chronologically throughout, for such developments as can be traced mainly affect the rendering of the single figure and the composition of conventional groups and these are less significant for our particular problem than, for instance, the introduction of entirely new scenes or of new versions of old themes, changes which cannot be forced into a sequence but appear sporadically, unconnected.

On the other hand the gradually modified rendering of the single figure does reflect very clearly the pre-occupation and mood of the New Kingdom as well as its reverence for traditional values. We need not give an extensive formal analysis here, since Dr. Wegner has already done so in a careful study.[1] He has shown that in painting the simple method of filling in an outline with a plain wash of colour was gradually superseded by a true painter's technique in surface treatment. Dr. Wegner's use of the term *malerisch*, however—as opposed to plastic—entirely hides the fact that what the Egyptian painter achieved here was usually only an approximation of painting to relief: the figures become more plastic because outlines are sometimes omitted, and sometimes act as shadows; and the lines of elaborate pleated garments reveal, instead of hide, rounded forms. And this same anachronistic term *malerisch* also obscures the fact that these painters were almost exclusively concerned with tactile values, with the soft texture of semi-transparent material, the stiffness of starched loincloths, with the smoothness of wigs saturated with oil, the wiriness of animals' hair

[1] See p. 78, n. 2. Unfortunately the terminology is quite anachronistic for Wegner is completely under the spell of Woelflin. This is particularly noticeable in his effort to systematize the development of New Kingdom art (*loc. cit.*, 153). Here the terms used seem to lose all bearing on the Egyptian material and appear pure *Hirngespinst*.

(Pl. XXXVII). This sensual interest in the quality of surface need not enhance the illusionary corporeality of the figures in a spatial sense, as purely colouristic painting would have done since this conjures up the atmospheric play of light and shade. The Egyptian painter merely emphasizes the 'haptic' quality of the figures, which are composed in the traditional canonic way.

Now it cannot be denied that in some cases changes occur in the actual drawing of single figures, which do affect their space-time character, noticeably so in the case of dancers. Here the Old and Middle Kingdom attempts at analysing their complex motion in its different stages have finally been supserseded. Not one single striking attitude has been chosen (which makes the figure, for all its contortions, appear frozen and lifeless), but the quality of motion as such has been caught. It is one of the miracles of Egyptian art that such delicate grace as we find in Pl. XXIXa, b could be achieved within the accepted scheme of rendering. The figures are, here also, 'spread out' on the surface, yet every gesture is both plausible and organically coherent, suggesting movement, yet conveying the stillness of restraint. For these are not 'dynamic figures', they are caught in an exquisitely harmonious pose. A small group of such figures may appear both natural and deliberately arranged; it may combine a certain lively and transient quality with the static perfection of a pattern. In these few instances Egyptian artists did transcend the limitations of their scheme without destroying it.

Extremely interesting also are the changes which occur in hunting scenes; here we find fleeing or pursuing animals in violent motion with four feet off the ground, attackers and attacked in a variety of contortions (Fig. 14). We shall not deal with the vexed question of the 'flying gallop' or the flying leap in detail, since it has been convincingly shown—with a wealth of circumstantial evidence—that this motif was developed under Aegean influence.[1] It is remarkable that although a number of variations and experiments occur, especially in the earlier part of the Eighteenth Dynasty in the tombs of Puymre, User, and Rekhmire, the 'flying gallop' did not become a standard motif in Egyptian art and that there is no question of a gradual development toward greater freedom of movement within the New Kingdom hunting scenes. On the contrary, already in the tomb of Rekhmire (Fig. 14)

[1] Helene J. Kantor, *The Aegean and the Ancient Near East* (Bloomington, Indiana, 1947), 62 sqq. Miss Kantor has also disposed of the theory upheld by Edgerton and others that since cinematography has revealed what the naked eye does not detect, namely, that for a split second the four legs of a galloping animal are in fact off the ground, this fact would in itself account for the Egyptian 'flying-gallop'. The argument is not only logically absurd but simply naïve from an art critical point of view.

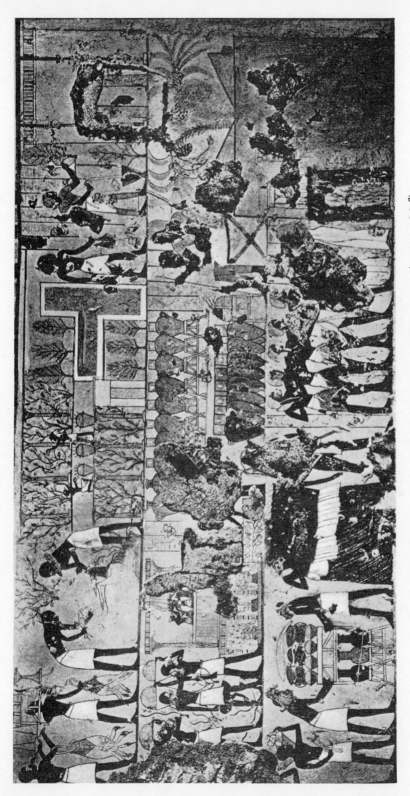

XXXII. SCENES FROM THE TOMB OF NEBAMUN (*pages* 90*f*)

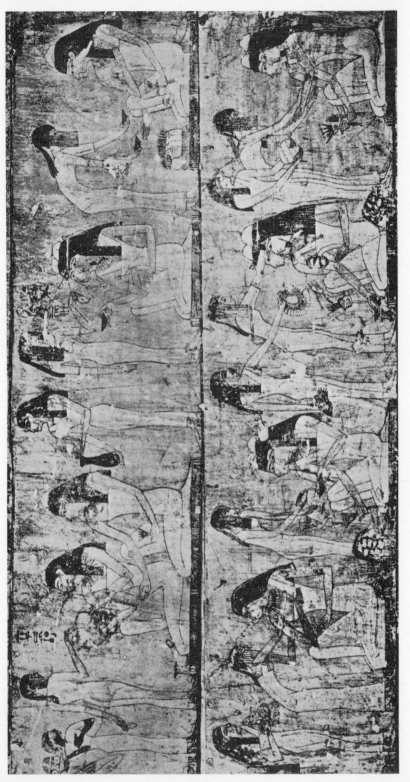

XXXIII. LADIES BEING ENTERTAINED, TOMB OF REKHMIRE (*page 93*)

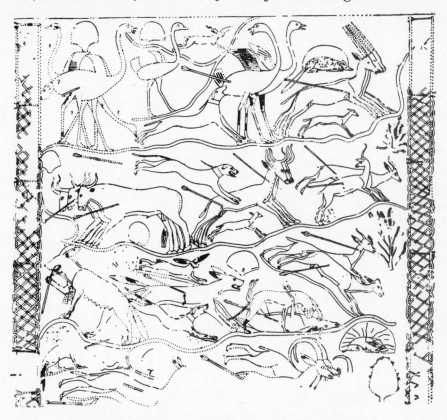

FIG. 14. *Hunting in the Desert, Tomb of Rekhmire*

the artist is on the whole at pains to fix his 'flying beasts' on to wild and scattered groundlines, while the painter of the slightly later tomb of Kenamun (Fig. 15) has lost interest in the motif altogether.

Changes in the composition of more traditional groups, such as wailing women at funerals, we shall consider later, and we shall now deal with those new scenes which centre around the activities of the tomb owner in his official function, for here, if anywhere, one might expect a less formalized rendering. Curiously enough, such scenes show a greater variety of activity by implication only and avoid with remarkable consistency depicting historical or dramatic actuality. This latter can only be expressed pictorially by a dynamic relation between the figures or—if a material setting is indicated—by an integration of the spatial and temporal aspects of the event. We find, however, generally speaking, the very reverse: the situations in which official functions are shown lack concreteness, their typical character only is stressed, and the classical device of a large figure bracketing a number of uncon-

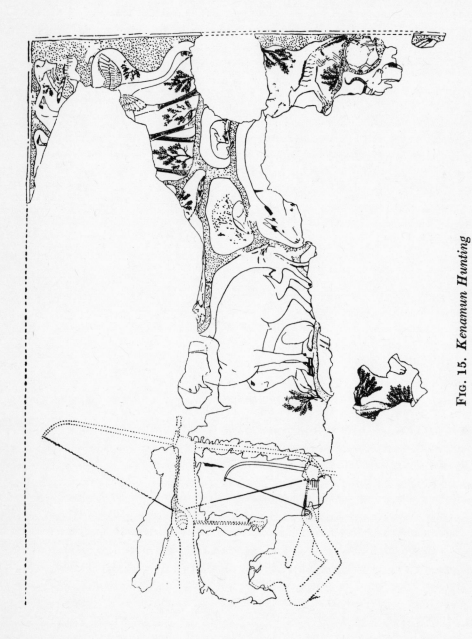

FIG. 15. *Kenamun Hunting*

nected scenes is used to indicate a conceptual rather than a spatial relation between them.

This is the more remarkable because sometimes both spatial and temporal considerations did play a part here. Not only typical acts but single great events such as the installation of a vizier (though admittedly this may be considered part of his function) were given; and in the rendering some local setting—a temple, royal dais, or kiosk—was used for the sake of clarity. But what was gained by this was clarity of statement, not pictorial actuality. For never was dramatic space[1] achieved or even aimed at. We may see the royal cortege moving towards the temple for the installation of the vizier, and his bodyguard striding in opposite directions after the event;[2] but no effort is made to give the movement of these bland figures space-time actuality beyond the mere indication that a temple played a part in the event. Even the rather abortive attempt in the Middle Kingdom at creating a spatial tension between the group transporting the colossus and its place of destination, namely, by showing figures moving from the chapel towards the group (p. 75 above), was not repeated before the Amarna period. The restraint shown in such scenes which fit effortlessly among the spatially indefinite, temporally indifferent classical scenes, will be more evident when we compare it with analogous representation in Amarna art, where every effort is made to achieve a maximum of actuality. This entailed a complete subversion of former aims, a fact which must be recognised even though the majority of Amarna drawings still remain within the bonds of a powerful tradition. We shall, when dealing with Amarna, refer back to the earlier scenes in question; the reluctance to depict historic actuality will then appear even more striking. The relation between monarch and functionary, for instance, is kept entirely within the range of a formal confrontation which, through the hieratic immobility of the king, is quite devoid of human tension. Even in the case of the ancient vizier who faces the king with a request for a coadjutor, the gesture is formal, and the signs of old age are explicative rather than expressive,[3] while there is nothing in the formalized figure of the king to suggest that the dialogue, which accompanies the scene, should refer to an actual event. Not in a single instance before the Amarna period is a gesture of the king recorded, either of exhortation or command; he embodies merely a divine presence, not a dynamic personality.

[1] See pp. 38f.
[2] See M.M.B. II, Dec. 1926, Fig. 5.
[3] In the tomb of Amenuser (see N. de Garis Davies, M.M.B. II, Dec. 1926, p. 9, Fig. 5).

Very striking also is the choice of scenes representing various functions in cases where the classical scenes of daily life could not be used to illustrate them. For instance, at a time of great military expansion, the only concern of generals seems to be drill and catering,[1] (Pl. XXX), the unvarying, the typical tasks of a military career, but battle scenes are conspicuously absent. In the tomb of General Amenmose, who took part in Syrian campaigns, no reference to these occurs except the façade of a Syrian castle and the suggestion of a wooded setting for it.[2] But the façade itself remains entirely unconnected, in a dramatic sense, with the tribute bearers. There is no scenic integration such as we find at least attempted on several occasions at Amarna and achieved in the Assyrian relief (Pl. LXXVIII) where the figures are clearly moving away from the building in the background. Even in the case of the vizier Rekhmire, presiding over his court of justice, something similar occurs.[3] The hall of justice is given in great detail and spread out in plan—an importat innovation which we shall discuss later—so that though the action is typical, the acting figures are clearly related to it or confined within its boundaries. But the figure of the vizier is separated from this definite spatial unit by a double line which, even if it should represent a column of the same building, removes his large, probably enthroned, figure from mere contiguity, let alone participation in an active scene.

In this connection, the presentation of foreign tribute is an interesting case in point. The king who was the recipient of these gifts was hardly ever pictured jointly with the long rows of foreign representatives. All that mattered in private tombs was to show the function of the vizier, who collected tribute for his monarch. This function was, however, rendered with complete indifference to the circumstances of what must have been a recurring but rather spectacular event. The figure of the vizier may or may not bracket the purely enumerative rows of tribute bearers, but no indication of the locality where the presentation took place occurs. Here a comparison with the most lively and dramatic picture of the complete event with detailed indication of the local setting in a tomb at Amarna will prove the most revealing (see pp. 105f.).

Some interesting changes in the rendering of space, however, do occur in connection with the new attempt at picturing garden plots and small artificial lakes (Pl. XXVIII). These presented a new problem for artists in the habit of reducing everything to the one plane dictated

[1] In the tombs of Thanuny (Wreszinski, I, 231, 236), Pehsucher (*ibid.*, 279, 280), Nebamun (*ibid.*, 287), Amenemheb (*ibid.* I, 94).

[2] Wreszinski, I, 168.

[3] N. de Garis Davies, *The Tomb of Rekhmire at Thebes* (New York, 1943), II, Pl. XXIV.

by the register groundline. A plot of ground could be as easily spread out on a vertical wall as a sheet of water had been previously;[1] but the objects it contained were orientated at right angles with it. The solution was as a rule to disregard this difference in orientation and to place the projected objects within the confines of the plot with the maximum of descriptive clarity in almost any direction.[2] But this procedure had a remarkable consequence, for now the interest in a definite plot of ground, even if it was as yet treated paratactically, led to a new 'geographic' interest. The rigid groundline already abandoned in earlier hunting scenes was, in a few instances, altered in agricultural scenes where not only the figures in action but the terrain itself becomes a feature.[3] The 'landscape', or at any rate the topographical description which results (Pl. XXXIa), is highly remarkable in that it shows a detachment from the classical scheme: here man's food-producing labours were all that mattered, not their contingent setting.

The tendency to give gratuitous actuality to typical scenes can also be observed in cases where trees are scattered—sometimes above the goundline—among the figures,[4] a trick which is extremely effective in the barber scene (Pl. XXXIb).

Far more remarkable, however, are experiments in topographical description in the hunting scenes, for here the vertical projection of a plot of ground conflicted with the older scheme of showing animals in motion on the contours of hills which act as groundlines. In the tomb of Rekhmire (Fig. 14) these contours are, as we saw, a device for providing a foothold for animals in a variety of postures—though even here they still form a rough division into registers. But the lines have been thickened into narrow strips and though they have been left blank, and are not solidified in any way, they are no longer unsubstantial but suggest—if rather timidly—a projection of the ground on which the animals are moving. The effect of the contour lines is thereby seriously impaired, while on the other hand the attempt to solidify the background by scattering pebbles here and there robs the strips of any topographical meaning they might otherwise have had. This was evidently realized by the remarkable artist of the tomb of Kenamun (Fig.

[1] In one case the zigzags indicating water are put vertically as an accolade for a fishing scene (Wreszinski, I, 250).

[2] Not only may trees adhere to the four sides of a garden plot in such a way that they point in four different directions, but even animals tied up for slaughter may be disposed that way (N. de Garis Davies, *Five Theban Tombs* (London 1913), Pl. XXI).

[3] N. de Garis Davies, *The Tomb of Nakht at Thebes* (New York, 1917), Pl. XXI; *Kenamun*, Pl. XLVIII; Wreszinski, I, 9.

[4] Wreszinski, I, 231–34; N. de G. Davies, M.M.B., 1927, p. 14, Fig. 11; Wreszinski, I, 186 and 187.

15 and Pl. XXXVII), who boldly sacrificed the old notion of contour lines altogether and by widening, solidifying, and unifying what were still fragmentary strips of soil in the tomb of Rekhmire, aimed at producing the effect of a coherent projection of the desert, in which the expedient of hillocks in profile could be dispensed with. He solved the problem of depicting the animals in this setting by surrounding each creature—resting on, in some cases slightly overlapping, the wide pebbly strips—by a plain coloured surface, which needless to say acts in contrast as *space*. It is true that the weird uneven network which results does not clearly suggest receding soil and that the plants and trees adhering to the strips in a variety of orientation are spatially confusing. But it cannot be denied that this unique experiment in going beyond the mere abstraction of a skyline is the nearest approach to topographical coherence in pre-Amarna Egypt—it is, in fact, a typical true painter's experiment—and that it has the remarkable effect of both binding and isolating the animals in space.

We can hardly expect that the liberties taken in hunting scenes would also occur in cases where the tomb owner was involved. There are, however, actually two cases where, again according to interpreters, the tomb owner is seen sitting in his garden, a situation so totally different from the prevailing tendency to avoid the single and concrete that it is worth studying these pictures somewhat closer. Now in the case of Enene,[1] the owner is placed outside the garden plot in a separate register. Here the intention may not have differed from the old confrontation between the dead and a delectable scene of life. In the case of Sebekhotep (Pl. XXVIII) and his wife, who are placed within the confines of the garden plot,[2] it is significant that the scene is explicitly stated to take place after death and is far removed from the spirit of 'genre' painting through the presence of the sycamore goddess—half tree, half human figure—whose comforting speech appears like a magic formula on either side of the lake. This scene differs from all the contemporary ones which depict funeral rites within the local setting of lake and garden, and might be considered a forerunner of those, usually called 'Elysian fields', which in the Nineteenth Dynasty shows the dead himself busily tilling fields and harvesting in the Hereafter. The latter are a late and rather ludicrous corruption of the classical scheme which will be better understood as an aftermath of the Amarna period. The Sebekhotep painting, which seems to hover on the brink of a new development, remains an isolated instance in the early New Kingdom, and its apparent concreteness, belied by the mythological figure in the tree and the texts, should not be used as an argument to explain complex

[1] Wreszinski, I, 60a. [2] Wreszinski, I, 222.

and puzzling scenes like Pl. XXXII in terms of a concrete situation. To say that Nebamun is sitting in front of his house[1] is a misrepresentation, because owner and house (in right-hand corner) are not even on the same groundline; and to insist that all the scenes given in the different registers represent the events of one 'day of feasting'[2] is merely fanciful. Why the house should be depicted at all is admittedly not clear; it would almost seem as if the detailed rendering of the vine bower and the small chapel, together with the contemporary tendency to depict detailed plots of ground, tempted to introduce yet another item. If so, then the restraint shown elsewhere is all the more striking, for there is no question of an indiscriminate rendering of all the features which might be connected with the layout of the pond and garden yet, no discursive rendering of the dead man's estate such as we find in the Amarna period and after. The nostalgic love of cool moisture and fragrance, or the part these played in funeral rites, did not entail a mere record of actual possessions. This we only find when the interest shifts from the essentially static older scheme to dynamic actuality.

Generally speaking, we might say then that, barring the new interest in terrain, the space-time implications of the older scheme prevailed. But significant changes will appear when we consider details in both the main and the subsidiary scenes. We do not refer here to noticeable increase in 'genre' incidents, which aim at rendering a single occurrence at a definite place. Similar incidents have throughout delighted artists on rare occasions without affecting the general character of funerary art at all. The incident is usually marked by some form of irrelevancy, like the conversation scene in Ti's tomb. In the New Kingdom a guest is seen sick at a solemn banquet;[3] in the middle of harvest activities a girl has fallen or hurt herself and is helped by a friend;[4] on a wall covered with military display (Pl. XXX) we not only see a barber in action, but soldiers lounging around in various attitudes of boredom.[5] Obviously such 'genre' painting has a kind of actuality, though in a limited sense, for it pictures events that may occur anywhere at any time; even the bull tossing his enemy looks, for all his quasi-violence, like any bull tossing any other.[6] Only detailed attending circumstances may accentuate the here-and-now character of such scenes, as is shown by the remarkable picture (Fig. 16) of the catering

[1] *Tombs of Two Officials*, Pls. XXXIII–IV. [2] *Ibid.*, p. 32.

[3] Wreszinski, I, 179; other references are given by N. de Garis Davies, *The Tomb of Two Sculptors at Thebes* (New York, 1925) p. 56, n. 3.

[4] Wreszinski, I, 231. [5] N. de Garis Davies, M.M.B., 1927, p. 14, Fig. 11.

[6] Wreszinski, I, 15. The posture of the bull is unconvincing both as regards the elogated horizontal back and the stance of the legs; it does not convey concentrated force.

soldiers; it is not so much the intricate grouping and overlapping, the general air of contingency, but the one soldier disappearing into a porch which unmistakably turns a typical into a unique moment. In this case, setting and action have been integrated in a way which to my knowledge is without parallel in pre-Amarna art.[1]

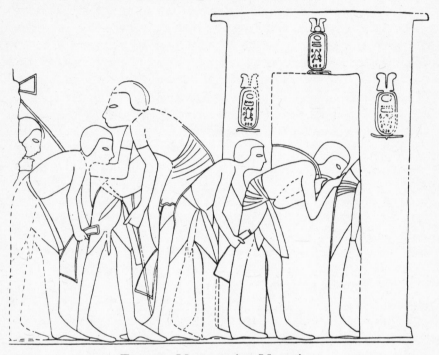

FIG. 16. *Men entering Magazine*

The significant changes to which we have referred are more subtle. They are of two kinds: the spectator may be unexpectedly drawn into the orbit of an otherwise quite conventional scene by the functional rendering of figures and groups (the former being extremely rare); secondly, he may share the suspense of a mood when either pyschological differentiation makes him feel face to face with a human presence rather than a typical figure, or when a truly dramatic situation is expressed, in however restrained a manner. In all these cases, we witnessed an emancipation by single gifted artists from the bonds of tradition.

The banquet scene in the tomb of Rekhmire[2] shows a distinct effort at functional rendering (Pl. XXXIII). It occurs in a large scene which,

[1] Wreszinski, I, 246. It is obvious that this incident cannot be compared with the typical situation of a man in hiding—that is, half covered by a papyrus bush—which occurs sometimes in fowling scenes.
[2] *Rekhmire*, Pls. LXIV–V. A single instance of a musician drawn in full back view has been recorded by Davies, M.M.B., 1923, Fig. 5.

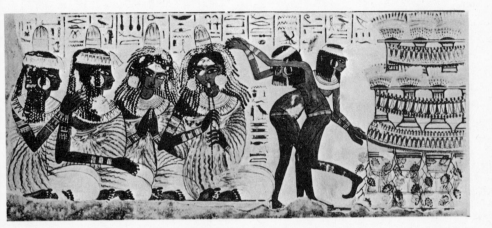

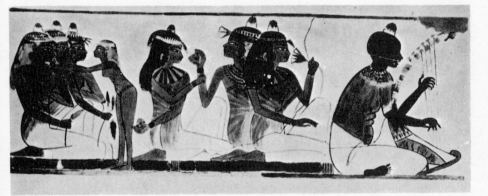

XXXIVA. MUSICIANS AND DANCERS

XXXIVB. HARPIST AND GUESTS, TOMB OF NAKHT
(*page* 93)

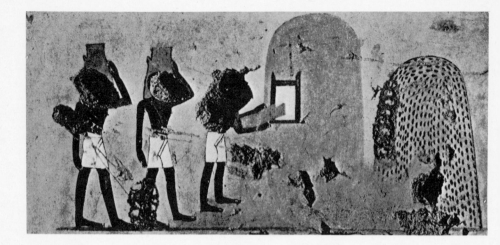

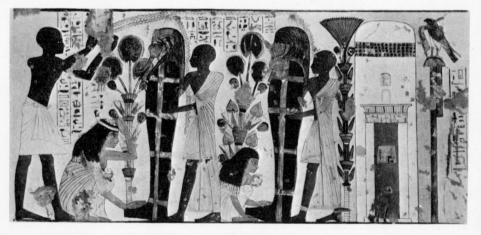

XXXVA. MEN FILLING GRANARY, TOMB OF NEBAMUN
(*page* 93)

XXXVB. LAST RITES BEFORE THE TOMB, TOMB OF TWO SCULPTORS
(*page* 95)

although the work is exceptionally delicate, appears at first quite conventional. Guests and serving girls are spread out over a number of registers; the grouping shows the usual duplication of figures intended to break up the monotony of rows of guests. Only in one case—and very unobtrusively—does duplication appear an arrangement in depth through the apparently so simple but never-repeated device of letting the serving girl stretch out both hands simultaneously to each of the overlapping figures (top right). In this otherwise smooth scene, however, the *trois quarts* back view of one of the girls (top left) is very startling indeed and seems quite incongruous; seen from a definite angle, she has—in contrast with all other figures—'corporeality', appears in fact in space. It is as if the artist was frightened by his own boldness, for he drew the feet adhering to the groundline in the traditional, and in this case absurd, old way.

Equally remarkable is the fact that around this time a few experiments at full-face rendering were also made. The extraordinary effect of a row of guests confronting the dead suddenly becoming a semicircle facing the spectator (Pl. XXXIVa) may have shocked rather than stimulated, for it was hardly ever repeated.[1] It should be noted that here, as in the earlier tomb of Nakht (Pl. XXXIVb), the incidental character of the scene is enhanced not only by gestures or intricate grouping alone, but by more subtle means: a slight shift of axis in the figures, a tilting of the head.

In connection with functional rendering, we should also mention here two rather abortive attempts at showing groups of agricultural workers receding in space (Pl. XXXVa);[2] but these remain quite isolated.

The second type of change we mentioned, namely, the effort to represent actuality as a pregnant moment rather than as a mere contingency or as a more concrete variant of an abstract scheme, is particularly significant because it foreshadows the 'emotionalism' of Amarna art and its aftermath. It is not surprising that this change occurred in the context of mourning scenes. It should not be forgotten that the representation of funeral rites had so far lacked an emotional overtone; for even the behaviour of mourning women—and their gestures of despair can already in some Old Kingdom instances be called excessive —was formally prescribed and therefore typical behaviour. It is, of

[1] Wreszinski, I, 91, has collected all the available evidence—mostly undated, except for one figure in *Tombs of Two Officials*, Pl. XXIII. It consists all in all of three sitting figures, one dancer; also one standing male figure in relief which may be post-Amarna.

[2] Wreszinski, I, Pl. 63. The decreasing size of figures is probably due to convention of a horizontal line of heads combined with the rising line of the feet.

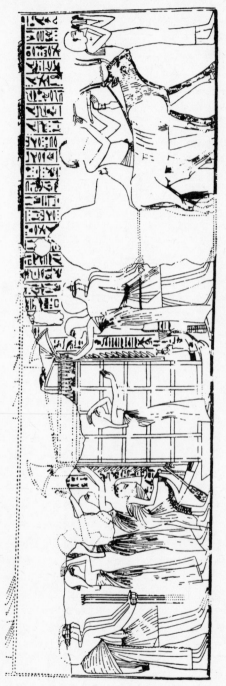

Fig. 17. *Funerary Procession*

course, possible that the amount of space allotted to and the imaginative skill spent on such scenes may reflect the mood of an artist or the temper of his time. But as part of the ritual they were entirely formal in intention.

The change we mean, and which occurred just before the Amarna revolution in at least one remarkable tomb, is significant because it insidiously undermines the purely ritual character of the mourning scene. As if to stress the isolation of individual suffering, the widow is detached from the group of mourning women, her action separated from the formal rites: we see her (Fig. 17), a lonely figure, standing in front of the catafalque; we see her, more poignant still, stroking the feet of the harsh grotesque mummy case in a final gesture of farewell (Pl. XXXVb). This leave-taking probably occurred in the immediate vicinity of the tomb, for the scene forms the last stage of a succession of rites and comes to a fateful halt in the rendering—half realistic, half symbolical—of the tomb itself. For the first time the formal sequence of the funerary ritual culminates in the simple rendering of actual human grief.

This particular scene was apparently never copied in the early New Kingdom (though similar ones occur in post-Amarna tombs), but henceforth the widow of the deceased was frequently separated from the group of wailing women. We shall not deal here with the increasing complexity and the differentiation of the figures within these groups, which have been studied in detail by Dr. Wegner. It is true that the grouping of figures overlapping in depth may appear as transient as the emotion expressed by the distorted faces (Pl. XXXVI), but nowhere, except in the case of the widow, has the sense of a single dramatic moment been conveyed so convincingly and by such simple means. There is one other instance of a tense moment depicted which artistically surpasses the ones we mentioned. It pictures again a situation in which inexorable death is faced, but one which does not contain a trace of poignancy, and in its setting not a hint of hope—we mean the ibex-hunting scene in the tomb of Kenamun which we discussed before (Fig. 15 and Pl. XXXVII). It is one of the most impressive scenes in all the history of Egyptian funerary art, perhaps the only deeply stirring one, and it is significant that such dignity in the face of inevitable disaster could only be expressed in animal form and in the relation of hunter and prey. The very immobility of the ibex facing his murderer has the tension of a tragic situation realised and accepted. It is enhanced with great subtlety by the unusual posture which suggest imminent collapse yet emphasizes the proud bearing of head and shoulders and also by the unexpected behaviour of the hound who,

lying down with forepaws crossed, looks up as if in awe and wonder. The restraint of this scene, the quality of stoic reserve, lift it above the level of terrible suffering and injured animal pride which the Assyrian artist expressed so superbly; beauty and pride are left inviolate here in one supreme moment of accepted fate.

<div align="center">C. THE AMARNA REVOLUTION [1]</div>

It seems justified to call the mural paintings and reliefs of the Amarna period revolutionary even though one may disagree with Professor Schaefer's insistence on the originality of Amarna artists. In reaction to his view several attempts have been made to discover traces of similar unconventionality in previous work but attempts of this kind are apt to overshoot their mark,[2] and on the whole Frankfort's careful analysis[3] of significant changes in the Amarna period still holds good. Such an analysis, however, although it touches on matters of space in several points, must of necessity ignore the core of our problem: it may elucidate stylistic trends, but it cannot be an attempt to correlate their space-time aspect with cultural changes in the widest sense.

Admittedly our approach to the problem of Amarna art, though it will justify the use of the word 'revolutionary', is one-sided and has to by-pass a number of data which would point to continuity rather than abrupt changes. It is, for instance, possible to trace in the earlier New Kingdom a stylistic development which in a way leads up to Amarna: one will find a more pictorial use of paint, delicate brush work which aims at plastic values;[4] a new interest in and a very sensuous treatment of surface texture, a tendency to greater 'realism' through softer, more voluptuous contours, slightly less rigid postures. Such development was only touched upon previously because it did not coincide with important changes in the rendering of space; if we may ignore it now for the same reason we may appear to overstress the element of discontinuity, but this cannot be avoided.

To those who considered funerary art up to this period as mainly narrative in intention—a display of the tomb owner disporting himself—some of the new scenes would merely appear a more lively story better told. The fact that in this story the heretic king himself played

[1] For the history and appreciation of the Amarna period see J. H. Breasted, *History of Egypt*, Chapter XVIII; J. D. S. Pendlebury, *Tell el Amarna* (London, 1935).

[2] Wegner, *loc. cit.*, 154 sqq.

[3] H. Frankfort, *The Mural Paintings of Tell el Amarna* (London, 1929).

[4] See above, p. 83.

an equally lively role would then seem no less strange than that his physical peculiarities should have been faithfully recorded. All this could be considered part of a general trend toward more natural and truthful rendering. But since we rejected this fiction of a cheerfully and naïvely garrulous funerary art in Egypt and found that its very restraint on the narrative side is highly significant, we must consider such scenes as, for instance, a royal tour of inspection to fortified police posts, or the decoration of officials with the gold of honour, which focus on the king's actual appearance and elaborate the local setting of these events, as insidiously subversive. For such scenes mean an attack on those basic conceptions which, both philosophically and artistically, had dominated Egyptian art, had given it its dignity and set its limitations. Whatever may have been the inconsistencies in earlier tombs—the experimental liberties taken, even the jokes made—in general the pre-occupation with various aspects of life had always meant a transmutation of the ephemeral into the typical and essentially timeless; it had generally ignored space-time definition since actuality was irrelevant in the face of death. Precisely at this point Amarna artists broke away from old bonds and struck out on a new course. It will be helpful for the appreciation of both the daring and the impotence of Amarna art to see it, first, against the foil of its unique historical setting.

In the strangely artificial town, built, after the religious and political schism, on clean desert soil, communal life was not only cut off from the burden of tradition, but also from its perennial values. It was, in all appearances, a gay uprooted irresponsible existence to which only the religious awareness of the beauty of life, expressed and fostered by the king, gave a kind of frail dignity and grace. This surely was the strangest effort ever made to live by the affirmation of joy and beauty alone, an artificial holiday which, if it was not to end in a kind of aesthetic dissipation, was bound to end in disaster. There is actually some evidence that it did both before it faded out, leaving few traces in a period of renewed acceptance of traditional values.

The lack of solemnity in some of the scenes then, their softness, their gaiety, may indeed be said to reflect an altered style of life, but the most important innovations are rooted in the revolutionary character of the movement itself, and the pivot of this revolution was undoubtedly the king. I do not mean by this that it is possible as yet to define the part Akhenaten played in it, though it may well have been considerable, but that the new doctrine implied a change in the very conception of kingship, and that this must have very deeply affected the life of the Amarna community and the art of the period. Its influ-

ences on art may have been partly indirect, and the romantic notion of a young king personally inspiring artists need not be taken too seriously, though we may assume that some definite royal instructions account for certain innovations. Even the written evidence on this score[1] should be treated with due reserve, while the eagerness with which modern critics have pounced on the term *Maat*—usually translated by 'Truth' and often recurring in statements attributed to Akhenaten—seems unwarranted. For the concept *Maat* has cosmic connotations and is far too complex, far too much bound up with traditional religious notions, to permit its translation by 'Truth' in our sense.[2] Let us, therefore, consider some practical and philosophical implications of Akhenaten's heresy.

The theology of kingship, developed but essentially unchanged through millennia, had linked the function of royalty both with celestial and with chthonic powers, the latter with a stronger emphasis on death and revival. The king was son of Re but he was also Horus, avenger and successor of his deceased father Osiris. Now the doctrine of the Aten worship monopolised the celestial, ignored the chthonic aspect of creation, and suppressed the Osirid affiliation. In fact, it is significant that in the titulature of Akhenaten the Horus name is recorded very rarely and only in the early years of his reign.[3] The king retained the name of Son of Re, but he was, theologically speaking, first and foremost the prophet of the sun-disk, the living Aten, and in that function became a separate, distinct, articulate power rather than the traditional *fons et origo* of national unity and well-being. The very emphasis on the king's religious teaching meant a shift from the symbolical and representative character of divine kingship towards its actuality. One probably has to see the earliest and most extreme efforts to render the king's physical peculiarities in this light. The colossal caricatures[4] (Pl. XXXVIII) in the Karnak temple dating from the first years of Akhenaten's reign, that is, before the capital was removed to Tell el Amarna, seem the work of artists baffled and confused by an unusual royal command and may be more symptomatic of the king's desire to stress his singleness, his individuality, than of an artistic bias or an aesthetic creed. But through this emphasis on Akhenaten's prophetic role and his direct relationship with the Aten, the mystery

[1] Von Bissing, *Sitzungsberichte der Bayerischen Akademie der Wissenschaften*, 1914, Abh. 3.

[2] H. Frankfort, *Ancient Egyptian Religion; An Interpretation*, (New York, 1947).

[3] In the tomb of Ay (*Amarna*, VI, Pl. XXXII); on one of the boundary steles (*ibidem*. V, 28 sqq.) and once in the quarries of Silsileh (Henri Gauthier, *Le Livre des rois d'Egypte*, II (Cairo, 1910), 346).

[4] *Annales du Service des Antiquités de l'Egypte*, 1929, 1930, 1931.

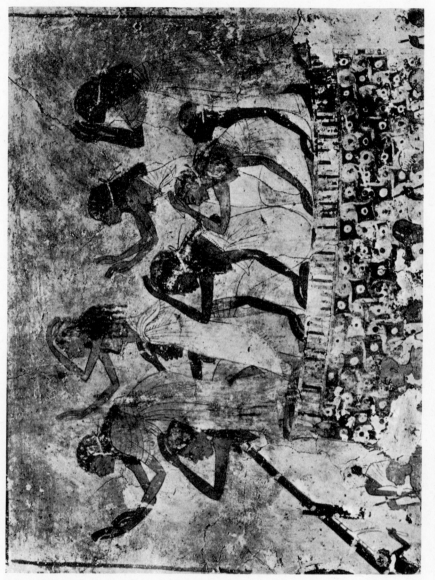

XXXVI. WAILING WOMEN ON FUNERARY BARGE, THE TOMB OF NEFERHOTEP

(page 95)

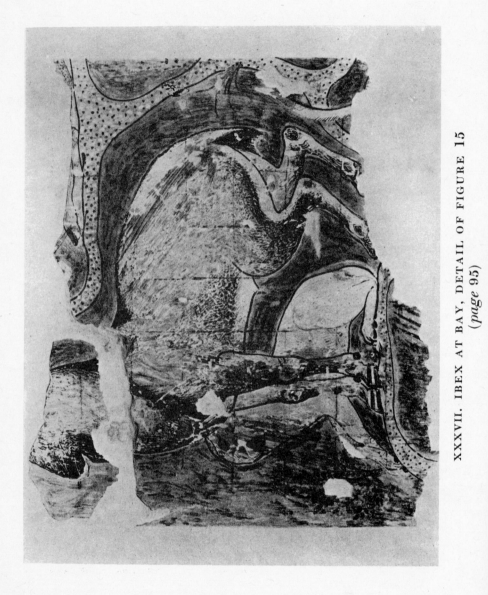

XXXVII. IBEX AT BAY, DETAIL OF FIGURE 15
(*page* 95)

of kingship, kept and safeguarded in elaborate rites of succession and of renewal of power, was dragged into the light of day and cut off from a whole complex of human emotions. The king had been the avenging son, whose office was sanctioned by his deceased father, who was protected by goddesses acting as his mother; the king was guarantor of justice, destroyer of enemies. Akhenaten's teaching stripped Pharaoh of most of his mythical qualities; since he had become a mouthpiece for the revelation of the 'living Aten', he was single, human, yet almost unaccountably divine. It is clear that this change posed a number of problems to artists who had to conceive new forms in which to express it. It must have been helpful that the setting of the royal reliefs at Amarna differed completely from previous ones. Akhenaten did not build a funerary temple, for this institution was bound up with notions which he either rejected or ignored, such as the relation between king and pantheon and the transcendent significance of military and political acts. Moreover, the iconoclasm of the new creed would not tolerate any symbol in the Aten temple except the sun-disk and its life-giving rays, so that the old confrontation of officiating king and gods could not be maintained. In fact, all the old repertoire of royal scenes had to be scrapped, and instead of repeating the classical robot figures which, though dull, had at least the dignity of beings engaged in symbolical acts or confronting deities on a footing of equality, artists were now commanded to depict the king as a single person in relation with a divine power which transcended human or animal form. This was done by the simple device of showing the orb above and the life-giving rays stretching toward the royal figure. But since the new significance of the king exclusively centred in his relation with the Aten, the repertoire was extremely limited. Little is known about the decoration of the almost completely destroyed sun-temple;[1] the fragments found, however, make one suspect that there the same device was repeated *ad nauseam*. It even recurred in the tombs and houses of private people —for since the images of other gods were forbidden small stelae with pictures of the royal family were set up in garden chapels.

The intrusion of the king's actuality in the tombs and homes of his subjects was symptomatic of incisive changes which the new religion brought into people's lives. Above all, that side was affected which from time immemorial had been directed toward the provision of a 'house of eternity'. Those who either enthusiastically or doubtfully accepted the new doctrine found themselves, by order, cut off as it were from the night-side of existence. The exclusive emphasis on solar power and glory made the preoccupation with the Hereafter, with the relation

[1] J. D. S. Pendlebury, *JEA.* XIX (1933) 113 ff.; XX (1934) 129 ff.

between life and death (of such supreme importance through millennia) almost irrelevant. The tradition of sculptured rock tombs was indeed kept up; their decorative scheme had throughout sufficiently paid tribute to life so that it could be made to harmonize with the new creed. But the old balanced concept of life-in-death had to be sacrificed, and since the light-side of existence was now all-important, the whole tenor of the decoration had to be secularized. In this process of secularization some religious vacuum had to be filled: a mere record of the glory and the gaiety of life in a funerary setting must have appeared rather senseless even to the most fervent Atenite. It has often been held against the tomb owners of Amarna that they were so exclusively preoccupied with their monarch or so obsequiously obeyed an imperious order that the royal figure was to dominate the scene. Actually there is something almost pathetic in the way they had to cling to the one traditional feature in an existence where so many old values had become meaningless: the king still retained his supreme and beneficial function; the king, though provocatively human, was still divine. Since it was, however, his actuality in word and deed that mattered most now, the old abstract confrontation of a formalized royal figure and his functionary had to be superseded: the tomb owner depicted in relation with his master was drawn inevitably into the realm of the latter's actuality. In this case that meant not only the very limited actuality of Akhenaten's reduced political and religious life, his visits to the temple, his public appearances, etc., but—and artists fairly revelled in this—the petty details of his human existence. This undoubtedly completed the process of secularization; life, the core of the Aten religion, was in the acts of his prophet brought down to the level of liveliness, and liveliness had apparently come to mean the purely trivial. Yet it must not be forgotten that even the cloying naturalness of hugging, eating, and family scenes[1] meant for the common man a manifestation of divine life, and this lifts them above sheer frivolity.

Before we discuss the details of the repertoire, the following facts are worth noticing:

The dating of the Amarna tombs presents a number of problems, but we can deal with them in roughly chronological order, for the group which is situated in the southern part of the bay was started earlier and work there was abandoned suddenly and without apparent reason in the eighth or ninth year of Akhenaten's reign in favour of a northern site.[2] The southern tombs have one feature in common: they all show the royal family adoring the Aten in the entrance of the tomb, as if to

[1] *Amarna*, II, Pl. XXXII; III, Pls. IV; VI; XXXII; VI, Pl. XXIX.
[2] *Amarna*, IV 8.

stress a break with the past; in the northern group the owner himself
is again depicted there. On the other hand, the repertoire in the former
still reveals—at least in one tomb—a considerable interest in the tomb
owner's activities (here also we find in one case a biographical inscrip-
tion, which is elsewhere omitted), though the emphasis is entirely on
the royal family. The northern tombs are almost exclusively concerned
with this latter subject. We find in the southern tombs a wealth of
architectural features, elaborate papyrus columns, carefully moulded
cavetto cornices, in striking contrast with Theban tombs and their flush
walls and simple square pillars. Such details are less exuberant in the
northern tombs though worked columns are used throughout. It would
then appear that this curious stress on architectural detail, which makes
the southern tombs 'almost reach', in the words of de Garis Davies,[1]
'the dignity of rock temples', was either a compensation for the fact
that so many of the old motifs had to be discarded, or that it was
symptomatic of an attempt to alter the character of the tombs alto-
gether. The work done on the southern side shows signs of almost
frantic haste, so that if we find finished and carefully moulded capitals
on shafts of pillars that have not yet been cut out of the rock, we may
assume that such architectural frills were part of a deliberate scheme.

It is difficult, owing to the unfinished state of most of the tombs, to
judge with absolute certainty to what extent the old repertoire was
abandoned, but we may safely assume that funerary scenes were absent.
Barring a unique scene in the royal tomb which we shall discuss later,
there is only one single instance known at Amarna in an exceptional
tomb, namely, the tomb of Huy,[2] superintendent of the harem, who
came in the retinue of Queen Ty from Thebes rather late in the reign
of Akhenaten. His tomb, the only one which was completed with
burial chamber, shows several Theban reminiscences such as agri-
cultural scenes, craftsmen, and even a slaughter scene, which he evi-
dently was not prepared to abandon. All of these are conspicuously
absent at Amarna, and if the traditional scenes of life were omitted,
and even the banquets with their posthumous connotation were
extremely rare,[3] we can be sure that the preoccupation with death was
barred altogether. Actually what we call the process of secularization
sets in exactly where we might expect it: in the relation of the tomb
owner with his king and—at least in one instance—in the rendering of
the former's official function, a subject which in the earlier New King-
dom came already dangerously near upsetting the old scheme. In one

[1] *Ibid.* [2] *Amarna*, III, Pls. XXII and XXIII.
[3] *Amarna*, II, Pl. XXIII, where the owner and his wife are called *makheru*,
'of blessed memory'; also on some small private steles, *ibid.*, V, Pls. XXI, XXII
XXIII.

FIG. 18. *Mahu and Vizier running before the Royal Chariot*

of the earliest southern tombs, that of Mahu,[1] chief of police, this aspect was seized upon with avidity and treated frankly with a view to space-time actuality and true narrative (Figs. 18–19). The result is that here we are suddenly face to face with the life and character of a single person, in a way never equalled in Egyptian art before or after.

We see a small man, vigorous, alert (probably rather snub-nosed), in every conceivable attitude and mood: eagerly running in front of the royal chariot (Fig. 18, middle register, extreme right), deferentially listening to his refined and rather decadent superior (Fig. 19, facing right), commanding a subaltern (id., facing left), excitedly telling a story while his chief listens with tired amusement (Pl. XXXIXa). We also see the great events of his life: the king and queen leaning over the balustrade of the Window of Appearance in the palace, rewarding him; the king inspecting his security measures on the outskirts of the newly built capital, police posts, chain fences, and blockhouse. We see him accompanying the king on a visit to the temple. And the brilliantly gifted artist who gave us these slices of Mahu's life never once succumbed to the temptation of pomposity by overstressing his employer's importance, but with a kind of humorous detachment, made him appear small, officious, likeable. In short, this artist did achieve what was virtually a complete reversal of all the characteristics of Egyptian funerary art. For there is no question here of a kind of timid playful 'genre' in subordinate scenes; the tomb owner nowhere appears as 'living dead' or caught in the amber of his glorified function, but as he was and acted, individual, alive.

We can observe a similar shift towards the singular and concrete in tombs where the owner's activities are not the main preoccupation— in this Mahu's tomb is quite unique—but where all interest is focused on the royal family. In typical events like offering to the Aten, visits to the temple, the awarding of the gold of honour, we see an effort to characterize the royal participants as individuals, and each scene as a single definite event. Where differentiation of mood was not insisted upon—the king and queen maintain a rather bland dispassionateness throughout—physical peculiarities are stressed, contingent acts and gestures introduced.[2]

It is irrelevant for our problem whether these changes are qualified as 'naturalism' or 'expressionism' and explained by a new interest in and observation of the natural world, or by an increased emotional sensitivity.[3] The truth of either explanation pertains to the psychology

[1] *Amarna*, IV. [2] *Ibid.*, IV, Pl. XXII, VI, Pl. XXIX.
[3] See controversy between Frankfort (*The Mural Paintings of Tell el Amarna*, pp. 1–30) and H. Schaefer, *ZÄS*, LXX (1934), 1 ff.

FIG. 19. *Mahu receiving and giving Orders; Market Scene; Police Post*

of art. For us the point of interest in this expressive naturalism lies in its space-time character. Here changes are subtle rather than obvious, for on the whole the use of groundlines, and often of registers, has been maintained so that the scenes still cling to the wall surface; yet they are unmistakable.

The 'watching' dead, aloof from space-time considerations, have disappeared; those persons who are not active are shown in some relationship which stresses the singularity of the situation—conversation scenes abound.[1] We saw already that the explicative gesture of active persons have often been superseded by emotional or purely contingent ones, but even more significant is the fact that the severe canon of paratactic rendering has been slackened; contours are softer, postures less rigid, so that these flabby bodies gain—though at the cost of structural clarity—a new organic coherence. Their gestures appear prompted from within and consequently they seem to act in a vague amorphous space that is not clearly three-dimensional yet differs from the problematic space of strictly paratactic rendering. Where smaller self-contained groups are concerned, like the family scene (Pl. XXXIXb), intricate arrangement of overlapping figures and their interaction adds to the suggestion of an event in space as well as to its ephemeral character. In short the self-containedness, the frigidity of the classical figures have vanished; the spectator watches with a different, more human, interest the individual antics of these gesticulating creatures which seem to move in an almost-familiar void.[2] In comparison, 'haptic' figures from the preceeding reign, like Ramose (Pl. XL), seem for all their clear, firm, sensitive modelling to belong to a different world.

This is not surprising; for now that the last trace of the original significance of the scenes has vanished, a different attitude of the artist toward his subject, a new relationship between scene and spectator, becomes possible. The artist's ambition is now to conjure up coherent event in a definite spatial setting.

We said before that the changes we are considering are subtle rather than bold; in connection with the larger scenes it is less their sum total than their interrelation which is significant. Very striking, for instance, are the attempts at rendering buildings in such a way that they can no longer be considered a schematic outline, plan, or façade of a house or temple but that, through an elaborate and quite specific combination of layout and front aspect, they represent *the* Aten temple,

[1] N. de Garis Davies, *Amarna*, I, Pl. X; IV, Pl. VIII; VI, Pl. XX, XXXVI.
[2] Strikingly so in the many cases where the king is leaning sideways out the Window of Appearance rendered in front view, e.g. *Amarna*, II, Pl. XXXIV.

the palace (complete with harem, doorkeepers, kitchen and staff), *the* Hall of Foreign Tribute, which we can identify in the ruins of today.[1] The rendering is admittedly discursive, nonfunctional, but the intention of depicting a single existing building must imply a desire for a fixed point in space to which action could be allocated. The larger scenes might then begin to represent a coherent spatial unit (Fig. 20).

FIG. 20. *Palace and Temple Gate*

We can observe two changes which point in this direction: (a) for the first time registers are ignored in such a way that superimposed figures may be part of the same scene; (b) the *horror vacui* had diminished to an unprecedented degree; we find large empty spaces in a number of scenes where the distance between figures is significant.

Now these innovations are merely tentative; scenic dramatic space, in the sense of a complete integration of the spatial and temporal aspects of an event, does not occur and superimposed figures are still apt to cling to fragments of groundline which preclude an illusionary relation in depth. On the other hand, there is at least one highly remarkable attempt in this direction; in Figure 21, river and garden are treated not only conceptually but pictorially as foreground. Recession is achieved by the bold expedient of two diagonal paths leading from

[1] For a description of the Hall of Foreign Tribute see Frankfort in *JEA*, 1927, pp. 209–10.

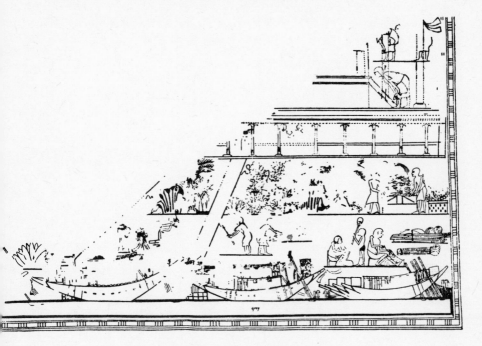

FIG. 21. *The Quay at El Amarna*

the river to the palace and intersecting quay and gardens. These diag-
onals have a different slant which can only be explained as determined
by the observer's viewpoint, the farther one appearing more horizontal.
This is in actual fact the nearest approach to true perspective which
the Egyptians ever achieved.[1]

The experiments with empty space with the purpose of stressing the
actual distance between the where-from and the where-to of dramatic
action (Fig.18) are clearly seen in most of the larger scenes.[2] In the case
of Mahu's conversation with the vizier (Pl. XXXIXa), the tensional
distance has been reduced by a line of hieroglyphs, but in the tomb of
Ahmes (Fig. 22) (one might expect it to be of the hand of Mahu's
artist)[3] the lonely figure of a trumpeter, flanked by two rows of soldiers
whom he summons, suggests the spaciousness of his loud call by facing
a completely empty register.

Perhaps the most interesting attempt at surreptitiously suggesting
a space-time unit, and that notwithstanding the usual division of the

[1] N. de G. Davies, V, Pl. V. The remnants of landscape in *loc. cit.*, III, Pls. VII
and VIII, do not seem to differ from similar scenes in the tomb of Nakht. See
above.

[2] Note the significant distance in the case of the forerunners in *loc. cit.*, II, Pl.
XIII, and the groups of meeting people, VI, Pl. XX.

[3] *Loc. cit.*, III. Pl. XXXI.

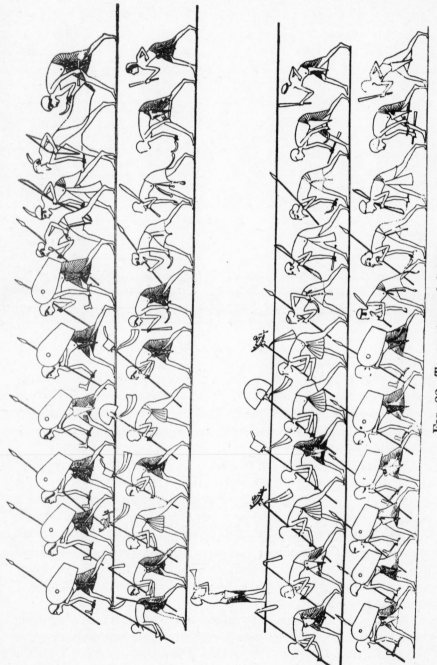

FIG. 22. *Trumpeter and Soldiers*

scene in registers, was made in the tomb of Ay. In the large scene of reward[1] the top register shows four standard-bearers waiting near guardhouses in conversation with some smaller boys. Short texts accompany the scenes, but these do not contain the usual sayings appropriate to a typical situation; they explain the lively acts of the boys by referring explicitly to the scene below and run as follows: the sentry asks: 'For whom is this rejoicing being made, my boy?' and the answer is: 'The rejoicing is being made for Ay . . . along with Ty. They have been made people of gold.' Another sentry says: 'Hasten, go see the loud rejoicing; I mean who it is; and come back at a run.' The boy replies: 'I will do it. Behold me.'[2] Thus they intend to relate in a space-time sense the different registers: the guards, within earshot of the festive event, are unable to see what is going on.

In reviewing the changes in Amarna scenes one is, however, struck by their artistic limitations. An exclusive preoccupation with narrative apparently held a danger for artists who drew their inspirations from a new love of life, but for whom, humanly speaking, this love of life lacked depth. We might sum up the actual changes in one word: the scenes were dramatized. But this dramatization was not coincident with a change of subject in the direction of historically pregnant or humanly significant event. This had been the case in the late Old Kingdom tomb at Deshasheh (Fig. 6) where a unique battle scene also represented a unique effort at true pictorial narrative and in the case of the famine scene in the pyramid of Unas (Pl. XXIIb). Similarly, some early New Kingdom artists achieved what the Deshasheh artist aimed at in potentially tragic scenes like mourning and hunting; for they did on one or two occassions as we saw (p. 95) render a pregnant moment as well as a concrete situation in a way which implies an imaginative recognition of the threat of death.

Amarna artists, on the other hand, though they were sensitive to mood, ignored the importance of secular achievement (such as military conquest), as well as the darker aspects of existence. In fact, only in one unpretentious little scene in a royal tomb—the king and queen standing near the bier of their daughter—has the subject of death been touched upon.[3] The form of dramatization at Amarna appears therefore correlated with the character of the revolutionary movement itself, which discarded the austere implications of an ideal of timelessness and focused on life as a joyous actuality. The very limitations of the religious and political scope of the Amarna movement are those of the artist's repertoire. Once the promising line of development in the

[1] *Loc. cit.*, VI, Pl. XXX. [2] *Loc. cit.*, VI, p. 23.
[3] Legrain, *Culte d'Atonou.* Pls. VI–XIII.

direction of a fresh interest in human character—so striking in the plastic portraits of the period—was abandoned for the sake of royal portraiture, the chosen course proved a sterile one. For the king, in the role of divine prophet, barred the road to monumental art as effectively as his predecessors' static perfection had done. The artists who decorated the hybrid cave structures—neither quite tomb nor temple—in his honour, had to fall back on festive celebrations and small events. No wonder the narrative side of Amarna art becomes repetitive and the representation then as dull as its liveliness is shallow. It is undeniable that, for all their revolutionary efforts, Amarna artists never produced a single relief or painting of the same quality as the monumental figure of the ibex in the tomb of Kenamun.

D. TRACES OF AMARNA INFLUENCE IN THE PERIOD OF REACTION

The Amarna movement, sustained at first by the superlative boldness of an attack on creeds and values which were most deeply rooted in Egyptian life, became too soon the fulfilment of a dream, the dream of a new life. In its new order the king alone, sole link with a transcendent cosmic power, was the justification of a strangely reduced political and social existence which oscillated between high-mindedness and hedonism and which, once the initial battle had been won, became rather anaemic. The religious movement of the Aten worship died with Akhenaten; the political revolution was soon undone; only in art can its influence be traced for two centuries. It is, of course, possible that once the town had been deserted, Amarna artists were employed even by those who disapproved of what Amarna stood for, and that they simply worked as craftsmen executing orders. But it is certainly paradoxical that when the mannerisms of Amarna art were discarded and the repertoire of tomb decorations was once more focused on the time-honoured problem of life-in-death, what must be called the few really great masterpieces in the Amarna style were produced. It may not be accidental that they nearly all occur in the tomb of Haremhab, Akhenaten's general, who finally took over the burden of kingship and restored political order, but who may not have shared the fanatic hatred of the priesthood of Amon for the 'criminal of Akhenaten'.[1] However, the influence of Amarna was more far-reaching than these few reliefs might suggest, which seem the belated fulfilment of an earlier promise. Amarna art, bound up as it was with a movement

[1] Jean Capart, 'The Memphite Tomb of King Haremheb,' in *JEA*, VII (1921), 31-34.

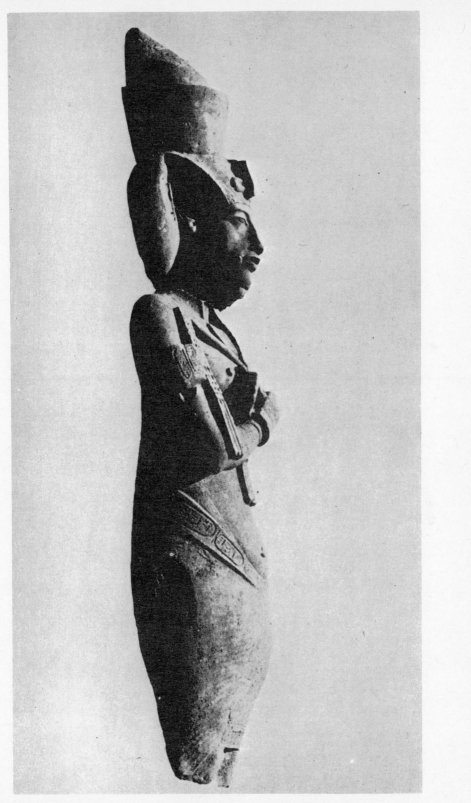

XXXVIII. COLOSSAL STATUE OF AKHENATEN
(*page* 98)

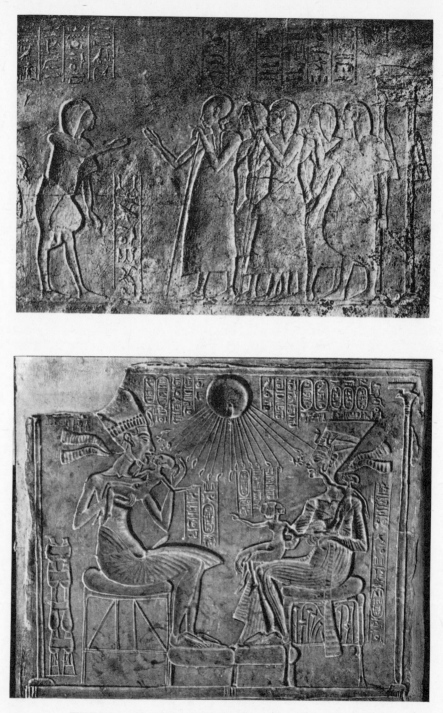

XXXIXA. MAHU REPORTING TO THE VIZIER
(*page* 103)

XXXIXB. AKHENATEN AND HIS FAMILY
(*page* 105)

which shook the very foundations of religilous faith and practices—and all their social implications—created a confusion far more insidious than the introduction of incongruous or heretic motifs which could be ignored in their entirety. The blatant humanity of some of the Akhenaten scenes, was, as we shall see, considered blasphemous, the secular character of the tombs probably both frivolous and senseless, but the new interest in space-time actuality was too vital to be suppressed, even though it was in conflict with the very significance of all previous tomb decoration. The artists of post-Amarna reliefs and paintings re-emphasize their funerary character, but in two ways pervert the old scheme by submitting to or developing Amarna notions: they either dramatize or concretize older motifs. In funeral rites the emphasis is now more frequently than ever on the personal grief of single near relatives (Pl. XLIa); the motif of the widow taking leave of the coffin occurs again.[1] On the other hand, posthumous existence is made concrete in more ways than one: the climax of a funeral may be a scene inside the tomb (which is realistically rendered) of the goddess receiving the dead in person,[2] while classical scenes of daily life, which used to be the object of the tomb owner's 'watching', are now transferred with him to the Hereafter; we see the dead busily cultivating Elysian fields (Pl. XLIb)[3] or fishing Elysian ponds.

We find an equally blatant disregard for former meaning in cases where, as in the early New Kingdom, the political function of the dead has been stressed. Generally speaking, this function is no longer related to the contemporary ruler and we find instead the formalized immobile figure of a king long since deceased as the focus of an adoration scene.

The only exception is in the tomb of Huy, Viceroy of Nubia, who lived in the reign of Tutankhamun, that is, immediately after Akhenaten. Here the king again presides over Huy's nomination, but the viceregal function has been turned into a biographical account with stress on the moment of departure and the actual return with tribute from the South.[4] Only in two cases has the Amarna motif of the award of gold by the king from the 'Window of Appearance' been maintained.[5] It is also typical for this period that in another tomb a royal scribe chose to be depicted

[1] N. de Garis Davies, *The Tomb of Neferhotep at Thebes* (New York, 1933), Pl. XXIV; Wreszinski, *Atlas*, I, Pl. 131.

[2] *Ibid.*, Pl. XX.

[3] N. de Garis Davies, *Two Ramesside Tombs at Thebes*, (New York, 1927), Pl. XXX.

[4] N. de Garis Davies, *The Tomb of Huy* (London, 1926) Pl. XI sqq.

[5] *Loc. cit.*, Pl. XXVII; N. de Garis Davies, *The Tomb of Neferhotep at Thebes*, IX, XV.

as *primus inter pares*, busily writing with his secretaries in the hall of the 'foreign office'.[1]

We saw that Amarna artists delighted in the rendering of specific buildings. In the Nineteenth Dynasty, this theme is mostly restricted to temples and is then elaborated with a description of the surrounding terrain, especially the approach from the Nile. In the case of Nefer-hotep the detailed outlay seems almost out of proportion with the importance of the event: the tomb owner is seen receiving a bouquet from the priests which he hands to his wife (Fig. 23). Not so when a religious festival is depicted in its setting, such as the procession of the statue of the deified King Amenophis I leaving the temple.[2] The love of topographical precision is evidently persistent, for it also invades funeral scenes: the situation of the tomb on a sloping hill is more than once indicated.[3]

But even if the 'triumph of actuality' did leave some traces in these scenes—as it did also in a certain liveliness of gestures and grouping here and there—a new type of formality and abstraction soon encroached. It is, in fact, paradoxical that the attempt to concretize the Hereafter led to introducing a number of abstract vignettes from the Book of the Dead; the tomb owner was now brought face to face with the deities that were supposed to play a part in his post-mortem struggle for existence. This not only removed the figures from such space-time considerations as had asked for a solution—a negative solution, admittedly—in the classical scheme; it dealt the death blow to this scheme itself. A new religious preoccupation slowly drained the old love of life which was the mainspring of Egyptian funerary art. It survived longest in the rendering of trees and plants, which are often delicately, lovingly drawn: we see the dead now surrounded by a wealth of foliage, and formalized trees serve as a background in those scenes where the tree-goddess refreshes the dead with libations. But by the end of the Nineteenth Dynasty the last trace of vitality seems to have ebbed from the art of the private tombs.

And yet, concurrent with this slow decay, one of the most remarkable developments in the history of Egyptian art took place. In the royal reliefs alone did the revolutionary spirit of Amarna and the new acceptance of traditional values find a superb synthesis.

[1] See Borchardt in *ZÄS*, 44 (1907), 59–61.
[2] Wreszinski, *Atlas*, I, 118, 129. [3] *Loc. cit.*, 114, 127.

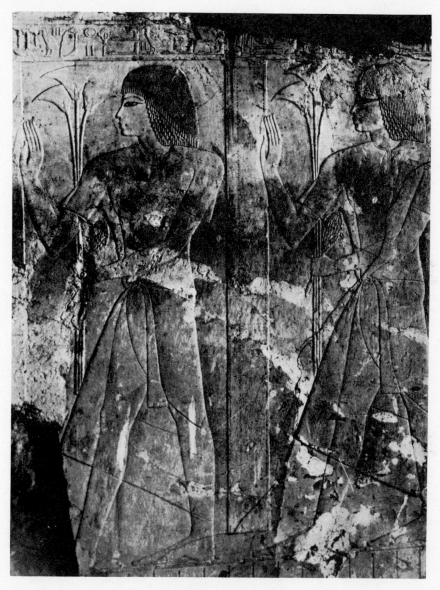

XL. MEN BEARING FLOWERS, TOMB OF RAMOSE
(*page* 105)

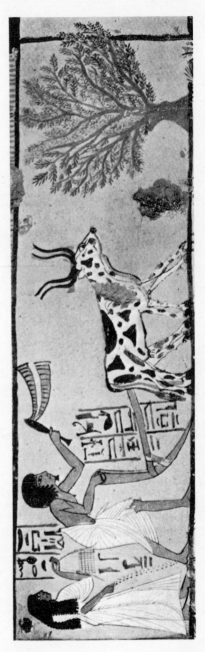

XLIA. FUNERARY PROCESSION, TOMB OF HAREMHAB (*page* 111)

XLIB. HATHOR AND LOWER IN THE HEREAFTER, TOMB OF SENNODEM (*page* 111)

XLIIA. ENVOYS IN PUNT, TEMPLE OF HATSHEPSUT

XLIIB. PLANTS AND BIRDS FROM SYRIA, TEMPLE OF THOTMES III
(page 116)

XLIII. USERHET HUNTING IN THE DESERT (*page* 118)

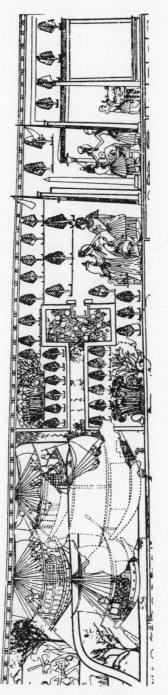

Fig. 23. Temple, Garden and Ships

The New Kingdom

E. THE DEVELOPMENT OF THE ROYAL RELIEFS AND THE TRIUMPH OF MONUMENTAL STATEMENT

The first New Kingdom funerary temple is a unique phenomenon in Egyptian history; it was built by Hatshepsut, the only woman who ever usurped the throne. We use the word 'usurped' deliberately because whatever the acts of the personages involved, the wills and passions that shaped this tantalizingly obscure episode, there can be no doubt that something sacred in the succession of divine kingship was violated; the mystic relation between father and son, Osiris and Horus, had become a mere pretence.

Now in comparing the reliefs of Hatsheput's funerary temple at Deir el Bahri with earlier and later work, it would be easy to see in the extraordinary preoccupation with the divine conception and birth of the queen a mythical justification of her act, and in the serene worldliness of some of the events commemorated a form of feminine complacency. But if we explain these new scenes as freaks, we miss something essential, for they do herald changes which are significant throughout the New Kingdom. There is undoubtedly a strong element of personal pride in the choice of subjects, such as the expedition to Punt or the transport of the great obelisks,[1] but it is balanced by a new humility; for these events are not merely the fulfilment of a royal command, they are acts of devotion. Whereas in the Old Kingdom the expedition to Byblos in the temple of Sahure set out from and returned to its ruler, the one Hatshepsut sent to Punt originated in an explicit desire of the god Amon, who in an oracle revealed his will to the queen;[2] and the climax of the event is therefore not the reception of the participants and the speech by the queen, but the presentation of all treasures to Amon.

It is, unfortunately, through lack of material, impossible to judge in detail whether the new element of self-assertion on the one hand and the shift in the relative importance of the king and god on the other was maintained in the later reliefs up to the Amarna period. But there is circumstantial evidence which in a general way points in the same direction. The Old Kingdom scene of the gods leading defeated enemies before the king (Fig. 5) is absent in both Hatshepsut's temple and in those of the late New Kingdom, but we do see Thothmes III and his successors offering captives and spoil to the god in the temple of Amon. Significant also is the layout of the temple, which was inaugurated by

[1] E. Naville, *Deir el Bahari*, III, LXIX; VI, CLIII–IV.
[2] Breasted, *Ancient Records*, II, 285.

114

Hatshepsut. The astonishingly beautiful scheme of her three rising colonnaded terraces was never repeated, but one feature had come to stay: tomb and temple were henceforth separated. The only Middle Kingdom temple at Deir el Bahri belonging to Mentuhotep—the only Pharaoh of the Middle Kingdom to abandon the pyramid-temple scheme—contains a tomb shaft; but for the sarcophagi and funerary treasures of New Kingdom sovereigns elaborate hiding places were burrowed in the formidable cliffs of the Valley of the Kings. The walls of the tomb chamber and the long passages approaching it were covered with the dreary stations of the posthumous procession of the soul—paintings which show a singular lack of dramatic force and are utterly devoid of climax both in conception and representation. The tomb once used was sealed and not even a false door linked the mystery of the soul's magic circuit with the place of offering and ritual; the funerary temples were built far away, usually near the edge of the cultivation. This new arrangement may partly be explained as a matter of expediency or even economy—rock tombs are less extravagant and easier to guard than pyramids—but it may well have had an unsought-for effect on the henceforth isolated temples, for, though these never lost their original character quite, they might now more easily become what they had never been primarily: a monument in the challenging sense, with strong emphasis on the secular aspect of Pharaoh's glory. In fact, the new political and religious trends of the New Kingdom would almost appear symbolized in the curious configuration of Thebes. The actual royal tombs, reminders of the mortality of the 'good god', are out of sight, hidden and guarded by desert cliffs, while the royal and the divine temples face each other in equal splendour across the Nile. Evidently the dogma of divine kingship was unshaken, yet royal power had found a potential rival.

Now it is remarkable that in the reliefs at Deir el Bahri we find no sign that the preoccupation with actual achievement or the new and more dynamic relation with the god (which both the myth of the royal birth and the injunction of the god to send an expedition to Punt imply) influenced the type of rendering in any way. On the contrary, the scenes are as remote from actuality as they could possibly be, seeing the subject matter. It is as if with the utmost restraint those tendencies were kept in check which might, and later did, become subversive, namely, an emphasis on the significance of transient matter instead of the true royal prerogative: timeless perfection revealed in acts. The so-called mythical scenes are mere explicative pictograms;[1] in those which deal with the transport of the obelisks the artist avoids

[1] *Loc. cit.*, II, Pls. XVII sq.

depicting their erection, which would have entailed some interest in the space-time aspect of this event, but concentrate on the less definite episode of the shipping alone. In the Punt expedition (Pl. XLIIa), it is true, the rendering of locality has not been shirked; we see even the confrontation of the expedition leader with the exotic-looking rulers, the native houses, the beasts and plants, the loading of treasure.[1] And yet, artistically speaking, the whole event, cut up in small static groups, is utterly devoid of dramatic actuality; logical sequence and even direction of figures and objects has been observed but nowhere are these spatially related even within the group: there is not a gesture made by any of the *dramatis personae* which would suggest a scene in the pregnant sense of the word.

We do not, unfortunately, possess a single fragment from the sadly dilapidated funerary temple of Thothmes III—a dynamic person if ever there was one—which might suggest whether or not the same attitude towards the time-honoured ideal of static abstraction was adhered to. The great founder of the Egyptian empire may for all we know never have been immortalized in true battle scenes; in fact, a strong argument against the assumption that these might have existed but were destroyed lies in the fact that the famous annals of his campaign on the walls of the Amon temple in Karnak (*not* in the funerary temple) are an elaborate document in script, while all we possess pictorially of the Syrian campaign described there is a catalogue of trees, shrubs, and plants brought from the Levant (Pl. XLIIb).[2] In fact, the only pictorial reference to the battle known to us occurs in a purely symbolical scene of the king holding a bunch of captives, where place names are given.[3] An *argumentum ex silentio* is admittedly dangerous, and the fact remains that there is a complete gap in our knowledge concerning royal reliefs from Hatshepsut's reign up to Amarna. But there exists one picture of Pharaoh's military exploits which does in a sense fill in the lacuna: on the chariot of Thothmes IV we find what is usually called a battle scene.[4] The term is misleading, for it is simply an elaboration of the pictogram of the victorious king which we know from an early date. As a matter of fact, the well-known scene (which we find even in Hatshepsut's temple) of the king as griffin trampling on his enemies is still given on the inside of the chariot, and it is interesting to note that in Fig. 24 the same hand which in the canonic representations usually grasps a bunch of prisoners by the hair here holds an empty bow (the left hand incongruously swings a battle axe) as well as

[1] *Loc. cit.*, VI, Pls. CLIII–IV. [2] Wreszinski, *Atlas*, II, Pls. 26–33.
[3] See Frankfort, *Kingship and the Gods*, Fig.5.
[4] Howard Carter, *The Tomb of Thoutmoses*, IV, Pl. 12.

FIG. 24. *Thothmes IV in Battle*

the locks of two prisoners who—with a new touch of realism—stand in a fleeing chariot. Where the king is actually shooting, the goddess Nekhbet steadies his aim.[1] The so-called battle turmoil in both scenes, however, is no more than a decorative foil for the dominating figure of the king, so much so that it looks as if transfer patterns of horses—one can hardly call them teams—were grouped rather haphazardly around the royal chariot while the bodies of gaudily dressed aliens, in every conceivable twisted posture, were made to fit the empty spaces, overlapping where need be. It is remarkable how high-handed the artist was in his use of enemy bodies, especially dead or dying. For, although as we saw, full face rendering is nearly always avoided, it here occurs in the case of enemies and occurs throughout in later battles scenes, not

[1] Wreszinski, *Atlas*, II, Pl. 1.

by any means because this would enhance the dramatic scenic effect with a view to the spectator but because a dead man was an object which could be rendered in front or side view; the grinning masks which seem to stare out of the picture are no longer those of human beings.

We may, however, well ask why the curiously unnatural diagonal posture of the horses—something between a prance and a gallop—was chosen. This occurs previously only in a chariot hunting scene (Pl. XLIII) in the tomb of Userhet, where the arrangement of the quarry roughly resembles that of the enemies on the chariot of Thothmes IV which we discussed. Although the tomb antedates this, the scene may well have been copied from a similar object.[1] For it is striking that elsewhere in the New Kingdom work in private tombs and at Amarna the movement of the horses was more level throughout. The reason for the diagonal stance in the case of Pharaoh and his chariot may well have been that here the emphasis was less on speed than on phenomenal power. Mere movement on the level could not have expressed the static self-sufficiency which the royal victory as a symbol demanded. The strange posture may therefore have been chosen intuitively for decorative as well as symbolical reasons because it represented both a violent and a halted movement. A group of falling bodies arranged vertically in front of the chariot and horizontally under the horses' bellies would fulfil the double function of both explaining and checking its impetus, which would be caught up, suspended in a more or less ornamental framework. This would result—and both the miniatures of Tutankhamun (Pl. XLIVa,b) and the Nineteenth Dynasty royal reliefs will bear out our assumption—in a pictographic 'motif' which is more dynamic than the classical one in which the king grasps his enemies by the hair or tramples them underfoot, but one which through a curious decorative equipoise seems quite remote from actuality and does not deserve the term 'battle scene' in a dramatic sense.

It is, of course, quite conceivable that this motif appeared on the walls of the funerary temples before it was used on the chariot itself, but there is no reason whatever to assume that actual battles were

[1] The fact that this scene occurs only once (see *Atlas*, I, 26a) points to its having been a royal prerogative, perhaps a standard feature of funerary temples. Both the sureness of the touch in the rendering and the fact that the 'unnaturalness' contrasts with the extremely realistic movement of the wild animals may be explained that way. At Amarna the by now probably traditional diagonal posture does occur but the tendency is to render a more natural gait (see our Fig. 18 and *Amarna*, III, Pl. XXXII, and V, Pl. XXII). A very normal level gallop also occurs in the early Nineteenth Dynasty tomb of Neferhotep (N. de Garis Davies, *The Tomb of Neferhotep at Thebes*, (New York, 1933) Pl. XVI).

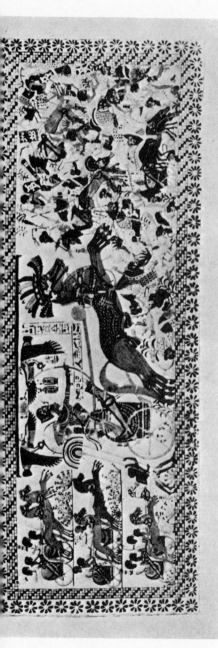
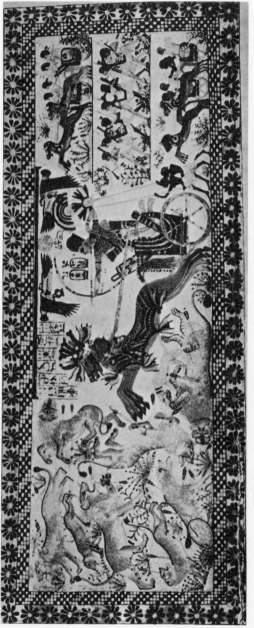

XLIVA. TUTANKHAMUN FIGHTING SYRIANS (*page* 119)
XLIVB. TUTANKHAMUN HUNTING LIONS (*page* 119)

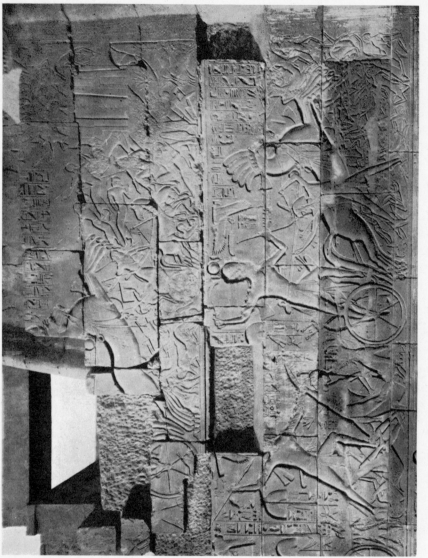

XLV. SETI I DEFEATS QADESH AND AMOD (above) AND LIBYANS (below)
(pages 122, 127)

pictured there as well; in fact, a strong argument against this assumption is that we find no reflection of such scenes in private tombs. Moreover, in the reign of Tutankhamun, when the artist of the restoration took up old themes again, no proper battle, but only the royal chariot motif with its foil of enemies (or in the hunting scenes, of beasts) was chosen. Only in the reliefs of his successor Haremhab rather timid traces of real battle appear—as far as we know—for the first time. Early New Kingdom art was, as we saw, in the main conservative, the royal reliefs probably more so; we therefore need not postulate more adventurousness than the available material, however scanty, reveals.

If we compare the royal scenes at Amarna with the mock actuality of the chariot scene of Thothmes IV, the originality of the former stands out even more clearly, but it is only seen against the restraint of the one, the excesses of the other, that the work of Nineteenth Dynasty artists can be fully appreciated.

Artists of the restoration faced a twofold task; Akhenaten had not only spurned the gods of old, but, by stressing the more trivial aspects of his humanity, he had insulted the very concept of kingship. Both evils had to be undone. Tutankhamun, who returned to the fold of the priesthood of Amon, appears mainly preoccupied with the first problem: the religious scenes from his reign commemorate in the traditional way the so-called festival of Opet when the god Amon visited his harem at Luxor.[1] The far more subtle problem of how to represent the king in a manner which did not ignore his actuality and yet preserved his dignity was, as far as we know, never tackled on a large scale. We do possess, however, four miniatures,[2] two hunting and two so-called battle scenes on a casket found in his tomb which are significant. The central motif in every one is that of the king shooting from his chariot, and in each case the diagonal movement of the prancing horses has been arrested by a more or less solid pattern of bodies. Least satisfactory is the scene with the gazelles which repeat the horses' movement and carry the eye away from the main theme, upsetting the balance. In the so-called battle scenes (Pl. XLIVa) the same device is used as in the chariot of Thothmes IV but with far greater subtlety and skill. The lion hunt (Pl. XLIVb) is, artistically speaking, by far the finest achievement, because through a contrapuntal grouping of the victims, the design remains both tense and harmonious, and in a curious way static.

We must stress that there is here no question of 'naturalistic' treatment and terms like cavalier perspective here, as in the case of the

[1] Walter Wolf, *Das schöne Fest von Opet*, Leipzig, 1931.
[2] Howard Carter and A.C. Mace, *The Tomb of Tut-Ankh-Amen I*, Pls. L–LIII.

chariot of Thothmes IV, are simply misleading. The absence of ground-lines does not necessarily mean that the victims are conceived in inarticulate space; the whole arrangement appears dictated by decorative necessity in so far as the symbol of a victorious king demanded a balanced group. The small plants which appear indiscriminately as a mere filling among beasts and slain humans alike show that there was no serious intention of indicating actual terrain. In fact, for all their liveliness, these elaborate 'vignettes' have a curious air of unreality, while the figure of the young king has a self-containedness, an unquestionable perfection which already shows a reaction against Amarna.

It is in the reign of Haremhab that the first trace of such an influence occurs. This former general, who, as we saw, served under Akhenaten and whose non-royal past must have made him in his own eyes and in those of his subjects a makeshift Pharaoh, has been extraordinarily unassuming in his pictorial ambitions. In the royal cortège at Silsileh[1] we see him a small figure far from dominating the scene. The very fragmentary battle scene there shows him not only shooting his enemies but shooting them in an actual setting.[2] This suddenly changes the by now fairly elaborate pictogram into an actual scene, for the king is obviously taking part in a definite event in space and time. The link with Amarna is unmistakable—we saw that Haremhab also for his tomb used Amarna artists (Pl. XLIa)—although the innovation is on a modest scale, but the import of it can only be gauged in the reign of Seti I, for then the shift from symbol to actuality led to a most remarkable development. In the royal reliefs of Seti I at Karnak we find the first truly monumental art in Egypt.

It is paradoxical that this great reactionary king should have condoned a type of scene almost as revolutionary as those of the 'heretic of Akhetaten'. This is too easily forgotten because both his successors Ramses II and Ramses III, who covered acres of wall at Karnak, Thebes, and Abu Simbel with scenes of carnage, never quite fulfilled and generally speaking annulled the promise of a new development, perhaps because it was ultimately contrary to a basic cultural tradition.

Unfortunately, only ritual reliefs remain of Seti's funerary temple; it would be most interesting to know what type of scene prevailed there, for the traditional and the revolutionary reliefs of Seti's reign occur in a completely different setting, namely, in the cenotaph temple at Abydos[3] and the Amon temple in Karnak, respectively. It would

[1] Wreszinski, *Atlas*, II, 161–62.
[2] Champollion, *Monuments de l'Egypte et de la Nubie*, I, 261.
[3] H. Frankfort, *The Cenotaph of Seti I* (London, 1933); A. M. Calverly, *The Temple of King Sethos I at Abydos* (I, London, 1933; II, 1935; III, 1938).

appear in keeping with the type of piety which Seti reveals, if the self-assertive scenes had been reserved for the Amon temple where they were countenanced as it were by the god to whom the results of the various exploits were dedicated, but this must remain a mere surmise.

It is certain that nothing could be further removed from pictorial adventurousness or personal pride than the reliefs at Abydos which occur in a building consisting of a temple mostly dedicated to the cult of Osiris and a vast underground cenotaph where the royal sarcophagus was placed on an island surrounded by subsoil water, as if it were the primeval hill of theological speculation. In architectural conception no more complete reversal to the chthonic aspect of regal power seems possible, and the style of the reliefs in the temple matches this archaizeing trend. An air of frigid solemnity pervades the scenes and not even the delicacy of the work can atone for its utter lifelessness. There is hardly a break in the monotony of ritual acts and theological abstractions unless it were in one unique and direct reference (but in a completely abstract way) to a dramatic mythical situation: we see Isis in the shape of a bird hovering over the prostrate ithyphallic figure of Osiris who begot his son Horus after death.

Seti's reliefs on the outside of the pillared hall at Karnak, on the other hand, are not only startling by contrast with those of Abydos, but because in a period when all traces of the Amarna revolution were finally wiped out, its greatest artistic contribution survived in a form undreamt of even at Amarna: not only gently trivial or recurring events are given 'actuality' but the tensest episodes of history: for the first time real battle scenes appear as part of a coherent narrative.

It is true that in most scenes which we shall treat as separate units the basic pattern we analyzed is clearly recognisable; time and again we find the triangle formed by the king in his chariot and his prancing horses balanced by an inverted triangular composition. But this decorative grouping has been turned in every case, as we shall see, into a concrete event while the units themselves are not mere successive stages of a complex happening, naïvely enumerated with total disregard of their spatial coherence, but are often joined in an epic way. We find, for instance, that the moment of departure has been stressed when the king, standing near his chariot on the point of leaving the scene of battle, turns round as if addressing the conquered people;[1] or when the actual stages of the royal route have been indicated: the walls, the fortifications which were passed, the place where the frontier was crossed.[2] In this way the scene of victory was spatially linked in a

[1] Wreszinski, *Atlas*, I, Pl. 47. [2] *Ibidi*., Pl. 43.

staccato manner with the scene of the homecoming, i.e. the presentation of prisoners and booty to the god Amon.[1]

If we now analyze the actual changes in the representation of the king and his acts we shall find roughly two types of scenes: in the first, the more or less heraldic figure of the king and the equally heraldic horses with their 'pivoted' flying gallop face the turmoil of a battle which has been made concrete by a maximum of topographical detail. In the other, the king himself is either violently active or stands inactive but is in some way dramatically related to the event.

To begin with the latter type, we do find several instances of the king fighting in his chariot where every effort has been made to make his gestures fit the contingencies of battle without as a rule giving up entirely the dignity of the original pose. One hand is almost invariably raised in the time-honoured gesture, the other may merely hold the bow or grasp an enemy by the beard, but in more than one instance the forward bend of the body, the straddled pose with foot across the front of the chariot and resting on the pole, is lifelike (Pl. XLV). In many cases where Pharaoh is shown in hand-to-hand fight, slaying an enemy on foot—tying up his own prisoners and clasping an armful of them while running toward his chariot[2]—every trace of heraldic pose has been discarded. In chariot-battles the posture of the horses remains unchanged, but whenever the chariot is standing still, either because the king is just alighting with one foot on the board, or standing outside it holding the reins, or even inside but looking round to survey the scene of battle, the horses are given a contracted, restless posture as if they might break into a trot.[3]

Some of these scenes show the disadvantages of Amarna art with a vengeance; the mock realism of the one in which the king grasps armfuls of prisoners, for instance, fails to be impressive and manages to be downright ludicrous. In others, the intended actuality comes to grief because the figure of the king so dominates the scene that the notion of a real fight is destroyed. Only occasionally something that may be called true monumental art has been achieved. In Pl. XLV, bottom right, the wounded victim stands upright in a posture, tragic and dignified, which repeats with subtle inversion the triumphant gesture of the king. For once the victor does not touch the victim, and though the unequal battle is a foregone conclusion, the tension has been expressed of a single moment in which a human being faces a superhuman being and his fate. It is striking that in such scenes the

[1] Wreszinski, *Atlas*, Pls. 37, 44, 48, 52.

[2] *Ibid.*, Pl. 36a; in Pl. 50 the king is shown actually fighting on foot.

[3] *Ibid.*, Pls. 34, 36a, 40, 41, 47, 51. The king looking round as if addressing the conquered: Pl. 40.

XLVI. SETI I DEFEATS THE CANAANITES (*page* 123)

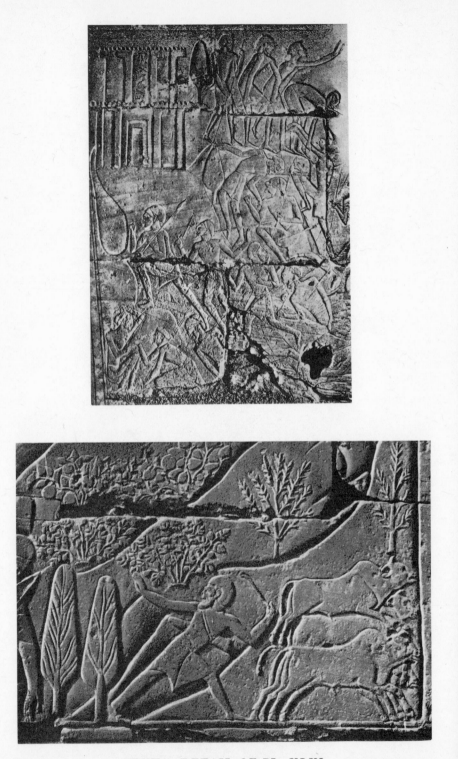

XLVIIA. DETAIL OF PL. XLVI

XLVIIB. HERDSMAN FLEEING FROM THE EGYPTIANS; DETAIL
OF PL. XLV (top)

(*page* 127)

figure of the king has been physically approximated to that of his enemy; though slightly larger and more powerful, he hardly seems to belong to a different order of beings, and, what is more important, seems to move in the same actual space.

In the topographical battles, on the other hand, the contrast between victor and victims, the ideal distance which separates them is usually so great, their actual spatial relationship left so vague that one might hesitate to speak of a dramatic scene at all were it not that a tension between the two has been expressed in a variety of ways. We find here that Seti's artists frequently resorted to a type of siege which could most naturally furnish the poised design of inverted triangles which we found in earlier work. In each case the apex of the triangle which was to counterbalance the impetus of the royal group was a fortified town crowning a hill top. Only in the case of the fight against the Bedawi has the town been omitted, obviously because they were nomads of the plain, but even here the hill has been maintained, probably for the same decorative reasons.[1]

It is highly interesting to compare the following four scenes in detail and to see how the artist grappled with the problem of actuality in a battle that was at the same time to proclaim the king's invincibility in a symbolical form.

In the Canaanite battle scene (Pl. XLVI) the bodies nearest the chariot merely form an untidy mosaic in the accepted New Kingdom manner, but the fight becomes tense and vigorous where the upright victim looking back marks the transition to the vertically orientated realistic scene on the left. The climbing figure with his elastic stride (Pl. XLVIIa) on the extreme left, offset against a plain background, epitomizes both the structure and the movement of the battle, while the dramatic actuality of his escape (intensified by touches of real scenery) is counterbalanced by the despair of the wounded and the abject behaviour of the surrendering citizens, especially those who crown the scene. With incredible subtlety does the limp posture of the vertical climber who is being helped by his friend stress the hopelessness of the attempt, for in his case surrender is a foregone conclusion. In this scene more than a decorative balance has been achieved; there is an inner tension, a true artistic correlation between the symbolical figure of the king and the actuality of battle which justifies the term monumental art, even though in the centre part the dramatic confrontation has been, in a sense, evaded by the *trait d'union* of scattered bodies which obscures the actual spatial relation between king and enemy. It is from this point of view especially that the capture of the

[1] *Ibid.*, Pl. 42.

FIG. 25. *Seti I conquers Yenoam*

town of Yenoam (Fig. 25) is interesting. This scene is a mixture of the two types which we distinguished above in so far as the king is actively engaged in battle and yet the device of the castle and hill has been used. But here a lively and detailed battle interferes between the royal figure and the roughly triangular hill which in the previous example gave the entire scene its more or less static unity. Artistically speaking, the Yenoam battle may be called a failure, though it must be admitted that the problem of how to achieve a static equipoise in the rendering of a dynamic event was solved in a highly original manner. We may add that this particular solution was apparently never repeated, whereas the previous one was copied again and again. The battle depicted is a chariot encounter, for it is obvious that when the king is pictured as actively involved, the fight is more tense and the royal victory more impressive when the king's team towering over shattered chariots and fleeing horses of the enemy dominates the scene.[1] In this particular case the actual battle has been impressively rendered, but it forms a rather confused dynamic centre part which spatially separates the king and the besieged town and prevents a dramatic relation between the two. The artistic function of the hill scene, which was to form a climax as well as a check to the impetus of the king's movement, was thereby lost and it could now only act as a full stop. The need for one can easily be recognised, for apart from the extremely lively action of the king, the movement of the entire group of fighting men has been intensified by the rendering of the horses. Nowhere has what we called the transfer pattern of the royal team been repeated mechanically; the posture of the wounded and collapsing horse has been equalled only in Pl. XLV, upper register; the flying gallop of the top left horse (the rider has for once a good forward seat) appears a tragic leap into space, as counterpart to the surge of the royal team, while the runaway horses with their crouched rider are realistically galloping on the level as if to differentiate their movement from the semi-static diagonal prance. Their impetus then comes to a sudden halt in the weird and ugly corner scene where underneath the town with its schematic and unconvincing indication of terrain, figures are seen hiding or crouching amongst trees. As if to stress a fatal check to the rider's course two full-face masks (of the type nearly always associated with dead enemies) peer from behind the trees and give this part of the scene a horrible kind of immobility.

The chariot battle in Fig. 26 may well be treated here although no siege is depicted. The artist has filled a rough triangle with the well-

[1] In our Figure 25 the body and one outstretched arm of the king appear in the right-hand upper corner. The body of his chariot and the hind legs and heads of his horses are lost.

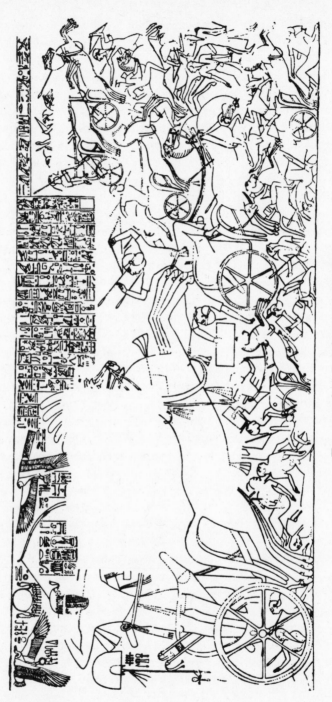

FIG. 26. *Seti I defeats the Hittites*

known pattern of horse teams all headed in the same direction. He has done this rather mechanically (we see, for instance, below, towards the right, a single horseman whose mount has been given the traditional eight legs of the 'pattern'), but the cumulative effect is quite dynamic. In this case their movement has been checked first of all by the group of the main victim, and not only by his gesture but by the static double volute of the wounded team, one horse rearing and one collapsing. This infinitely strengthens the second device of counteracting the impetus: nearly every enemy in the scene is looking backward as if mesmerized by the epiphany of the royal chariot. Here again the strange equipoise of a monumental situation has been achieved.

But perhaps the most interesting of all is the attempt in Pl. XLV, top, where the mosaic of falling figures underneath the horses is less abstractly contrived than in Pl. XLVI, so that the whole scene has more unity; all figures seem to move in the same space. The figures are larger, absurdly large in fact for the building, but the relation between it and the king has been given a dramatic emphasis by the new device of a figure half emerging from a porch and stretching out his hands in an antithetical movement. The hill on which the castle stands has been indicated by several contours which underline the diagonal composition, and has been left bare except for trees and shrubs. This throws into relief what is perhaps the most vital part of the whole scene, the small figure in the right-hand corner (Pl. XLVIIb). Again the triangular composition of the frantically striding cowherd, trying to save his cattle, repeats the general movement, but the backward glance and the inimitable gesture of a terrified man trying to ward off disaster make him, dynamic and transfixed at the same time, the epitome of the whole scene.

What makes these fragmentary scenes, which we have treated as separate units, unique in the history of Egyptian art is that here the the conflict between symbol and actuality, momentariness and timelessness has been artistically solved. The Amarna revolution, with its trend toward actuality, stopped short of the very requisites of monumental art. The action depicted, the representative moment chosen, never had the significance of a unique and symbolically pregnant situation. It is a moving thought that the same monarch who restored the transcendent dignity and the actual power of kingship after it had passed through the worst moral and political crisis in its history, was the one in whose reign the paradox of monumentality was grasped for the first and last time. Under the reign of his grandson, the long-lived and vainglorious Ramses II, the very acreage of the battle reliefs testifies to a loss of quality: the inner tension dissolves in discursive

description; and we find the rambling inventiveness of artists pre-occupied with content alone; symbol and actuality are no longer co-related.

It would be tempting to view the Ramessid reliefs mainly as a parody on a preposterous scale of the intentions and achievements of Seti's artists. There is, as we shall see, enough material to justify such a contention, yet it would be unjust, for it would ignore the fact that the aims of Ramessid artists differed in one respect from all previous ones in Egypt. Their true originality lay in a new ambition to give a faithful pictorial record of historical event. Artistically speaking, this proved disastrous, for it resulted in a type of loquacious journal which lacked both unity of vision and a recognition of essentials. Only in one single case has mere description been transcended in a manner which almost puts it on a level with true monumental art. But it is remark-able that at the very end of a long development of singularly 'timeless' art we should find this emphasis on the temporal aspects of Pharaoh's personal achievement, and it is ironical that this monarch's main claim to celebrity lies in the length of his reign and in a remarkable aptitude for usurping credit due to his predecessors. The type of blatant self-assertion which he insisted on lacked the very quality of metaphysical conviction which lay at the root of previous restraint. It stimulated artists and gave them a new scope but it did not really inspire them, and their prolific output is merely a symptom of imminent decay.

We shall, then, deal first with those scenes which are most clearly copied from or inspired by the Seti reliefs, mainly scenes of assault on a hill crowned by a fortified town or castle. This was evidently con-sidered a temptingly decorative motif for it was endlessly repeated, though its artistic possibilities were pitifully mishandled. In the Seti reliefs the dramatic tension between the symbolical and the realistic part of such scenes depended, generally speaking, not only on the respect with which both were treated but on the fact that neither the actual nor the ideal distance between the groups was lost sight of. The problem of their actual spatial relation, though often left vague, was never ignored but solved in a subtle balance of movement and counter-movement, while the ideal distance was stressed not only by the crude method of enlarging the figure of the king but by the fact that he faced the enemy in complete isolation. On all these points the artists of the Ramessid reliefs failed completely. The lively topographical details of Seti's hill scenes are missing, so that much actuality is lost; on the other hand, the king hardly ever fights alone but is surrounded by his own men and this reduced the royal stature. As far as the spatial rela-tion between the groups is concerned, we either find complete indiffer-

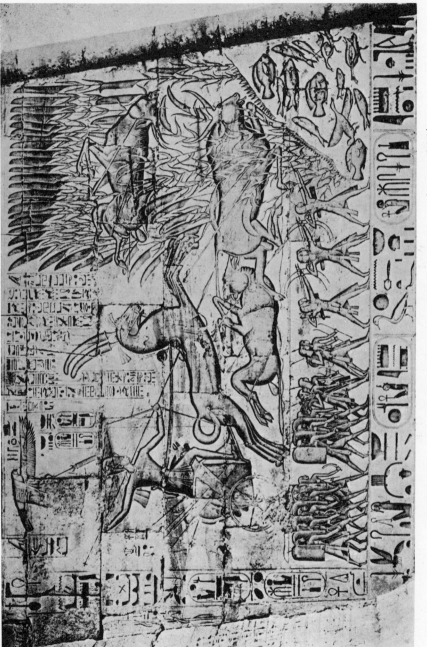

XLVIII. RAMESES III HUNTING WILD CATTLE (*page* 139)

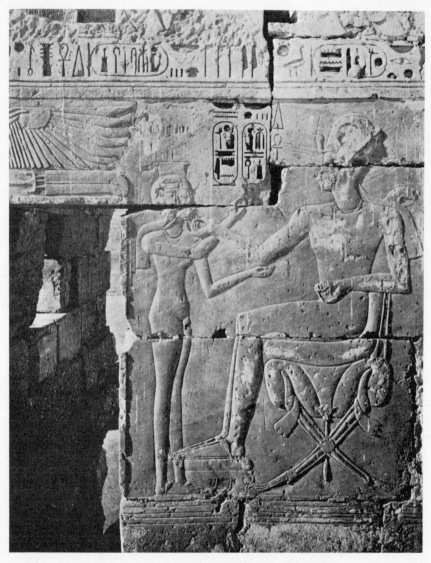

XLIX. RAMESES III ENTERTAINED
(*page* 141)

ence to actuality, e.g. when not even the mêlée of battle separates the chariot and the city and the horses' feet practically touch the town wall, or even worse, a completely spurious kind of realism, when the king himself lifts one enemy out of the besieged town (Fig. 27). The

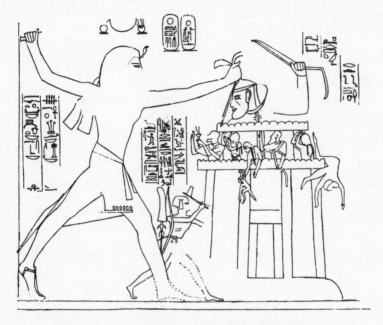

FIG. 27. *Ramses II attacking the City of Mutir*

subtleties of movement and countermovement are almost invariably discarded in flabby design; in fact, the significance of countermovement as a check to violent speed and as a means to intensify the dramatic power of a scene has been missed altogether even where motifs were very closely copied. It is interesting to compare the Ramessid cowherd who simply moves out of the picture (Fig. 28) with the earlier one (Pl. XLVIIb), or the siege in Figure 29, where the diagonal arrangement of the figures merely repeats the diagonal of the royal teams in a similar upward movement, with Pls. XLVI, XLVII. Nor does it help matters if Ramessid artists add lively details to intrinsically boring scenes of carnage; it merely leads to overcrowding. In Seti's reliefs simultaneity of various acts and happenings appears implied throughout, but their extreme here-and-now character never conflicts with the fact that they were at the same time to symbolize inexorable defeat in the face of an ever-victorious Pharaoh. In the ones of the Ramesseum, cluttered as they are with accidentalities, various stages of siege and surrender appear within the scope of one single scene; discursive histori-

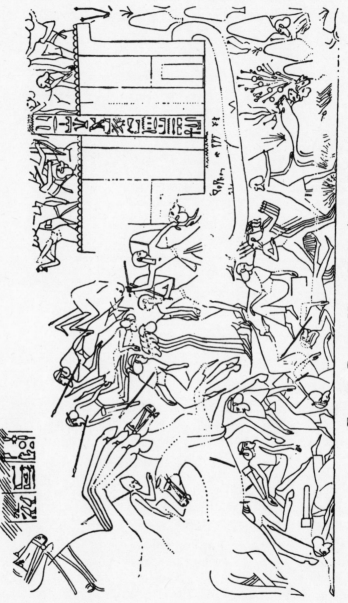

FIG. 28. *Ramses II attacking a Syrian City*

cal narrative encroaches and disintegrates its unity.[1] It was, however, this very preoccupation with event in time which led to a new development, a last original effort in Egyptian art, namely, the vast description of the battle of Qadesh at Luxor,[2] Thebes, and Abu Simbel.[3] The

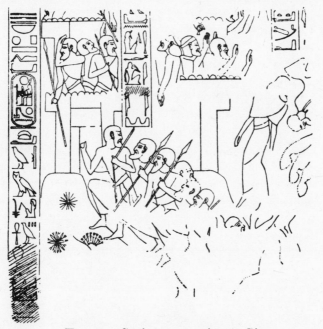

FIG. 29. *Syrians retreating to City*

subject of these scenes was the one great military event in the reign of Ramses II when the young king through his own bold initiative turned an almost inevitable and ignominious defeat into what he would like us to believe was ultimate victory. The written annals which these reliefs were to illustrate differ completely from the bald record of facts which Thothmes III gave in the Luxor temple or the abstract formal grandiloquence of the poem in his praise which was recorded on a stele there. They also differ from the impersonal reticence of Seti's short captions which accompany the scenes we described. The texts of Ramses II insist with rather touching humanity on dangers run, decisions taken, and brave acts performed by the king. They contain such remarkable statements as: 'This manner in which I am standing here fighting against the Hittite town such as the picture of Pharaoh shows, has truly been the manner of acting of His Majesty', or 'His Majesty has grasped his armour to put it on after he had fought at the head of his mounted troops and his foot troops for two hours without wearing an armour.'[4]

[1] The Ramesseum reliefs are published by Wreszinski, *Atlas*, II, Pls. 90–109.
[2] *Ibid.*, Pls. 63–89. [3] *Ibid.*, Pls. 169–79. [4] *Ibid.*, text of Pl. 78.

The young Ramses II, in order to throw into relief his purely personal valour, emphasizes implicitly his vulnerability, and the reliefs, which were to commemorate the vicissitudes of battle and the king's individual acts, paradoxically destroyed the myth of divine kingship in a manner far more insidious than the all too human behaviour of Akhenaten in some Amarna scenes. For the timeless aspect of royal victory was sacrificed in favour of a pictorial epic.

Now epic rendering in representational art, unless it can sum up complex event in one actual and pregnant moment, is of necessity reduced to a sequence of pictorial statements. We saw already that in the Seti reliefs, the sequence and the spatial coherence of the different scenes had become a matter of concern, but that as yet no more was achieved than a summing-up of consecutive events and places in the time-honoured manner of arranging them in registers. The effort at Amarna to break away from the ban of such registers by treating big tracts of wall as a vague spatial unit in which different stages of an event—such as a royal visit or a royal reward—could find their natural allocation, was not followed up in Seti's time perhaps because the logical sequence of events was less clearly indicated in this way. Ramessid artists, driven by the necessity of depicting the configuration of extremely complex battle tactics, were apparently less concerned with chronological than with topographical clarity. Since this could only be achieved in a vertical as well as a horizontal arrangement of figures, they used the Amarna device with extraordinary boldness. It must have been helpful that in the motif of the victorious king in his chariot groundlines had already been discarded, first for decorative reasons and later in dramatic scenes, and also that the New Kingdom interest in topography made the projection of groundplots and the use of curved groundlines less of a novelty. In the Seti reliefs rocks and hills gave a plausible foothold, but the curve of winding rivers and the awkward spatial relationship between these and human figures had been avoided rather anxiously. Ramessid artists, once embarked on their course, boldly plunged into the difficulties of rendering aquatic scenes. They had to, because both in the topography of the battle and in the actual fighting the river Orontes played an important part.

I cannot give here a detailed analysis of the strategy of the Qadesh battle[1] but will mention the main points stated in the annals and illustrated in the reliefs, not only because the latter cannot be under-

[1] See J. H. Breasted, *A History of Egypt*[2] (1924), 427–35; John A. Wilson, 'The Texts of the Battle of Kadesh,' in *American Journal of Semitic Languages and Literatues*, XLIII (1927), 266–83; Charles Kuentz, *La Bataille de Qadech*, Cairo, 1928. For the site: Maurice Pézard, *Qadesh; Mission archéologique à Tell Nebi Mend*, Paris, 1931.

stood without them but also to show the staggering novelty of the artists' undertaking. The events which led up to the fight are: the ruse of the enemy which lured the king and part of his armed forces into a dangerous position; the catching and interrogation by the king (after rough handling) of Hittite spies who gave away the enemy's position; and the sending of a messenger by the king to summon more troops. Then follows the Hittite attack on the royal camp, Ramses' failure to break through the enemies' ranks, and his decision to make room for himself by fighting his way towards the river and driving the enemy into the water. The failure of the Hittite chariotry to drive home the attack because the soldiers start plundering the camp gives Ramses time to establish his position with the aid of unexpected reinforcements and to await the arrival of another division which enables him to drive off the enemy. We may add that this, though a fine enough achievement, barely deserves the epithet of victory, since the aim of the expedition, the taking of Qadesh, was not achieved.

Now, it is obvious that the task of illustrating the annals, even if it were imposed on Ramessid artists by royal command, involved more problems than could be faced, let alone solved, at once and in their entirety. The bold effort made in the Abu Simbel reliefs, of combining all important anecdotal details in one huge picture, is in fact the climax of a series of attempts and partial solutions. And it is interesting to reconstruct the steps which led up to it, for we shall find that the artist's growing love for topographical description and the very notion of historical illustration mutually required and strengthened each other. Unfortunately, the dating of the various reliefs is still a matter of some uncertainty, but the available evidence nowhere contradicts and in one point strengthens our argument based on stylistic criteria.

What was probably the earliest picture of the Qadesh battle occurs in the funerary temple, the so-called Ramesseum; it was obliterated by a later version (Fig. 31), but traces of it have come to light which justify the assumption that it consisted of a traditional juxtaposition of royal chariot and Hittite town. It is unfortunately not clear if the pattern of a fortified town on a hill top was used and whether or not a battle scene intervened between the two. But it is significant that the design was considered unsatisfactory. If we are right in assuming that the scene on the pylon of the Luxor temple (Fig. 30) was the second version, the change would be indeed considerable, but artistically the scene was still fairly close to the Seti reliefs. The extreme formality of the design offset against a brocade-like background of battling figures

[1] This evidence, as yet unpublished, has been kindly put at my disposal by Dr. John A. Wilson.

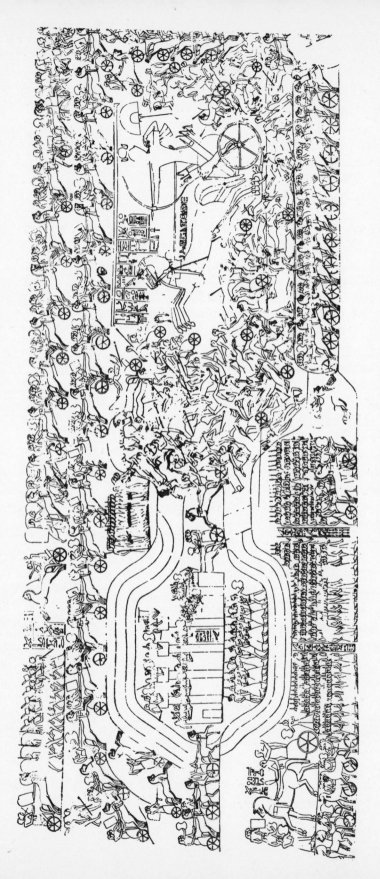

Fig. 30. *The Battle of Qadesh*

and relieved by only a few touches of realism (such as the horse enter-
ing the gate or the Hittite messenger approaching his king, bottom
left) may have been partly dictated by the gigantic scale of the work,
but it enhances its symbolical character. The confusion of the subsidiary
figures throws Pharaoh's solitary splendour into relief, the simplified
outline of the city walls make it appear a trap in which the fleeing enemy
must inexorable be caught, and the two groups thus subtly correlated
form a fine balance of movement and fatal immobility, only surpassed
by some of the Seti reliefs.

It is true that the actual defeat of the town is not depicted, but its
implicit fate must have appeared to those who knew events a monu-
mental hoax. Was it because Ramses' pride recoiled from it that he
himself indicated a new design for his mortuary temple which might
do justice to his actual achievement? If so, he must merely have pro-
vided another stimulus to artists who on a minor scale and in more
subsidiary scenes were probably already actively engaged on historical
scenes of a purely descriptive character, such as the war council, the
interrogation of the spies, and the Hittite attack on the Egyptian camp.
None of these go much beyond Amarna in the matter of spatial repre-
sentation; both plan and elevation are used to show the details of the
camp, and, though registers are on the whole avoided, the allocation of
the various other scenes has been left completely vague. The battle of
Qadesh on the Ramesseum pylon (Fig.31), on the other hand, goes well
beyond it. Here a clear geographical description is given so that the
spatial coherence of different groups can no longer be a matter of doubt.
To talk of cavalier perspective here is again misleading (see p. 119);
the matter of perspective does not enter at all, for the viewpoint of the
spectator—we saw that only once at Amarna this apparently played a
part—was not a matter of concern. All that was aimed at was to
illustrate the disposition of two armies on what is virtually a map of
the enemy's country, the main feature of which are the Orontes River
and the town of Qadesh. It is interesting to note that the diagonal
curve of the Orontes plays, decoratively speaking, almost the part of
the hill in Seti's reliefs, but the older balanced design is practically lost.
The scene is discursive, untidy; the transfer pattern of the royal
chariot, awkwardly placed, fails to be impressive; the solid phalanx of
the unbeaten Hittite king across the river remains a dead mass; the
two seem unrelated. Not even a wealth of new realistic details, especi-
ally in connection with drowning figures, can atone for a complete lack
of dramatic tension. Artistically speaking, the scene is a failure.

We do not know the date of the Abydos temple and the remains
are too fragmentary to judge if it ever contained an equally ambitious

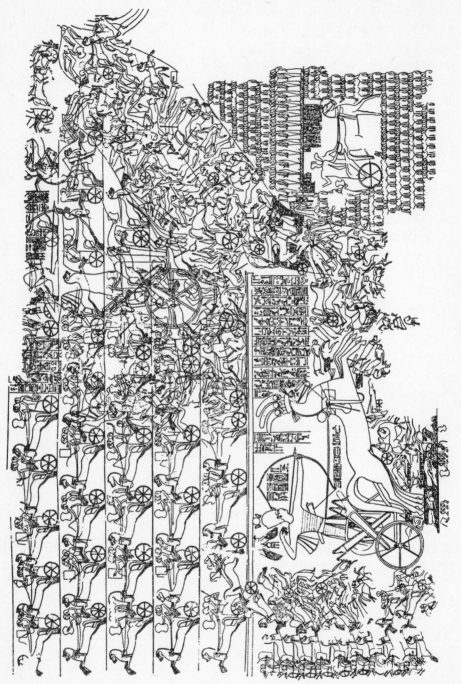

FIG. 31. The Battle of Qadesh

effort to cope with historical actuality.[1] The rather absurd preoccupation with aquatic fights and drowning figures—we even see Ramses standing ankle-deep in water—would suggest that they are copied or at least inspired by the Qadesh battle in the Ramesseum; the high-handed manner in which groundlines are discarded might point to the same influence. It is, however, certain that the Qadesh scene at Abu Simbel is the last known effort of this type—the reign of Ramses II was, as we saw, rather poor in heroic incident—it forms at the same time the peak of an artistic development to which a reaction set in already under the reign of Ramses III.

The Abu Simbel reliefs (Fig. 32) are epic in the sense that they aim at a coherent narrative in which not any one single event or single figure predominates and where, in a more or less articulate setting, events are unfolded in time as well as fixed in space. This may appear an overstatement seeing the clumsiness of the transition of the scenes, the lack of clarity achieved, but these failures should be measured by the stupendous boldness of the attempt.

It was evidently considered impossible to combine the interrogation, the camp scene, and the main battle in one spatial unit. The wall space has therefore been divided into two strips by bands of Hittite and Egyptian charioteers meeting head-on in the centre and symbolizing, quite involuntarily, no doubt, the undecided character of an equal battle. Below on the right is the interrogation scene and on the left centre the attack on the Egyptian camp, but it should be noted that the enemies attacking on the extreme right and those near the camp at the back of Pharaoh clearly show that he has been indeed surrounded. This brings the two scenes into a kind of spatial relation and the same happens with the reinforcing troops on the left who are realistically turned towards the camp while the fight is in progress. At least the intention of some spatial and temporal coherence cannot be denied here. The top scene is, however, far more remarkable. Here the more or less static diagonal composition has been completely discarded. The king's dramatic encirclement by enemy forces has been expressed by the serpentine band of enemy chariots which only leaves the smallest loophole for his escape. The Egyptian messenger sent to bring up auxiliary forces is outside this band (at the top, in the centre) and the very unobtrusive countermovement of the Egyptian troops has been stressed by turning the enemy chariots nearest to them in opposite direction, without however breaking the encircling ring, except at the bottom of the scene on the right. The horizontal 'accolade' of the Orontes River does no more than spatially isolate the never-captured

[1] Wreszinski, *Atlas*, II, Pls. 16–25.

enemy town and the king's escape on the extreme right is by no means the dramatic climax of events, although the paraphernalia of victory, the prisoners and the enemies' hands, are duly displayed. It is the rather small stooping figure of a worn-out royal soldier that faces them, looking back on a scene of near defeat.

No more truthful historical record of the supreme moment in Ramses' life could be given and not even Amarna art could represent the king more humanly, more devoid of transcendent dignity or power. Even the paradox of Seti's monumental reliefs is lacking here and the battle scenes at Abu Simbel remain the most dynamic, that is, the most time-bound, of all known royal temple reliefs in Egypt.

There is an almost tragic irony in the fact that one single youthful exploit, the lifelong obsession of what was probably a rather insignificant ruler, should have been the main source of inspiration of his artists, while in the reign of his grandson Ramses III, when the country experienced the bitter reality of a threat of enemy invasion, the very notion of historical illustration was discarded. The battle against the 'peoples of the North', camped near the border, against the 'peoples of the sea' attacking Egyptian harbours, against the Libyans pressing in from the West, were amongst the most desperate battles Egypt ever fought. Ramses III, we know, was a soldier of calibre, yet the accounts of his exploits are reticent, formal, couched in the abstract terms of traditional hymns of praise and the scenes which illustrate them lack actuality; they have only one theme: the symbolical figure of the victorious king towering over defeated enemies. It is as if the chaotic events of his day, the terrifying upheaval of a *Völkerwanderung* on an unheard-of scale and a deliberate concerted attack on the rich peaceful Nile Valley could only be imaginatively rendered by confronting it with the figure of invincible majesty. In this abstract confrontation all sense of actuality, all interest in dramatic reality, was lost.

Various scenes are given in a roughly historical sequence on the walls of the funerary temple at Medinet Habu,[1] where the pylons only show the traditional motif of the king holding a bunch of prisoners. The stages of the three main battles are practically the same: the king's injunction to his troops before departure, his journey to the battle front, the main scene of carnage, and the dedication of prisoners and

[1] This great temple has been recorded by the epigraphic expedition of the Oriental Institute of the University of Chicago. The epigraphic work was under the direction of Dr. Harold H. Nelson, the architectural survey and the excavation under Professor Uvo Hoelscher. See for the first series Oriental Institute Publications, VIII (1930); IX (1932); XXIII (1934); LI (1940), and for the latter series Oriental Institute Publications, XXI (1934); XLI (1939); LIV (1940). See also W. F. Edgerton and John A. Wilson, *Historical Records of Ramses III* (Chicago, 1936). See also Wreszinski, *Atlas*, II, Pls. 110–160b.

booty to Amon Re. The battle sequence has been interrupted by hunting scenes; apart from the traditional gazelle chase we find a lion hunt and one in which wild bulls are pursued and driven into marshes (Pl. XLVIII). These are rather remarkable, the first because a more or less static group has been achieved by making the king turn round and spear a lion attacking the chariot from behind.[1] This is the only instance known in Egypt where the king's invincibility has not been taken for granted and the danger to which he was exposed makes his act appear one of human courage. In the second, the impetus of the pursuit has been checked by what we might call a remnant of diagonal composition; in the right-hand corner beyond the collapsing bull a triangular strip of water closes the scene. The two superimposed victims half-covered by finely drawn reed bushes form, intentionally or not, a near approach to cavalier perspective. For us the main interest lies in the battle scenes—the other historical scenes being completely conventional—and especially in the remarkable absence of any preoccupation with the rendering of space. The enemies form a solid pattern—one could not call it mass—of twisted limbs and bodies interspersed with a few and barely discernible upright Egyptian soldiers. This is not the confusion of battle, this is pure chaos.[2] The very possibility of tension between royal victor and vanquished has been lost in the bald juxtaposition of absolute victory, absolute defeat. In the sea battle (Fig. 33) where the disposition of the enemy's ships is as mechanical as that of their bodies, the placing of the Egyptian vessels at least indicate the fatal encirclement of the enemy craft; it is, so to speak, the only concession made to dramatic actuality. The only redeeming feature of these scenes is that the attitude and bearing of some of the prisoners has been imaginatively rendered. The proud defiance of the Philistines seems almost a tribute paid to an enemy more formidable than the battle scenes suggest.

In the reliefs of Medinet Habu New Kingdom art appears to have swung a full circle; it ends where it began with a paean to the divine ruler. Even the tensest of battles are immobilised, reduced to a symbolical statement that the king's victory was absolute. If this statement was, artistically speaking, not a climax, it has a special poignancy because it was made on the eve of what proved to be in Egyptian representational art a long period of senile decay. In view of this one

[1] This scene has been studied by J. H. Breasted in *Studies Presented to F. Ll. Griffith*, 267–71.

[2] The Egyptian soldiers form groups placed in horizontal registers, while the bodies of the enemies fill the space all around them and so achieve the effect of chaos. This method of composition has been elucidated by Dr. H. H. Nelson, Oriental Institute Communications, No. 10 (Chicago, 1931), especially Figures 13 and 14.

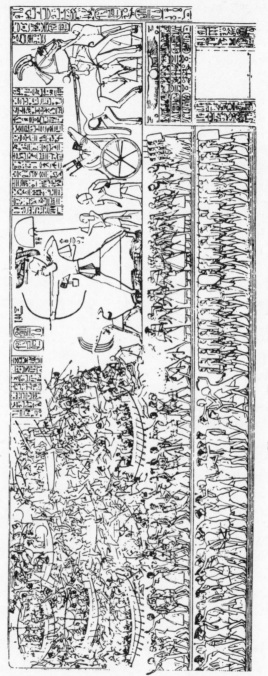

Fig. 33. *Ramses III defeating the Sea-Peoples*

might even sense a trace of corruption in the only efforts made to stress the human side of Ramses III: on the High Gate that formed the entrance to the temenos wall of the temple we find the dull erotic scenes (Pl. XLIX) of Pharaoh seeking entertainment.[1]

The following ten centuries were absolutely barren of new ventures in either painting or relief, in tomb or temple. Time-honoured pictorial formulas were endlessly repeated and the reverence for the unchanging which they imply proved a poor substitute for an ideal which had inspired the Egyptian artist through the ages: a form of representational art in which the flux of the phenomenal world had been transcended. Mere reverence for the static meant a parody of this; it ended in fatuity.

[1] See Uvo Hoelscher, *Das Hohe Tor von Medinet Habu* (Leipzig, 1910).

Book Two
MESOPOTAMIAN ART

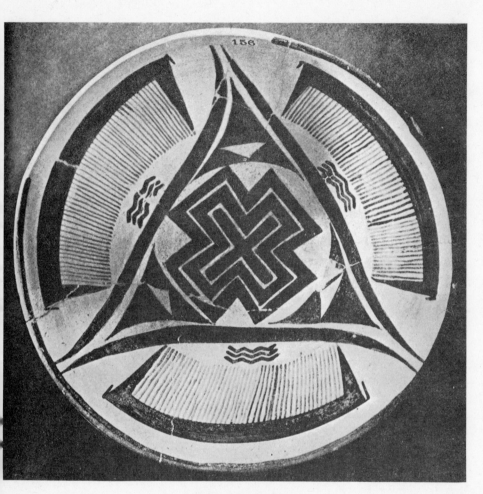

L. BOWL FROM SUSA

(*page 146*)

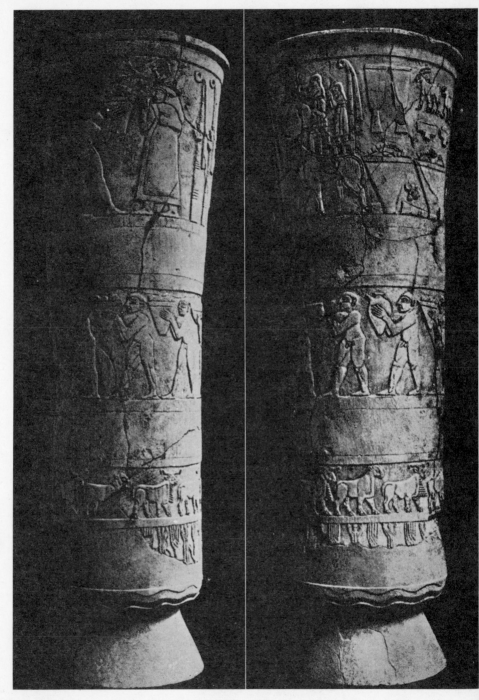

LI. ALABASTER VASE FROM WARKA
(*page* 151)

The Integration of Figure and Design in the Pre- and Proto-dynastic Period

Whoever turns from the comparatively smooth flow of Egyptian art history to Mesopotamia will be struck by a startling lack of stylistic coherence and continuity. This is partly due to the uneven quality of the work. Egyptian art, as a whole, suffers from the monotony of an almost uniformly high and a severely restricted type of performance; the tradition of good craftsmanship may give the dullest work a spurious dignity, the acceptance of a formal code may almost hide the originality of outstanding artists. In Mesopotamia the opposite holds good: the best work has a quality of singleness and daring, the worst one of unredeemed incompetence, which makes them seem worlds apart.[1] Moreover, violent changes often occur in consecutive periods which may or may not be due to an influx of different ethnic strains. In short, Mesopotamian art, as a whole, is complex and varied; whatever links the different phases lies beyond the range of form-critical catchwords; and yet, seen under the aspect of our particular problem, the continuity of its development will prove to be unmistakable.

When we started our survey of the Egyptian material with a brief reference to the figures on early pottery, we found that these were on the whole representational rather than decorative in character; the surface used was usually an opportunity for, not a dominating factor in, the shaping or spacing of figures and groups. This lack of concern for decorative values was in a sense prophetic. For although representational art in Egypt proved throughout extremely surface-conscious, though it reduced 'corporeality' and all it implies for organic form in the manner we indicated, it rarely considered the shape of the avail-

[1] H. Frankfort, *More Sculpture from the Diyala Region* (Chicago, 1943), Pls. 5, 8.

able surface significant in itself. Surface space on walls of temples or in rock tombs, merely meant a practical limit to the limitless possibilities of adding figure to figure, group to group. In the enumerative process of composing ritual and funerary scenes the actual boundaries of each separate rectangular wall were nearly always respected. Such units suited to perfection the confrontation of static groups which the scene usually demanded. But although these walls rather sternly held together figures not dynamically related, they never imposed their formal presence as it were. The decorative possibilities of the rectangle, the tension between verticals and horizontals, for instance, were generally ignored except, as we saw, in the case of the chariot motif or in the Seti reliefs where a diagonal achieved a finely balanced design within small sections of a long register.

Prehistoric art in Mesopotamia, in many ways the aesthetic antithesis of its Egyptian contemporary, proved equally prophetic. In its earliest mature form, the pottery of Susa,[1] the repertoire of animal and human figures is extremely limited, but there exists an intimate correlation between figure and design which, as we shall see, persists through many phases of later Mesopotamian art. We shall analyse the syntax of the Susa vases (Pls. I, L) without considering the vexed question whether or not the use of animal figures had a symbolical as well as a decorative significance. In the case of eagle and ibex this is at least probable but it must remain mere conjecture and does not affect the question of their decorative function. It is clear that representational figures were by no means essential to the design of even the finest examples, yet it would be a mistake to speak here, as is often done, of 'geometric' patterns; for this suggests that the distinguishable elements, the horizontal bands, the circles (interrupted and unbroken), radii, vertical strokes and triangles, were patterns which could be conceived in the abstract and mechanically applied. In the case of Susa pottery the opposite is true, for here, more clearly than in any of its derivatives, these patterns were suggested by and in turn were meant to articulate the actual vase form, the elements of its structure, the character of its plastic movement. Hence the significance of the irregularities we find, because in these swelling and shrinking, meeting and diverging lines the subtlety of the delicate shapes, their splaying and contracting, was emphasized and a rare harmony of shape and pattern achieved.

It would be impossible to separate the representational and nonrepresentational elements in Pl. I without ignoring the fact that they also were conceived in conjunction; the wide band at the top and the

[1] See J. de Morgan, *Mémoires de la Délégation en Perse*, Vol. XIII.

metope are not mere spaces left to be filled with animal figures; on the contrary the decorative possibilities of the latter equally determined the type of space they were to occupy. The long-necked birds near the rim emphasize the tallness of the beaker, the horizontally stretched-out hounds—they remind one of the joined spirals on Danubian pottery —carry the eye round the circumference; while in the slightly splaying metope, the contracted pose of the ibex, the upward swing of the nearly circular horns epitomize both the vessel's slender height and its roundness. And yet organic form has not been merely made subservient to decorative function and treated high-handedly in the process; the essential character of the animal's shape and posture has been integrated with what we might call the inorganic movement of vase form and design. This subtle balance was only rarely maintained and in the long run animal character was sacrificed to decorative function. The bowl in Pl. L, for instance, evidently suggested an emphasis on circumference and radii, but the barely recognisable elongated fringed body of a goat or sheep was a mere pretence at organic form.

The figures on Susa pottery are nearly all painted in solid black. We have shown (p. 2 *supra*) that such shadow figures frustrate the efforts of imagination which tends to fill in an outline. This is another reason why the allotted surface never appears a mere emptiness against which the figures are seen, so that these lack a halo of three-dimensional void. They are, as we said before, pure form.

The rare perfection of such a great number of Susa vases is all the more astonishing because they remain an isolated peak of achievement within the confines of a more or less coherent Highland culture. The village settlements of the Al Ubaid period, on the other hand, which are generally considered an offshoot of this culture in the now inhabitable plains of Mesopotamia, produced nothing more aesthetically remarkable than mediocre pottery painted with abstract patterns. This chalcolithic Ubaid culture stretches with depressing monotony from the Persian Gulf to Northern Iraq and appears to have remained stagnant for many centuries.

We lack any hint of more daring artistic efforts which might form a prelude to the monuments of the earliest literate period.[1] Mesopotamian art, perhaps also through the scarcity of archaeological data, is apt throughout to spring on us surprises in the form of astonishing artistic *faits accomplis*, but the parthenogenesis of representational art in the Protoliterate period should be the despair of every orthodox art

[1] This period comprises the remains which in the archaeological literature are assigned to the Uruk and Jemdet Nasr periods. See P. Delougaz and S. Lloyd, *Pre-Sargonid Temples in the Diyala Region* (Chicago, 1942), p. 81, n. 10.

historian, for though it emerges mature and confident, yet it is full of contradictions, it courts naturalistic as well as fantastic and even heraldic design, it renders devout ritual acts and what may be wholly secular scenes.

Its appearance coincides with what is usually called the dawn of Mesopotamian history, that is, with the building of cities, architecture on a grand scale, and the earliest written documents—in short, with a stage of cultural development comparable with protohistoric Egypt. In Mesopotamia, however, historical monuments, in the sense of challenging reminders of single persons and events, are with one single and doubtful exception conspicuously absent both in the art and in the writing of this period. The repertoire of sculptors was not dominated by the figure of a specific ruler and his acts. Nor did personal or topographical identity play any part in the earliest writing. The documents include (alongside mere 'bureaucratic' records or aids to memory), two further types: first, accounts in the sense of binding contracts, and second, rather enigmatic word lists in which a number of natural phenomena was arranged in some kind of systematic order.[1] The earlier phases of the Protoliterate period thus appear both in written word and image strangely anonymous and impersonal when compared with Egypt. In fact, the term 'protohistoric' seems hardly warranted. Yet it must be admitted that here also we find, at least in the first type of document, a preoccupation with certain aspects of time: in the contractual accounts a monumental challenge is implied. Here a practical transaction, a relation between man and man, which has significance for the future, has been made articulate and given an abiding form. We may assume that from time immemorial, in the case of oral obligations, divine sanction had been invoked; but by means of this written account man himself imposed order, and challenged the disrupting influences of change and chance and the temporality of a dual will's decision.

The word lists, which have no parallel outside Mesopotamia and have puzzled scholars a great deal, do not entail such a challenge. On the contrary, they may be considered the obverse of a desire to impose order in the orbit if human affairs.[2] These lists, consisting of a systematic grouping of objects, beasts and plants, apparently embody an attempt to recognize an implicit coherence within the baffling multiplicity of phenomena—for it is very striking that the stars whose movement epitomizes cosmic order, were never mentioned. The lists had, as far as we can judge, no magic function whatever, but they were

[1] A. Falkenstein, *Archaische Texte aus Uruk* (Berlin, 1936).
[2] W. von Soden, in *Welt als Geschichte*, II (1936), 412–64, 509–57.

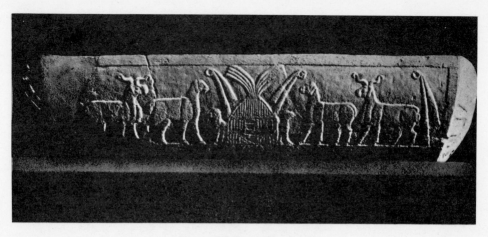

LIIA. STONE TROUGH
(*page* 152)

LIIB. BASALT STELE FROM WARKA
(*page* 152)

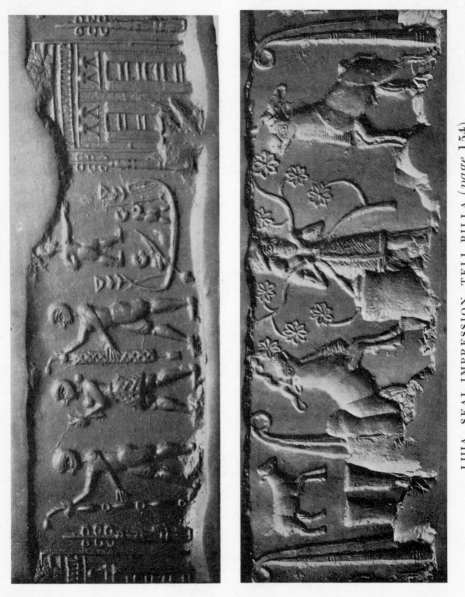

LIIIA. SEAL IMPRESSION, TELL BILLA (*page* 154)

LIIIB. SEAL IMPRESSION, WARKA (*page* 154)

composed and elaborated up to a late date, were considered throughout with reverence and never made to serve a specific purpose. As mere devout classifications they may not reveal great speculative depth but one must admit that there is both philosophic detachment and an extraordinary serene humility in this unique attempt to apprehend and state order and coherence as a fact of transcendent importance. In this respect the lists show a concern which differs from the one revealed in the interpretation of omina which may, for all we know, go back to an early date, although only in later texts and practices it became a veritable obsession. The use of omina also presupposes a coherence of phenomena, but here all interest was focused on the dynamic relation between superhuman powers and human fate, and on the possibility of predicting events by reading the signs revealed in certain objects, by observing coincidences. The aim here was to gain some negative power (namely, the power of avoidance by foreknowledge) over the shaping of personal and political destinies. The lists, more reverent than fear-ridden, ignored the dynamic implications of cosmic order; these earliest encyclopaedias merely satisfied the need of some kind of intellectual pattern within the range of concrete phenomena which were closely observed. Historically speaking, the contractual accounts are more significant for they proved the basic form for future attempts to regulate and stabilize all manner of human relationships, social, economic, political, even religious, as we shall see.

I have discussed these early written documents at some length because both explicitly and implicitly the deep concern for 'order, measure and relation' which they reveal does also play an important part in representational art. Explicitly because, as we shall see, contractual accounts were in historical times frequently given the form of a pictorial statement. Implicitly because throughout representation was made to harmonize with, often made subservient to, the orderly coherence of design. We shall find that rarely, if ever, a given surface was used as a mere opportunity for representational display and also that human and animal figures were used to form a pattern—not only in the manner of decorative or applied art but as an independent, a pure design.

We shall now consider the remains of the Protoliterate period in detail; these fall roughly into three categories: we have one fragment of what was probably a stele (Pl. LIIb), that is, a single upright stone slab used for the purpose of exhibiting a sculptured design; also a number of cylinder seals and impressions (Pl. LIII, Figs. 34, 35, 36); and finally two stone vessels: a semicylindrical trough (Pl. LIIa) and a tall almost cylindrical limestone vase (Pl. LI). We shall

first deal with the latter which is by far the most impressive and mature work.

FIG. 34. *Seal Impression, Warka*

It is significant that this shape was chosen for this particular scene. In Egypt, where stone vases abound at an early date, only one late protodynastic one shows a sculptured decoration. The votive slate palettes offered a flat heartshaped surface which determined, at first,

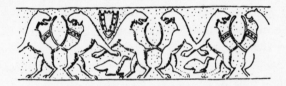

FIG. 35. *Seal Impression, Warka*

the grouping of figures (Pl. VIIa). They became, however, the vehicle of a pictorial statement which ignored the actual shape and function of the object used (Pls. VIIb, IX). The contemporary maceheads and the single stone vase of King Scorpion which may have been used in the same ritual acts in which the palettes functioned, were apparently used *faute de mieux*, for the scenes neither fit nor suit this type of surface. In the case of the tall Warka vase, on the other hand, the parallel bands of relief form an extremely suitable decorative scheme and what

FIG. 36. *Seal Impression. Susa*

is more important still the circular movement of the figures harmonizes with the peculiar character of the events depicted. These are not, as has been assumed for a long time, mere offering scenes, nor do they (as in Egypt) emphasize the importance of a single historical figure; they are the monumental rendering of a supremely important but a recurring event, the sacred marriage of the goddess Inanna, by which the cycle fertility in all creatures—men, beasts, and plants—was to be ensured.[1] In this ritual of the divine wedding of the mother goddess and her own son, the god of fertility, the latter was sometimes represented by the priest king. On the vase, the mother goddess, standing in front of her sanctuary, faces a row of tribute-bearing figures headed by a man who carries the 'first fruit'; behind the symbol of the shrine is a ritual object representing the goddess and the priest or priest king who acted as substitute for the divine lover. The second band shows a continuous row of figures carrying the presents which introduce and accompany all wedding ceremony; the lower register is filled with alternate rams and ewes and underneath it are depicted plants, barley and date palm. What makes this work so very striking in Near Eastern art is the liveliness of the scenes, achieved within the bounds of a very austere decorative framework and a minimum of dramatic action or even variation of pose. We are not even aware of a repetition of figures in the middle register; each of these squat muscular men, firmly striding, slightly stooping, intent on his task, is an individual presence, organic, alive. They are rendered in almost pure profile with the exception of the right shoulder which appears pressed forward rather awkwardly. The result is that their 'corporeality' is as convincing as that on early black-figured Greek vases where, curiously enough, we find the same muscular strength concentrated in thighs and shoulders and the same vital, confident bearing. This characteristic of all early Sumerian art may lead in some later instances to figures almost wholly consisting of very plump buttocks and arms,[2] compared with which the long-legged, long-flanked Egyptian bodies appear conceived entirely from the point of view of graceful outline and are totally lacking in organic vitality.

The top register has an almost weird concreteness. The goddess, without qualifying insignia, and the equal in size of the tribute bearers, faces them clad in a long robe; the sheer humanity of this figure and the restraint of the gestures, gives the confrontation a curious actuality. The action is wholly undramatic and yet the impression of a momen-

[1] See a forthcoming study by Professor Thorkild Jacobsen in *Journal of Near Eastern Studies*.
[2] G. Contenau, *Manuel d'Archéologie Orientale*, I, Fig. 304; *Encyclopédie Photographique de l'Art*, I, 180.

tous meeting prevails; the scene has the very quality of dynamic space which is so completely absent in the juxtaposition of figures in ritual acts in Egypt.

It should be noticed that, while the second and third register show a continuous circular movement, the upper scene, although it has its climax in the group of goddess and shrine, does not show a break or an antithetical arrangement of figures. The presents piled up between tribute bearers and shrine may represent objects which either have been or will be brought as gifts, and this slight ambiguity makes it a perfect *trait d'union* in a virtually unbroken continuity. Although a cult object was used here as an opportunity for a religious scene, this has not been treated as a mere design. The vase offered an ideal surface for the representation of a cyclic event and the liveliness of the figures is unimpaired by their rhythmic sequence in a broad strip which seems a self-contained spatial world.

The decoration of the trough-like stone vessel (Pl. LIIa)[1] entirely lacks the monumental character of the vase. It has a simple symbolical design antithetically arranged, two lambs emerging from the shrine of the mother goddess on either side and flanked by ewes and rams. Yet here again the fact that the lambs are pictured half outside the shrine gives the scene a peculiar actuality. We saw that in Egypt a similar device was very rarely used in the New Kingdom and with the same effect.

The fragment of a basalt stele (Pl. LIIb) shows a hunting scene; two figures, probably representing the same person, attack a lion with lance and bow. This monumental treatment of a purely secular event at such an early date is extremely surprising; it is in fact unique, for the emphasis is here not on the beasts, as it is on the hunter's palette (Pl. VIIa) or the knife handles in Egypt. The lions are, in a sense, subordinate; they stress the dominant strength of the human figure. If this figure represents the king, as is most likely, it is remarkable that neither an association with divinities nor a military feat with political implications but sheer concrete vigour should have been chosen to convey the challenging statement of his power. It may be accidental that this statement is anonymous and the damaged state of the stone does not preclude the possibility that we have here only a fragment of a more complex scene, but its anonymity and its concreteness would be in keeping with the character of the cylindrical vase. The most striking difference with the latter lies at first sight not so much in the roughness of the workmanship—for we find the same type of plastic vigour—as in the utter disregard of decorative considerations. And

[1] *British Museum Quarterly*, III (1928), Pl. XXII.

yet the quasi-casual grouping of the superimposed figures, the absence of groundlines, agree with the roughly vertical boulder which was probably used in its natural shape, put upright as a solid exclamation mark, the more emphatic because it was a rare phenomenon in an alluvial plain. When dealing with the role which stelæ play in' Mesopotamian art we shall have to keep this earliest monument in mind. It is clear that in this case the surface of the stone does not represent a single spatial unit; the king is represented twice and the two superimposed figures therefore merely float in a kind of vacuum.

There are several fragments of stone vases with plastic figures, lions and bulls, which according to some can be dated as early as the Proto-literate period proper, but since they belong typologically to a series of vessels and sculptured groups which form a chronological link between protohistoric and early dynastic cultures we shall discuss them later. They seem, moreover, alien in spirit and style when compared with the tall limestone vase and the Warka seal impressions with which we shall deal now.

The superb glyptic art of this period is a most baffling phenomenon, not only stylistically, as we shall see, but because one is tempted to ask why it should exist at all, why so much effort was spent on an inverted process of plastic rendering upon an awkward and 'elusive' surface. Speculations on the origin of the seal cylinder are apt to be fruitless; it is, of course, plausible that a people whose building and writing material consisted of the ubiquitous mud of marshy plains should have discovered the charm of repeating pattern through the accidental rolling of an engraved bead. But why the half-practical, half-magical measure of sealing with 'the stamp of ownership' should have induced artists to choose the hardest possible way of producing one remains unexplained. Nor does it help if a causal reasoning is changed into a teleological one and the aesthetic predilection for continuous friezes, which so many seal patterns show, is used to explain the choice of cylinders at an early date.[1] All we can say is that if cylinder seals are engraved with figures—and this is the case with all the early ones we possess—they are a form of art which is *sui generis* neither purely decorative nor purely representational in intention; they embody, in fact, a *representational design*. This does not mean that the cylinder surface was not sometimes used for rendering a coherent scene; it occasionally was. But whereas such a scene would be entirely self-contained if the cramped surface of a stamp seal was used—or even misused—for this purpose, this is never the case with the cylinder seal.

[1] For theories about the origin of the cylinder seal see H. Frankfort, *Cylinder Seals*, p. 3.

The Integration of Figure and Design

Here the seal impression is a strip of indefinite lengthwise extension and this will always make even a coherent scene appear a repetitive design. The early artists, who evidently delighted in concrete representation rather than abstract pattern, were therefore faced with a problem of opposing values: they had to solve a conflict between the order of pure design and the self-sufficiency of scenes or figures. This conflict lay at the root of a remarkable dialectical development, for in the course of Mesopotamian history it was solved at the expense of either the one or the other value. Moreover, we can clearly see already in the case of the Protoliterate seals that the conflict had other implications. It has been stressed by the best authority on Mesopotamian glyptic that the aim of the artists was to produce a continuous frieze.[1] This is undeniably true, but it leaves out of account the problem of movement of the figures which constitute the design. For a continuous frieze may consist of a mere repetition of static motifs—which then form a kind of staccato rhythm—or of figures in motion.

In the first case either a small coherent scene may be used (such as a confrontation of figures in adoration or cult acts; Pl. LIIIa) or single figures, by no means necessarily inactive, in which the notion of movement implicit in left and right orientation has been avoided through a frontal position (Pl. LIIIb).

As regards moving figures, we saw that the tribute bearers on the cylindrical vase embody a movement which returns in itself. The seal impression is, however, not a circular band but a mere strip of indefinite length. Here only a design which shows bilateral movement could be considered a satisfactory decoration. It is therefore remarkable that we find relatively few examples with a simple row of men or animals heading in one direction, but that we do find a number of experiments in arranging figures in such a way that the suggestion of directed movement in the one has been annulled by an antithetical movement in the other. Sometimes animals simply move in opposite direction in different registers, sometimes figures facing each other have been arranged in such a way that 'tensional space' and 'hiatus' alternate (Fig. 34).

The most fertile discovery, however, decoratively speaking, was that of a closely knit antithetical group, the possibilities of which were grasped at an early date. It was early realized that the inner tension of each group could be balanced by an outward movement of the figures composing it, that bodies facing and heads turned away, for instance, could achieve both static coherence and bilateral movement (Fig. 35).

Seen in the light of such preoccupation the astonishing variety of

[1] See H. Frankfort, *loc. cit.*

154

early types of seal patterns seems no longer to be due to haphazard experiment. The indefinite frieze, as an independent, not an applied, art form, posed problems which were solved by sacrificing scenic and naturalistic rendering to a bilateral grouping which for lack of a better word we might call heraldic. We can already here notice the curious effect of heraldic grouping on organic forms. It immobilizes them, robs them of their autonomy, their potential life. Heraldic figures do not appear caught at a certain moment, a phase of transient movement. Heraldic grouping makes even a plausible rendering of violent action appear transfixed, curiously unreal, and as soon as its function as a mere design is obvious the background of the figures no longer appears scenic space at all, as a comparison between Pl. LIIIa and Pl. LXI will show. The possibilities of heraldic friezes were, however, by no means exploited to the full yet in the Protoliterate period and in the transition between protohistoric and historic times (the so-called 'Jemdet Nasr' phase) the friezes disintegrate into a mere reversible pattern in which the integration of figure and design no longer plays a part. It is also in this period that a new bold type of plastic relief and with it a new motif appears which seems quite alien to the serene and placid Uruk representations, but which was to play an important part in later Sumerian art, namely, the motif of a hero, man or bull-man, subduing wild beasts. The fact that on an early vase[1] the hero is holding down two bulls in either arm might invalidate the theory that he should be a kind of protecting genius of the herds. Even if cattle were domesticated at as early a date as sheep or goats, the wild bull might for long have been considered as terrifying as a lion. Both might have been interchangeable in the symbolical function of denoting bestial force, and the motif need mean no more than just the expression of the conflict between human or half-human power and animal violence.

Now it is worth noting that the only figure of a bull in the posture of a human being holding down two lions occurs on one of the proto-Elamite seals (Fig. 36) which, though their date is not absolutely certain, show close affinities with those of the Protoliterate period.[2] Only stylistically, however, for the imagery differs: we find a persistent preoccupation with monstrous form which is rare in the art of Warka. It might therefore be tentatively argued that the sculptured vases which appear in the late Protoliterate period and which are decorated with plastic figures, have Elamite rather than Sumerian affinities (Pl. LIVa). Antithetical grouping prevails also here, and where plastic

[1] H. R. Hall, *Babylonian and Assyrian Sculpture in the British Museum* (Brussels, 1928), Pl. II, 3.

[2] A. Delaporte, *Catalogue des Cylindres Orientaux, Musée du Louvre*, I (Paris, 1920), Pls. 27, 40–45.

animals adhering to the surface are arranged in rows we find that the movement is frequently halted by the heads being turned outward in front view (Pl. LIVb). Some allied though slightly later steatite vases are completely covered with low relief (Pl. LV); these show an unusual disregard (for Mesopotamia) of a relation between surface and design; in fact, every available inch was covered by figures which form a solid, quite amorphous tapestry of birds, beasts, humans, and monsters. At the bottom of one fragment from Bismaya a kind of procession of musicians can be recognized, but the effect of a coherent scene is diminished by superimposed figures in the wildest postures. If these are to be considered part of the scene, not a mere tapestry filling, the spatial effect they might have had is destroyed by the absurd proximity of touching heads and feet.

The art of the first historic age proper shows no strong affinities with these rather barbaric carvings except in so far as the hero and beast motif survives and dominates from now on the repertoire of the seals. The problem of the interrelation of figure and design will here again prove most important. But only here, for in this period the preoccupation with historic actuality set a problem which demanded a new solution.

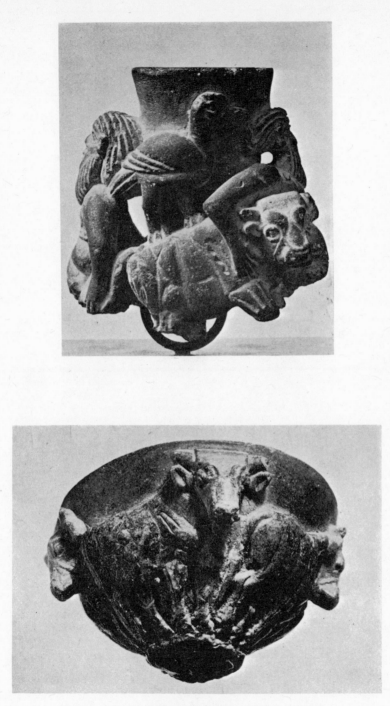

LIVA. SCULPTURED VASE WITH HERO
(*page* 155)

LIVB. SCULPTURED VASE
(*page* 156)

LV. FRAGMENT OF STEATITE VASE, KHAFAJE
(*page* 156)

Secular and Consecratory Motifs in Early Dynastic Monuments

T he first Mesopotamian kings to challenge oblivion by proclaiming their identity remain as elsewhere shadowy figures but the tantalizingly vagueness of a mere name was here given substance at a very early date by the combination of imagery and a written record of acts. It is characteristic of the difference in status and function of kingship in Mesopotamia as compared with Egypt that neither image nor acts recorded vaunt superhuman qualities or display superhuman power. On the earliest known relics—the Blau monuments, one small vertical, one squat oblong stele[1]—where image and text appear in conjunction, the king is shown bringing offerings and supervising the making of cult objects while the as yet untranslatable inscription probably states the number and nature of the gifts. It is, in fact, no more, no less than a pictorial donation contract meant for a divine recipient.

We have one more or less legible relief of slightly later date[2] which shows the king, generally referred to as the 'personage aux plumes', a solitary figure touching with one hand the entrance of the temple of Ningirsu; the text, a fairly elaborate donation contract, this time forms the background of the scene. But the first monument with a legible king's name is not a stele, it is a square stone plaque with a hole in the centre similar to and roughly contemporaneous with anonymous ones found at various sites (Pl. LVI). Some of these plaques were fixed horizontally near the altar, the hole being used for inserting the standard of a god; they can therefore be considered a monumental and at the same time a decorative object. The representation is here more ambitious in the sense that a greater number of figures—those of King Urnanshe and his family—are given. The larger figure of the king carrying a basket on his head either shows him starting the building

[1] L. W. King, *A History of Sumer and Akhad* (New York, 1910), Pl. VI.
[2] De Sarzec, *Découvertes en Chaldée*, Pl. I bis, a b.

of a temple or represents him in a symbolical act which was part of a dedication ritual; his holding a drinking cup in the lower register probably refers to a feast in connection with the consecration of the building. The arrangement of the figures is less naïve than on the earlier monuments, it takes the shape of the stone into account and achieves some kind of decorative balance. We have therefore here again the picture of an act of devotion and it is only in the stele of Eannatum (Pl. LVIIa, b) that we can speak for the first time of a historical monument in the sense of a pictorial reminder of an important secular event. The stele, however, was not erected for this purpose alone. It is a boundary stone inscribed with a contractual settlement betweeen conqueror and conquered. Nor were the scenes by any means a mere glorification of the king and his acts. On one side (Pl. LVIIa) the god Ningirsu sanctions, or rather wins, the victory. He has caught the enemy in his net, a symbol of the absolute power of the god, the absolute helplessness of his victims. On the obverse we see the king, a *primus inter pares*, leading the solid phalanx of his troops with the enemy underfoot. The lasting significance of Eannatum's victory has therefore been expressed in a manner which not only differs from the Egyptian way of timeless abstraction—for it takes actuality into account—but also from monumental art in the pregnant sense (pp. 21 ff. above). For there is no correlation, within the scope of a single scene, between the actuality of the depicted battle and its transcendent significance; both aspects of the event are pictured on different sides of the stele. The paradox of monumentality has thus not been solved artistically and yet it must be admitted that the definite relation which exists between the conceptual content of the separate sides may well have influenced in a subtle way the rendering of the battle scene. For it is striking that—apart from the king's wielding a spear—there are no signs of actual fighting here and the undramatic stolid invincibility of Eannatums' phalanx, merely executing a divine decision, does in a way express the irresistible quality of a god-given victory.

This most remarkable historical monument remains so far an isolated phenomenon in early Sumerian art apart from a few doubtful fragments found at Khafaje[1] and is significantly the last one known for which a free standing stele was used. Until the dynasty of Akkad the perforated plaques which held the standards of the gods were common, the only other scenic representations known to us being on the so-called standard of Ur (Pl. LVIII)[2] and remnants of similar objects found at

[1] H. Frankfort, *Sculpture of the Third Millennium B.C. from Tell Asmar and Khafaje* (Chicago, 1939), Pls. 110 C.; 113.

[2] C. L. Woolley, *The Royal Cemetery* (London and Philadelphia, 1924), Pls. 91, 92, 93.

Kish and Mari.[1] We do not know exactly what these standards, fragile *objets d'art* with shell and lapis lazuli inlays, were used for. Judging from the fact that the scenes refer to war and to some festive celebration but that they do not contain any contract between victor and vanquished, it seems most probable that they were votive commemorations of victory for ceremonial use or dedicated to a temple. They would then have a curiously ambiguous function, neither quite monumental nor merely devout; and it is remarkable that this ambiguity seems somehow reflected in the style of the representation. This lacks the emphatic challenge of the stele as well as the almost business-like abstraction of the consecratory plaques. It lacks, in fact, all unity of conception. The rectangular surface of the broad truncated pyramid has been divided into parallel registers, a simple and rather mechanical scheme. In the top register, the king, slightly larger than the other figures and placed in the centre, gives some coherence to the group. Elsewhere it would be rash to speak of scenes at all, especially of battle-scenes; in the smooth sequence of soldiers, chariots, and captives the paraphernalia of battle are given, the pattern of war, not its actuality. On the obverse we find a similar display of booty and what is probably a religious celebration of victory. As a commemoration of actual events it is therefore hybrid in character and the simple method of enumeration, though it fits the decorative scheme, is artistically rather childish. The main value of this 'Kleinkunst' lies in the delicacy of workmanship—especially the prisoners of the Mari inlays are intensely alive—but compared with the Eannatum stele it is insignificant.

The inlays, though in a class by themselves, are stylistically not far removed from the rough stone plaques we mentioned before and which represent the most frequent and rather dismal efforts at scenic sculpture in Early Dynastic art. The use of some of these plaques is known (p. 157). We were certainly justified in calling the plaque of Urnanshe monumental in the commemorative sense but the term may not seem warranted in the case of some of the earlier examples which are anonymous and represent simple scenes of worship or celebration. Yet these would remain inexplicable as a type of temple utensils unless we assume that they also had a commemorative intention, namely, that of stating explicitly or implicitly, devout acts performed by single people. Not only do we have a sufficient number of plaques in which this intention has been made quite clear,[2] but the form of the statement is revealing and gives the clue to their meaning: it is again in the

[1] S. Langdon, *Excavations at Kish*, I, (Paris, 1924), Pls. XXXVI, XXXVII. *Syria* XVI (1935) pp. 132 ff.

[2] H. Frankfort, *loc. cit.*, pp. 43–48; *idem*, *More Sculpture of the Diyala Region.*

form of a donation contract, the lasting evidence of a good deed done, by which a relation is established between man and god. This type of pictorial commemoration is therefore still farther removed from the concept of a dramatic challenge than the standards. The bland, almost businesslike assertion that an offering had been made, a feast been celebrated (or the costs of either defrayed) did certainly not prove particularly inspiring to Sumerian artists. The recording of acts of devotion does not, in fact, entail the complexities of monumental art, the tension between actuality and transcendent significance. For the importance of even the most trivial acts—such as the work of the stone-cutters on the Blau monument—is self-evident as soon as they are acts performed in honour of the god; while conversely, since they are single acts of single persons they imply a self-evident kind of actuality. It is very striking that, once commemorative art loses its challenging and paradoxical character, artistic inventiveness appears to wither. Admittedly, Sumerian artists suffered under a serious handicap; stone was extremely scarce and mud brick architecture offers no vast walls which could tempt them to more adventurous undertakings. But the scheme itself lacked imaginative scope, and this, more than paucity of material, may have contributed to the fact that this art bogged down in a display of smugly devout little figures engaged in stereotyped acts of feasting. Even the attempt to introduce a little liveliness in the lower registers remains purely haphazard and unintegrated.

As regards the rendering of space, the plaques show neither daring nor originality. The artist of the Eannatum stele, for once superbly indifferent to the decorative claim of a balanced design on a flat surface, made his figures move in one direction and boldly doubled the rows of his soldiers' heads to make their phalanx appear more solid. He thus produced with primitive means almost an effect of recession in depth. Nothing of the kind was ever done on the plaques. The gestures of the figures, usually arranged antithetically, are often quite lively and so organic that the space separating them has the character of dynamic space. Moreover, the rather inarticulate drawing and modelling makes their nonfunctional rendering less obtrusive than in the Egyptian canon of the human figure, and the result is that occasionally the void surrounding them seems less a 'problematic' than a narrow stage space. But even this cannot relieve the dullness of these hybrid temple decorations.

It is interesting to note that both the lack of imaginative and emotional depth which these plaques reveal, and their devout insistence on a personal link with the god, are revealed in a different way in the development of the contemporary sculpture in the round. Here we

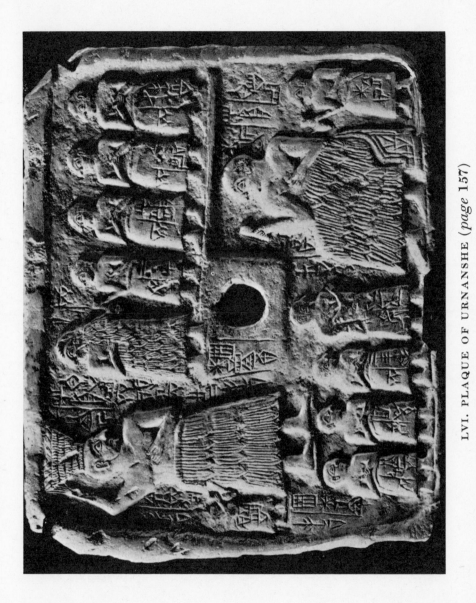

LVI. PLAQUE OF URNANSHE (*page* 157)

LVIIA, B. STELAE OF EANNATUM (*page 158*)

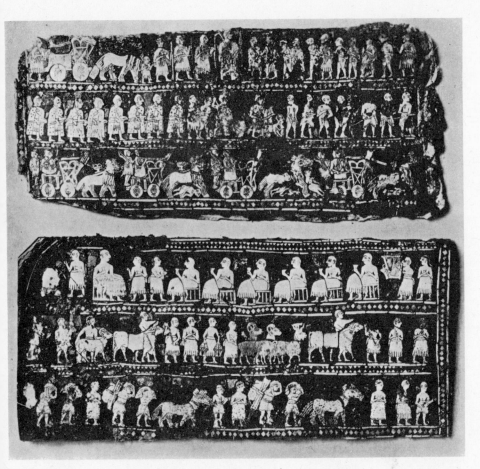

LVIII. THE 'STANDARD' FROM UR
(*page* 159)

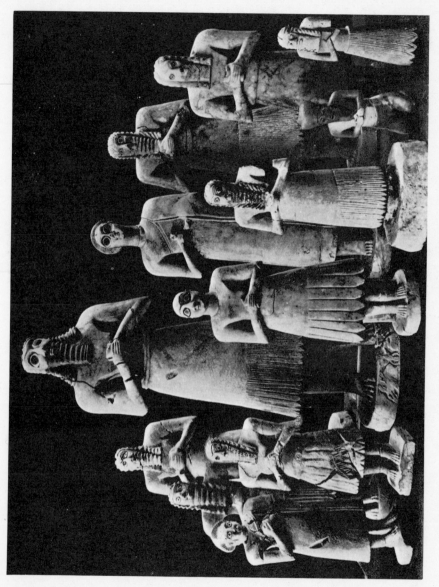

LIX. GROUP OF EARLY DYNASTIC STATUES, TELL ASMAR (*page 161*)

find a most unusual conception of the relation between god and worshipper. The earliest group of statues found at Tell Asmar (Pl. LIX)[1] contained two cult statues different in size from the others and distinguished by the enormous size of the eyes, which (especially in the case of the male god) gave the formalized head a weird but most convincing superhuman character. With these cult statues was found a number of figures representing worshippers, also formalized yet strangely individual, an almost pathetically motley crowd which must at one time have been set up in the cella of the small temple. There is no parallel known outside Mesopotamia for a temple arrangement in which the figures of single persons were thus brought in relation to the god's epiphany and naïvely, trustingly, exposed to his uncanny stare. Yet there need be no irreverence in this arrangement, and in these early statues awareness of the god's presence has been unmistakably expressed, above all in the figure of the priest, whose head seems lifted in awe, almost in ecstasy (Pl. LX). Gradually, however, the very tension implied in this confrontation may well have slackened; it seems that by and by all effort was concentrated on the rendering of single persons whose singleness was insignificant in itself. The wish to appear in effigy in the god's temple may ultimately have lacked the depth of religious awareness which gave to the earlier ones their rather awkward but moving dignity. It is a fact that solitary Egyptian tomb statues hardly ever lose the true monumentality implicit in a contrast between harsh immobile body and lively individual head. There is no such contrast in the Sumerian ones, for these are either quite formalized or singularly concrete: posture and gesture is in this case less robot-like, the face at least in the better ones more expressive; but this expression, if religilous awe is absent, may hover between serene placidity and a trivial smugness hardly rivalled elsewhere in ancient art.

We still have to deal with the glyptic of the period which contrasts surprisingly with the poor quality of the plaques, for the seal designs are vigorous and beautiful. There is no doubt that this is largely due to the fact that the seal cutters discovered in the motif of the hero subduing wild beasts—which first appeared on the sculpture of the preceding Jemdet Nasr period—one of extraordinary liveliness and dramatic force, yet one which could fulfil to perfection the decorative claims of the cylinder frieze. Frankfort has analyzed in great detail the ingenuity with which the possibilities of this motif were exploited. The most intricate patterns were produced (Pl. LXIa) in which sometimes an enlarged antithetical group, sometimes a continuous frieze, solved the problem of a bilateral movement. Frankfort called this style 'imagina-

[1] *Ibid.*, Pl. 1–27; Pls. 82–91.

161

tive' and the term is certainly justified as regards decorative inventiveness; the only danger is that it might make us lose sight of the fact that in some respects this type of ingenuity completely frustrated imagination. For the motif must have had at one time a definite mythical significance and it has in its earlier form a stirring vigour; reduced to a mere pattern it is apt to lose both. What we said in connection with the heraldic use of organic form is even more valid here. A tense situation rendered in this manner becomes an arrangement of figures transfixed in violent postures which are determined not primarily by the action itself but by decorative considerations. Thus the temporal aspects of the action and its correlate of scenic space are robbed of their truly dramatic character. These heroes have in fact become a mere sport for playful designers.

Historic Act and Fulfilment of Divine Command as Themes of the Akkadian and Early Babylonian Period

W e said before that Mesopotamian art is apt to spring surprises on those who look for coherent development. Its greatest surprise is undoubtedly a monument erected by the third king of the dynasty of Akkad. Here the break in tradition is so marked that one is tempted to link it with the coming into power of a different ethnic group (speaking a Semitic language), which had for long co-existed with and was submerged by Sumerian civilisation and may have made itself felt for the first time.[1] Although historical evidence is not conclusive on this point, the possibility need not be discarded that the abrupt change in style, representational content and even function of the monument in question might partly be accounted for in this way. The stele of Naramsin (Pl. LXII) is the only complete one known in Mesopotamia in which a historic event has been represented dramatically in terms of human achievement alone. It is, barring one of later date, the only one which is not subservient to a written statement of any kind, for the present inscription is a later addition. Even if it were used as a boundary stone the representation was self-sufficient; the challenging statement of the king's overwhelming power was expressed entirely in terms of art, and the fact that in one coherent scene both the actuality and the transcendent significance of the victory was stressed justifies our use of the term monumental art in the pregnant sense for the first and the last time in Babylonian history.

Before we analyze the Naransin stele we want to consider some fragments of a roughly cone-shaped one which bears the name of Sargon, Naramsin's predecessor, and which in more ways than one

[1] Thorkild Jacobsen, in *Journal of the American Oriental Society*, LIX (1939), 485–95.

heralds the change and can be rightly considered a transition between Sumerian and Akkadian work.[1] They are fragments of a battle scene arranged in registers; the procession of prisoners and the king at the head of his soldiers resembles the motif of the standard but the hand-to-hand fighting has remarkable actuality, largely through the strange and varied postures of the enemies. A peculiarly concrete touch of horror has been added to the vulture scene by dogs joining in their gruesome feast. The most significant change of all, however, we find on the fragment which repeats the motif of the Eannatum stele: the enemy is caught in a net, but here we may conclude—although the scene is badly damaged—that it was not the god who held the net but the king himself. The figure facing the king was, apparently, a god and to him it was that the spoil was dedicated. The victory then was sanctioned, not won, by the god.[2]

The actuality of the scene on the Naramsin stele is not only due to lively action and an absence of divine interference, but is much enhanced by the setting of the event. The topography, though partly formalized, has convincingly concrete details, and both it and the incidents of the battle hold a subtle balance between the decorative and the dramatic. The roughly triangular grouping, for instance, fits the shape of the stone, but it also underlines the climax of the action; and the upward surge of the conquerors is balanced by the falling and collapsing figures, halted by the rigidity of the four doomed survivors on the right. The smooth cone of the mountain top, rising well above the impressive figure of the king, does not dwarf him in any way but seems to emphasize his human stature and at the same time check the impetuosity of his stride. For the king's posture epitomizes the movement of the soldiers, yet he appears almost immobile at the moment of his triumph, holding the enemy transfixed with fear, and though his towering figure has a symbolical quality, the spatial relation between him and his prospective victims has been made more concrete by the tilting of their head at different angles, the lower ones looking increasingly upwards. The king is thus not only the symbolical and decorative but also the actual dramatic centre of the whole composition and the empty surface surrounding him emphasizes his spatial isolation. This aloofness is enhanced, not minimized by the divine symbols at the top of the stele. This victory, blessed by the heavenly powers, was a solitary achievement.

We have no other monuments from this period which even approach

[1] *Revue d'Assyriologie*, XXI (1924), 65 sqq.

[2] A. Spyckert in *Revue d'Assyriologie*, XL (1945–46) wants to identify the figure with the net on the Eannatum stele with the king on the basis of the Sargon fragment. This means to ignore all textual and pictorial evidence.

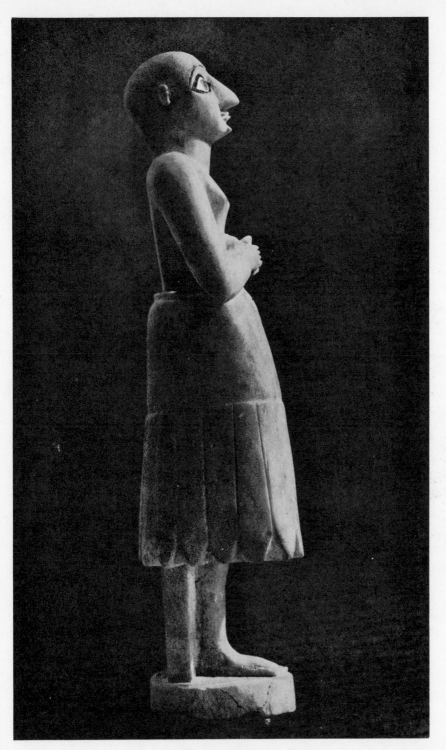

LX. PRIEST, TELL ASMAR

(*page* 161)

LXIA. EARLY DYNASTIC SEAL IMPRESSION
(*page* 161)

LXIB. AKKADIAN SEAL IMPRESSION
(*page* 165)

LXII. STELE OF NARAMSIN

(*page 163*)

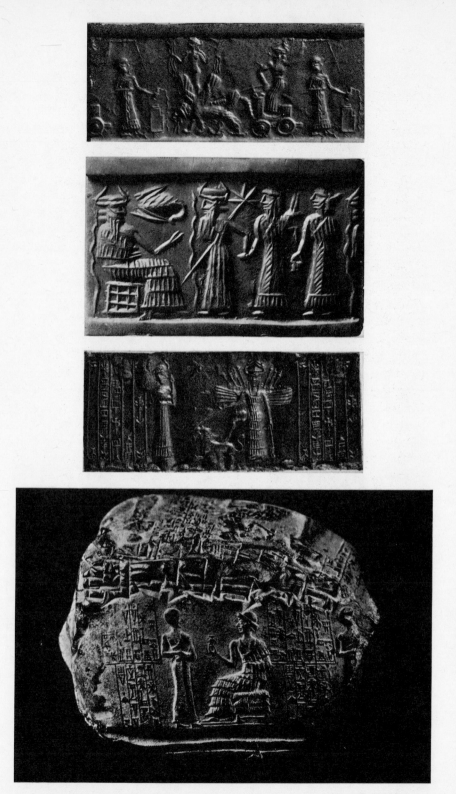

LXIIIA. WEATHER GOD IN HIS CHARIOT (*page* 165)
LXIIIB. 'PRESENTATION SCENE' (*page* 166)
LXIIIC. SEAL DEDICATED TO ISHTAR (*page* 166)
LXIIID. PRIEST BEFORE KING IBISIN OF UR (*page* 167)

the originality and daring of the Naramsin stele, the commemorative plaques disappear altogether and we do not know what—if any—temple decoration took their place. The glyptic, on the other hand,[1] shows an equally remarkable break with the Sumerian tradition. It seems deliberately to move away from formal design and a preoccupation with ritual acts or feasting. First of all, the pattern of hero and bull-man fighting beasts (Pls. Vb, LXIb) loses its intricacy; the emphasis is now on the articulation of well-spaced figures performing well-defined acts. The result is by no means successful, for the motif retains its decorative character and therefore does not lend itself to a really dramatic scene; too great a stress on the concreteness of the figures impairs their character of a heraldic pattern, while the neat antithetical grouping is a dramatic absurdity.

More important is the fact that we find a completely new type of very lively religious scenes. The world of man and his historic deeds which in the Naramsin stele appears, if not divorced from, at any rate no longer dependent on, the acts of the gods, finds in the seal designs a counterpart in an equally self-contained world of acting divine beings: we find for the first time in history the dramatic rendering of myth. It is ironical that these mythical scenes should, as far as we know, have been only carved into the cramped and awkward surface of a cylinder seal where they were, decoratively speaking, not satisfactory and were soon discarded. Yet their appearance is highly significant, for the dramatic representation of myth is the reverse of secular monumentality, it stresses the supreme importance of acts and events, not in order to rescue them from oblivion, but in order to emphasize their actuality, their present importance, although they are beyond recall in terms of time. The tiny cylinder surface did not give the artists much scope for scenic display except in a kind of shorthand rendering. Yet the scenes are lively and discursive; the scant topographical indications, even some divine attributes, give unmistakable actuality. The dragon, for instance, pulling the weather god's chariot (Pl. LXIIIa) is a most convincing creature and there is no doubt, even in the case of the sun boat's voyage, that the spectator is watching a dramatic event, not a conglomeration of symbols. Both secular and mythical monumental art, though they are worlds apart, have usually as their subject matter violent action, but the relation between man and god can in that case play no part in either. It is true that occasionally a human figure offering or standing near an altar flanks a mythological scene but there is no connection between the divine and the human plane.

This does not mean, however, that the old problem of their mutual

<hr />

[1] H. Frankfort, *Cylinder Seals*, pp. 79–91.

relationship was entirely ignored; on the contrary it formed the subject of yet another type of scene, the so-called presentation or adoration scenes which make their first appearance now and soon gain in popularity (Pl. LXIIIb). In these scenes, however, all action is avoided, man and god meet face to face. The common occurrence of the theme in later times is apt to make one forget how startling and original it is when seen against the foil of early Sumerian art. Here is no ritual act to hyphenate the human and the superhuman spheres, nothing to detract from the stark confrontation of incompatibles, except the presence in most cases of a divine or semi-divine intercessor who holds the hand of the mortal. The immobility of the scene, the shrinking attitude of the human figure, has, in the earlier examples, a dramatic finality (easily lost in a mechanical repetition of the theme) which is the opposite of the trusting and complacent reverence in Sumerian religious art. Sometimes the intercessor, as a comforting link between man and divinity, altogether replaces the human figure. (We picture one scene (Pl. LXIIIc) in which a seal cutter (according to the inscription) dedicated a specimen of his craft to the goddess Ishtar.) Here the adorant hides his identity behind the intercessor, who, as if unable to meet the goddess's presence from near-by and face to face, is separated by Ishtar shown in front view by a blank space.

The conception of adoration scenes—though these could be and were reduced to a mere formula—differs from the Sumerian preoccupation with religious acts, in that, paradoxically, it is both less formal and less concrete. The ultimate reaction between man and god stripped of all ritual trappings is here removed from the sphere of human action, reduced to a mere awareness. Religious imagery, though enriched by mythological scenes, was therefore at the same time poorer in motifs, and it is significant that a new interest can be noticed now in purely secular human activities; we find for the first time 'genre', namely, pastoral and hunting scenes and even an expedition into the mountains.[1] We shall see later that a similar dichotomy occurs in Assyrian art, where, however, the secular predominates. In Akkadian glyptic this is rare.

We have now to consider the last phase of purely Sumerian civilisation which occurred after the downfall of the dynasty of Akkad and an interval of political confusion owing to foreign invasion. The remains from the reign of Gudea and the Third Dynasty of Ur do not reveal a trace of either monumental hybris or reverence for myth nor, characteristically, the old superabundant faith in divine power: most of the glyptic of this period shows scenes of worship but in many

[1] H. Frankfort, *Cylinder Seals*, pp. 137–41.

instances it is not the god but the king to whom homage is rendered (Pl. LXIIId). In his turn Gudea, the ruler of Lagash (who admittedly also had a stele made with a 'presentation' scene), put up a great number and variety of his own effigies and had them inscribed with a text which insists on his own identity and on his merits toward the gods with wearying emphasis. One of the very few reliefs of the period is on a stone basin[1] which shows the alternate figures of a rain-god or demon and a fertility-god both pouring out the blessing of water so needed in a reign which suffered from terrible drought.

We do, however, possess one remarkable stele of Urnammu, king of Ur, which, though it differs completely in style and intention from the stele of Naramsin, resembles it in one respect: it is a commemorative monument pure and simple, not a boundary stone or legal document (Pl. LXIV). It does not, however, render a royal victory but only the good works of the king in honour of the god. The composition of the scene is formal, the stone has been divided into registers which contain on one side ritual acts and on the obverse festive celebrations. Added to the first is—as far as we can judge from tantalizing fragments—a very concrete and lively picture of building activities, and it is significant that in this scene alone the rigid division into parallel strips has been ignored: a diagonal ladder linked the second and third register and must have given this section more coherence. The top of the stele, though badly damaged, is very remarkable indeed. Judging from the obverse the group of the king facing the god was matched by a similar arrangement on the left, and this rather mechanical duplication would rob the royal figure entirely of the dramatic effect which it has now. On the other hand, these confrontations crowning a record of good deeds have a significance which similar ones on seal designs lack; they are here the summing-up of a life's work in the service of the god and this gives them the character of a momentous climax. Challenging pride in human achievement and deep humility are finely balanced, and the significance of the confrontation seems to transcend the simple act—probably a libation—which the king performs. As if to emphasize the fact that the water of libation is a blessing received as well as be-stowed by the king, the same strange, almost angelic, figure which occurs on Gudea's basin, only half visible and descending from above, pours out the water used for the ritual. Thus god and king appear united by a reciprocal act of blessing, a concept of the relation between god and man which is more profound and more dynamic than the old contractual statement. Although the surface on which these figures

[1] E. Unger. 'Die Wiederherstellung des Weihbeckens des Gudea von Lagasch', in *Itanbul Asariatika Muzeleri Nesriyati* (Istanbul, 1933), Tafel IV.

appear cannot be conceived as one coherent dramatic space, in the manner of the Naramsin stele—the duplication of the royal figures makes that impossible—yet the tension between king and god is undeniable.

It is remarkable that when, after another period of disruption, the country was unified under a Semitic ruler in Babylon, the first monument of the new dynasty, the famous stele of Hammurabi (Pl. LXV), seems closer in spirit to that of Naramsin. This may appear an absurd statement, for the tall stone which was covered by the elaborate codification of case law known under Hammurabi's name, can hardly be called a historical monument and the scene which crowned its façade only contained two figures. Yet the text does not—as do the Urnammu scenes—emulate acts of devotion, but exemplary acts of justice by the king which refer to the world of man alone, and the main difference in intention between this and the Naramsin stele resides therefore in the fact that the relation between god and man, which in the latter was not touched upon, formed here the theme, both pictorially and in the introductory part of the text. The treatment, however, has this in common with the Akkadian work that, notwithstanding the extraordinary simplicity of the scene, it has great dramatic power. For there is no act depicted, not even the simplest ritual, to detract from the starkness of a situation in which a human being faces his god in order that his efforts may be sanctioned and turned to lasting benefit.[1] There is no reciprocity of service rendered here, but transcendent power and majesty on the one hand, dignified humility on the other, have been expressed with an economy of means and a convincingness never surpassed in ancient art.

With the stele of Hammurabi we have reached the last significant monument known to us in Babylonia. Nor is there much reason to believe that the loss of more perishable work, such as wall paintings, left a serious gap in our knowledge. The frescoes found at Mari[2] show a dull decorative scheme which reminds one of an enlarged seal impression. They would, in fact, invalidate the theory that glyptic owed its inspiration to mural art. Kassite murals show an equally dull sequence of identical figures.[3] The only remains of any importance are small pottery plaques with religious motifs. These are admittedly more

[1] A. Scharff, in *Wesensunterschiede Aegyptischer und Vorderasiatischer Kunst* (Der Alte Orient, Band 42, Leipzig, 1943, p. 21) points out that the eyes are rendered in profile. This appears to be the case but actually the relief is so thick that the eyes rendered in front view are seen foreshortened. The effect is, however, the same: it intensifies the relation between the two figures.

[2] *Syria*, XVIII (1937), pp. 325–54, Pl. XXXVII–XLI.

[3] *Iraq*, VIII (1946), Pls. XII-XIV.

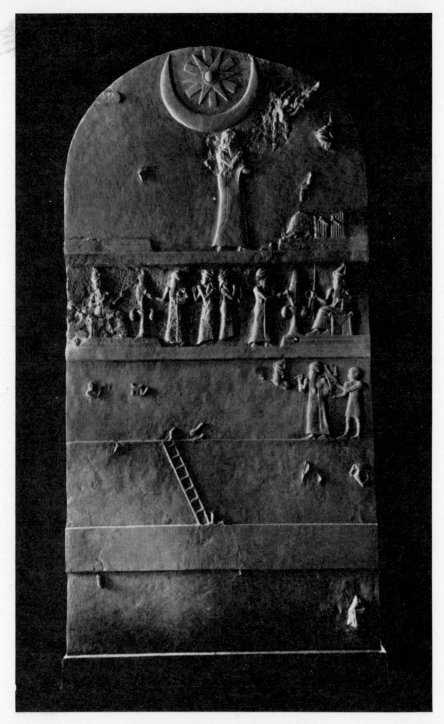

LXIV. STELE OF URNAMMU
(*page* 167)

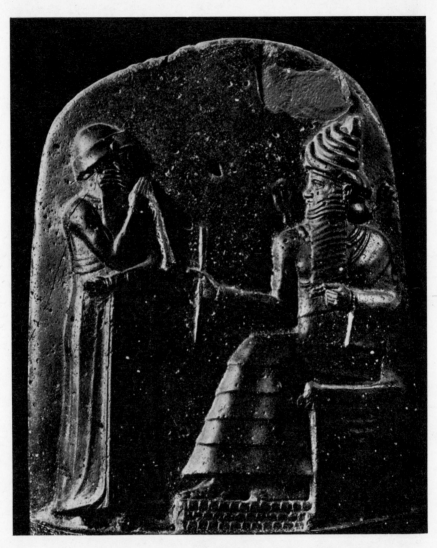

LXV. UPPER PART OF STELE OF HAMMURABI
(*page* 168)

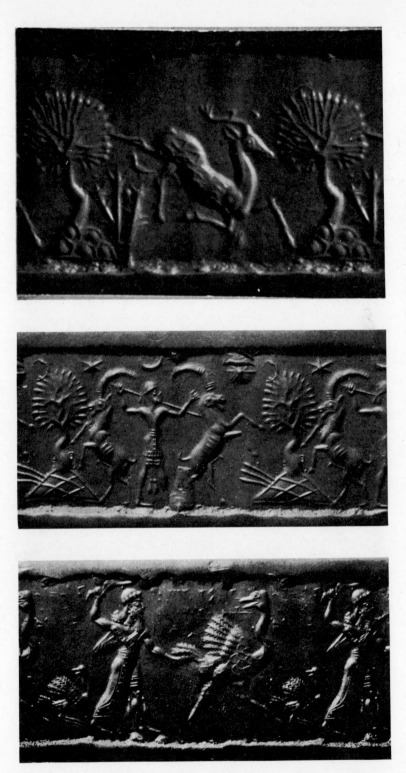

LXVIA–C. MIDDLE ASSYRIAN SEAL IMPRESSIONS
(*page* 170)

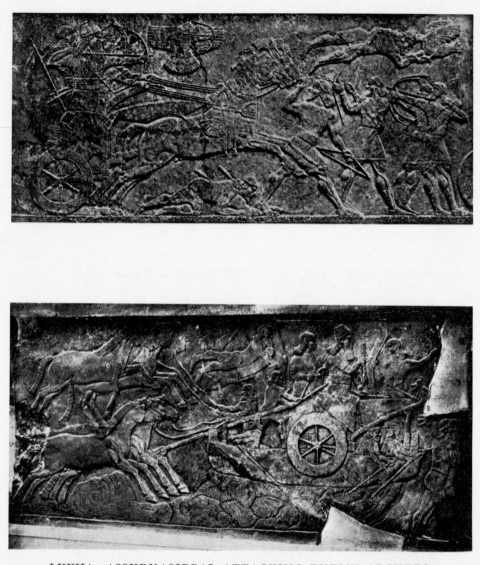

LXVIIA. ASSURNASIRPAL ATTACKING ENEMY ARCHERS

LXVIIB. ASSURNASIRPAL AND HIS ARMY CROSSING A RIVER
(*page* 173)

varied but artistically too poor to be of any interest except to the student of religion.

To look back on the long historical development which we traced means to experience the fascination of watching a dialectical development. As regards glyptic, we saw already that there is a conflict inherent in the very notion of a representational design, that this conflict was solved in a variety of ways in the Protoliterate period, was practically ignored in the slovenly patterns of its concluding Jemdet Nasr phase, most satisfactorily solved in the decorative use of the hero-and-beast motif in Early Dynastic times, while in the Akkadian period the stress was again laid almost exclusively on dramatic scenes. The most static of these, the so-called presentation scenes, were finally adopted as a classsical motif.

In representational reliefs the matter is more complex. The confident and joyful proximity of the human and the divine in religious celebration which we find on the vase (Pl. LI) never occurs again in Mesopotamian art. The significance of the later scenes seems to oscillate between a contractual statement of a religious nature and a monumental—a challenging—statement concerning individual acts. In Early Dynastic times the stress is on the former, the hybrid 'scenes' on decorative plaques predominate. The free standing stele of Eannatum (a contract too but in a different sense) is, however, a truly pictorial monument. We saw that one highly original and imaginative motif, namely, the god catching the enemies in a net, was copied by the first Akkadian king, but with a shift of emphasis from the religious to the secular. Only on the stele of Naramsin has individual historical achievement been given the form of monumental art, without explicit reference to divine aid or devout purpose.

In the subsequent period, the Sumerian dynasty of Ur, there is again a swing back toward the devotional, yet the stele of Urnammu as far removed from the early plaques as from the Eannatum stele, may be considered a synthesis of both, for it is a pictorial record of historical acts performed in honour of the god.

It is remarkable that in the art of the Middle and Late Assyrian period, that is, at a considerably later date, in a different geographic and ethnic setting and within a different political organisation, the pendulum swung toward secular interest again, in a way unparalleled in the whole ancient Near East. And it is also remarkable that whereas Mesopotamian art throughout had shown little concern with space-time actuality, either in a positive or in a negative sense (except in their few purely historical monuments), this now became an overwhelming preoccupation.

CHAPTER IV

Dramatic and Scenic Coherence in the Secular Art of the Assyrians

Assyrian art, baffling and full of contradictions like so much that pertains to Assyrian culture, brings one most striking innovation: the commemorative reliefs of the royal palaces are entirely secular and narrative. To see this fact in its true perspective more than a mere sketch of historical events and cultural changes would be needed. The shift of power to a northern centre after a period in which Syrian, Indo-Eurpoean, and other north-eastern influences prevailed in Mesopotamia under Kassite and Mitannian rule, presents a historical problem that bristles with unanswered and perhaps unanswerable questions. Moreover, the archaeological material from the Middle Assyrian period is so fragmentary that we cannot trace even a formal development which would lead up to the reliefs of Assurnasirpal and the surprising boldness of this new artistic venture. All we can do at present is to point out some significant changes in the few extant reliefs and the glyptic of the Middle Assyrian period which appear to have cultural implications and then to see if these new trends can be tentatively correlated with a changed attitude where the rendering of event in space and time is concerned.

Both Frankfort and Moortgat have discussed the degenerate glyptic of Kassite and Mitannian origin and stressed the remarkable freshness of the Assyrian seals which mark a new beginning (Pl. LXVIa–c).[1] The main points of interest for our problem are a new delight in dynamic scenes such as animals on the move or hunters attacking quarry—actual or mythical—and a vigorous naturalism which even affects the traditional antithetical groups of animals, so that their attitudes appear contingent rather than heraldic. Most remarkable is that this interest in animals and hunting develops at the expense of religious

[1] H. Frankfort, *Cylinder Seals*, 186–91; A. Moortgat, 'Assyrische Glyptik des dreizehnten Jahrhundert's', in *Zeitschrift für Assyriologie*, XLVII.

subjects. Presentation scenes are altogether absent, such adoration scenes as occur have least pronounced Assyrian characteristics and are stylistically close to Babylonian ones, while the few reliefs of the period which we possess seem to avoid likewise the well-worn scheme of divine and human confrontation. On the earliest one known, an 'obelisk' showing a number of captives being brought before the king, the epiphany of the god Assur consists of a pair of hands emerging from a cloud and and handing down a bow as symbol of the king's power.[1] Here divinity was for the first time shown quite literally transcending the realm of man. In the faïence tile of Tukulti Ninurta we find the same god in a more emblematic form—a winged disk containing his feathered figure—in the act of shooting a bow, floating above the royal figure in a battle scene.[2] On two roughly contemporaneous altar stones we see in the one instance the king flanked by the symbols of the sun—not facing its image—and on the other two royal figures, one kneeling, one standing before an altar which again only supports a symbol.[3]

All the available material of the Middle Assyrian period would therefore confirm Frankfort's observation, which he based mainly on later Assyrian glyptic, that: 'the higher power has become inaccessible and direct contact apparently ceased.'[4]

It would be rash to draw the conclusion that the presence of historical scenes on palace walls and a remarkable absence of religious scenes in the temples could be entirely explained by a changing concept of divinity and a different relation between a more transcendent god and man. The part the god Assur played in fertility rites and his connection with the sacred tree[5] are too obvious and at the same time too obscure than that the transcendence of this lord of hosts could be taken for granted. There does indeed appear to be a curious hesitancy in confronting god and man. There is also, as we shall find, cleavage between secular and non-secular—that is mostly ritual—representation, even within the scope of the palace reliefs. For the secular scenes delight in rendering concrete detail, the religious ones shun actuality—if we may use this term to denote a type of religious imagery in which gods appear and act in human form and in situations analogous to actual life. This same cleavage finds expression in yet another way: the textual recording of the king's achievement on building inscriptions loses its character

[1] Sidney Smith, *Early History of Assyria*, Pl. XVII.
[2] W. Andrae, *Farbige Keramik von Assur*, Pls. 7, 8.
[3] W. Andrae, *Die Jungeren Ischtartempel in Assur*, Pl. 29–30.
[4] H. Frankfort, *loc. cit.*, 196.
[5] Sidney Smith in *Bulletin of the School of Oriental Studies*, IV (London, 1926–28), 69–76.

of a religious dedication, which it had had throughout Mesopotamian history and becomes a purely historical record. We find therefore that at a moment when secular art on a large scale makes its first appearance in history, significant changes had already occurred both in religious pictorial idiom and in texts, and that these seem symptomatic of a widening gulf between the world of man and of the divine.

But before we turn to the battle and hunting scenes on the palace reliefs we must discuss yet another innovation which accentuates the distance between secular and non-secular art: a host of winged monsters in various beneficial functions invades the ritual scenes. Now we cannot discuss here the problem of monsters in Mesopotamia nor speculate on the reasons why these should have appeared throughout such remarkably convincing entities, whether they were composite animals, bullmen or merely fantastic creatures. It is a fact that they occur mostly in semi-decorative context and especially in popular glyptic art, so that we may assume that they were at home in the realm of folk religion. The Assyrian winged creatures which appear on the seals have been fully discussed by Frankfort,[1] those on the reliefs are either in human form or animal headed, for the human-headed bull which in gigantic form guarded the palace entrance occurs only once in an actual scene sporting among fishes in a naval battle.[2] These monsters apparently filled a gap produced by a less concrete religious imagination, yet they failed to inspire the artists of the reliefs. Whether or not they emerged from remoter layers of religious awareness, they gained in the hands of subtle and sophisticated craftsmen an—for monstrous form—almost absurd concreteness in muscular detail. Yet, arranged in stereotyped postures on either side of a formalized tree in a ritual act they lose whatever demonic life they may have had originally and are impressive only through sheer size and workmanship. We shall in our discussion of the late Assyrian reliefs ignore all ritual scenes because they are entirely formal and have no bearing on our problem.

The palace reliefs of Assurnasirpal (885–860) present the first narrative art we possess in Mesopotamia.[3] It has been suggested that they might have been inspired by either first or second-hand knowledge of the Egyptian New Kingdom reliefs;[4] this is at least a possibility, but even so the differences between the two would be more significant than any hypothetical plagiarism and we shall only refer to the Egyptian

[1] H. Frankfort, *loc. cit.*, p. 198, also *Archiv für Orientforschung*, XII (1937–39), 128–35

[2] *Encyclopédie photographique de l'art*, Tome II, Pl. 2, 3.

[3] E. A. Wallis Budge, *Assyrian Sculpture in the British Museum. Reign of Assurnasirpal* (London, 1914).

[4] J. H. Breasted in *Studies Presented to F. Ll. Griffith*, pp. 267–71

ones in order to throw into relief the peculiar and consistent character of the Assyrian work. It is, for instance, very striking that nowhere in the actual battle reliefs the king should dominate the scene either by his size or by his action; the king looks and acts like any of his soldiers. Fighting is throughout at close quarters and slain victims are strewn about the scene; but the defeat of the enemy is not a foregone conclusion: enemy soldiers striding away from the royal chariot turn back and shoot at the king and repeatedly one of them grabs at a horse's mouth in an effort to halt them (Pl. LXVIIa). The enemy, moreover, never shows abject terror; the fight is fierce and virile. It is also entirely episodic, not a single battle scene contains a clue to its outcome; consequently, the spectator is held in suspense till he moves on to the next episode, where rows of prisoners or a city in flames complete the story. Such scenes lack entirely the symbolical character which made the Egyptian ones a timeless assertion of inevitable royal victory; they show ephemeral events changing before the spectator's eyes from one phase to another. There are no clear breaks in this pictorial epic, nor is action ever suspended; the movement of figures in one direction always seems purposeful even if no explicit aim is indicated; rows of prisoners seem on the march towards their destination, not displayed in a formal aimless stride. Movement is rarely met by countermovement except in the case of a siege where the town formed the centre of action (in the reliefs of Seti I at Karnak this was never the case) and the attackers were arranged antithetically. In chariot scenes the galloping horses are not tilted diagonally, although the extended forefeet are off the ground. In fact, all horizontals are usually stressed in this case, the reins, the arrows, the prostrate figures under the horse's belly, so that the level movement is unchecked.

The drawing of the horses, in a surprising variety of gait and posture, is throughout superb. The draughtsmen must have known and lived with them as no Egyptian artist ever did, and with a delicate observation—completely absent in their human figures—could render shades of mood and temperament in sensitive horses' heads, beautifully coordinated movement of neck and body in horses starting to pull up, horses swimming (Pl. LVIIb), horses straining up a mountain slope when the rider slackens his rein.[1] These creatures move in a scenic space which, if the register groundline is adhered to, will lack all suggestion of topographical recession, but the register acts as horizon so that the scenes appear as real as life. Frequently, however, the horizon line is

[1] Compare the facial expression and the position of the ears of swimming and stepping horses in Pl. LXVIIb and Pl. LXIX. Also note the helpless pawing of the swimming horse in the top left corner of Pl. LXVIIb and the muscular tension of the climbing horses in Budge, *loc. cit.*, Pl. XXV, 1 and 2.

ignored and figures superimposed without apparent concern about their spatial relation. The effect may vary but the action is usually so closely knit that such 'floating' figures seem part of a coherent group in space. In the camp scene, for instance (Pl. LXVIIIa), the superimposed groom and horse form with the feeding animals a somehow fairly convincing unit in depth although they are spatially not co-ordinated with the tent which ought to form their background but fails to do so since it has been fastened onto the groundline. In the rather narrow registers in which the narrative has been arranged topographical indications are insignificant—the scenes have enough actuality without—but in Pl. LXVIIIb, where (in contrast with the Egyptian habit of merely plotting rivers or strips of water) emphasis is laid on the vertical aspect of the river bank, this gives a remarkable suggestion of receding space. We have one interesting example of true scenic background, though not yet of stage space, in Pl. LXIX, where the royal cortege is seen passing below the city walls. Figures do not yet always appear in pure profile, there is frequently an awkward twist in the shoulder region, though the burly rather amorphous bodies, almost entirely hidden in long garments, do not make the non-functional drawing so obvious that it interferes with the impression of organic corporeality which they convey.

Apart from these details of spatial rendering the following facts stand out: the narrative scheme of consecutive scenes in fairly narrow strips has nowhere been abandoned in favour of one which would allow for a dramatic climax, a summing-up of complex event in one pregnant situation; nor can we observe anywhere a tendency to transcend actuality in the manner of monumental art. The story told remains discursive. This may explain the limitations of the experiments made in the rendering of space: scenic space was intended throughout but it merely depended on the choice of episode whether the horizon line of the register sufficed or whether—especially when the action took place on or near water or was spread out over a large terrain—the problem of the disposition of figures in space had to be faced. Topographical coherence then began to form a new preoccupation for the artist.

Under the reign of Assurnasirpal's successor Shalmaneser an important innovation was made which enhanced the character of scenic space: from now on human figures nearly always appear in pure profile, that is, in a definite relation to the spectator's viewpoint. The remains of this period consist mostly of bronze reliefs which covered the palace gates at Balawat.[1] They are narrow scenes arranged in double strips in such a way that the movement of the figures in the upper row is in

[1] L. W. King, *Bronze reliefs from the Gates of Shalmaneser* (London, 1915).

opposite direction to that of the lower one. This work, obviously decorative in intention, is strictly narrative in character, but though technically bold it is artistically rather dull. The monotony of the depicted horrors, the records of a series of campaigns, is practically unrelieved and the work is on too small a scale to allow for much experiment. In one instance when a non-military event was depicted Pl. LXXa) topographical scenery was ventured on and the attempt made to represent the head of a valley surrounded by mountains on both sides with a subterranean stream visible through 'windows' in the mountainside. Here some kind of recession has been aimed at in rendering the mountains on the far side of the valley; usually, however, all scenes run parallel to the surface.

The rather fragmentary remains from the reign of Tiglathpilesar III, and the reliefs of Sargon show a continuation and further development of earlier trends. Profile rendering is maintained and the superposition of figures in the now slightly wider registers is more frequent. Groups without groundline are put in at different levels in Pl. LXXb and the line of goat's feet is actually sloping down towards the nearer ones so that the general impression is that of a coherent scene in space although the figures are not yet topographically related. The ox-cart leaving the town (on the left) has been put on the register line, the more distant town walls and gate are slightly higher. This frequently happens in pictures of mountain sieges, but in this case there is no indication of mountainous terrain at all, and the curved diagonal joining gate and groundline, and marking the road down which the cart moved, appears less a contour line than an attempt to link foreground and distant background, a rather primitive way to indicate recession. Remarkable also is that in Pl. LXXIa the figures active on ground level are offset against a solid background of scaly pattern, a conventional method of indicating hilly country. This preoccupation with background recurs in a different form in the Sargonid relief of Pl. LXXIb, where the stage-set for the hunt, although formal, has a remarkable solidity, concreteness. These massive pines are neither merely decorative nor explanatory; they give—although the problem of depth has been ignored—the actual and contingent setting for action. We have one scene[1] showing King Tiglathpilesar III, flanked by his officers, standing with one foot on a prostrate enemy. This is the nearest approach to a symbolical scene, but placed in a lower register as one scene among many, it loses even the character of a dramatic climax and appears curiously episodic.

[1] E. A. Wallis Budge, *Assyrian Sculpture in the British Museum from Shalmaneser III to Sennacherib*, (London, 1938), Pl. VIII.

The reliefs of Sennacherib,[1] less subtle, less dramatic than those of his successor Assurbanipal, are full of experiment in the rendering of scenic space and especially in the disposition of figures in depth. The interest is largely focused on complicated activities involving large

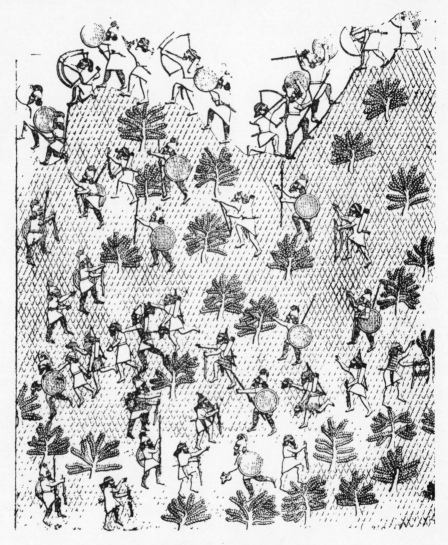

FIG. 37. *Battle in the Mountains*

groups of people and the relation between these and their local setting. It is interesting to see how persistent efforts were made to emphasize spatial coherence as well as unity of action. In a mountain assault, for

[1] 705–681 B.C. See A. Paterson, *Assyrian Sculpture in the Palace of Sinacherib* (The Hague, 1915).

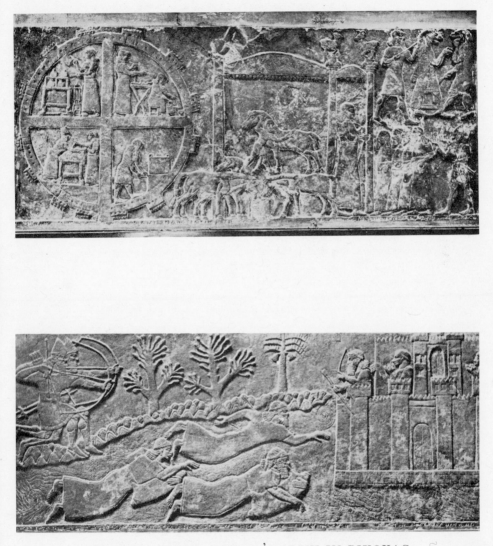

LXVIIIA. ASSURNASIRPAL'S ARMY IN BIVOUAC

LXVIIIB. ENEMIES FLEEING ACROSS MOAT ON INFLATED SKINS
(*page* 175)

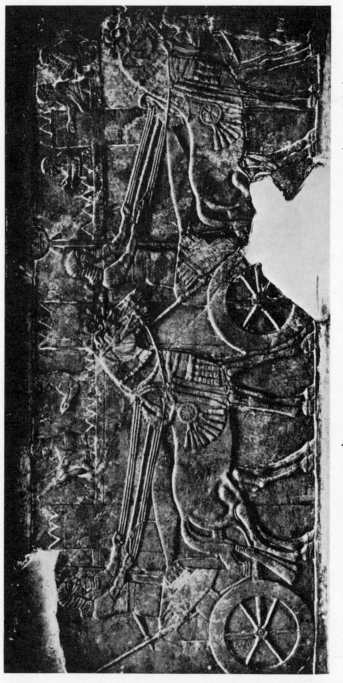

LXIX. ASSURNASIRPAL'S CHARIOTS PASSING A FORTIFIED CITY (*page* 174)

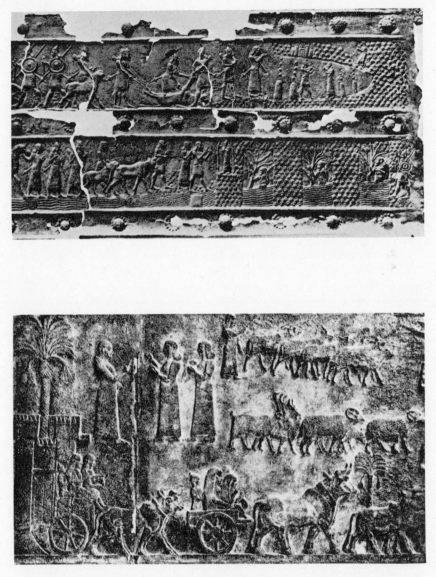

LXXA. THE SOURCES OF THE TIGRIS, BRONZE GATES OF
BALAWAT

LXXB. SCRIBES OF TIGLATHPILESAR III NOTING BOOTY
(*page* 175)

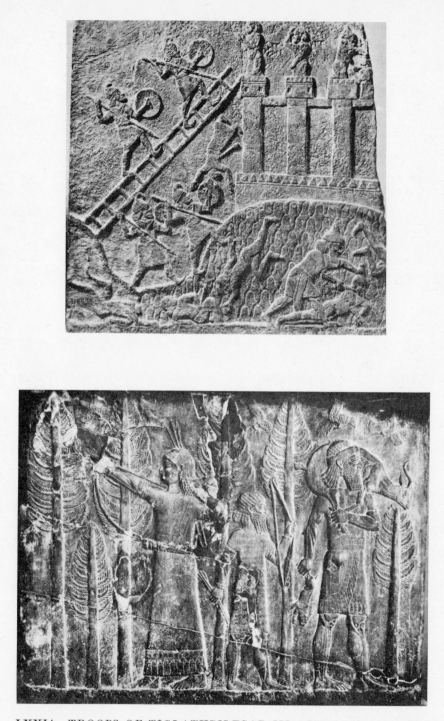

LXXIA. TROOPS OF TIGLATHPILESAR III ATTACKING A CITY

LXXIB. HUNTING IN THE WOODS, SARGON'S PALACE
(*page* 175)

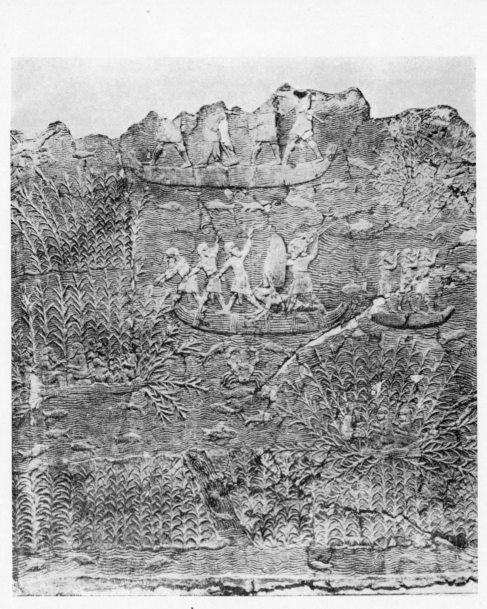

LXXII. SENNACHERIB'S TROOPS ATTACK MARSH DWELLERS
(*page* 177)

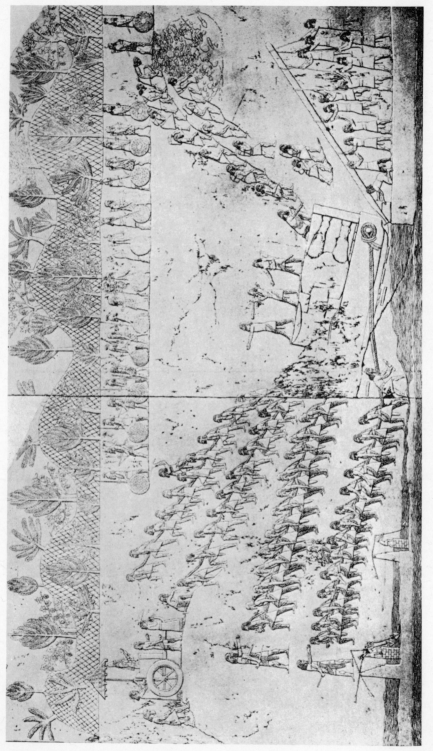

LXXIII. TRANSPORT OF A COLOSSUS (*page 177*)

LXXIV. ATTACK ON MOUNTAIN FORTRESS (*page 178*)

instance, soldiers are scattered among trees over a wide area marked with the conventional pattern of a mountain side, which can only be conceived as receding (Fig. 37). One might be tempted to use the term cavalier perspective here, but strictly speaking both it and 'bird's eye view' presuppose a definite, if unusual, spatial relation between observer and things observed, which is totally absent here. It is true that the receding surface of the mountain side has been made more or less concrete by the conventional pattern and that thereby the scattered human figures and trees could be definitely fixed in relation to it and to each other. Yet they give no clue to the observer's viewpoint, because from a high viewpoint which might reveal their disposition as clearly as the picture shows, the trees could not appear in plain front view. It is, however, undeniable that some sort of spatial coherence of figures and objects, and some illusion of recession has been achieved. How important this coherence of receding space was considered can be gauged by the almost absurd insistence on a patterned background which the reliefs show; trees stuck into such a background must of necessity be conceived as spatially related, and if they are superimposed this can only mean also related in depth.

The same holds good for the marsh scene (Pl. LXXII) where the superimposed islands are so carefully joined by well-drawn strips of water that there is no loophole for spatial ambiguity, each figure, each object is definitely fixed in relation to every other and yet the viewpoint has not been clarified. Again the illusion of a bird's eye view strengthened by the centrifugal arrangement of some of the reed bushes, is destroyed by the front view rendering of others. But nowhere—as was almost invariably the case in the few Egyptian topographical scenes we discussed—has any of the surface been left blank. The full consequences of illusionistic scenic rendering, with its challenge of complete spatial coherence, had been accepted.

More ambitious if rather less successful are the attempts to picture the transport of colossi or the making of artificial mounds for Sennacherib's palace. We are far removed indeed from the first Egyptian effort at such a scene (Fig. 7). Here the action is very lively and in each of the different versions we possess a definite moment, a definite place has been chosen to mark the actual phase of the event (Pl. LXXIII). The most remarkable is that where the colossus has to cross a dip in the ground near a strip of water. While in some other renderings the rows of figures straining at the ropes have the support of a groundline; here they are merely spread out on an amorphous plain from which the hillock rises where the king in his chariot overlooks the scene. Here again the river in the foreground with its narrow dams and shadufs at

work (all given in straight elevation) are incompatible with a high viewpoint which part of the scene would suggest; and the relation between plain and hill on the right is not clear.

Yet the same passionate interest in receding space leads to another curious experiment. The sieges of hill towns or mountain strongholds had already become livelier and livelier, they were now frequently offset against a mountain background which in some cases rose above the town or castle walls. Diagonal scaling ladders had often lent a dramatic touch to the event,[1] now however it became a matter of ambition to render the actual approach of the attacking army on the mountain side. Such an approach is of necessity in a diagonal line and so we suddenly see, instead of ladders, solid paved diagonal paths leading up to the strongholds (Pl. LXXIV, LXXV), and that means, at any rate conceptually, away from the spectator. The effect is weird in the extreme, the more so because in a misguided effort at realism the angle of ninety degrees between these paths and the climbing figures has been maintained so that the soldiers appear to be falling backward. The wild pattern of diagonals nowhere achieves the illusion of recession or of topographical coherence, but the boldness of this attempted short cut at landscape perspective on a vast scale is astounding and unsurpassed till Hellenistic times.

Sennacherib's innovations must have been considered aesthetically barbarous by those who planned the Assurbanipal reliefs, for they did not venture any further in the direction of illusionistic recession. With the restraint of true and very great artists they did not pursue a naturalism already run wild along topographical lines. The most gifted of them either brought their figures back to the relief surface in fairly narrow parallel scenes or bound them by subtle means in a dramatic situation that could dispense with locality altogether. It is true that some of the motifs survived, but it is interesting to note that when an artist indulges in topographical scenes, as when an aquaduct in its setting is rendered (Pl. LXXVI, top register) and the strange diagonal rivers are obviously inspired by the diagonal paths, the scene is empty of figures and is therefore much more plausible. In Pl. LXXVII the fleeing Elamites are arranged in parallel registers as of old, but the deserted town walls looming above them tier upon tier, reminders of the threat they must have held, make the implicit victory appear an even more formidable achievement than if a lively siege were given. The new restraint is thus dramatically most effective. One other motif in which an attempt at rendering recession had been made before, namely, that of fugitives or looting soldiers leaving a town, has been

[1] Paterson, *loc. cit.*, Pl. 15.

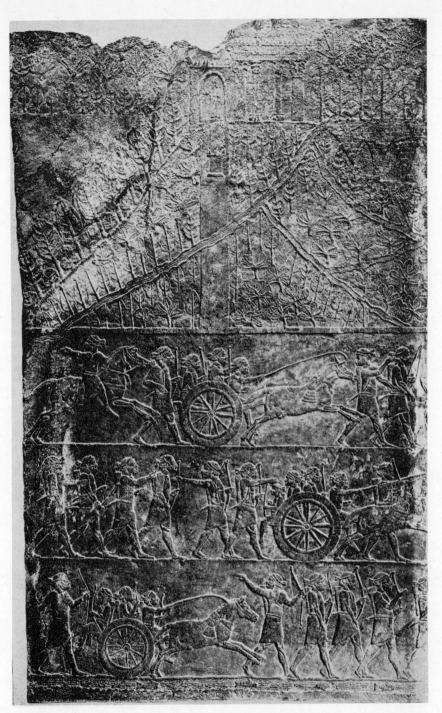

LXXVI. ELAMITES FLEEING PAST TEMPLE AND AQUEDUCT
(*page* 178)

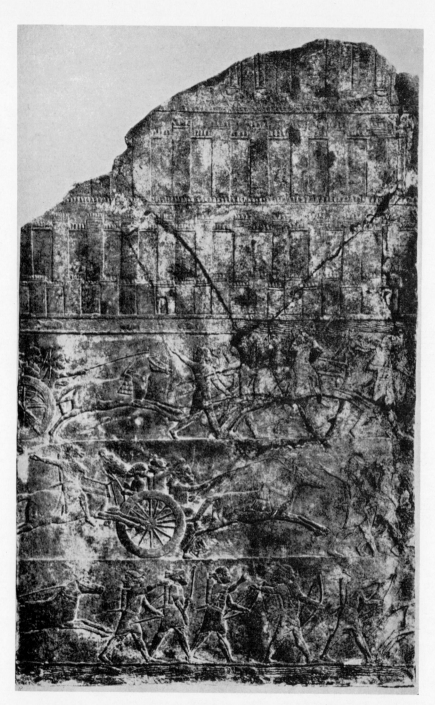

LXXVII. ELAMITES FLEEING PAST FORTIFIED CITY
(*page* 178)

developed further. Already on a remarkable relief of Sennacherib (Fig. 38) two superimposed town walls and a vertical row of soldiers leaving the buildings suggest recession. On another fragment[1] fugitives appear to be walking on a mountain contour line. This motif is repeated more plausibly in an Assurbanipal relief.[2] In Pl. LXXVIII, however, the looting soldiers are leaving the gate on a road, clearly indicated by a double line, which widens toward the spectator. The figures, it is true,

FIG. 38. *Looting soldiers leaving a City*

are clinging rather timidly to the boundary line, not walking in the middle of the road, but the effect of their marching downhill and *toward* the spectator has been unmistakably achieved by what is virtually true perspective.

However, as we said before, the greatest artists of the period merely arranged their scenes parallel with the observer; they also were great innovators in the matter of rendering space but not recession; dramatic space was what they aimed at and paradoxically this aim was not achieved with human figures in action, but with animals.

[1] Paterson, *loc. cit.*, Pl. 39.
[2] H. R. Hall, *Babylonian and Assyrian Sculpture in the British Museum*, Pl. XL.

Dramatic and Scenic Coherence

There is only one extremely 'human' scene of the king on his couch and a queen or concubine sitting upright on a chair at his feet, which also has an odd if restrained dramatic quality. The head of a slain enemy hanging in a tree near the musicians destroys the illusion of domestic bliss and gives to the festivity an overtone of cruel sensuousness.[1]

Otherwise it would appear as if commemoration of the same human, if unhumane, pursuits, the same patterns of warfare, repeated and elaborated now for centuries, must have wearied at least one artist whom we must consider the greatest of all. The historical epic was, as we saw, discursive and though astonishingly inventive in matters of detail, it lacked the very quality of all great art; being time-bound and space-bound, it never transcended the purely episodic. Throughout a period in which the violence of one small nation brought a staggering amount of suffering on countless peoples, pictorial art recorded battle after battle in a scenic display unhampered by metaphysical considerations, with a brutal secularity which, for all its freshness and vigour, had something shallow and naïve. Victory was a man-made thing, it was devoid of the symbolical quality which it had had before both in Egyptian and Mesopotamian art, and which it was to gain later on in Greece in a mythical form. And since victory was man-made and ephemeral, defeat also was a contingency; it lacked that touch of the tragic which gave to the Seti reliefs their peculiar dignity. The artist of the hunting scenes took up a motif as old as mankind and as unchanging; in doing so he not only displayed an astounding virtuosity in the handling of animal form, but showed that he possessed the emotional depth which could convey the tragedy of suffering and defeat, of desperate courage and broken pride.

There is nothing in these scenes (Pls. LXXIX–LXXXI) to detract from the actual or imminent disaster that befalls those who provide sport for the powerful. There is no indication of locality or background for these groups of hunted horses and gazelles, yet they form a coherent unit in a space we must conceive as a receding plain. The very emptiness makes them appear more vulnerable, more exposed. The gazelles grazing restlessly, warily, appear under the threat of imminent danger; the backward glance of the male leader gives a peculiar tenseness to their movement. In the group of wild horses the possible escape heightens the tension and lends a horrible poignancy to the mare looking back at her young. In the lion hunt disaster is inevitable; here the group on the right (Pl. LXXX) has no dramatic unity, each dying creature is alone in his agony, and this lack of spatial as well as emotional coherence is emphasized by the separate groundlines of the

[1] H. R. Hall, *loc. cit.*, Pl. XLI.

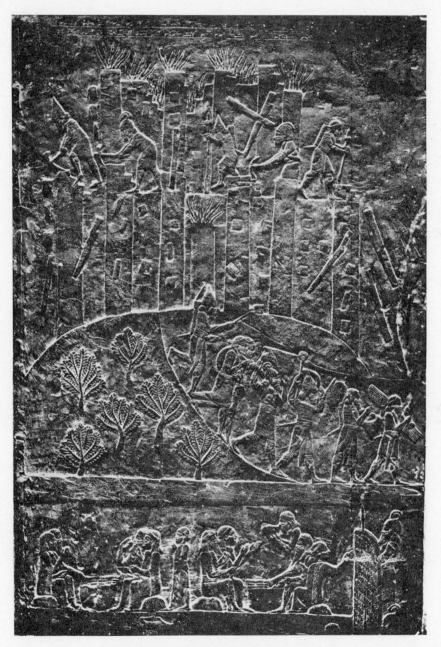

LXXVIII. DESTRUCTION OF A CITY
(*page* 179)

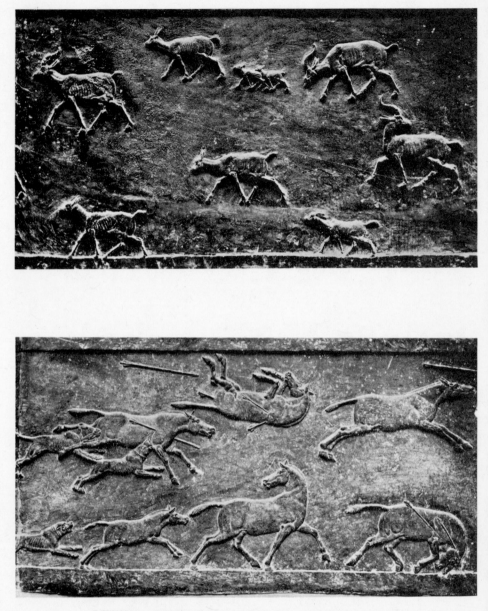

LXXIXA. HUNTED GAZELLES, ASSURBANIPAL

LXXIXB. HUNTED WILD HORSES

(*page* 180)

superimposed figures. The greatest dramatic intensity is reached not in the group where the royal chariot is attacked with mad fury, but on the right, where the battle is as yet undecided (Pl. LXXXI); a crouching lion and the terrified horse and his rider are separated by the most dramatic of 'significant voids' ever achieved in Near Eastern art.

It is strange to consider that shortly before the disastrous finale of the Assyrian Empire, the same people under whose dominion the world had shuddered brought forth an artist who revealed the depth of his fear and pity for these doomed creatures and raised his scenes to the stature of tragedy.

Assyrian art, flowering on the periphery of Mesopotamia proper, occurred on the very brink of a new era. Alien to the predominantly religious character of older Mesopotamian work, and bound, as no other form of art, to the secular power of single monarchs whose achievements it recorded, it vanished when this power was exterminated. One may well ask if not a vestige of its influence could be traced in westerly direction, toward the Greek world. So far this question can only be answered in the negative.

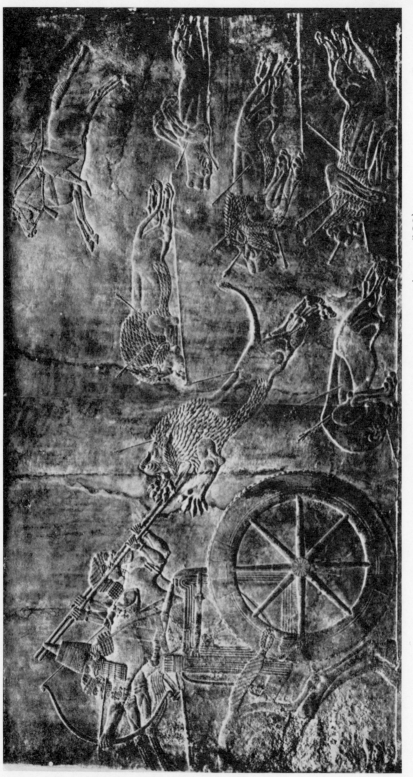

LXXX. ASSURBANIPAL HUNTING LIONS (*page* 180)

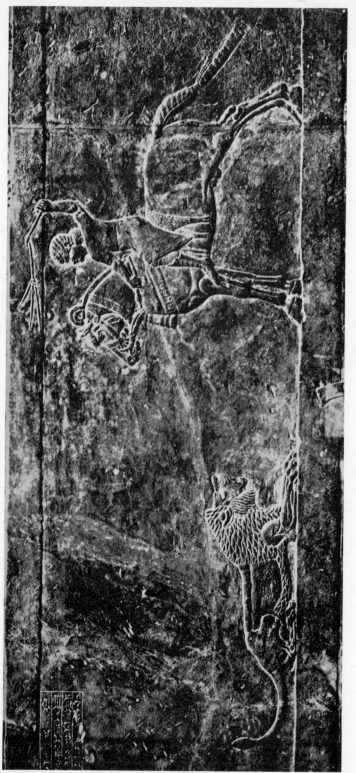

LXXXI. LION FACING HORSEMAN (*page* 180)

CHAPTER I

The Cretan Enigma: Homo Ludens

It was Professor Rodenwaldt who, in discussing the colourful remains of Minoan frescoes, first confessed that Cretan civilisation held for him the enchantment of a fairy world.[1] The phrase—echoed by at least half a dozen eminent German scholars—may seem a rather charming absurdity and yet it is illuminating, for it touches on a rare difficulty which a sensitive observer of Cretan art has to face: this art seems both more familiar and more alien than any we discussed so far and is part of a cultural life to which normal historical access is barred. The mass of archaeological data cannot yet be interpreted in terms of cultural history, and the aura of mystery surrounding a people whose art appeals to us but whose script we cannot read and whose language is unknown has hardly been lifted since it could be proved that practically all textual material we possess is of a legal or commercial nature.[2] Little understanding is gained by the knowledge that Rodenwaldt's fairyland was probably organised on strictly bureaucratic lines and was extremely preoccupied with matters concerning goods and ownership.

In the face of Cretan relics the enchantment and the wonder remain, the sense prevails of a world intellectually and morally beyond our grasp, a world sensuous, alive and yet elusive. What, then, is this puzzling doubt one feels, the suspicion that all scholarly methods are somehow bound to miss essentials so that even if we knew the factual history of this people—their political organization and religious practices, commerce, domestic habits and crafts—the secret of their values, the rewards of their existence might well elude us after all?

If we give ourselves up to the naïve enjoyment of what Cretan pictorial art has to offer: the passionate beauty of plants in bloom, of youths at their games, the delicate mysteries of subaqueous life, colour and movement—but movement even more than colour—seem

[1] G. Rodenwaldt, *Der Fries des Megarons von Mykenae* (1921), pp. 1, 60.
[2] *Palace of Minos*, IV, 2, p. 684 sqq.

to be the secret of our enchantment, and above all its naturalness, the beauty of its freedom. For even human beings here move with the joyous ease of creatures at play. Can it be that the faint air of unreality which so many of the figures have for us, and which Rodenwaldt seemed to hint at, is in some way related to the fact that we have lost the grace of serious play so that we look upon it charmed but doubtful as something incompatible with our maturer world?

We would be guilty of an even worse absurdity than Rosenwaldt if we were to overstress the playful character of Minoan culture on the basis of an uncritical experience of its art. Yet we shall find that the concept play may be more illuminating than appears at first sight. For the content of the scenes in fresco and relief, when compared with Egyptian or Mesopotamian work, is strikingly devoid of the peculiar seriousness which is theirs. Cretan artists not only revel in the beauty of natural forms; they also avoid depicting human achievement, whether in the modest sense of manual work—as in Egyptian tombs— or in the challenging one of battles won, political power asserted. They do not even boast of slaughter made in honour of the gods, or the building of temples. In fact, the lack of 'monumental art', so often emphasized by scholars who use the term more loosely then we do, is but a symptom of the very strangeness we are trying to define: Cretan civilization is unhistorical not only in the sense that the modern historian happens to be unable to write an articulate account of its past, a record in which events and personalities have name and character, but because it lacked the desire for monumental statement, pictorial or otherwise. We find no interest in single human achievement, no need to emphasize, to rescue its significance.

But if the scenes in which humans occur are thus devoid of this peculiar seriousness, they are by no means wholly frivolous, and here the concept play may be more than a tempting metaphor. I do not want to suggest that the action depicted pertains to that irresponsible world of play which feeds on the impulse of the player and dies with that impulse, a self-willed world under self-willed rules that can be called to life, annihilated, and revived at will. The acrobatic bull-jumping and the dances are neither irresponsible nor without function, for they are ritual acts, parts of religious festivals. And what distinguishes ritual from secular play is just the character of its seriousness.[1] We might speak here of objective, as distinct from subjective seriousness. For it is true that secular play also may be 'taken seriously', but its importance remains within the framework of a limited self-created

[1] See J. Huizinga, *Homo Ludens* (Haarlem 1938). This stimulating work is least satisfactory on the subject of ritual play.

Book III
CRETAN ART

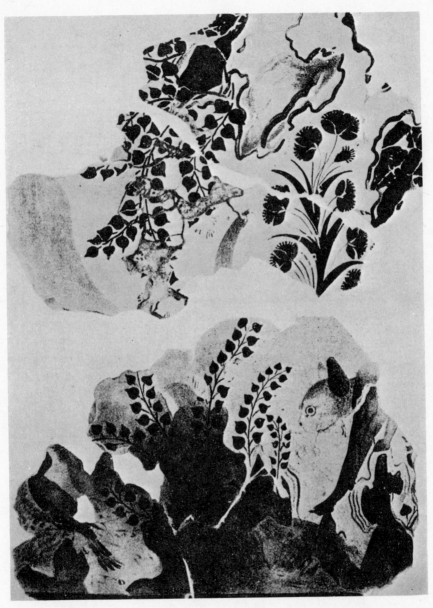

LXXXII. CAT STALKING BIRD, HAGIA TRIADA
(*page* 195)

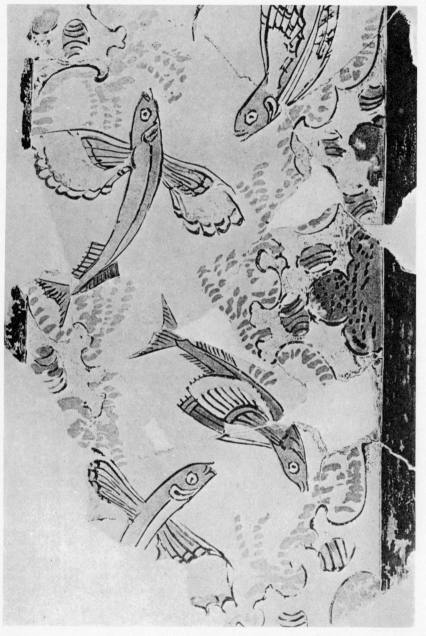

LXXXIII. FLYING FISHES, PHYLAKOPI (*page 200*)

world that can always be recognized as such. Even the values of such a play-world are fictitious, the skill and courage required never wholly valid outside the limitations of the game's concrete fantasy; a self-imposed conflict or problem, and an arbitrary solution or victory, are its scope. But for the participants of ritual games, contests, and dances these have an objective importance, for the issue is no more, no less than the problematic relation between human and superhuman forces, a problem mimed, that is, experienced and stated at the same time. Here the contest is not felt to be self-imposed but, as it were, forced upon the players; and victory or solution not a feat, valueless outside its own restricted sphere, but a significant achievement.

Significant, yes, but anonymous as far as the actors are concerned; and, as regards the action, representative rather than singular, for it lacks the uniqueness of historical achievement. Now it is true that all ritual acts are formal, repetitive, a matter of circumscribed movement; ritual play, however, differs in one respect from the acts of offering and adoration which we encountered in Mesopotamia and Egypt. In the latter instances human action, entirely formalized, is subservient to a religious event which transcends the action. In ritual play, however, the human agent entirely incorporates the event which depends dramatically on its action. Both secular and ritual play, therefore, have this in common, that whether they need physical courage and strength, or ask for grace and beauty, a certain self-centred pride of bearing, joy of movement, is their very essence. We shall have to bear this in mind when considering the problem of 'arrest and movement' in Cretan art, but, seeing the scarcity of factual data, I shall not venture on a more precise interpretation of the meaning of the scenes until we have understood more clearly the space-time character of the representation, thereby reversing the method used in the case of Egypt and Mesopotamia.

CHAPTER II

Complexities of the Cretan Problems: Crete and Mycenae

W e have, however, first to face a peculiar difficulty: the problem of Cretan art is closely linked with that of Mycenae and this complicates our approach in more ways than one. Crete, through its geographic proximity to mainland Greece and its cultural links with the Mycenaean kingdoms, has throughout been considered within the realm of Greek archaeology and has been subjected to the refined and scrupulous methods of an almost oversophisticated discipline. The memory of Cretan culture survives in classical times only in the form of myths and it is remarkable that the ambivalent attitude towards Crete which marks them is also noticeable in those scholars for whom the Greek world has in turn acquired a transcendent significance. The phenomenon of Cretan art has baffled, enchanted, and irritated in turn because it seemed preposterous that it should be the historical antecedent and yet the absolute antithesis of what is most deeply valued in classical art. Hence a certain self-consciousness in the scholarly approaches, efforts either to overpraise Cretan 'naturalism' and to link it with something similar in Greek art or to overemphasize its undisciplined waywardness and thereby to prove its utterly alien character.[1] In fact, the only comfort for the harassed Grecophile has been throughout that this strange island culture, so uncomfortably close, so mysteriously linked with the mainland, was not 'oriental'. Indeed it is not, even if the term should mean to us something more definite, more positive, than the stigma of massive barbarity.

[1] G. A. S. Snijder, *Kretische Kunst* (Berlin, 1936) gives a good summary of both trends. The Greek, or at any rate European, affinities of Cretan art were first stressed by Furtwangler, *Die antiken Gemmen*, III, 13 sq., and for a variety of reasons by Glotz, Deonna, Gordon Childe, Charbonneaux, Forsdyke, Matz and Schweitzer. The difference between Greek and Minoan is emphasized by Rodenwaldt, Praschniker, von Salis, Karo and Snijder.

Complexities of the Cretan Problem

But this very preoccupation with wider problems has been the reason why stylistic criteria have frequently been overburdened with cultural significance and since, as we saw, the Cretan remains float in a kind of cultural vacuum, more than one scholar has been tempted first to hypostatize their character as the manifestation of a *Kulturseele* and then to postulate a purely imaginary correlation between them. We fully realize the methodological difficulties but believe that a circular argument can be avoided if in interpreting the meaning of the scenes we err in the direction of the obvious rather than the speculative.

Unfortunately, however, even the best of intentions may well come to grief in the face of such extraordinary difficulties as the material presents. For the remains of mural frescoes and painted reliefs are very fragmentary and have been published in the form of ingenious reconstructions which are sometimes unsound; it is, for instance, sad to realize how much learned speculation has been wasted on a mysterious person called a 'blue crocus gatherer' who turned out to be a monkey.[1] Fragments of scenes in relief on stone vases often lack a clue to their interpretation, and in the case of glyptic, the mass of intricate imagery which would in any case tempt the most scholarly mind to fantasy, is shot through with specimens not found in scientific excavations. This is all the more serious since a number of these bought pieces have been accepted as genuine by Sir Arthur Evans and have been liberally used for the purpose of interpretation by others.

However, the elimination of such material and the risk involved of losing valuable evidence by being over-sceptical, are minor problems compared with one which cannot be definitely solved in the present state of our knowledge: that is, the actual relation between Cretan and Mycenaean works of art. Here again, scholarly chauvinism and the fact that the publication of the Mycenaean shaft graves was so long delayed, have added to the confusion of what is at best a baffling complex situation. Not until Professor Karo's standard work appeared[2] did there seem much reason to doubt that the majority of Mycenaean seals, gold cups, and daggers were Cretan imports—in fact, some undoubtedly are—and attempts to play up the merits of a Mycenaean style seemed at their best overdone, at their worst, perverse.

Yet, so cautious and unbiased a scholar as Professor Nilsson was amongst the first to warn—on general archaeological grounds[3]— against ignoring a difference in character between authentic Mycenean and Cretan material, and Professor Karo has now considerably sub-

[1] See J. D. S. Pendlebury, *The Archeology of Crete* (London 1939), 131 sq.

[2] G. H. Karo, *Die Schachtgraber von Mykenae* (München, 1933).

[3] Martin P. Nilsson, *The Minoan-Mycenaean Religion and its Survival in Greek Religion* (Lund 1927).

stantiated this view. Both have rejected, on very good grounds, the notion that Mycenae was a mere outpost of a Minoan empire[1] and have made a strong case for the assumption that Cretan artists working at Mycenae may have executed orders for their overlords and that their work may therefore reflect an alien influence. Without taking sides in the controversy about the hypothetical events which determined the political and economic relationship between Mycenae and Knossos, we have been forced to accept this view because it alone can account for the fact that there is both a similarity in style and a considerable difference in content between some so-called 'Minoan' imports found on the mainland and authentic Minoan material. This difference is, in my opinion, even greater than Nilsson and Karo have seen. I have therefore avoided—especially in dealing with religious and sacramental scenes—the interpretation of Minoan scenes by using Mycenaean material and vice versa. This practice has already caused a great deal of confusion, which we hope to eliminate by treating the Minoan material on its own merit alone.

[1] See also Helene J. Kantor, *The Aegean and the Ancient Near East* (Bloomington, Indiana, 1947), p. 62 sqq.

Pivotal Motion in Early Design

It will be necessary—as in the case of Egypt and Mesopotamia—to start with a short survey of early decorative art. It is true that in early glyptic few, and on early pottery no representations of figures occur, but the general character of this art can be shown to present a remarkable analogy to later developments. Here the subtle and conscientious work of Friedrich Matz[1] has contributed more than any other to the formal understanding of early glyptic and vase painting. Matz goes beyond the mere study of motifs and tries to find, by a comparative method which is far less esoteric than his abstract terminology suggests, what he calls 'stylistic principles' in the decorative treatment of given surfaces. These principles, he shows convincingly, differ in character from those underlying, for instance, the painted pottery of Susa or the patterns on early Egyptian seals with which he compared them. He found that in designing stamp seals[2] the Cretans, generally speaking, did not cut up a round surface lengthwise or crosswise, like the Egyptian seal cutter, nor did they treat a given circle tectonically by stressing circumference and radii as did the artists of the Susa bowls. The Cretans emphasized both centre and circumference and thus produced a circular and dynamic pattern, a whirling movement in the design. This corresponds with a preference for spirals of all types and in the case of animal figures with a curious spiraliform twisting of the bodies. Where human figures occur, these again have a certain mobile quality: spidery limbs fixed on to a triangular torso seem often pivoted in the centre and this, incidentally, appears a prelude to later types of figure drawing.

A different but related principle can be detected in the treatment of globular vase surfaces where, in a manner unexemplified in either Egypt or Mesopotamia (but occurring on the Greek mainland) the

[1] F. Matz, *Die Frühkretischen Siegel* (Berlin–Leipzig, 1928).
[2] Even in the case of cylinders the flat (not the cylindrical) surface was carved.

attempt is made to emphasize their roundness in a bold diagonal sweep. 'Torsion', as Matz calls it, is the key word to a design which is atectonic because it does not analyze the irrational curve in verticals and horizontals but grasps it directly in an oblique pattern which carries the eye up and down and around the surface.

On large flat decorated surfaces Matz detects a similar interest in atectonic coherence. Here he finds patterns, the movement of which can be followed in all directions. He calls the decorative principle of these 'unending *rapport*'.

FIG. 39. *Kamares Vase, Phaestos*

FIG. 40. *Kamares Vase, Knossos*

Matz's analysis is not only subtle but extremely interesting because the three principles—whirling movement, torsion, and unending *rapport*—seem interrelated, and one might be tempted to ask if similar principles could not be found in Cretan representational art also. Matz has wisely abstained from following up this question, which will occupy

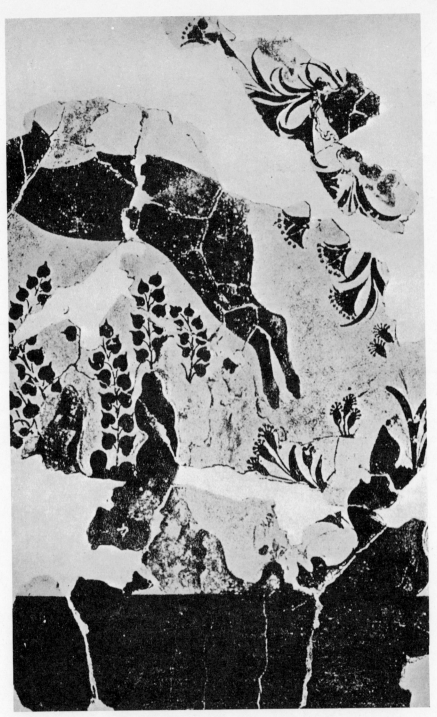

LXXXIV. JUMPING DEER, HAGIA TRIADA
(*page* 195)

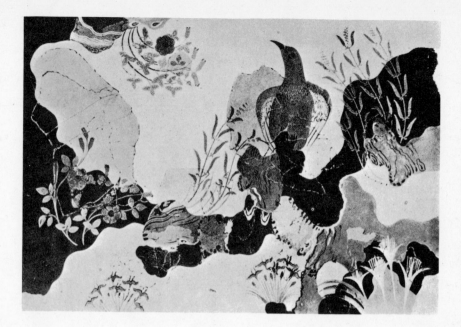

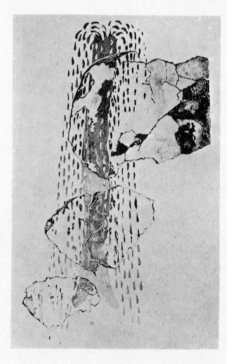

LXXXVA. BLUEBIRD, KNOSSOS

LXXXVB. FOUNTAIN, KNOSSOS
(page 195)

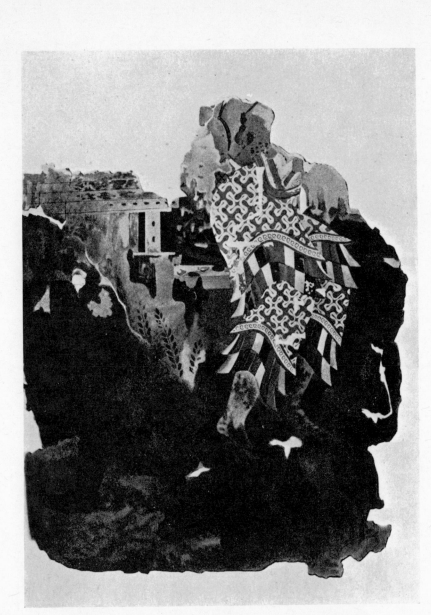

LXXXVI. DANCING WOMAN, HAGIA TRIADA
(*page* 198)

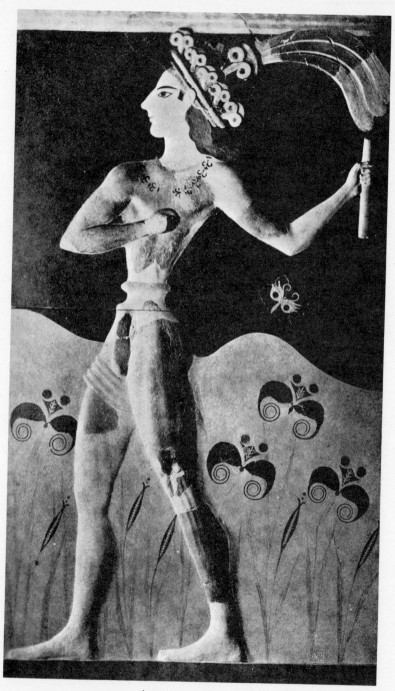

LXXXVII. 'PRIEST-KING', KNOSSOS
(*page* 199)

us in a different form later; his principles have not run away with him and he stops practically with the treatment of the so-called 'Kamares' ware, a very fine polychrome pottery which chronologically and stylistically just precedes the sudden efflorescence of scenic seal designs and fresco painting. The search for abstract decorative principles would seem here, on the face of it, absurd, for we find in Kamares ware throughout an astonishingly original but wilful 'free' design of multi-coloured motifs scattered over the surface: unconnected spirals, wavy lines branching out into droplike appendages and dotted rosettes. Scattered, yes, but not without a subtle sense of colour values and harmony of movement. For the Kamares artists delighted in 'moving' patterns, like scrolls and arabesques, and this not only makes for a dynamic coherence of disparate motifs but gives each one of them a curious independence as if they were charged with life. There is a sense for the organic even where organisms were not depicted, a tendency to make lines sprout from hollow curves as if from axils, to make them bend and thicken like leaves or curl like tendrils. There is also an increasing preference for rounded cell-like shapes. In some of the finest examples a balance of centrifugal and centripetal movement within the large roundish patterns makes the designs as irrational and as convincing as organic form (Figs. 39, 40).

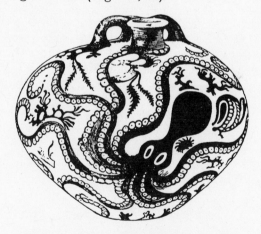

Fig. 41. *Vase with Octopus, Gournia*

In the later stage—after a short decline in the potter's craft when all artistic interest seems focused on scenes in mural frescoes and glyptic—plant and animal motifs appear in profusion. The choice of single motifs clearly shows a purely decorative intention: the tallness of a vase may be stressed by stems of lilies, the tentacles of an octopus embrace a globular vessel (Fig. 41); while the small nautiluses floating

apparently so unconcerned around the vase of Fig. 42 are carefully interspaced by patterns of rock, rounded and cell-like as amoebas and

FIG. 42. *Vase with Nautilus*

form with them a live decorative network in which an unmechanical 'unending *rapport*' can be easily detected.

Yet the same fine sense for organic form prevents these motifs from being subordinated to decorative function; they are not schematized, not dissected; singly beautiful, singly alive, each creature plays its part in a symphonic design.

CHAPTER IV

'Absolute' Mobility in Organic Forms

Cretan representational art bursts into bloom in the Late Middle Minoan period[1]; it then appears with startling suddenness in mural frescoes and in glyptic, probably slightly later on carved stone vases and in painted relief. Its period of efflorescence is surprisingly short; it fades as rapidly, as inexplicably, as sometimes the genius of a child prodigy. The comparison may seem forced but it is not altogether unjustified, for in Crete the best work shows a striking lack of development, in the sense of latent artistic conflicts solved, latent possibilities explored. The consequence is that we can rarely place single works, with any certainty, within the rough stratigraphical sequence, which is the only objective dating evidence at our disposal. In this sequence the so-called 'scenes of nature' appear before coherent scenes of action, but they may well overlap, and valid stylistic criteria for dating are lacking. All good work has spontaneity and daring; poor work is dull because it is repetitive. It is quite possible that every new artistic venture, early or late, had its mechanical aftermath, but one thing is certain: Cretan art could not survive on the strength of technical competence alone, as happened in some barren periods in Egypt; when life ebbed out of it, it disintegrated.

We shall, therefore, in dealing mainly with good work, frequently have to disregard moot points of dating and treat the material as one. If all the same we discuss the 'scenes of nature' first (Pls. LXXXII-LXXXV), this is largely because their startling originality has tempted critics to use terms which are confusing and ought to be eliminated.

The first reaction of those who, knowing Near Eastern and classical art, recognized the beauty of these paintings was one of utter amazement. From time immemorial man, not nature, had been—and would

[1] Snijder, *loc. cit.*, 27, has convincingly argued against the early dating of the so-called crocus gatherer.

be for millennia—the artists' main concern. Beasts and plants had served as accessories of man's pursuits, 'scenery' as a setting for his actions. But here nature was self-sufficient as pictorial content.

And this was not the only source of wonder: these frescoes are *paintings* in the modern sense of the word; the creatures, flowers, stones depicted, are part of a closely woven texture, the colouristic harmony of which defies analysis. We find, in fact, a type of coherence which is the very opposite of the deliberate clarity which prevailed elsewhere in the ancient Near East: of single figures painstakingly outlined in groups painstakingly composed. No wonder anachronistic notions occurred to those who were not satisfied by merely translating into a word picture the elusive charm of these scenes and who either talked rashly of 'naturalism' and 'landscape' or more subtly stressed the purely colouristic or decorative function of the figures.

Unfortunately, what seems most easily accessible in this art will prove most alien, so that our very criteria of judgment become useless. To speak of naturalism, for instance—that is, of a conscious interest in, and respect for, the appearance of the phenomenal world—may be tempting in the face of forms so buoyant with life, yet it means ignoring the fact that several of these forms cannot have been observed at all; blossoms and leaves of different plants have often been high-handedly combined, birds' plumage altered.[1] To speak of landscape may be equally tempting, yet this would make the term quite meaningless. True, all the requisites are there—plants, trees, rocks, watercourses (even a fountain occurs (Pl. LXXXVc)—but the essence of landscape, the rendering of natural phenomena *in space*, is lacking completely. Not only depth, but even up and down, from the spectator's viewpoint, are often ignored; rocks and plants above the central figure point downward while the spatial relation between figure and setting remains enigmatic. Figures appear to float—by no means *in vacuo*—but, as it were, suspended, caught, like a patch of colour in the centre of an intricate design. In fact, the more one tries to interpret these scenes in terms of naturalistic landscape, the more one is forced to admit also their decorative character, to the point where one might be tempted to treat the natural forms as capricious patterns only. Yet if these frescoes are not illusionary windows, conjuring up illusionary vistas, they are not like ornamental tapestries either, for they do convey authentic movement of beasts and plants in an authentic, if by no means articulate setting.

The tendency to overstress the significance of either content or form alone is particularly dangerous if scholars look for parallels outside the Aegean in order to throw some light on the strange phenom-

[1] *Palace of Minos*, II, 2, p. 454ff.

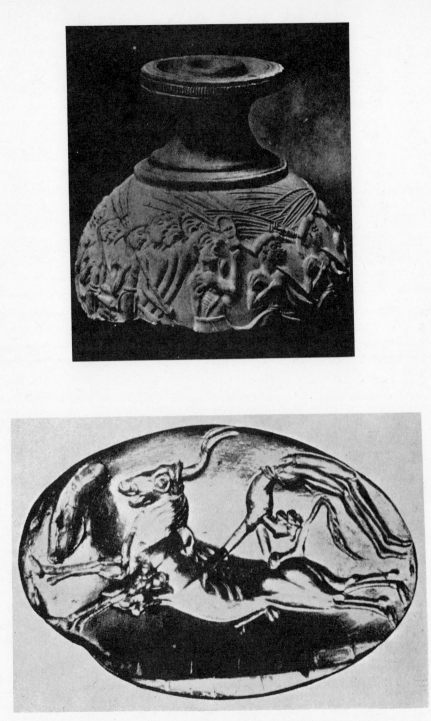

LXXXVIIIA. HARVESTER VASE, HAGIA TRIADA
(*page* 199)

LXXXVIIIB. RING BEZEL WITH BULL JUMPER, ARKHANES
(*page* 200)

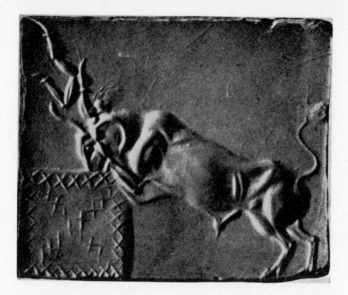

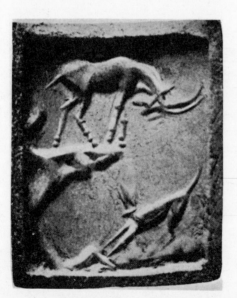

LXXXIXA. BULL AND MAN ON ENGRAVED GEM, KNOSSOS
(*page* 199)

LXXXIXB. DOG AND IBEX ON ENGRAVED GEM, KNOSSOS
(*page* 200)

enon of Cretan art: both China and Japan have been quoted. Such comparisons, however, are not illuminating, for neither Chinese nor Japanese art should be considered apart from its cultural context, and to speak indiscriminately of Far Eastern landscapes means to ignore the philosophic and nostalgic pantheism which permeates the one, the almost formal aestheticism which dominates the other. The poignant beauty of Chinese landscapes of the Sung period, for instance, lies in the fact that here, more often than not, the vulnerable finite world of man or beast is blended, in subtle contrast, with a mysteriously intangible, receding universe. In Japan, again, the reverence for the 'given' beauty of the phenomenal world by no means implies a simple love of nature but a deep concern with its transcendent significance. In the absence of cultural data it will be as useless to look for such complexity and depth in Cretan art as it would be to look for perspective in their scenes, the primitive character of which has been again and again stressed by sensitive observers.

On the other hand, it is not helpful either if another extreme of comparative method is used and this very primitiveness explained— as has been done by Snijder[1]—by postulating a peculiar type of visual memory which Cretan artists would have shared with palaeolithic man on the one hand and a modern mentally deficient child on the other.

An analysis of the space-time character of Cretan art has two advantages over this type of treatment: it can avoid interpretative speculation and yet need not ignore the representational content as such.[2]

Ludwig Curtius, in a fine poetic paraphrase of the scenes, characterized them as 'überhaupt Leben', life absolute.[3] The phrase might well serve as a motto for any treatment of Cretan art for movement, organic movement seems of its very essence: movement in beast or man, in wind-blown flowers with petals dropping, in the writhing stems of creepers clinging to rocks, even in the rocks themselves, which seem a substance barely solidified. But it is not with movement alone, but its peculiar character, that we are here concerned, and in order to define it we have to analyze the figures singly, consider the question of their mutual relationship, the coherence of figure and setting. The first question which arises, then, in connection with the single figure is this:

[1] Snijder, *loc. cit., passim.*

[2] Valentin Müller gives a careful analysis of Cretan ' Raumdarstellung' in his Kretisch-mykenische Studien, *Jahrbuch des Deutschen Archaeologischen Instituts,* 1925, p. 85, and 1927, p. 40; it suffers, however, from the limitation of a purely formal treatment and the result is a purely negative statement that Cretan art is 'Flachkunst'.

[3] L. Curtius, in *Die Antike Kunst* (Handbuch der Kunstwissenschaft), II, *Der Klassische Stil*, p. 64 sq.

has the structural complexity of these mobile creatures been grasped, their 'corporeality' in the widest functional sense been made explicit. The answer is that this is not the case and that—most strikingly in the earlier painting and glyptic—the functional relation between the different parts of the organism, the problem of the relation between it and the surrounding world have been largely ignored. If we are to characterize the type of movement in the fragments here depicted, the term 'absolute mobility' suggests itself. It is admittedly a logical paradox which could only justifiably be used in the case of amoeba and molluscs moving in the unresisting medium of aquatic worlds, or—at one remove—in the case of birds in flight. Yet the term suggests what we do, in fact, find in these scenes, namely, an unparalleled quality of freedom which not only transcends the limitations which a harsh, angular structure imposes on earthbound creatures, but even ignores their heaviness, their tensional relation with a resisting substance. In Cretan scenes movement seems effortless, a quality epitomized in the 'flying' gallop (most Cretan of inventions) and recognizable also in the 'floating' dancers whose feet hang limply, ineffectively, so that the swaying figures seem detached from earth, not even resilient (Pl. LXXXVI). The fact that Cretans rarely depict feet firmly striding but often more or less dangling, has been noticed before,[1] but it is equally remarkable that when they render a sitting figure it is—at least in the work of the best period—never immobile in the sense of rigid or relaxed nor does it ever rest on an identifiable solid seat. Most remarkable of all, however, is the fact that the Cretans sometimes depict their gods explicitly as airborne creatures, whose epiphany occurs in a birdlike descent with hair streaming upward and feet pointing down.

The term 'absolute mobility', therefore, is not a mere facetious paradox; it will prove a central concept, the implications of which will enable us to group a number of peculiarities in Cretan art in a way which makes them appear both coherent and significant. What we called the lack of harshness and structural clarity in organic form, for instance, is striking for Cretan figure drawing and modelling throughout, although this can be easily overlooked in cases where either the convincingness of the movement (such as the feline stretching of the catspaw in Pl. LXXXII), the contortions of the tossed youth in Pl. XCIVb, or a mass of surface detail make one forget it. Snijder, in an obviously biased but very shrewd analysis,[2] has shown how it is always the suggestions of rippling muscles rather than of bony frames and tendons which predominates in even the most detailed rendering

[1] Snijder, *loc. cit.*, 35 sqq. [2] *Ibid.*, 43 sq.

of human figures. But this negative judgment misses something essential, namely, the quality of unhampered movement which is the correlative of this lack of structural rigidity.

This unhampered movement, however, is 'free' in yet another sense; it is, namely, rarely functional, nearly always unrelated, is in fact self-contained, and we shall find that both formally speaking and also as regards the type of action chosen, the notion of self-containedness in movement will prove the key to much that appears enigmatic in the character of Cretan scenes.

As far as the gestures and posture of the single figure are concerned, each movement is apt to be balanced by a countermovement within the figure, which makes it appear self-centred yet never at rest. In the vast majority of cases, animals in 'flying gallop' have their heads turned back, whereby the forward impetus is changed into a circular twist. Nearly all human figures show what appears superficially a curious S-shaped outline or diagram; this is, however, by no means a mere idiosyncrasy of pattern, with stress on buttocks and chest, but a dynamic formula in which forward thrust and backward stance—or vice versa—are combined. This is particularly striking in the case of all sitting figures (Pl. XCIII), of dancers and wrestlers, but even the posture of the so-called 'priest-king' (Pl. LXXXVII) does not suggest a simple forward stride, and in nearly every instance of Cretan figure-drawing the union of an antithetical movement is emphasized by an extremely narrow waist which seems the pivot of a double volute.

Even in the case of a group of massed figures in movement, something similar can be observed. In the 'harvester vase' (Pl. LXXXVIIIa) the forward surge is not only counterbalanced by a forest of forks pointing backwards, but the upturned heads, the exaggerated lifting of the knees, makes the movement of these youths not that of marching yokels but as light and as complex as a dancer's.

An immobile standing figure is extremely rare; we have, in fact, only one good example in a scene which is also in other respects exceptional and which we shall discuss later.

Where the movement is not self-contained in the sense we indicated, other figures may provide the countermovement within the context of the scene, as for instance, in bull-jumping scenes, where the bull is invariably given in a flying gallop but the head is not turned back. Here the youths perform a salto in the opposite direction (Pl. LXXVIIIb). In Pl. LXXXIXa the diagonal posture of the bull suggests a slow lifting movement; this is counteracted by the downward slant of a man's violent assault, which remains scenically unexplained but creates a dynamically balanced design. The seals provide, in fact, a

number of instances where grouping seems to aim at a balance of movement and countermovement rather than at a scene of action, such as the flying fish in Pl. LXXXIII. The superb seal with ibex and dog (Pl. LXXXIXb), the only instance known of a topographically clear and plausible scene of action, manages to combine a tensional situation with a subtle form of antithetical (but by no means 'heraldic') arrangement which entails a circular movement in the design.

It is, of course, tempting to treat this and other instance merely as a decorative device, an attempt at creating a pattern. This is justified up to a point but, as so often happens when the pictorial content is left out of account, it ignores yet another and very remarkable aspect of 'self-containedness' in Cretan art, namely, the fact that actions are rarely purposeful and have their fulfilment in themselves. The flying gallop in animals means speed but not flight; it is hardly ever related to a hunting event; in fact, the absence of hunting scenes in Crete as compared with Mycenae is very striking indeed. We do find scenes of action in which more than one human figure is involved; these cannot be satisfactorily dealt with unless we touch on the vexed question of their significance and we shall therefore discuss them in the next chapter. But this much can be said already that in these scenes, usually religious dances, rites or games, the action is significant in itself, not subservient to an ulterior achievement or one which proclaims a single deed done. In mimes or dances each phase of movement is an act fulfilled and the climax is no more than a mere phase.

If we now turn from the problem of the single figure to that of the relation between figure and setting, the term 'absolute mobility' will prove to be illuminating in a rather unexpected way. For if we observe those very creatures to whom this notion does actually apply in their natural setting, then the similarity with Cretan art is most striking. Marine creatures are in actual fact surrounded by an unresisting medium and, if we observe them in their setting, vegetal and other forms may suggest a scenery, but this will never be an unambiguously three-dimensional world; it will remain not only haptically, but also in a sense optically impenetrable. Now if we were to characterize the relation between figure and setting in Cretan scenes of nature, we might well use similar terms; for here such figures as appear (roughly in the centre of the scene) are 'surrounded by' a profusion of forms, vegetal or other, that are neither a decorative foil nor a realistic setting, surrounded in a manner which eschews the hard facts of functional relationship. There is, for instance, no suggestion of a possible take-off—nor was there probably a landing—for the jumping deer of Pl. LXXXIV; we do not see where the cat's paw (Pl. LXXXII) is supposed to rest, or

what is the spatial relation between the bird and the rocks in Pl. LXXXV. There is no question of illusionistic recession, of creatures seen against a partly form-filled void, nor of the haptic clarity of near-view, that is, of plastic forms appearing in one plane. There is no near, no far, barely up and down. Such separable entities as occur in the form of single beasts, plants, and stones—though plants frequently seem to merge into one another—are caught in the web of a living world that has indefinite orientation and indefinite multiple relations. This is most striking in the scenes of nature, but even in scenes of action where, at any rate, the orientation of human figures is more definite; rocks may hang and plants may sprout from any point of the scene's enclosure and in the later frescoes a wavy pattern of stereotyped rocks may surround it like a picture frame. The suggestion of sur-roundedness is upheld throughout.

In glyptic, where we often find religious scenes, dances, and rites, the more precise, more plastic work of the seal cutter yet manages to convey the same sense of indefinite coherence, although by different means. In this case it is the disposition of the single figures (all in their 'self-contained' postures or acts) which gives the impression of a vague dynamic relation in an indefinite space. These figures are neither bound to the surface by a groundline nor is there any topo-graphic indication of a receding void. The gestures of the dancing women in Figure 43 which lead from one figure to another and dynami-

Fig. 43. *Dancing Women, Isopata*

cally underline the circular grouping, suggests a roundelay; but there is no attempt to define their relative position in space; they remain floating figures. We may find an indication of rocky soil in what can only be called the foreground of a scene (Fig. 44), but in these cases the scene itself is never held together topographically by it, as little as its unity is dependent on explicitly coherent action. It is interesting how critics have again and again spoken of sacred enclosures even in cases where no such thing appears, simply because in some subtle way the

201

FIG. 44. *Dancing Man and Women, Mycenae*

action of self-contained figures was yet made to appear dynamically coherent. Such stage props as are given—a sacred tree, altar, or shrine—are placed near the circumference and do not act as solid centrepiece. Action is never grouped antithetically on either side of a divine figure —in fact, such antithetical grouping seems alien to the character of Cretan art and only occcurs late and in foreign context (Fig. 45). Nor do

FIG. 45. *Goddess upon Mountain*

we find—except in the late tribute scenes—that the core of the scene is a dramatic confrontation. There is no greater difference conceivable than that between the arrangement of genii flanking the mythical tree of life in Assyrian reliefs and (in Fig. 46) the passionate movement

FIG. 46. *Dancing Man and Woman, Vaphio*

towards and away from the twisted olive tree which seems to join in the sacred dance. In the finest glyptic scenes the human figures move

independently yet harmoniously, and it is the aesthetic harmony of their movements which forms their bond. Yet here again, to treat the disposition of the figures as if it were merely dictated by the decorative demands of a circular filling means to ignore the possibility that the choice of this particular surface need not have been a contingency at all, that the nuclear character of the scene and the circular surface mutually required each other. However this may be—and we shall return to this question later—it is certainly striking that in the case of a vase (Pl. XC) and a rhyton (Pl. XCI) (where the harsh pointed shape may have suggested the use of registers or at least a horizontal band of figures) the result is unsatisfactory. In Pl. XC the unusual rigidity of the two figures fits the shape of the vase—if seen from one angle—to perfection, but it does not carry the eye round the surface as does the sweeping movement of the scene on the harvester vase (Pl. LXXXVIII). Something mechanical, repetitive seems to enter into the decorative scheme of those vases: the identical posture of the wrestlers on the one, the massed shields (or, according to some, the cowhide garments) of the other. We shall later deal with the famous Vaphio cups, found on the mainland, which both from the point of view of content and of movement in space cannot be considered typical, and may not be purely Cretan; and we shall now consider a most remarkable attempt at scenic coherence which we find in the so-called 'miniature' frescoes.[1] Fragments of these have only been found at Knossos and belong to the 'transitional' period; the scenes of nature apparently precede them there. In these fragments (Pls. XCII, XCIII) we can still recognize the attempt to render a vast and complex scene: a festive gathering for a ritual performance which includes the spectators, some in more or less amorphous masses, some displayed on a 'grandstand' with fashionable ladies conversing in their private boxes. The boldness of the attempt is staggering, although it must be considered an artistic failure. Formally the disposition of the figures is by no means unlike the scenes of nature, for the dancers are again 'surrounded by' the spectators in a way which lacks topographical precision. But here the similarity ends, for the very definition of the subject matter precluded the possibility of weaving a harmonious texture of living forms, and the complexity of the scene made it impossible to concentrate on the dynamic coherence of single figures. A mass of spectators is no more lively than frog spawn, and not even Cretan artists could make it pictorially interesting. It is astonishing to see, though, by what bold means they tried to enliven, to differentiate, such dull amorphous material: not only by 'shorthand' sketching-in of heads and limbs but, in the manner of true

[1] *Palace of Minos*, II, 585; III 46–65, Pl. XVI: II 66–74.

painters, by bold sweeps of different colours, red for male, yellow for female spectators. However, these attempts lack subtlety—in the scenes of nature rocks and stones had been more lovingly treated—and only in the preciosity of a conversation piece (Pl. XCIII) did the artist find more scope. The charm and liveliness of the *grandes dames* has often enough been praised; what mainly interests us here is that within the large, if small-scale scene, which lacks both colouristic subtlety and dynamic coherence—for even the dancers look scattered and forlorn—the nuclear treatment of a small group of sitting figures can again reveal what we found most characteristic of Cretan art. We cannot say how—not even clearly *where*—these figures are seated; they are apparently neither looking at the dancers nor at each other; each graceful gesture is as little purposeful, as self-contained as a dancer's, and it is the harmony of these movements which creates the unity of the scene.

We said at the beginning of this chapter that the span of life of Cretan art was short. We might ignore the careless flabby work of the late period but for the fact that the symptoms of decay show up most clearly in the loss of 'absolute mobility' and all its space-time implications. Figures are no longer self-contained in act and posture, no longer pictorially integrated—in however vague a manner—with a surrounding living world. The use of registers and mural friezes leads to the use of groundline and this impairs the freedom of nuclear movement in an amorphous setting. We now find tribute bearers marching in file, endlessly repeated.[1] Instead of scenes of nature used as decoration, we find human forms subjected to the discipline of a decorative pattern, subservient to a mechanical rhythm. We even find a large religious scene in fresco, but life and movement have gone out of it; the vibrant quality of the early glyptic scenes has faded into a dull confrontation of seated figures—truly seated this time.[2] On a probably contemporary seal we see, not participants in a sacred dance, but the standing figure of a goddess stiffly perched on a mountain top and flanked by lions, antithetically arranged (Fig.45), in fact both a simple confrontation of figures and a heraldic grouping of animals begin to prevail in glyptic art.

To state these changes means to raise a number of unanswerable questions; we have no clue to their cultural implications nor to the historical events which accompanied them. The problem of decay in Cretan art, however, has a peculiar fascination: it forces our attention back to the short period of its bloom, to ask where lay its strength and

[1] *Palace of Minos*, II, 2, 704 sq., Pl. XII.
[2] *Ibid.*, IV, Pl. XXXIa.

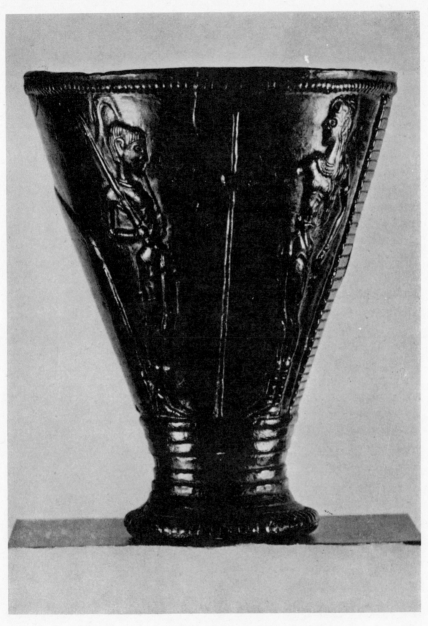

XC. STEATITE VASE, HAGIA TRIADA
(*pages* 203, 207)

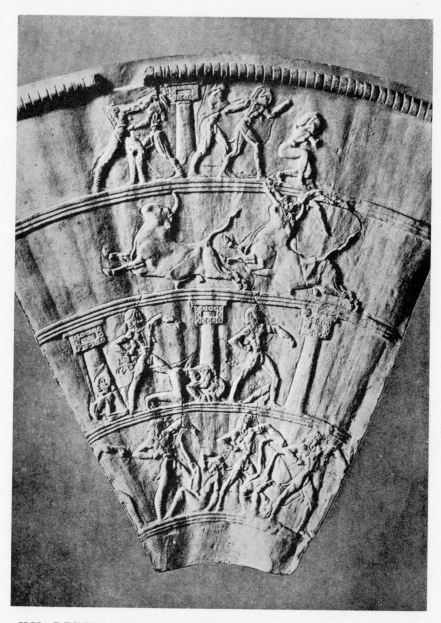

XCI. DEVELOPMENT OF RHYTON WITH BOXING AND BULL
JUMPING SCENES, HAGIA TRIADA
(*page* 203)

where its weakness. To ask this means to face a problem we have avoided so far: the extremely controversial topic of Cretan religion. To deal with it exhaustively is outside the scope of this essay. Moreover, on major points differences of opinion among scholars are still appalling. All we can do is to consider those aspects which seem relevant for the art of a very short period in Cretan history. This means that we shall leave out of account a number of monuments which for the historian of religion are most important, for it is paradoxical that only with the decline of Cretan art (which was, as we shall see, essentially religious art) articulate religious scenes (in the sense of elaborate ritual and the confrontation of man and god) begin to predominate. Our main concern must be to search for the meaning of scenes which, though most original as works of art, are less explicit. That the answer can be no more than tentative and vague does not relieve us from the necessity of considering Cretan art also as significant form.

CHAPTER V

Mystic Communion and the Grace of Life

When, in our introductory chapter, we surveyed the extraordinary difficulties which the Cretan material presents, we suggested that the concept 'serious play' might prove illuminating. It will, but only indirectly, not if the term is used as a catchword or a stamp with which to force a spurious similarity on a variety of content. In Cretan representational art the scenes fall roughly into two groups and these have on the face of it a completely different character, namely, religious scenes, concerned with ritual acts, and scenes of nature, in which human activity is disregarded.

We shall for the present leave the latter out of account, for we shall find that an interpretation of the religious scenes will throw some light on their significance. Moreover, it will be necessary first to amplify our statement that the other scenes all have a religious character; no less a scholar than Professor Nilsson has expresssed strong doubt on the subject.

Now it is unfortunate that most treatments of Cretan religion which are based on the monuments suffer from two defects: a tendency to rely on Greek mainland material for interpretation and a reluctance to accept Cretan evidence at its face value.[1] We saw already that the enigmatic role played by the Mycenaean kingdoms in the history of Crete accounts for the first. The second defect can only be explained by anticipating our results: Cretan religion is in many respects a unique phenomenon and as such almost defies understanding. Hence a tendency amongst scholars either to look for more familiar Near Eastern parallels and to hail them without enquiring if they really elucidate the stranger aspects of the Cretan material, or to explain away this strangeness in terms of modern common sense. This is the reason why we find again and again that an Asiatic type of mother-goddess of the

[1]Hence the almost ludicrous difference of opinion among scholars in the interpretation of details.

Ishtar type—with or without son-lover—has been foisted on the Cretans or that their 'bull sports' have been treated as if it were a football game.

At the risk of falling into the opposite extreme, I intend to isolate the Cretan material rather than to link it, at all costs, with the Asiatic or European mainland. In either case a comparative method is needed, but we have found that contrasts are more significant than similarities in trying to find a clue to the character of this strange island culture.

We shall, then, before we discuss particular types of Cretan scenes, point out some remarkable differences between the subjects of these and of Mycenaean work, both in painting and glyptic. We saw already that, as compared with Egyptian and Mesopotamian art, there is a marked absence of any monumental intention in Crete; compared with Mycenae there is a lack of purely secular motifs as well. Authentic warlike scenes occur in the Mycenaean shaft-graves but not in Crete, where we find only one, probably a late instance of a bearded alien holding a bow on a vase fragment.[1] The well-known scene (Pl. XC) of a young 'prince' confronting what is usually called an 'officer' and a row of shield-bearing 'soldiers' has in all probability not a secular but a sacramental significance. Already Evans pointed out[2] that the so-called 'officer' holds a ceremonial sprinkler and, according to K. Mueller, the supposed shields should be interpreted as stiff cowhide garments used in a religious ceremony.[3] Whether or not this interpretation is a correct one, we must admit that the scene, in contrast with most other sacred imagery in Crete, is not self-evident, and that both as regards the content and the manner of representation it is exceptional. The fragment of a miniature fresco which renders 'the captain of the blacks'[4] running in front of his troops seems anything but warlike. All the same, another fragment showing massed figures probably holding lances has been promptly explained as 'soldiers hurling javelins in an attack',[5] whereas the most likely interpretation is in either case a march or processional dance such as we find on the famous harvester vase, but in this case performed by soldiers. Evans based his interpretation on an authentic scene of war which occurs on a silver rhyton found at Mycenae.[6]

Equally striking is the almost complete absence in Crete of hunting

[1] Maraghiannis, *Antiquités Crétoises*, II, Pl. 50; Kurt Mueller, Frühmykenische Reliefs, in *Jahrbuch des Deutschen Archaeologischen Instituts*, 1915 (30), 242, does not consider this scene Cretan but foreign import. The Zakro seals, *Journal of Hellenic Studies*, Vol. XXII (1902), Pl. VI, nr. 12, 13, are not scenes of combat, there is no indication of arms.

[2] *Palace of Minos*, II, 792. [3] Kurt Mueller, *loc. cit.*, 246.

[4] *Palace of Minos*, II 2, p. 755, Pl. XIII. [5] *Palace of Minos*, III, 81.

[6] Karo, *loc. cit.*, Figs. 83 ff.

scenes,[1] which abound in Mycenae, and of armed combat between individuals such as we find on at least one Mycenaean seal[2] In Cretan scenes of nature animals are not subjected to a secular pastime, while such fighting scenes as occur have invariably a pugilistic character (Pl. XCI), not that of deadly serious encounters. We shall see later that this by no means implies that they should be considered mere sport in the modern sense of the word.

As regards scenes occurring in Crete but not on the mainland, one of the most remarkable differences—although it is generally glossed over—lies in the fact that a favourite topic of Cretan artists, namely, the acrobatic bull-jumping, does not occur on the mainland at all. This game entails a somersault lengthwise across what has been usually considered a charging bull, with the horns used as levers and performed by boys and girls alike. Sir Arthur Evans, when asking the opinion of an expert on American rodeo performances, must have been rather astonished to hear the verdict that the feat was considered impossible: to seize the horns of a charging bull would not only be suicidal, the impact would be too great—it would not be possible, for a bull charges head sideways, with one horn close to the ground.[3] Now it is interesting that in the bull-jumping scenes the Cretan bulls were pictured in pure profile and in a flying gallop—this had soon become a stereotyped mannerism with Cretan artists—but *not* in the act of charging. For since a bull charges with its head turned sideways and since—as we saw—a round or even a backward twist of the head was a much favoured device in rendering animals in motion, we can be almost certain that this would have been used if a charging bull was meant. The leap seems therefore to have been performed over comparatively peaceful beasts, holding their heads straight; the danger of a sudden assault would then have made it a sufficiently exciting game.

Now bull acrobatics of this type are conspicuously absent from the mainland repertoire, and the famous Vaphio cups, found in the Peloponnese, picture an entirely different subject, namely, the catching of bulls. On the one cup this is done by peaceful means—the bull is lured by a cow (Pl. XCIVa). In this case the interpretation is admittedly uncertain; it is conceivable that the beasts are merely pictured free in nature, but the first interpretation is at least possible and would form a parallel to the one on the second cup. Here we see one bull caught in a net, one apparently in the act of escaping, a third (Pl. XCIVb) in the act of charging, head down and sideways, and tossing a youth. This boy

[1] Matz, *loc. cit.*, 17, enumerates the very few exceptions. Interesting is, for instance, the lion hunt seal (P.M. IV, p. 547 Fig. 508) where the action of the hunter is unconvincing and the lion extremely badly drawn.

[2] Karo, *loc. cit.*, Fig. 87 [3] *Palace of Minos*, III, 212.

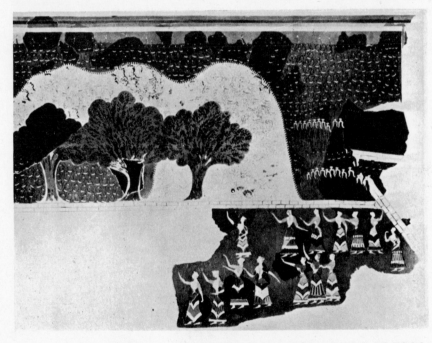

XCII. SPECTATORS AT PERFORMANCE, MINIATURE FRESCO,
KNOSSOS

XCIIA. RECONSTRUCTION OF DANCE AND SPECTATORS,
KNOSSOS
(*page* 203)

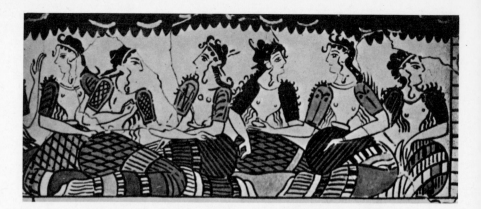

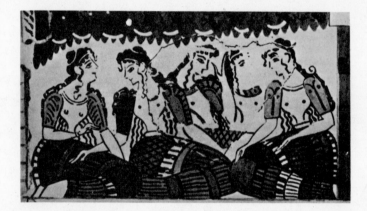

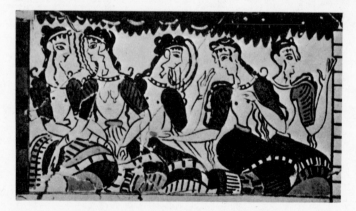

XCIII. DETAIL FROM PL. XCIIA
(*page* 204)

grabs the ear—*not*, it should be noted, the horns—of the bull, while another falls lengthwise in a posture that does not suggest even a failed somersault. The work is certainly Cretan in style. It is, for intance, striking how beautifully plausible the twisted figure of the tossed youth appears until one attempts to analyze it, when one finds —as in the case of the stalking cat—that it is structurally obscure. On the other hand, the scene is not completely Cretan: the clarity of the spatial setting, the diagonal contour lines by which the soil has been indicated and a functional relation between the receding scene and the spectator has been more or less successfully achieved, are quite unusual. More unusual still is the fact that here the figure of the falling youth repeats the movement of the bull instead of creating a countermovement. And, most important fact of all: that the subject of the scene is un-Minoan. If the cup was made by a Cretan artist, the remarkable concreteness and vigour of the rendering may well owe something to the fact that in this case it was a fresh topic suggested by or chosen for the sake of those to whom bull-acrobatics were either alien or meaningless. In the case of the Vaphio cup the charging bull was victorious; not so on the two feebly drawn Mycenaean seals[1] which show a particular type of bull-catching proper, namely, the rather brutal trick, later performed in Roman arenas, of violently twisting the neck of a galloping bull in order to make him powerless or even to kill him. There are parallels for this *tour de force* both in Thessaly and Asia Minor, which Sir Arthur Evans has duly noted,[2] but this game obviously differs completely from the Cretan one, so that the absence of the latter on the mainland, of the former in Crete, is extremely significant. It is unfortunate that an exceedingly bad and confused rendering of a man and a bull in a circular seal composition[3] and also the seal we pictured in Pl. LXXXIXa and which shows no plausible likeness to a real bull-catching scene at all, have been used as evidence for the occurrence of such scenes in Crete and that on the basis of this Persson calls the feat of twisting the bull's neck and maybe killing him 'the climactic feat' of the acrobatic game.[4] We do not know of any such climax and the only evidence we possess for the killing of bulls other than for sacrificial purposes and by a figure clad in the acrobat's attire, is a scene on a Thisbe seal[5]—here the bull is killed by a dagger in the manner of Spanish bullfights—and the Thisbe seals which were bought, not found in sites, are, we think, extremely unreliable evidence. Bulls were sacrificed, as we know from one Mycenaean and one stylistically

[1] *Palace of Minos*, Fig. 162, 164a. [2] *Ibid.*, 229 sq.; P.M. IV, 23, 45.
[3] *Ibid.*, III, Fig. 163.
[4] Axel W. Persson, *The Religion of Greece in Prehistoric Times*, p. 96
[5] *Palace of Minos*, III, Fig. 160, IV, Fig. 542b.

late Minoan seal and from the late sarcophagus found at Hagia Triada. But there is no ground whatever to connect these scenes with the bull sports.[1]

If, then, we eliminate spurious similarities, the singular character of the Cretan bull-jumping scenes stands out more clearly and the question is all the more insistent whether or not we are justified in calling them 'religious'. To deny the possibility that they had a ritual significance seems unwarranted. Even spectators of modern Spanish bullfights admit that a strange quality of potent ritual, no longer understood, is the main secret of their fascination. Moreover, mythological and folkloristic evidence points in the same direction. In ancient times all games that formed a part of large-scale festivities were serious, ritual games. W. B. Kristensen has shown this to be true even of the Olympic games and Miss Levy has convincingly proved that the touching of a bull's horn formed part of an ancient tradition of fertility rites.[2] Moreover, classical myths do not suggest that the Cretan bull was an object of playful sport. In the face of all this evidence Nilsson's doubts[3] seem an almost perverse scepticism, which balks the approach to any form of understanding. Only if we recognise the seriousness of the game, the numinous quality of the bull (which is entirely lost in the realistic treatment on the Vaphio cup) shall we grasp the meaning of such confident and playful sport with death in order to increase life's potency. In this strange rite, a bold and graceful leap over a creature embodying terrifying power, the tragic climax of sacrifice appears redundant; brutality and fear have been transcended.

Once this is realized it need no longer astonish us that bull-jumping and wrestling occur side by side and that in either case the so-called 'sacred pillars' (which are frequently associated with religious representations in a narrower sense) may occur in the context of the scene. In fact, there is no reason to disagree with those who argue that also in the pugilistic scenes we have to deal with serious games not unlike the agones of classical times. And seeing that the main preoccupation of the artists was with religious, or at any rate ritual subject matter, it becomes even more significant that the mercilessness of hunting scenes or the tragic realities of battle are absent. But one objection should be

[1] For lentoid bead seal in Candia Museum see Nilsson, *loc. cit.*, 162. Nilsson notes that in neither of the sacrificial scenes does the double axe occur; we therefore need not assume that it was used to kill the bull.

[2] G. R. Levy, *The Gate of Horn*, 229. It should be noted that although the touching of the horns and the jump across the bull also occur in the Gilgamesh epic, they are here the preliminaries of a violent assault on the animal. The main point of the story here is the killing of the bull. Instead of using this as evidence for a sacrificial sequel to the bull sports, it might be used to throw the original character of the Cretan games into relief.

[3] Nilsson, *loc. cit.*, 322.

countered. We saw that in the miniature frescoes a grandstand and a mass of spectators were pictured. At least in one set of fragments the centre of the performance was a group of dancing women, but it can be argued that the same type of arena was used for bull sports and competitions. If these had a religious implication, is it conceivable that the scene was pictured in a way which took in the spectators as well? Or should one suspect here a kind of *fin de siècle* frivolity which no longer laid the emphasis on the main acts? Here again all that is needed for our understanding is to stress the singularity of the phenomenon by taking it at its own specific value, which is radically opposed to what we have learned to take for granted in neighbouring countries. For elsewhere in the ancient Near East we find invariably in religious scenes a careful rendering of single figures, in actions and attitudes traditional, prescribed, and most frequently a confrontation between priest or king or god. The comparison with Egypt and Mesopotamia is, however, misleading, for what was pictured in Crete reflects a different type of religiosity altogether. It is entirely justifiable to see in these festive gatherings something more in the nature of mysteries or sacred mimes—for even games may have a mimetic character. In that case they would be less acts of devotion than of participation in a numinous and beneficent event. In such—as in all dramatic performances—actors and spectators mutually require each other; the former may vicariously represent an occurrence of transcendent importance, the latter by their very presence affirm the signficance of what can only be thus expressed and shared. The difference between such religious events and those which in Egypt and Mesopotamia are reflected in the so-called 'dramatic texts'[1] (that is, texts recited and partly acted by priests within the temple enclosure on particular occasions) is probably this: that the former are less articulate, less concerned with dogma and more akin to magic-religious practices. It is a difference comparable to that which exists between the act and recitation of a Catholic mass (which has a dogmatic connotation) and the sacred procession or the mystery plays.

Some glyptic scenes bear out our assumption indirectly, although the religious acts depicted do not pertain to ritual games in the narrower sense and may not have had the character of a public event. In fact, it may be significant that the particular scenes we refer to only occur in glyptic whereas on the whole the repertoire of glyptic and painting shows great similarity. But seals have, apart from their eminently practical function, served as a kind of amulet as well. It is

[1] See Kurt Sethe, *Dramatische Texte zu Altaegyptischen Mysterien Spielen* (Leipzig, 1928).

211

therefore possible that some purely religious imagery—such as the epiphany of a god or goddess or acts not commonly shared—would only appear on these small objects meant for the private use of religious or semi-religious functionaries.

It is obvious that in trying to interpret the glyptic scenes, we can only touch the fringe of the problems involved. Even so, we shall have to avoid a number of pitfalls; there is first of all the danger of using later seals for the interpretation of earlier ones; secondly, that of treating contemporaneous but alien Mycenaean work as authentic Minoan[1] and, finally, such prejudices as that in Cretan art as elsewhere a god or goddess can be expected to preside over all ritual acts.

As regards the dating difficulties, it is well known that stratigraphical evidence is particularly unreliable in the case of small precious objects which get easily lost and may have been handed on for generations. Since there exists to date no critical re-examination of the material, Sir Arthur Evans' admittedly rough chronological grouping is all we have to go by. We would like, however, to make two reservations: rigid antithetical grouping is not only conspicuously absent in earlier seals but so alien to the stylistic character of the best work that it seems warranted to call them late, especially since in at least one instance (Fig. 44) the figures thus arranged are lions, which, though common in Asiatic and mainland imagery, do not, as we saw, occur in the Cretan fauna. Similarly we should be inclined to date the seals which show a tribute scene (that is, an adorant holding a rhyton or other vessel and facing what is probably a goddess) to a fairly late period, firstly because the fresco of the well-known cup-bearer, dated by Evans to Late Minoan I, already shows definite signs of decadence;[2] secondly, because the rigidity of the confrontation is characteristic of Late Minoan and also more explicit ritual scenes.

Both the second and third difficulties, however, make themselves unpleasantly felt at the beginning of our discussion, for it has almost become a habit among scholars to take as starting point a magnificent Mycenaean ring bezel (Fig. 47) contemporary with the best work in Crete which represents a goddess seated under a tree and facing adorants or acolytes presenting poppies. Above the scene but quite unconnected with the main activity is the figure of an airborne divinity in the act of descent. That the drawing of the seated figure is Cretan in style no one would deny, but for the scene itself we find no parallel in Crete what-

[1] Even Karo, *loc. cit.*, 331 sq., maintains that the material is indistinguishable.
[2] Here the matter is somewhat less certain because there exists a fragment of a steatite vase of fairly good workmanship which shows a similar scene (*Palace of Minos*, II, 752, Fig. 486). The fragment is, however, too small to enable one to judge the style of the scene.

ever. Sacred trees do occur but never do we see a goddess seated underneath. There is apparently one exception: on a small seal from Mochlos both a tree and what is presumably a goddess are pictured in a boat; no adorants are present.[1] This quite exceptional scene may refer to some mythical event, but it cannot be compared with the scenes under discussion. Moreover, a closer examination of the Mycenaean seal makes it clear that the stiff posture of the standing figures is definitely un-Minoan, that we have no parallel for the use of poppies as religious offering except in classical times in the Demeter cult, and that it is strange, to say the least, that the epiphany of the god or goddess behind the shield in the left top corner should occur behind the back of

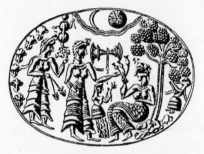

Fig. 47. *Religious Scene, Mycenae*

the adorants. In fact, if we were to characterize the scene we could do no better than use the words of Nilsson, who called it a kind of pantheon,[2] the summing-up of a religious repertoire. Now if such a representation were made for the ruler of a related but not an identical cultural community—and we discussed this possibility before—then it would of necessity have to be fairly explicit and might well be incoherent. It is, however, exactly in the matter of pictorial coherence and of a peculiar lack of explicitness where the divine figures are concerned that the character of the Cretan seals proper shows up most clearly.

The Cretan material is admittedly scanty but remarkably homogeneous if we consider those specimens which belong stylistically to the best period. In it we included the seal found on the mainland which we discussed before (Fig. 46) because both in the drawing of the single figures and in their spatial disposition it has striking Minoan parallels. We exclude, however, a ring bought by the National Museum of Copenhagen, since the doubt expressed by Nilsson about its genuineness seems fully justified.[3] The figures kneeling in adoration are indeed a serious anachronism in what must be judged otherwise a clever fake.

[1] *Palace of Minos*, II, Fig. 147a.
[2] Nilsson, *Minoan-Mycenaean Religion*, 348. [3] Nilsson, *op. cit.*, 241, n. 1.

Now if the scenes we have reproduced in Figures 43, 44 and 46 had been considered by themselves, then I doubt if unbiased scholars would have attempted to identify any one of the figures as the representation of a goddess, for there is nothing in either size, gesture, posture or attribute which would single them out. We see a number of figures engaged in a ritual dance or act which in some cases appears to culminate in a violent gesture with which a sacred tree is touched. Where, as on the ring of Isopata (Fig. 43), no tree occurs, the movement is more restrained. If we do not arbitrarily single out figures from what are pictorially coherent groups engaged in similar action, then we must admit that however elusive the meaning of their gestures, however indefinite their actual relationship, what is rendered is a concrete, not a symbolical situation. It may be objected that in some cases the epiphany of a divine person has been unmistakably rendered, namely, where the small rigid figure of an armed youth—armed as a hunter not a warrior—appears in the act of descending from the sky above the actual scene.[4] It is uncertain if the tiny figure in a bell-shaped skirt at the top of the ring from Isopata (Fig. 43) must be considered a female equivalent. If so, this strengthens our contention that the divinity does not take part in the action of the scene but quite literally transcends it.

One must admit that it would be difficult to conceive a more dynamic representation of a religious event, nor one in which the relation between the human and the divine world is further removed from all known Near Eastern conceptions. Here usually the god looms large in symbolical acts or as the focus of sacrifice and worship. But in these Cretan seals the pictorial emphasis is entirely on the human agent; the actual presence of the god may be manifest in sacred trees, altars, or stones, or in a vision of his airborne descent, but it is dynamically revealed in the swaying of the worshipping figures, their raised hands; divine presence means here a mystic relationship which entails communion, ecstasy, sometimes epiphany.

It has often been a source of astonishment that in the vast outlay of luxurious palaces, such places of worship as could be identified were insignificant and the sacred objects found there are almost absurdly primitive—for the more elaborate faïence figures holding snakes may well have been priestesses or votaries. Centres of worship in Crete were mountain tops and caves, as a profusion of votive objects shows. In fact, one is, in dealing with Cretan religious phenomena, forcibly reminded of what characterizes mystery religions elsewhere: the central figure is both elusive and ubiquitous, the worshippers experience the

[4] Nilsson, *op. cit.*, 506.

XCIVA, B. GOLD CUPS, VAPHIO

divine presence through action, dynamically. In this case the experience need not have been orgiastic; it need never have lacked in Crete the dignity and the restraint of form. Comparisons, in any case, are dangerous, for whereas the matter of death and the renewal of life lies at the root of nearly all mystery religion, here the central concern may have been more the mystic intensification of the experience of life than the transcendence of death, as we shall see.

We said that the central figure was elusive; now it cannot be denied that in Crete the image of a goddess does occur in tribute scenes (even if on stylistic grounds we have to assume that this was fairly late) and that such a formal confrontation of man and god is incompatible with the notion of mystery religion. It is, of course, conceivable that gradually in Crete—in art as in worship—a change in the direction of the formal took place. But if we compare these tribute scenes with similar ones in Egypt and Mesopotamia the difference is very striking. In the Cretan scene goddess and tribute bearer or adorant, the one a powerful and vital presence, the other in an attitude which holds the balance between pride and awe, between self-assertion and self-abandonment (see Fig. 45 right), are united in a situation which recalls the mystic experience of an epiphany and which perhaps for that reason could so often dispense with symbolical trappings. For it should be noted that the goddess lacks qualifying attributes or emblems. In fact, although Nilsson's scepticism as regards the concept of the Cretan mother-goddess may go too far, he gave timely warning against rash comparisons with Near Eastern goddesses whose attributes are known and whose character is often more or less circumscribed by myth. The Cretan goddess is unlike the rather savage hunting goddess carrying her quarry which is found on Greek mainland seals.[1] If she was ever conceived as a life-giving mother it is striking that no infant ever accompanies her—for any attempt to associate with her the small figure of a male god is unwarranted on the basis of the Minoan material alone. Only on a Mycenaean ring of poor and not typically Minoan workmanship are these two figures confronted and appear to touch hands. Nor is she associated with the perennial care of flocks and harvest in this geographically sheltered, climatically favoured island. If therefore on a late seal she appears flanked by lions it looks as if Asiatic and mainland influences had ousted earlier images of the divine.

Thus the meanings of the various religious scenes seem to converge in one direction and the absence in the repertoire of astral deities and

[1]The apparent exception of a late Minoan bead seal (*Palace of Minos*, II, Fig. 517) is un-Cretan in that the figure shows one pendulous breast only, like the Mycenaean example, Karo, *Schachtgraeber* . . . Karo tentatively links this peculiar feature with the equally un-Cretan myth of the Amazones.

of a solar god need no longer astonish us. It is justified up to a point to interpret this as a peculiarly primitive trait, since elsewhere in the ancient Near East speculative thought and a concern with moral and political problems developed almost exclusively in and around a theology preoccupied with sky and solar deities, as epitomizing transcendent order. We do not know the political implications of this Cretan 'primitiveness' because the structure of what was probably a hieratic social organization must so far remain obscure.

What concerns us here is not the possibly negative aspect of a one-sided religious orientation but its bearing on a unique artistic development. Cretan art ignored the terrifying distance between the human and the transcendent which may tempt man to seek a refuge in abstraction and to create a form for the significant remote from space and time; it equally ignored the glory and futility of single human acts, time-bound, space-bound. In Crete artists did not give substance to the world of the dead through an abstract of the world of the living, nor did they immortalize proud deeds or state a humble claim for divine attention in the temples of the gods. Here and here alone the human bid for timelessness was disregarded in the most complete acceptance of the grace of life the world has ever known. For life means movement and the beauty of movement was woven in the intricate web of living forms which we call 'scenes of nature'; was revealed in human-bodies acting their serious games, inspired by a transcendent presence, acting in freedom and restraint, unpurposeful as cyclic time itself.